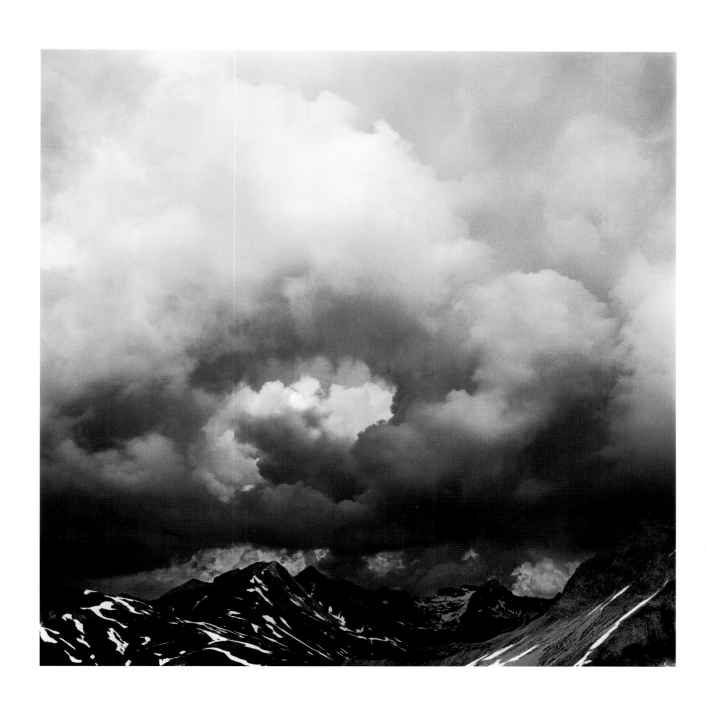

All photographs in this book are available
as limited edition fine-art prints.

For an overview of all photographs,
please see the index at the end of this book.

www.timhallphotography.com
www.teneues.com

TIM HALL

MOUNTAINS

BEYOND THE CLOUDS

To Fabulous Munirah

*a collection of mountain
landscapes for you to
meditate over*

with Best Wishes

2016.

teNeues

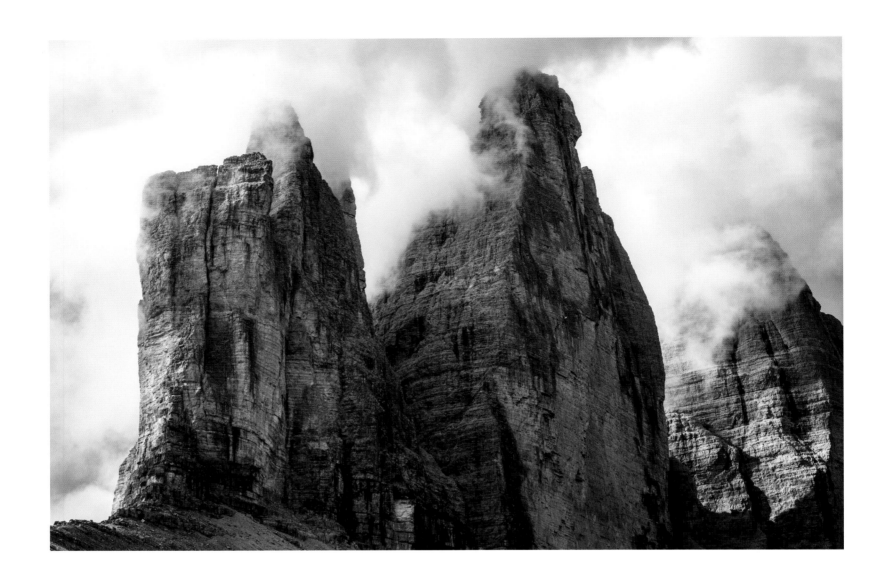

Beyond the Clouds

Sophie Benge

Tim Hall's photographs document his own grand tour through Europe's most famous mountains. In the spirit of artists and writers who have gone before, he has forged his own route through the peaks and valleys of the Alps from Chamonix in France, through the famous resorts of Switzerland and Austria to Cortina d'Ampezzo in Italy. *Mountains: Beyond the Clouds* charts his journey spanning eight years and multiple modes of transportation: on foot, skis, by car, helicopter, and train.

Tim's deep love for the mountains began on family ski holidays as a child. "It's only up here where I become acutely aware of all my senses all at once," he says. "The palpable silence, sense of freedom, and sheer awe at the drama of the landscape never cease to excite the photographer in me."

His work sensitively respects the majesty of the mountains that can quickly morph into a mirage on the whim of the weather. He most likes to shoot not when the sun is high in the sky, but when the mist curls over the ridge, allowing him to capture a more ethereal image. "I believe that less visual information creates more impact. I want the viewer to go into their own reverie beyond what is seen," he says.

Tim's choice of subject matter and keen eye for composition reflect the patterns and shapes that exist in nature. His square-format camera adds a sense of symmetry and space to his frame. The result is a cohesive oeuvre that straddles abstraction and reality, photography and painting. As Hubert Schwärzler, the former head of tourism for Lech, Austria, commented, "Tim simply paints with his camera."

Yet alongside the romance, Tim's works convey his interest in man's mark on the mountainside. Serene distant peaks contrast with tracks in the snow, the chaos of criss-crossing lifts and streaks of skiers. He purposefully chooses his vantage point—be it an aerial view from a helicopter or a distant take of climbers trudging up an incline—to explore the fragile relationship between the natural world and those that venture within it.

After 40 years of skiing Tim still marvels at his experiences on the slopes. "Once I've fitted my helmet and pulled down my goggles, I feel very much alone in my own space, yet in this vast space, too. It's pure meditation." This resonates in his photographs, collated here in *Beyond the Clouds*.

Jenseits der Wolken

Sophie Benge

Tim Halls Fotografien dokumentieren seine große Reise durch die bekanntesten Gebirgslandschaften Europas. Auf den Spuren von Künstlern und Schriftstellern längst vergangener Tage sucht er sich seine eigene Route über die zerklüfteten Pässe und durch die malerischen Täler der Alpen, vom französischen Chamonix in die exklusiven Wintersportresorts der Schweiz, über Österreich bis ins italienische Cortina d'Ampezzo. *Mountains: Beyond the Clouds* illustriert über einen Zeitraum von acht Jahren diese Reise mit diversen Fortbewegungsmitteln: zu Fuß, auf Ski, per Auto, im Hubschrauber oder mit der Eisenbahn.

Schon als Kind, während eines Skiurlaubs mit der Familie, packte Tim die Leidenschaft für die Berge. „Nur hier oben kann ich mir all meiner Sinne zugleich bewusst werden", erklärt er. „Die beeindruckende Stille, das Gefühl von Freiheit und die schiere Ehrfurcht vor der dramatischen Landschaft begeistern immer wieder den Fotografen in mir."

Auf einfühlsame Weise berücksichtigen seine Arbeiten, wie sich die erhabene Würde der Berge durch einen Wetterumschwung schnell als Trugbild herausstellen kann. Am liebsten fotografiert er nicht etwa, wenn die Sonne hoch am Himmel steht, sondern wann immer die Nebelschwaden über die Kämme kriechen und es ihm ermöglichen, ein ätherisches Bild einzufangen. „Ich glaube, dass die Wirkung beeindruckender ist, wenn es weniger visuelle Information gibt, und ich wünsche mir, dass der Betrachter des Bildes in seinen eigenen Traum entführt wird – weit über das hinaus, was sichtbar ist", so Tim.

Die von ihm ausgesuchten Motive und sein hervorragender Blick für eine gelungene Bildkomposition reflektieren die Muster und Formen der Natur. Seine Mittelformatkamera verleiht dem Bildausschnitt ein Gefühl für Symmetrie und Tiefe. Das Ergebnis ist ein in sich geschlossenes Werk, das eine Brücke vom Abstrakten zum Realen schlägt, vom Gemälde zur Fotografie. Hubert Schwärzler, der ehemalige Leiter des Tourismusbüros im österreichischen Lech, hat es so ausgedrückt: „Tim malt mit seiner Kamera."

Aber jenseits aller Romantik vermitteln Tims Arbeiten auch sein Interesse an den menschlichen Spuren im Gebirge. Erhabene Gipfel in der Ferne bilden einen Kontrapunkt zu den Fußabdrücken im Schnee, den Drahtseilen der Skilifte, die sich kreuz und quer über die Abhänge ziehen, und den streifenförmigen Bahnen, die Skifahrer hinterlassen haben. Er wählt die Perspektive für ein Foto mit Bedacht – sei es eine Luftaufnahme aus dem Hubschrauber oder ein weit entferntes Motiv mit Bergwanderern, die sich an einem steilen Hang in die Höhe arbeiten –, um das empfindliche Gleichgewicht zwischen der Natur und den Menschen, die sich in sie hinauswagen, auszuloten.

Nach vierzig Jahren Erfahrung als Skifahrer staunt Tim nach wie vor über seine Erlebnisse am Hang. „Sobald ich den Schutzhelm aufsetze und die Brille über die Augen ziehe, fühle ich mich ganz allein – sowohl in meiner unmittelbaren Umgebung als auch in diesem unermesslich großen Raum. Es ist die reinste Meditation." Seine hier zusammengetragenen Fotos spiegeln dieses Gefühl wider – *Beyond the Clouds*.

Au-delà des nuages

Sophie Benge

Par ses photographies, Tim Hall documente les plus célèbres massifs de son périple européen. S'inspirant des artistes et écrivains qui l'ont précédé, il s'est tracé un itinéraire propre par les monts et vallées des Alpes, de Chamonix (France) à Cortina d'Ampezzo (Italie), en passant par les célèbres stations de ski suisses et autrichiennes. *La montagne : Au-delà des nuages* témoigne d'un voyage de huit ans effectué avec différents modes de transport : à pied, à skis, en voiture, en hélicoptère et en train.

Tim s'est pris de passion pour la montagne enfant, lors de vacances aux sports d'hiver en famille. « C'est là que je prends pleinement conscience de tous mes sens, déclare-t-il. Le silence palpable, la sensation de liberté et le profond respect inspiré par la dramaturgie du paysage ne cessent d'exalter le photographe en moi. »

Son travail est un hommage délicat à la majesté des montagnes qu'un caprice météo peut vite muer en mirage. Ce qu'il préfère, ce n'est pas photographier lorsque le soleil est au zénith, mais lorsque la brume enveloppe les crêtes, pour saisir une image plus éthérée. « Je crois que l'impact est plus fort avec moins d'informations visuelles. Je veux que le spectateur s'abandonne à ses rêveries au-delà du visible ».

Son choix de thèmes et son sens aigu de la composition reflètent les motifs et formes de la nature. Son appareil moyen format carré introduit symétrie et espace dans ses clichés. Le résultat est une œuvre intégratrice reliant abstraction et réalité, photographie et peinture. Comme l'a dit Hubert Schwärzler, ancien directeur de l'office du tourisme de Lech (Autriche), « C'est comme si Tim peignait avec son appareil. »

Outre de l'amour de la montagne, le travail de Tim témoigne d'un intérêt pour l'empreinte de l'homme sur ce milieu. La sérénité des pics lointains contraste avec les traces dans la neige, le ballet des remontées mécaniques et les hordes de skieurs. Il choisit à dessein son panorama — une vue aérienne d'hélicoptère ou une prise au zoom de grimpeurs s'élevant péniblement — en vue d'explorer le lien fragile entre l'univers naturel et ceux qui s'y aventurent.

Skiant depuis 40 ans, Tim continue de s'émerveiller de ses expériences sur les pentes. « Une fois que j'ai enfilé mon casque et mes lunettes, je me sens très seul dans mon propre espace, à plus forte raison au milieu de ce vaste espace. C'est de la méditation pure. » Cela se reflète dans ses photographies, réunies ici dans *Au-delà des nuages*.

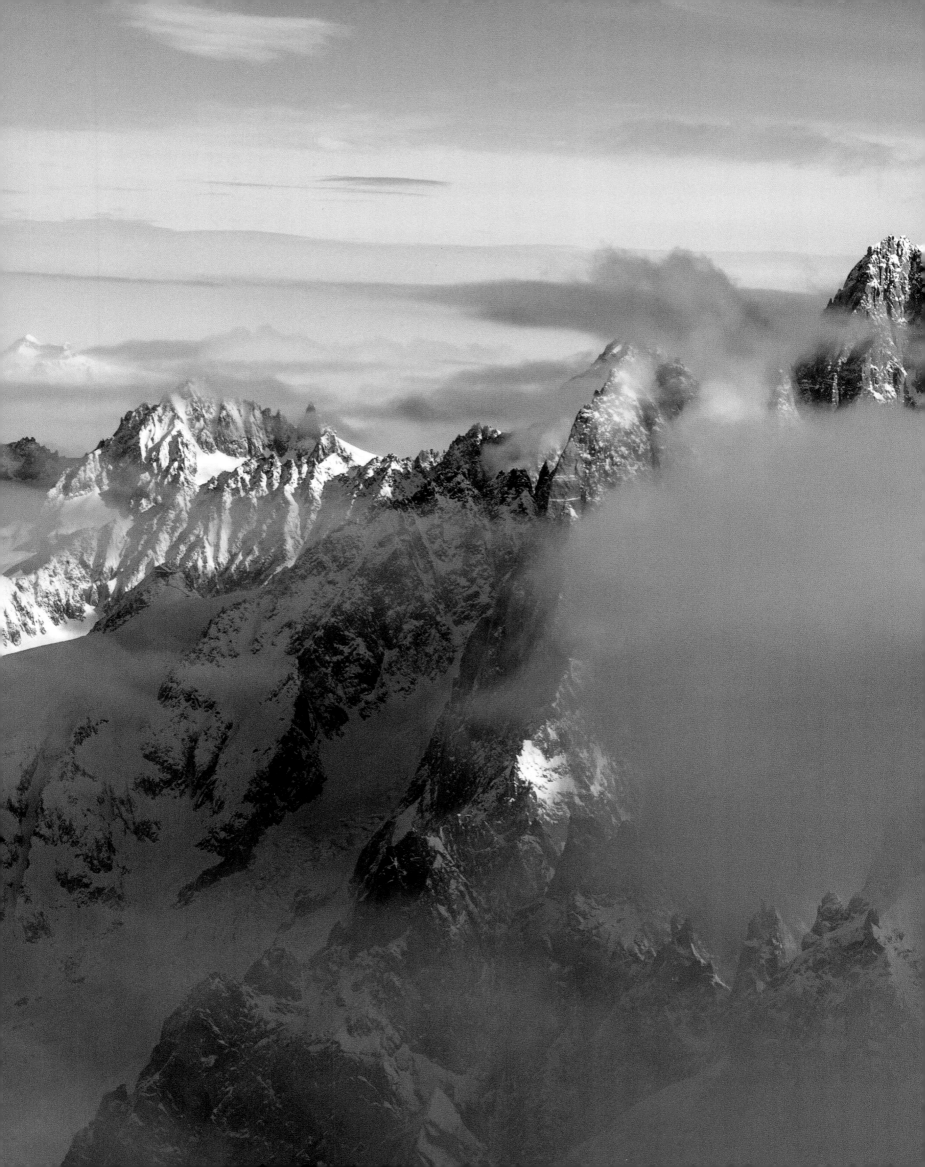

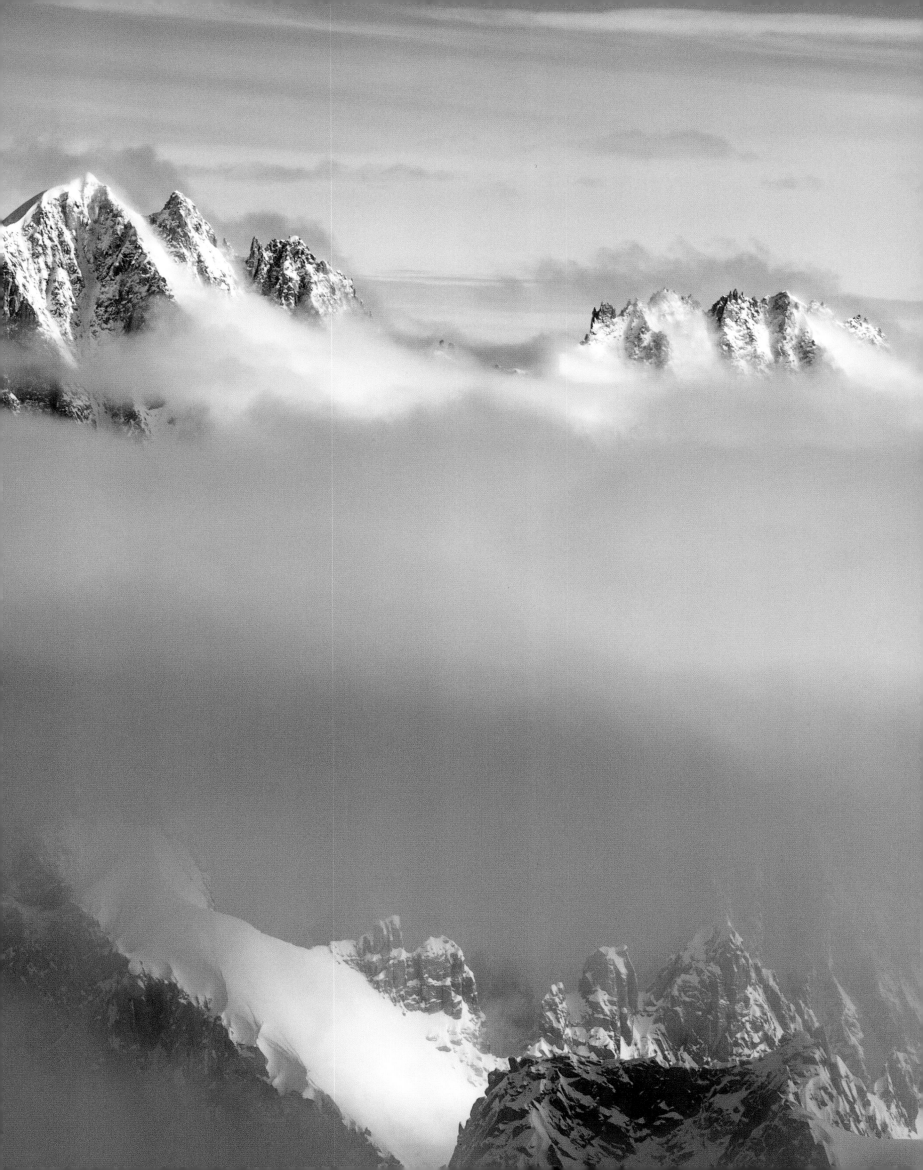

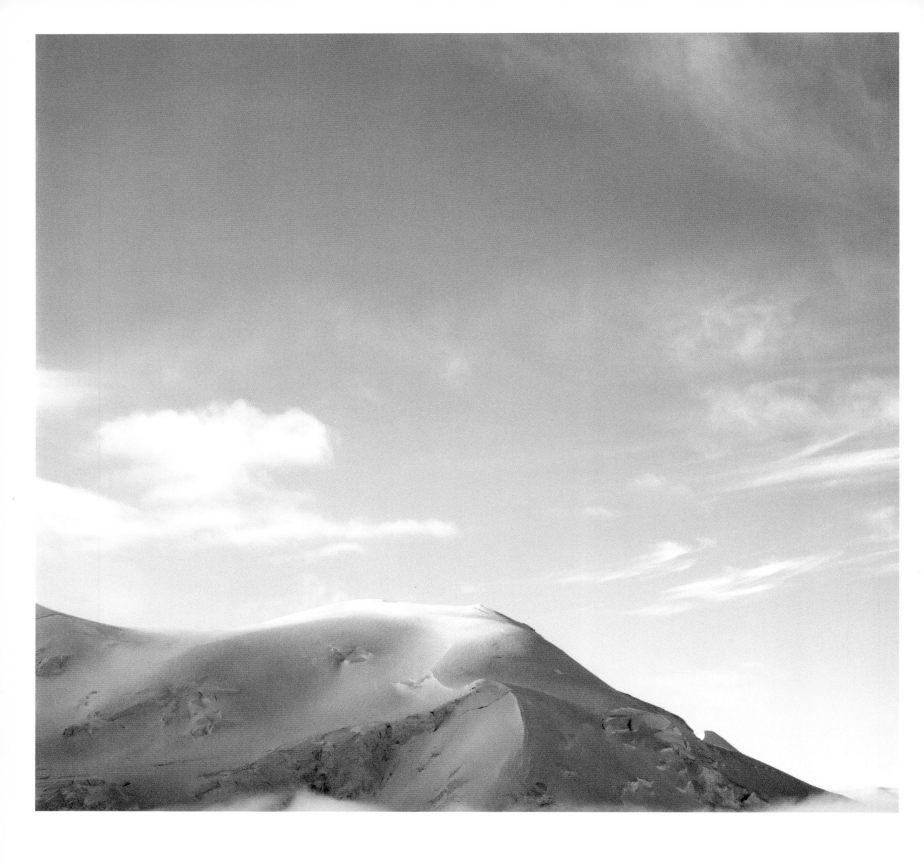

Dôme du Goûter, Haute-Savoie, France

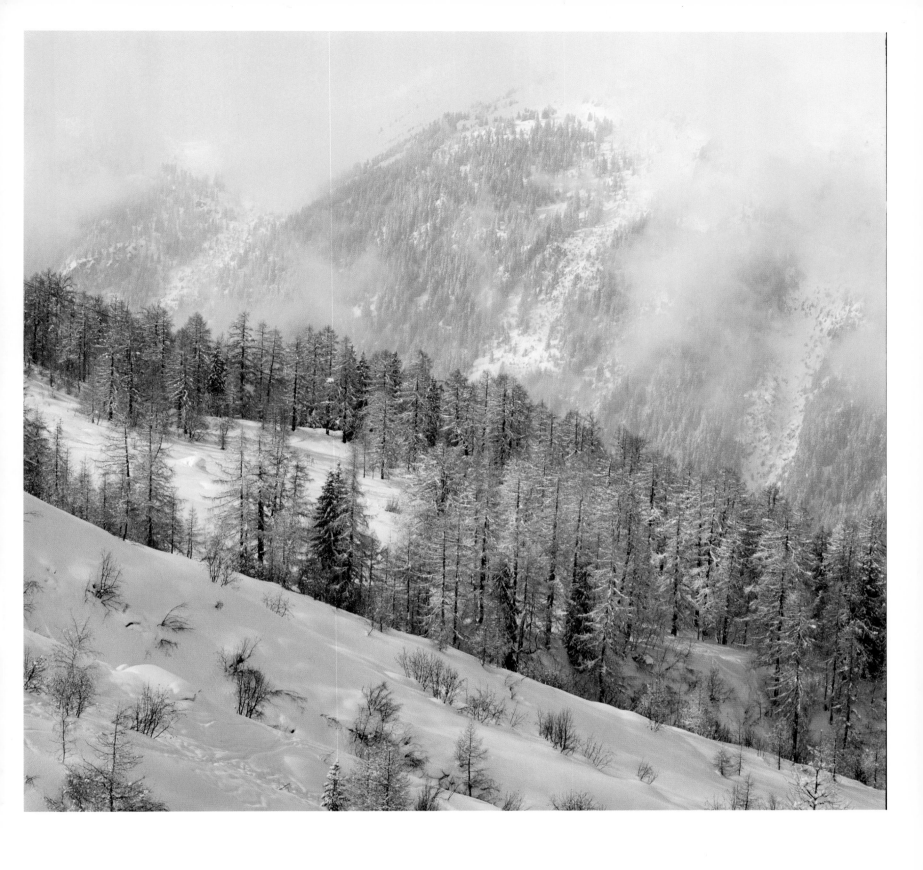

Argentière, Haute-Savoie, France

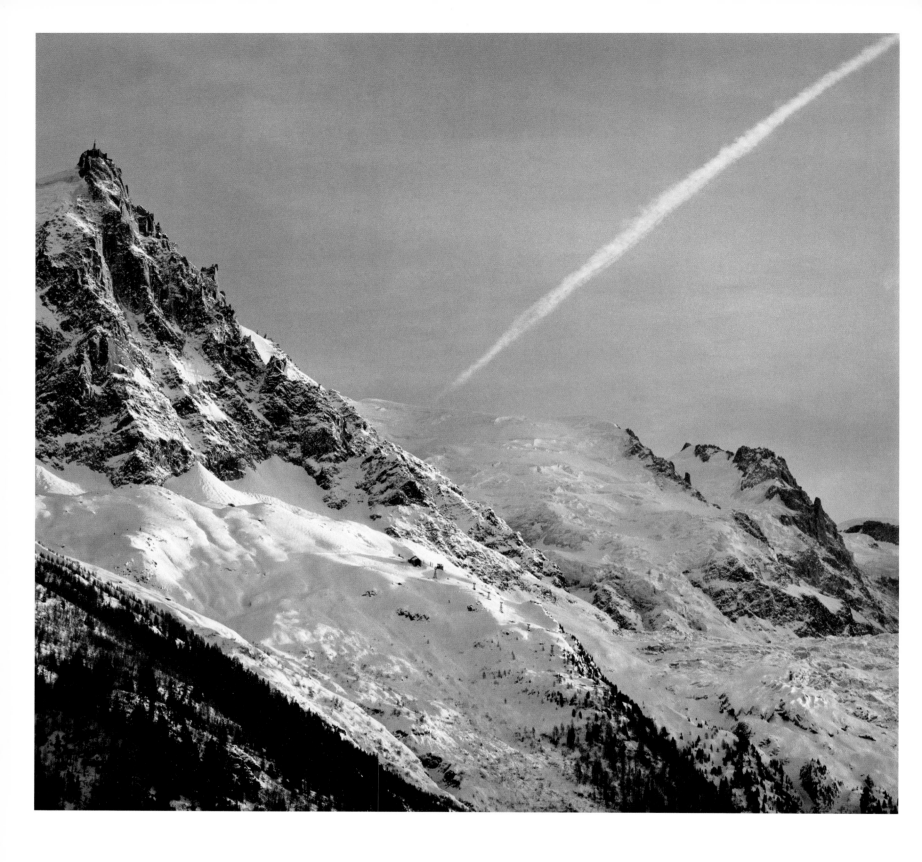

Aiguille du Midi, Chamonix, France — 12,605 ft | 3,842 m

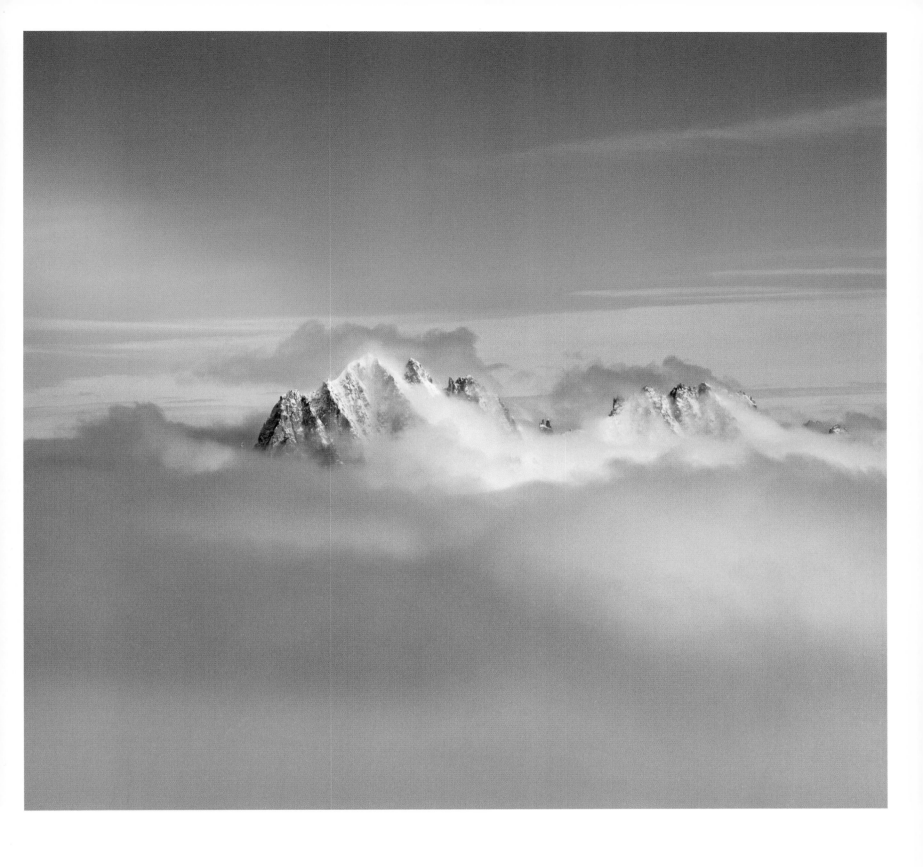

Aiguille Verte and Les Droites, Haute-Savoie, France

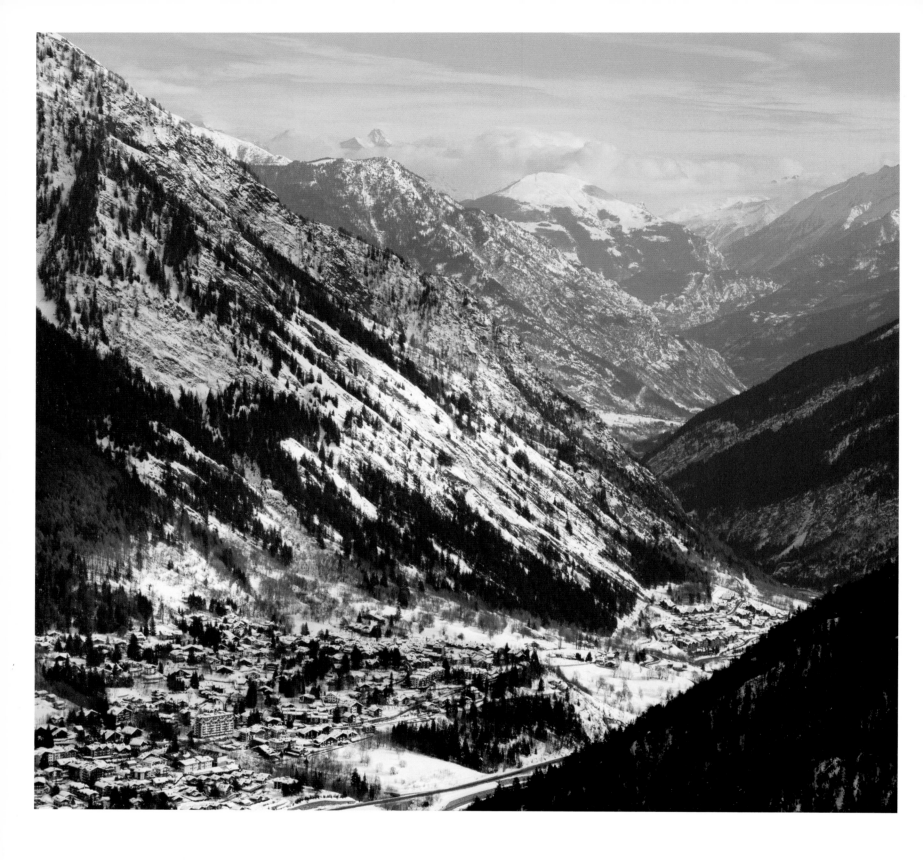

Valle d'Aosta, Cormayeur, Italy

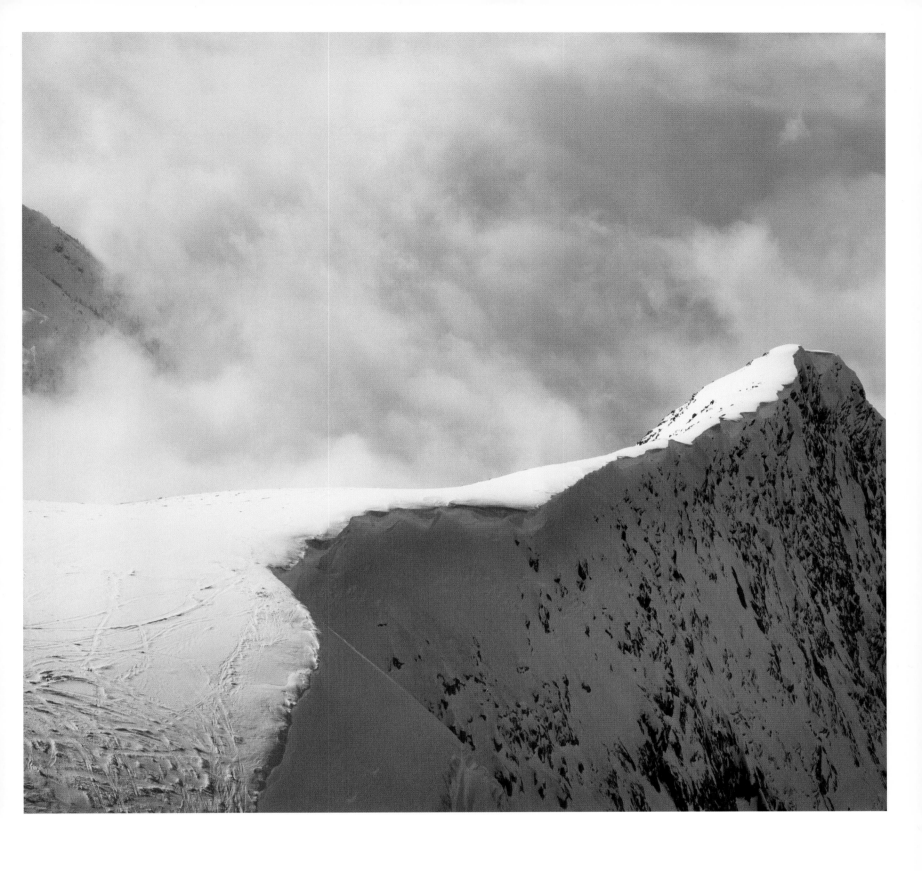

Grands Montets, Argentière, France

"One forgets that there are environments which do not respond to the flick of a switch or the twist of a dial, and which have their own rhythms and orders of existence. Mountains correct this amnesia."

Robert McFarlane (b. 1976), Travel Writer, *Mountains of the Mind: Adventures in Reaching the Summit.*

„Wir vergessen dabei, dass es Gegenden gibt, die nicht darauf reagieren, wenn ein Schalter umgelegt oder eine Wählscheibe gedreht wird, sondern ihre eigenen Rhythmen und Regeln haben. Die Berge korrigieren diese Amnesie.“

Robert McFarlane (*1976), Reiseschriftsteller, *Berge im Kopf: Die Geschichte einer Faszination.*

« On oublie qu'il existe des milieux que l'on ne peut influencer en appuyant sur un interrupteur ou en tournant un bouton, car ils ont leurs propres rythmes et hiérarchies. La montagne corrige cette amnésie. »

Robert McFarlane (né en 1976), rédacteur touristique, *Mountains of the Mind: Adventures in Reaching the Summit.*

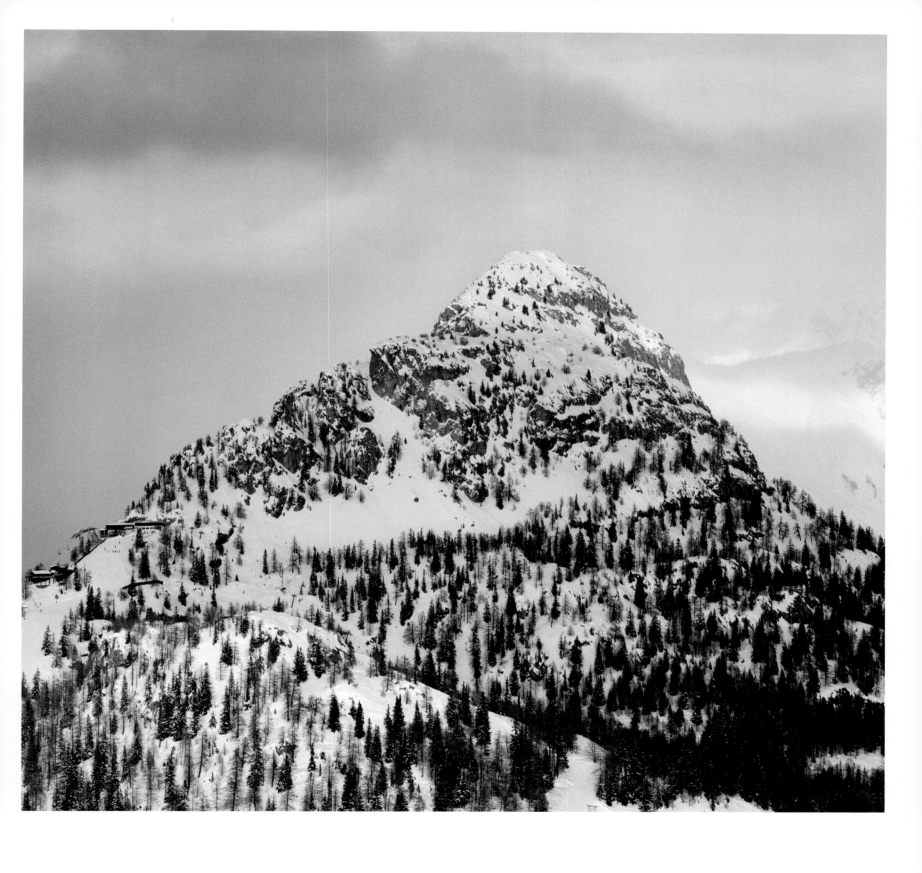

Valle d'Aosta, Cormayeur, Italy

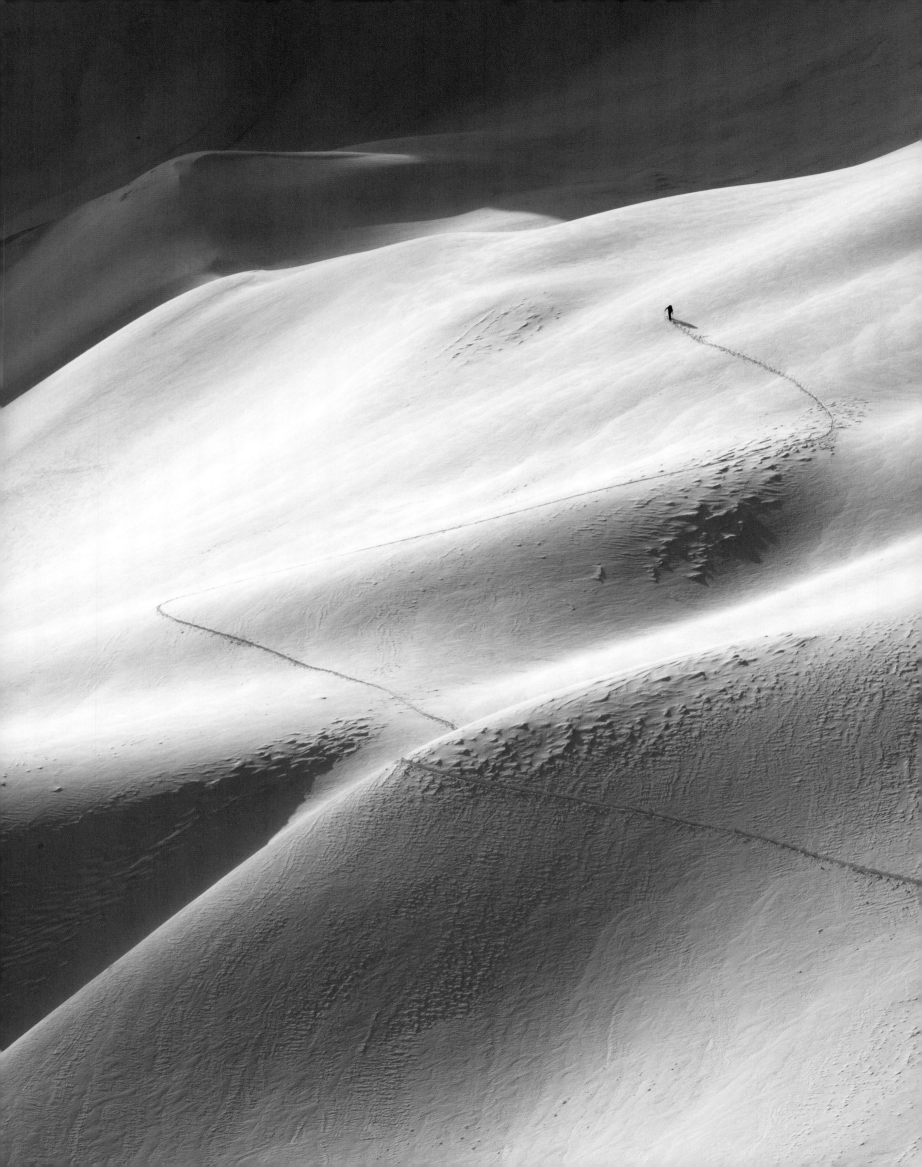

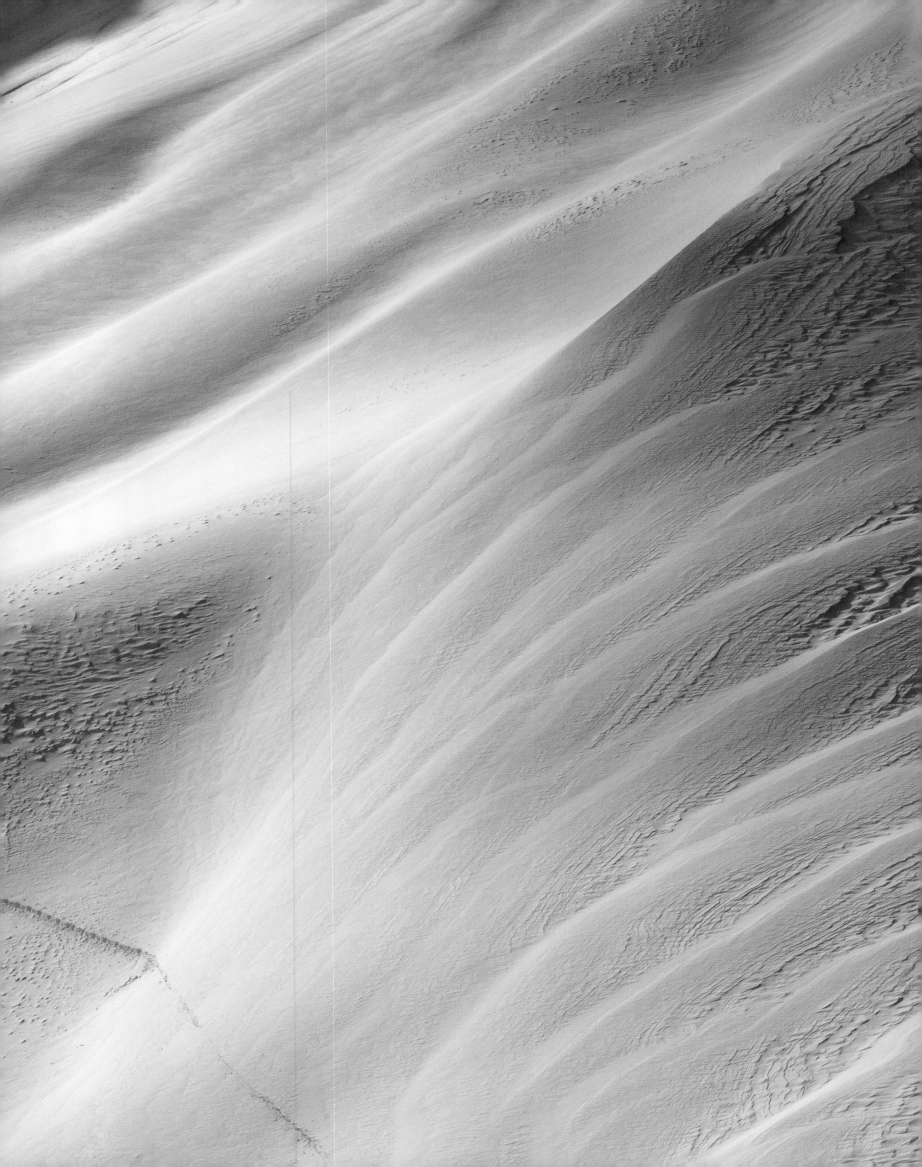

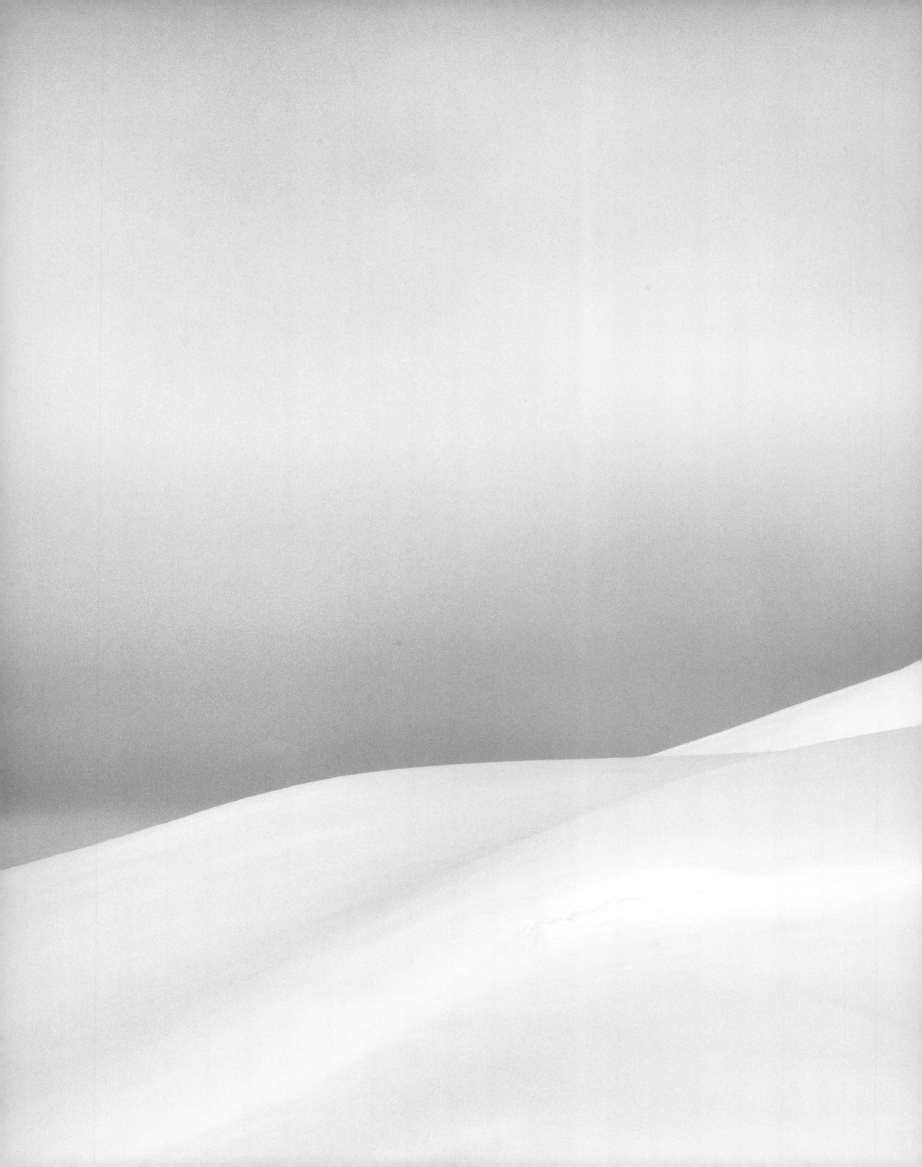

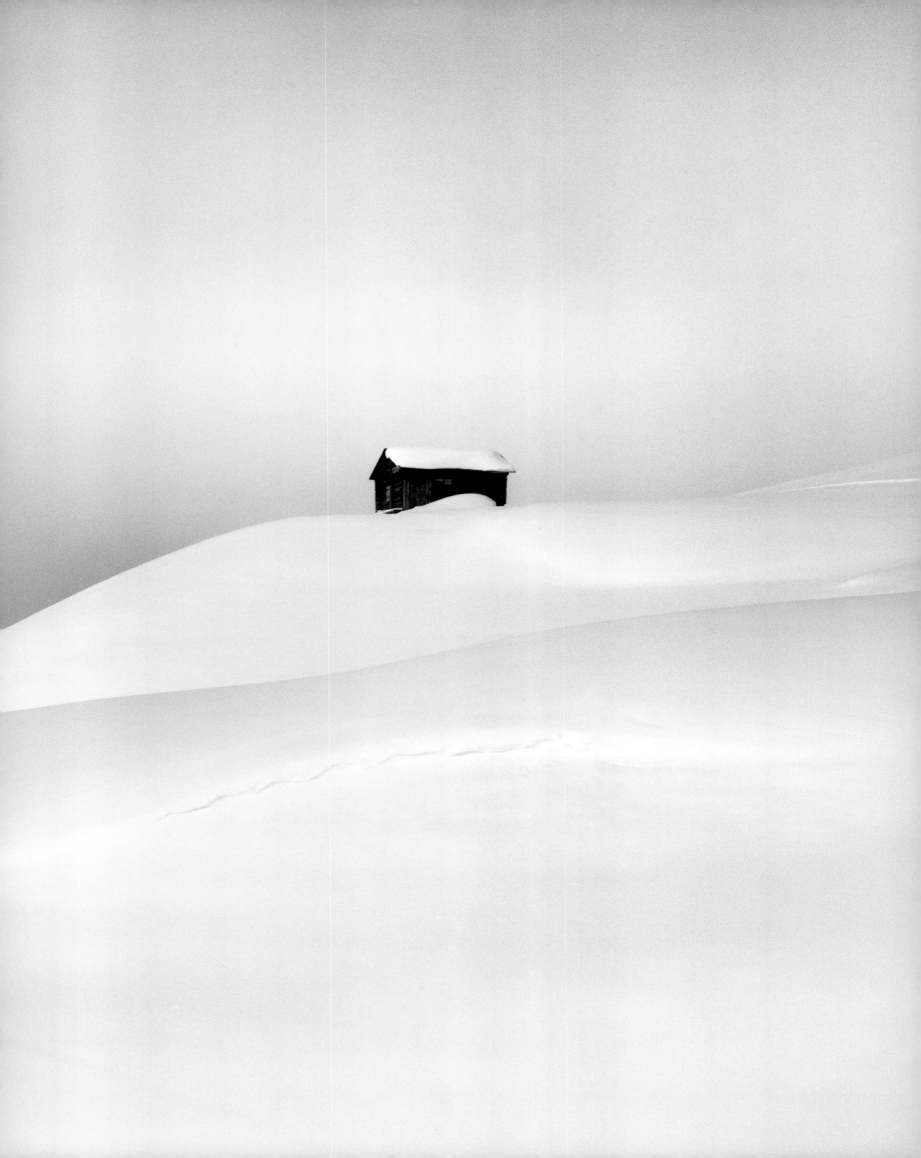

Attelas, Verbier, Switzerland

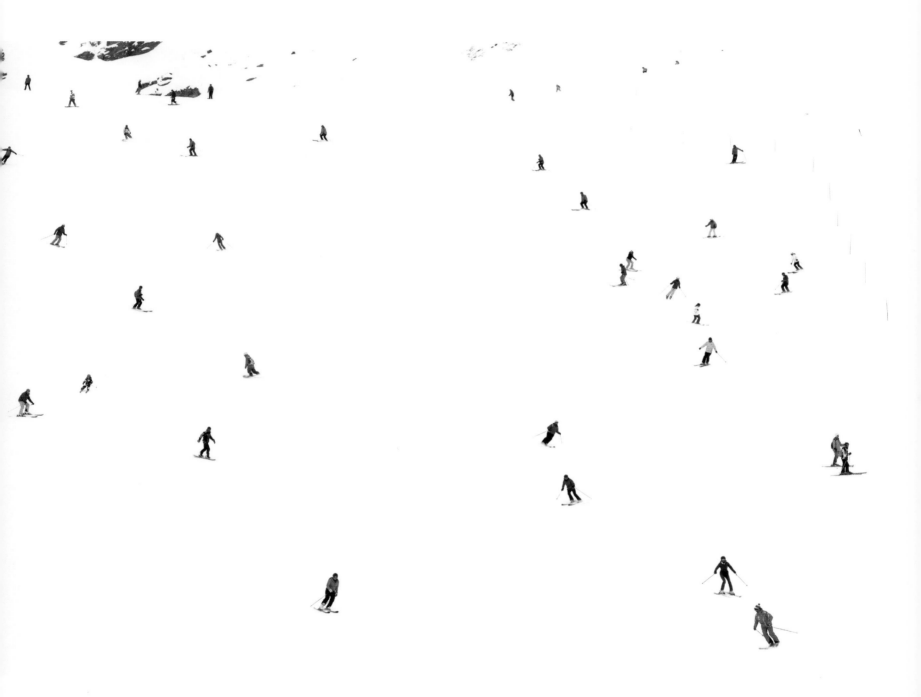

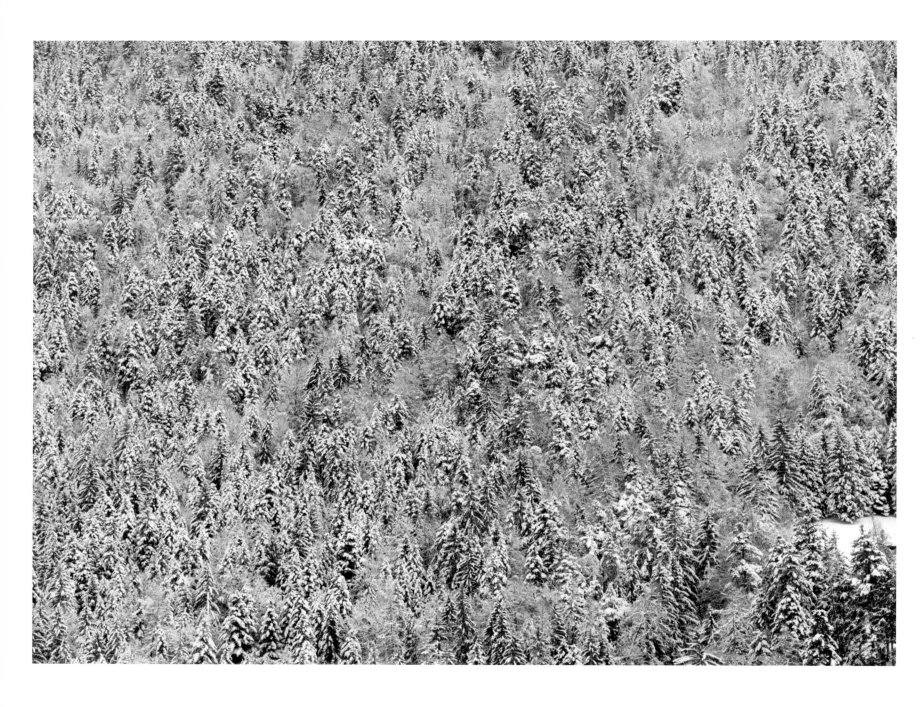

Verbier, Switzerland

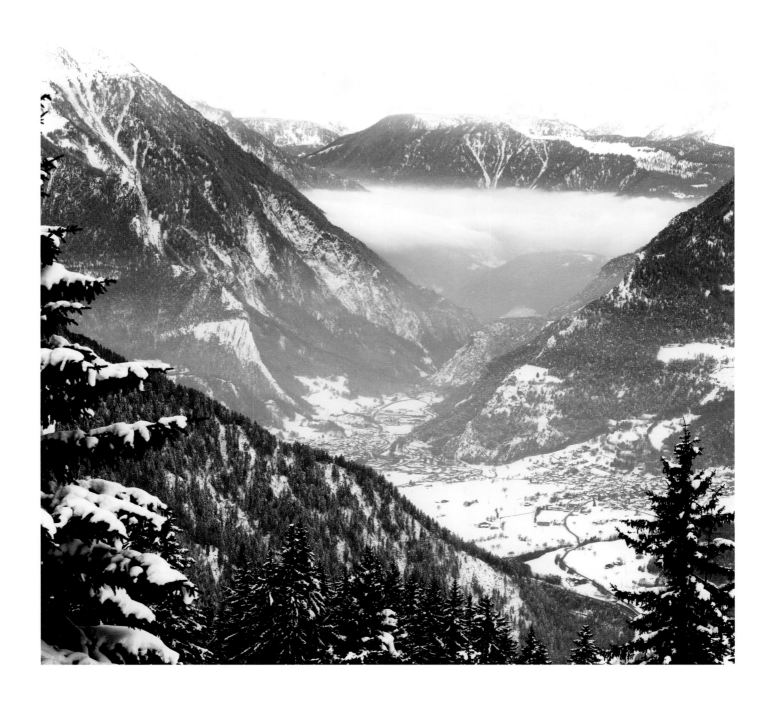

Les 4 Vallées, Switzerland

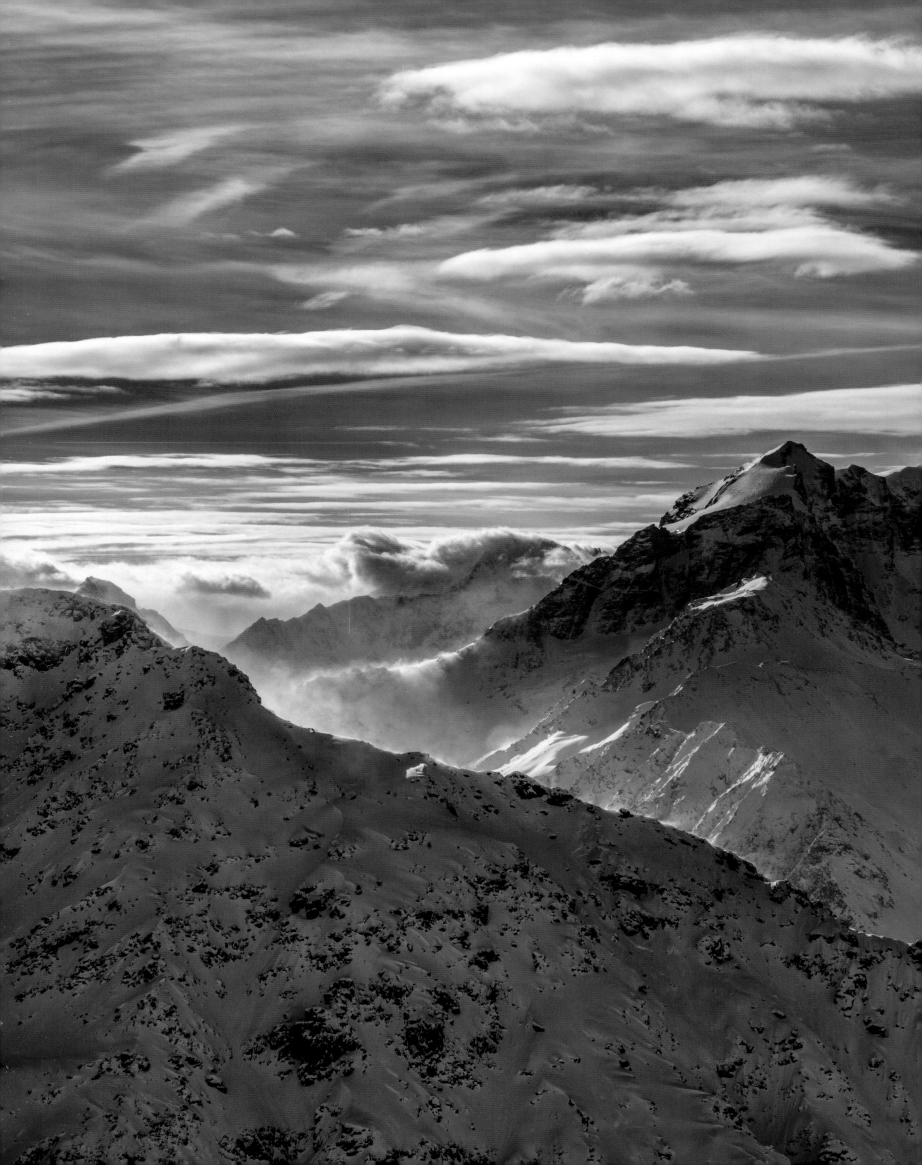

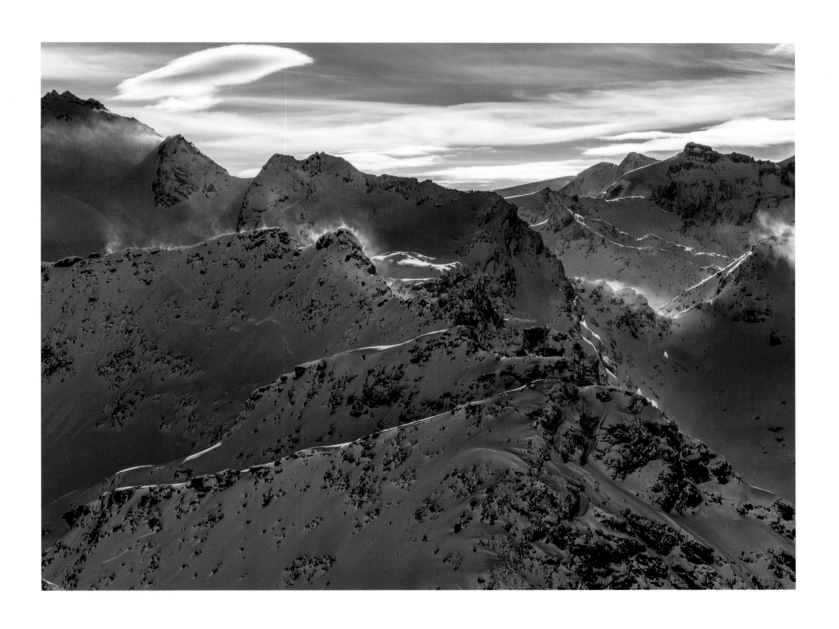

Bec des Rosses, Verbier, Switzerland

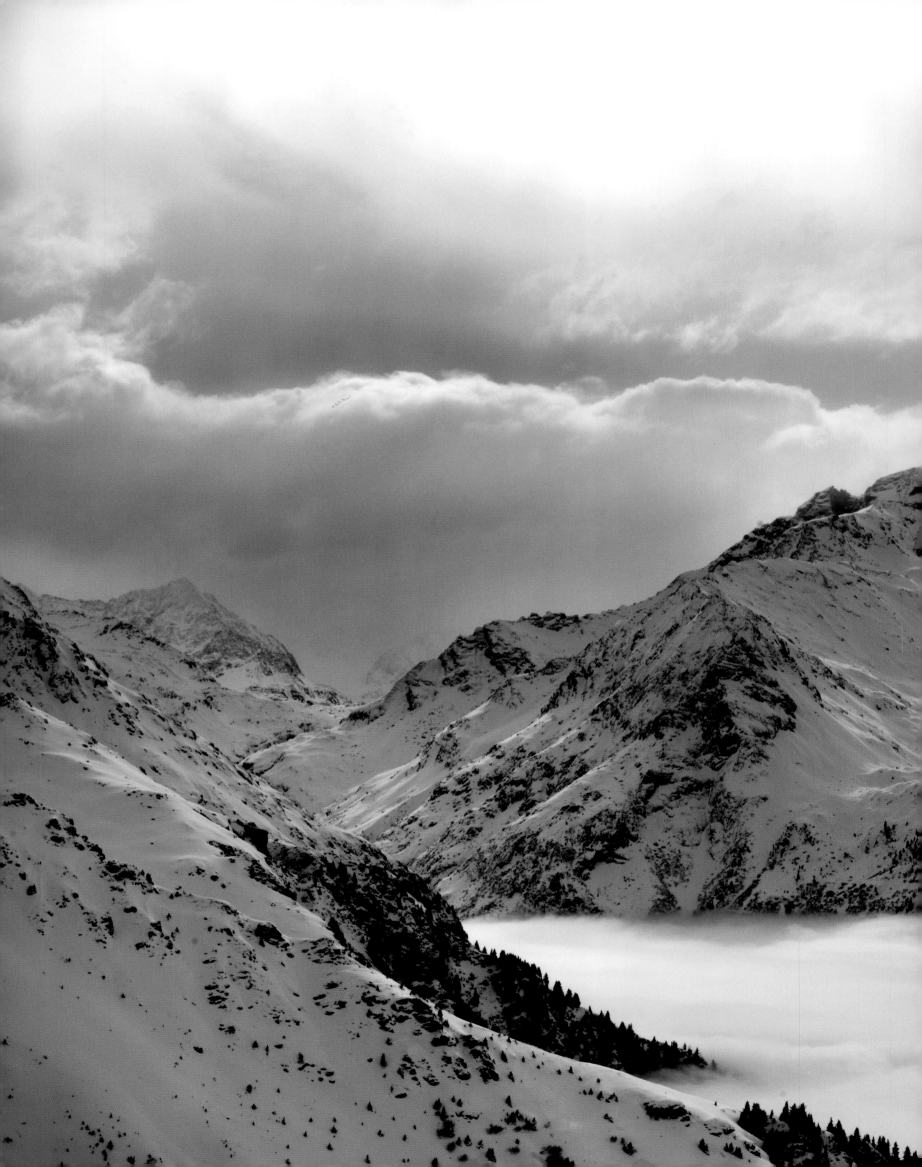

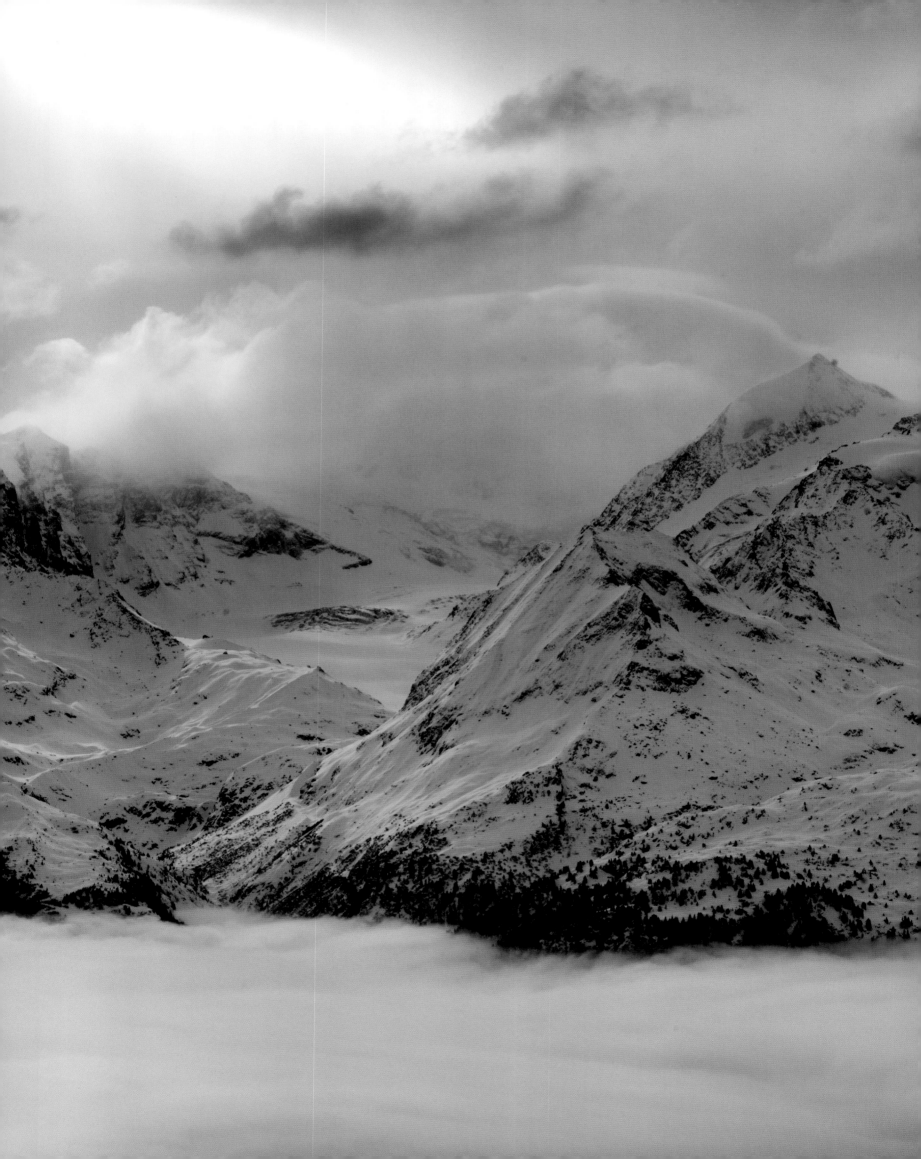

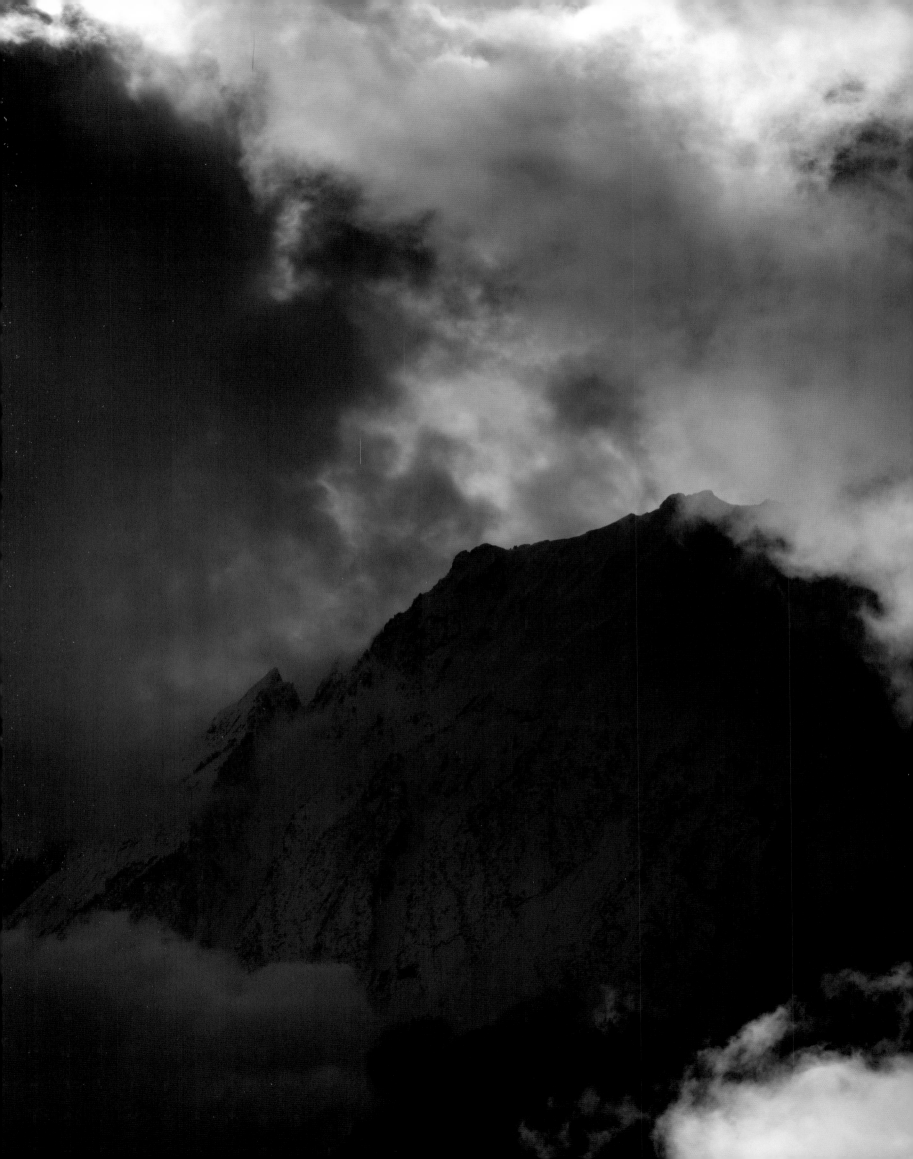

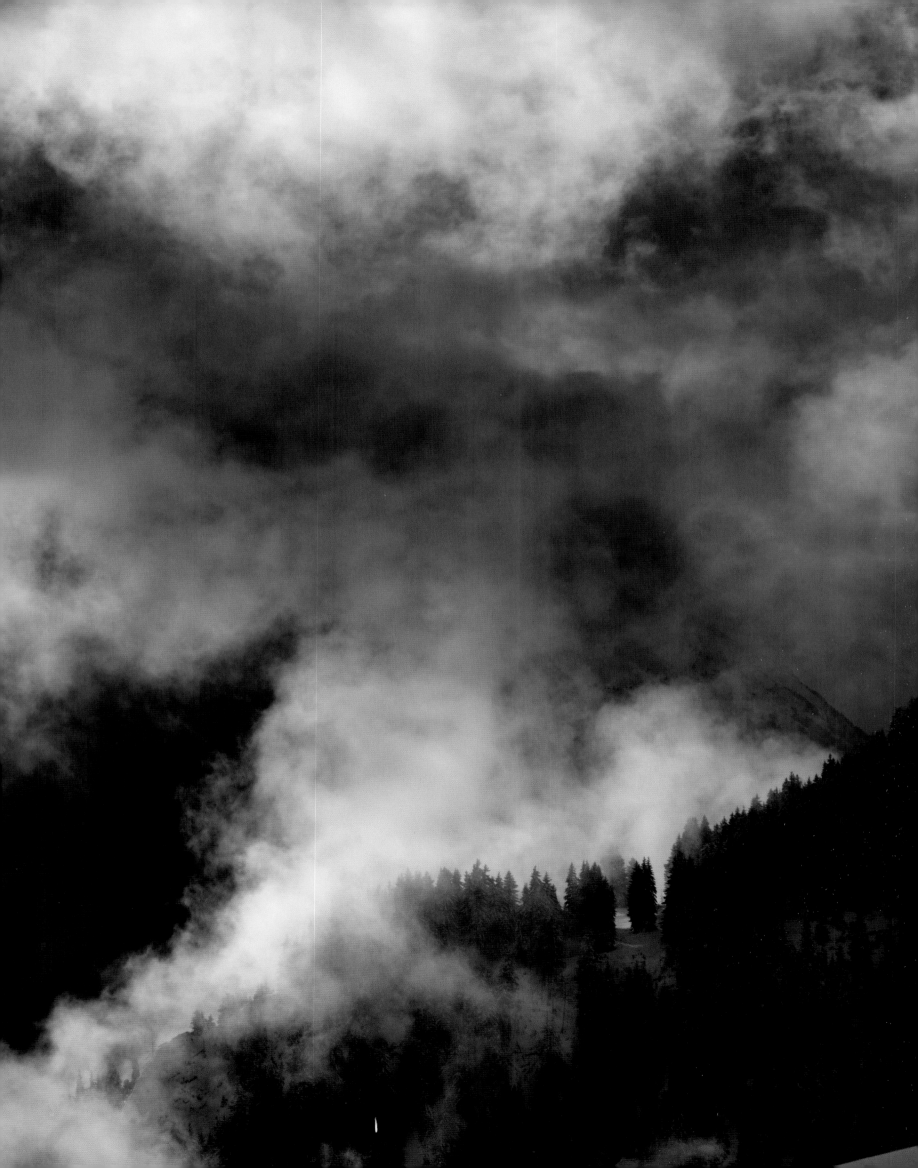

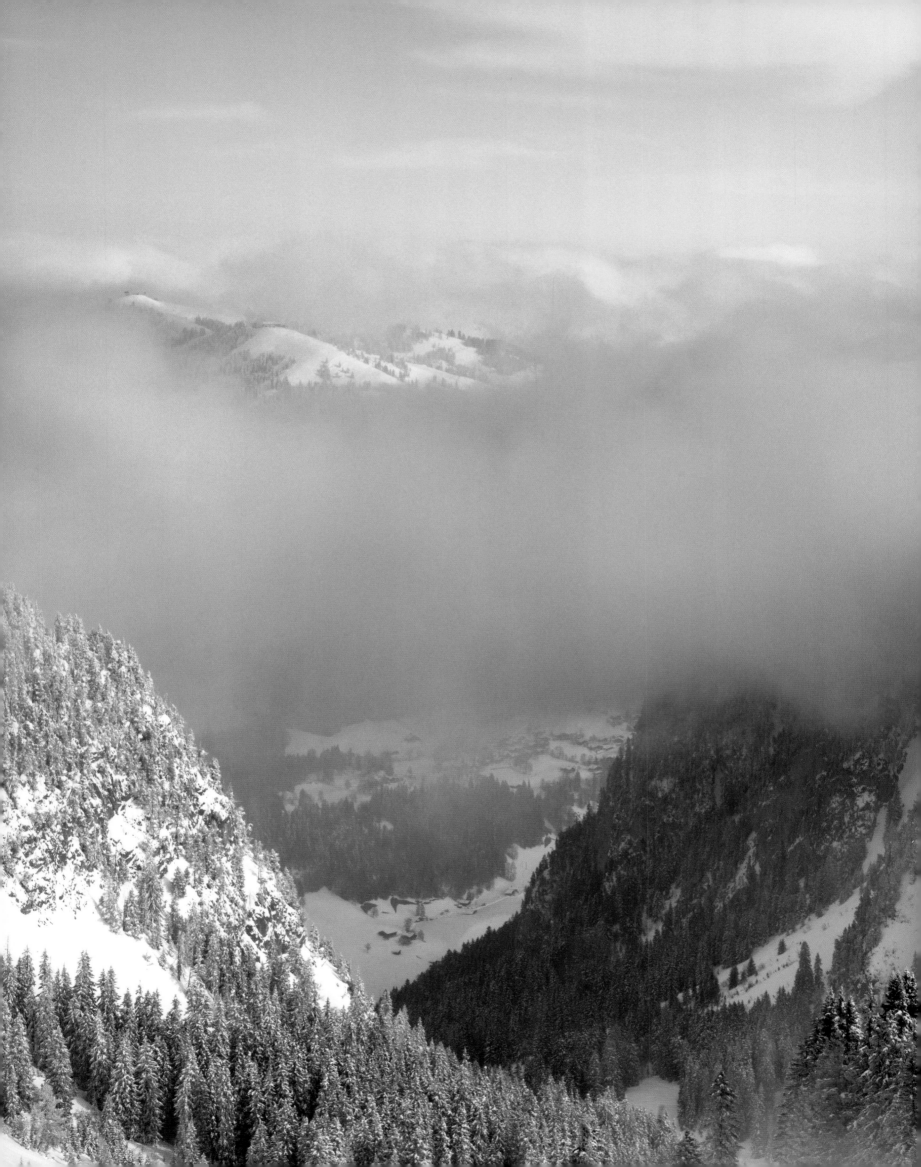

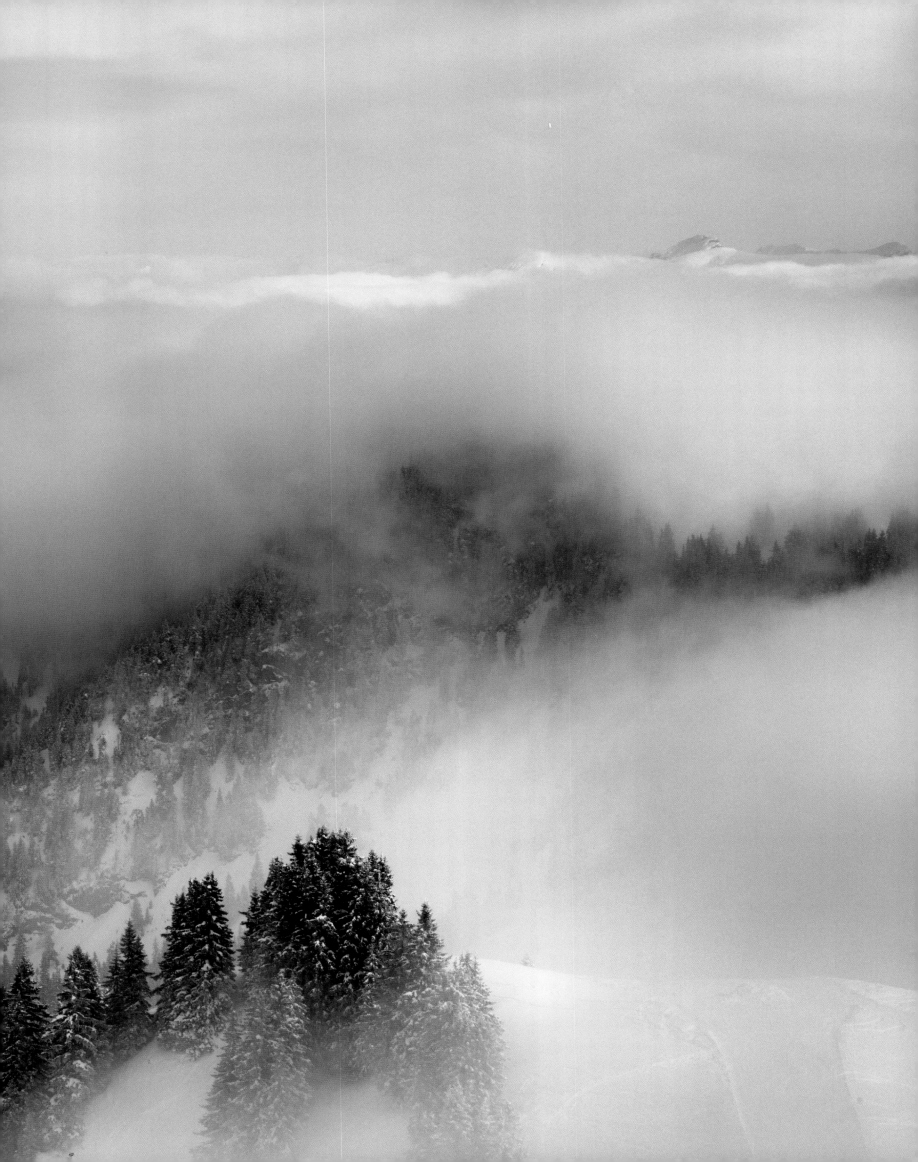

"Do not go where the path may lead,
go instead where there is no path and leave a trail."

Ralph Waldo Emerson (1803–1882), American essayist and poet

„Gehe nicht, wohin der Pfad dich führt; gehe stattdessen
dorthin, wo kein Pfad ist, und hinterlasse eine Spur."

Ralph Waldo Emerson (1803–1882), US-amerikanischer Essayist und Dichter

« N'allez pas où le chemin peut vous conduire, allez plutôt
là où il n'y a plus de chemin et laissez une trace. »

Ralph Waldo Emerson (1803–1882), essayiste et poète américain

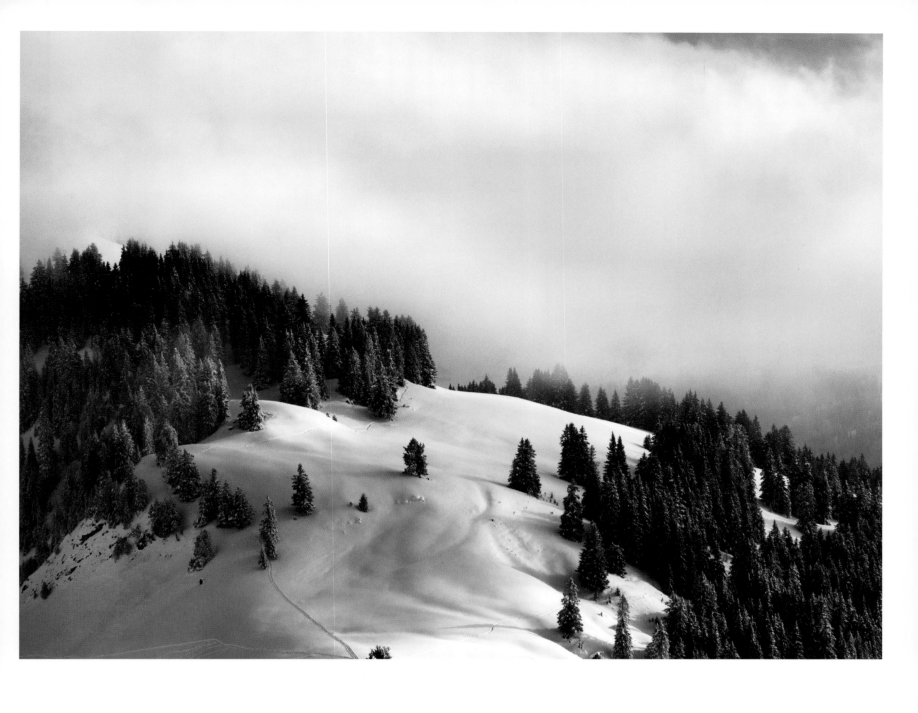

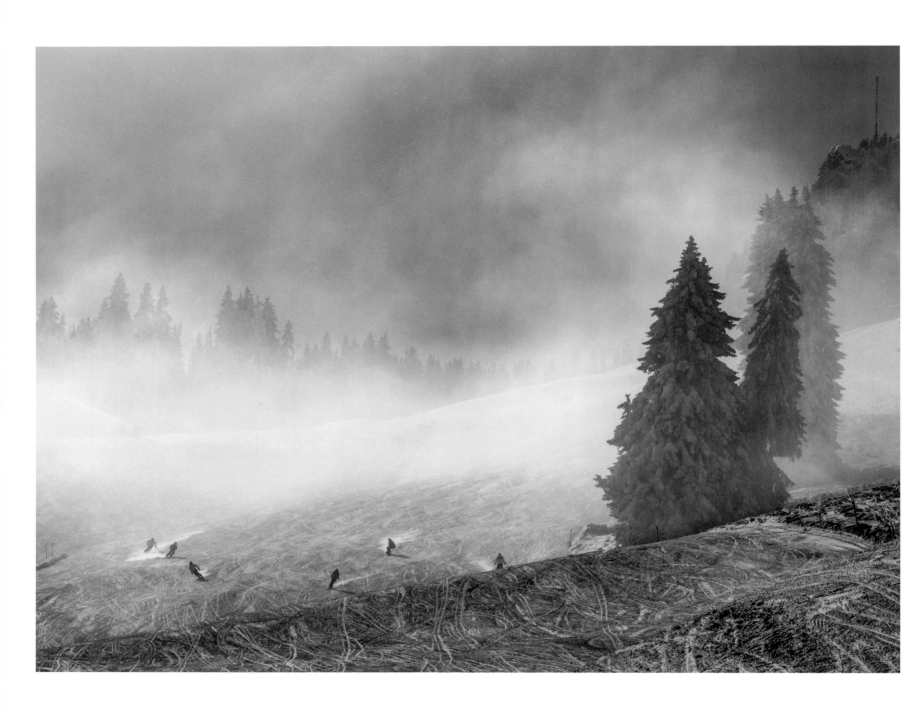

Saanersloch, Gstaad, Switzerland

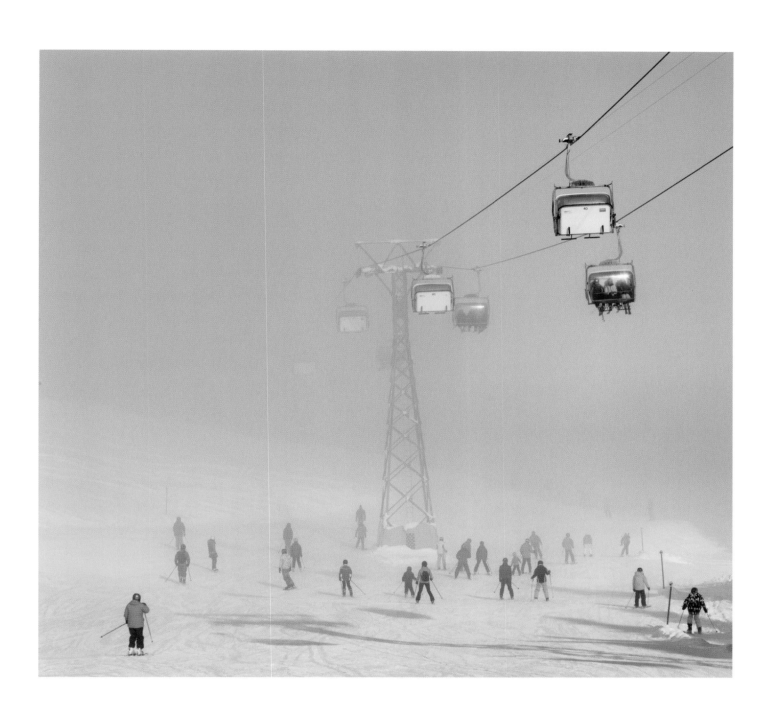

Hornberg, Gstaad, Switzerland

Les Gouilles, Chalberhöni, Gstaad, Switzerland

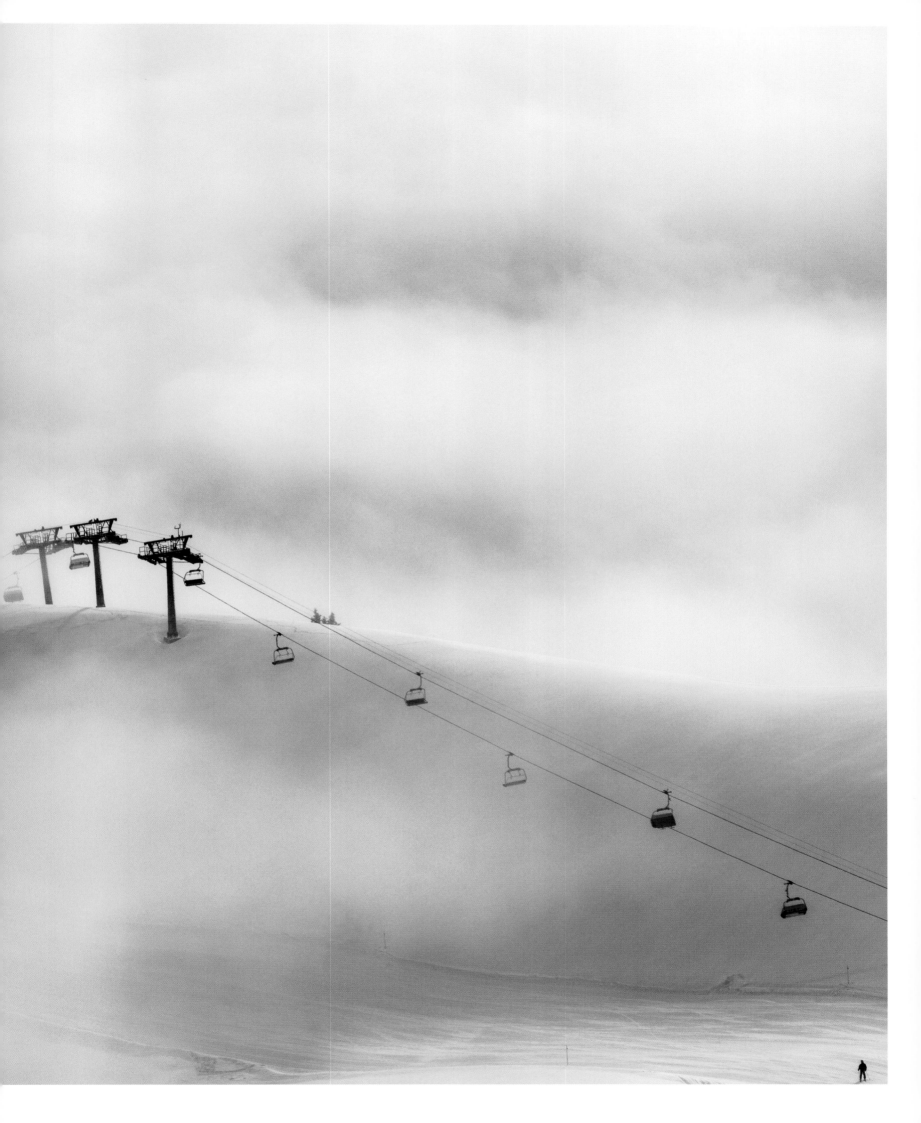

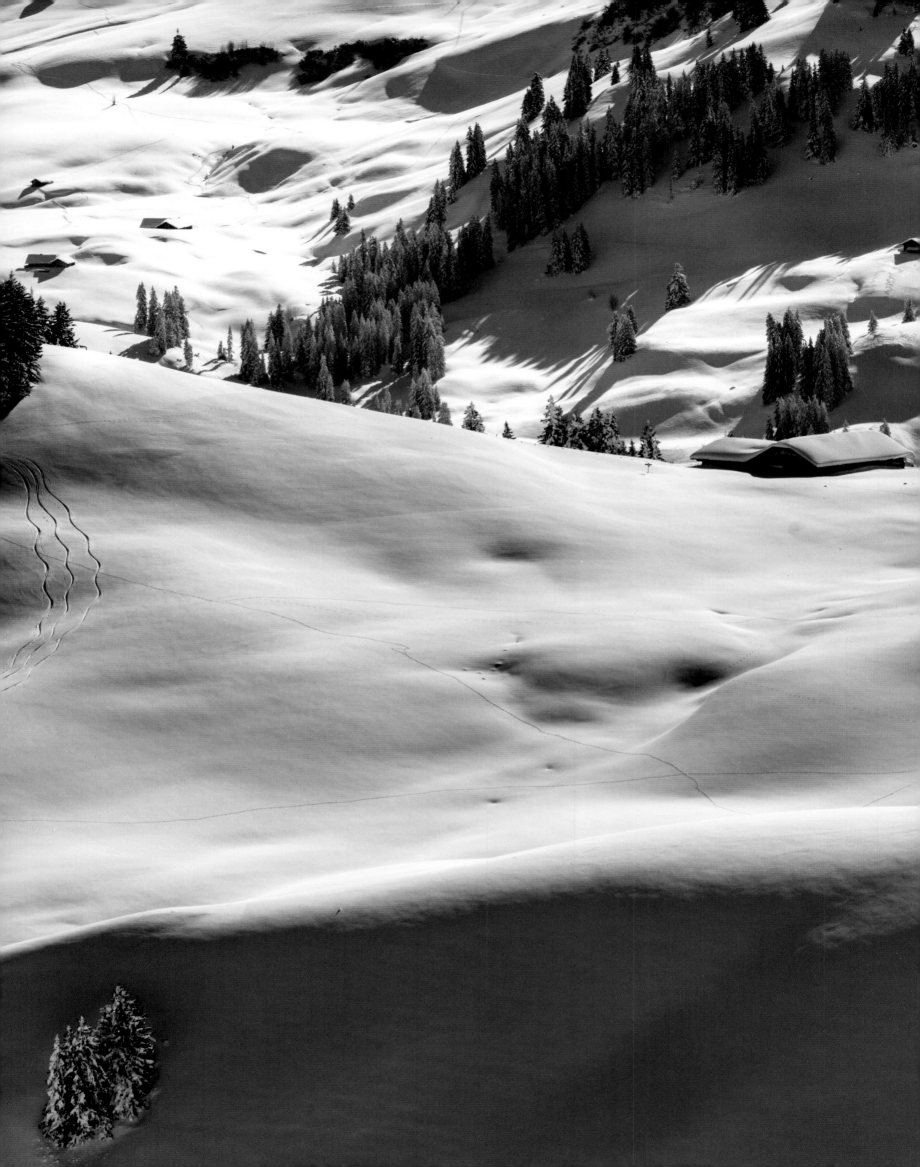

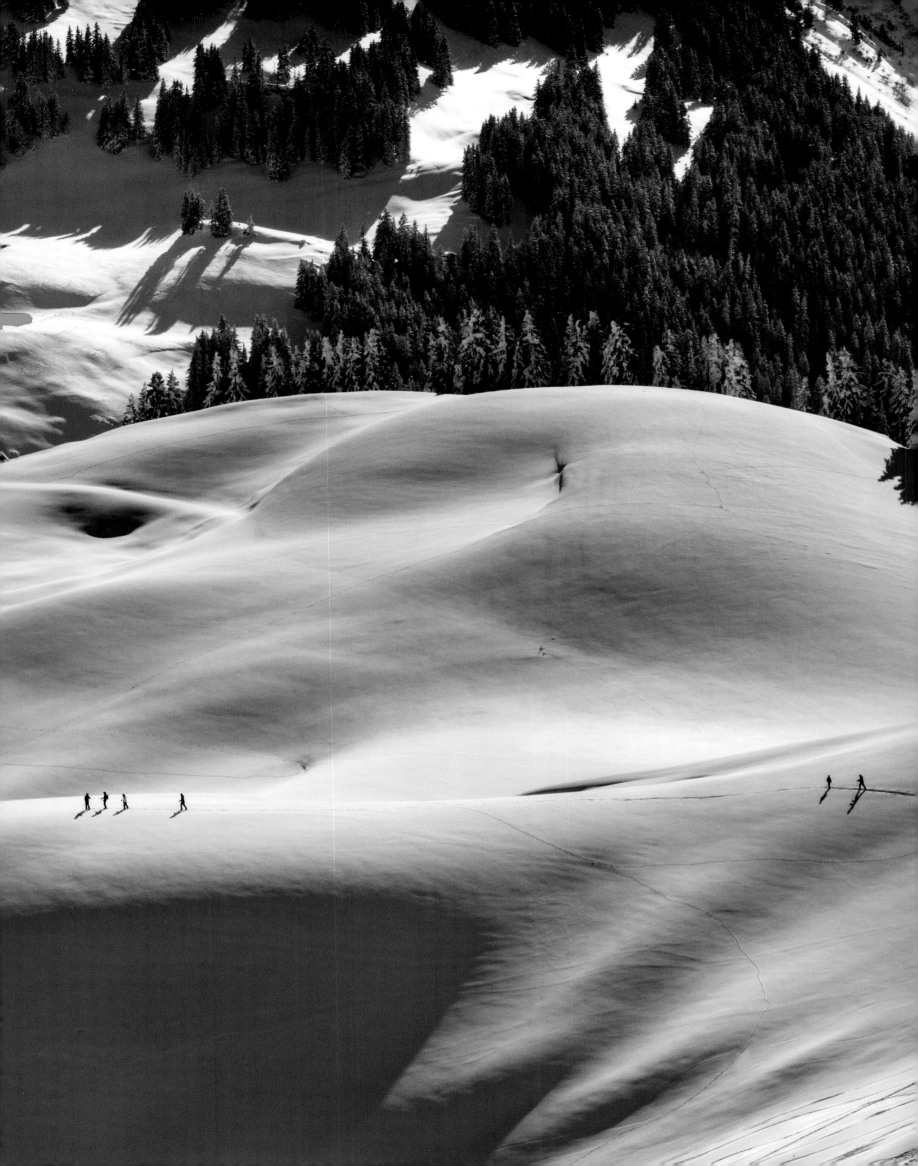

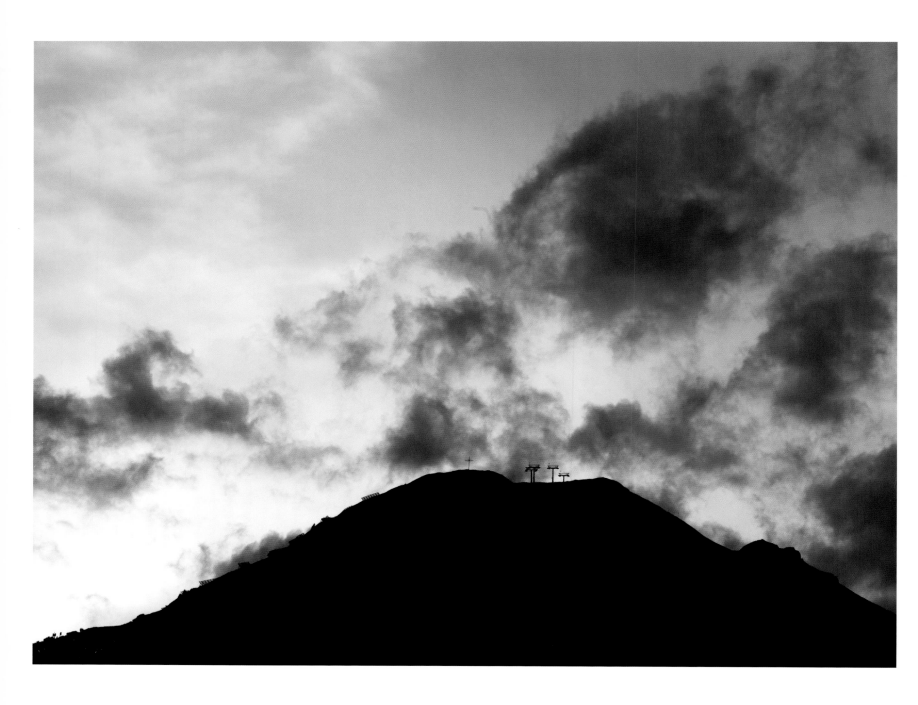

Lech, Austria

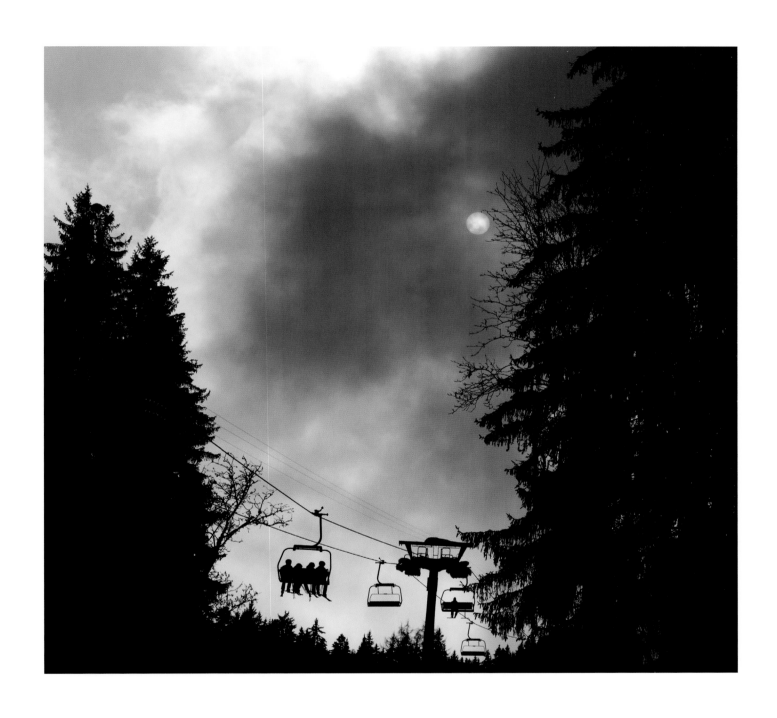

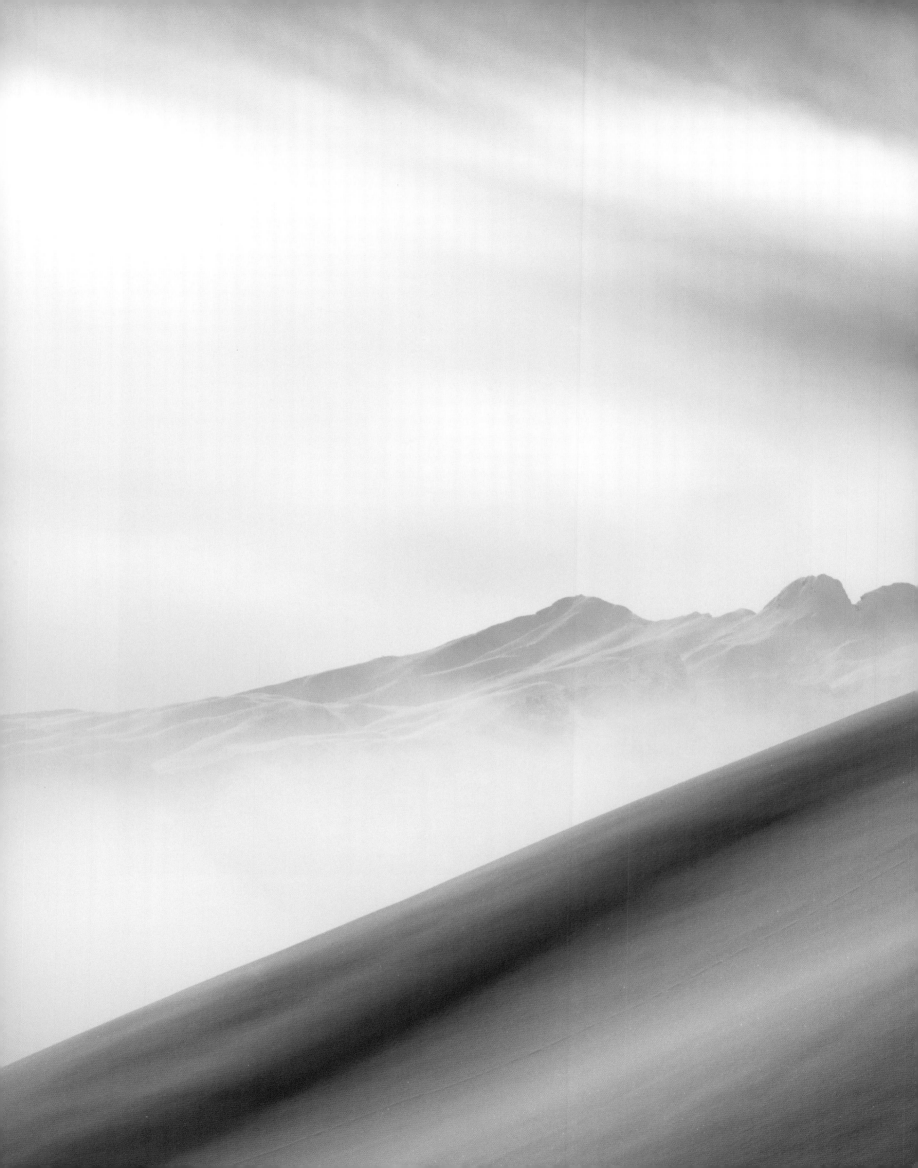

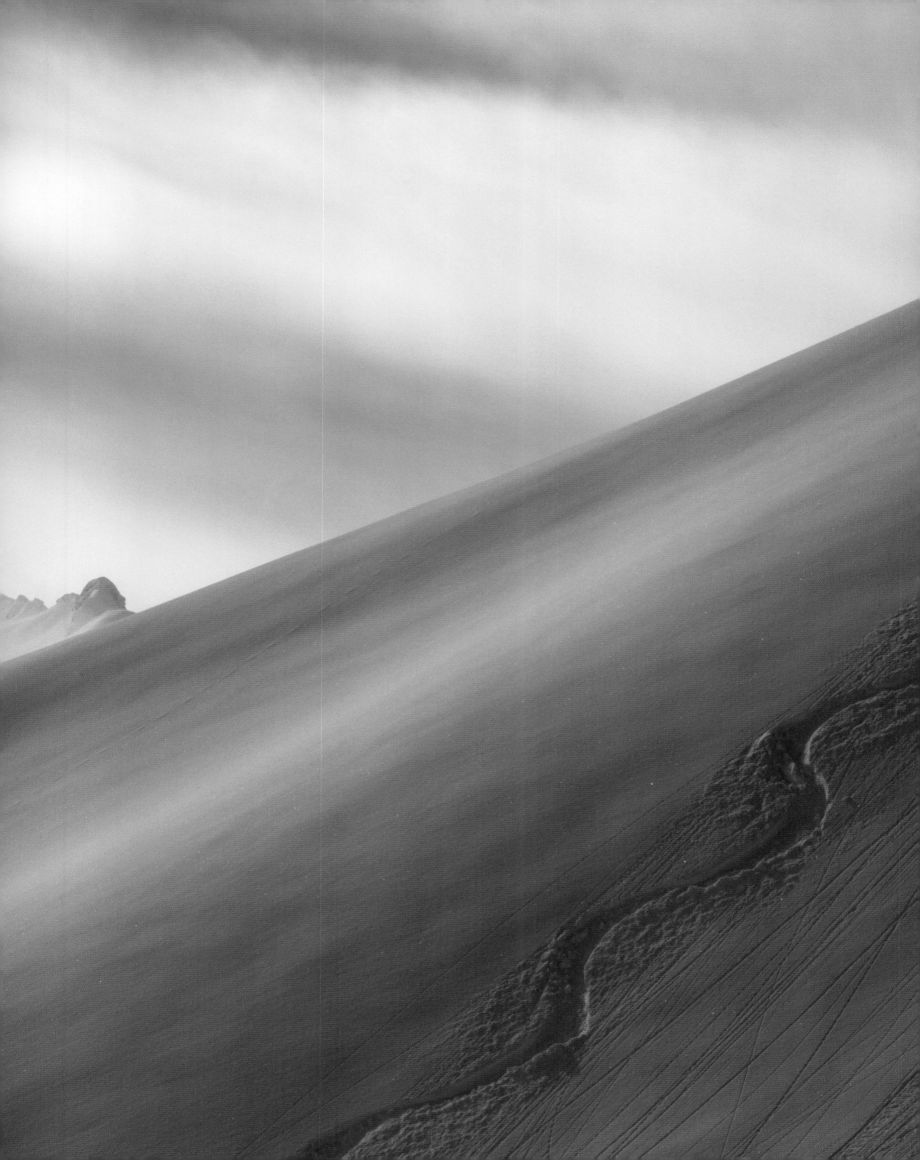

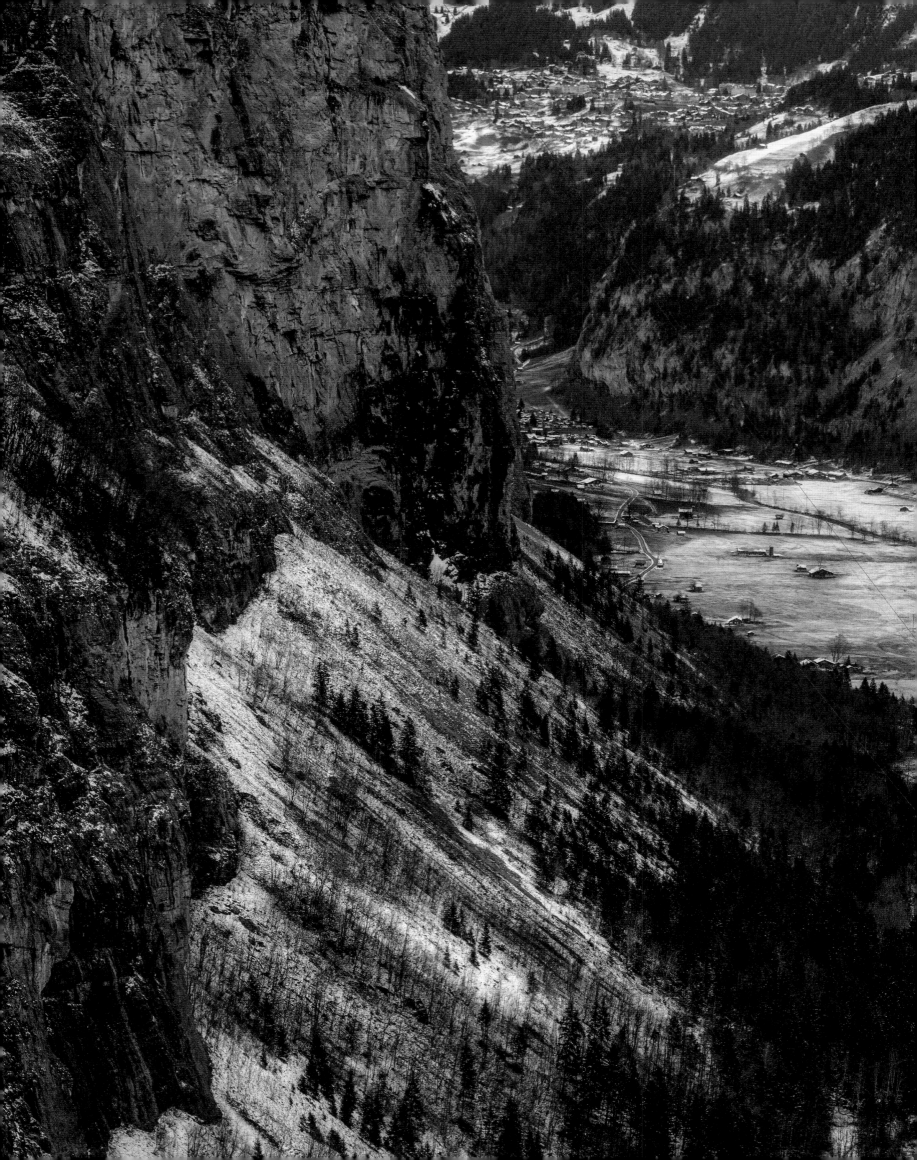

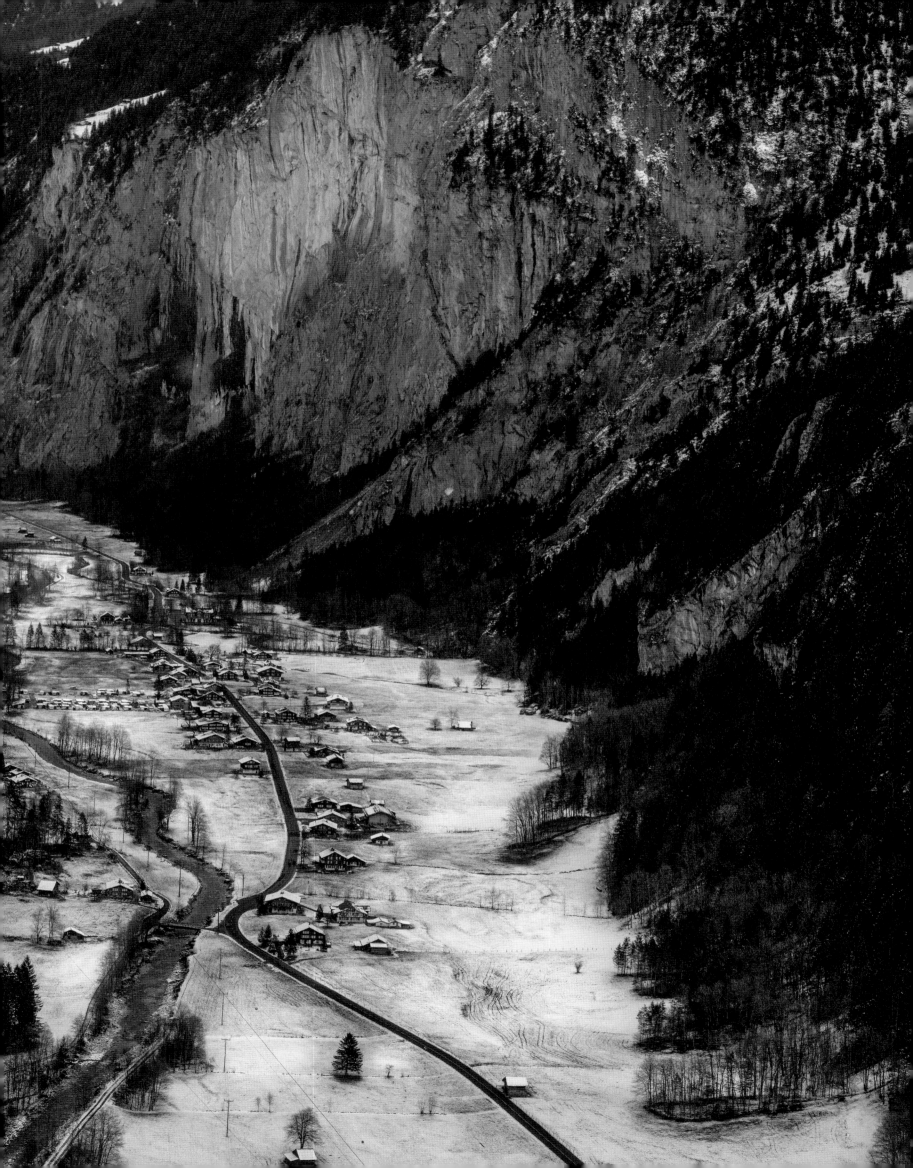

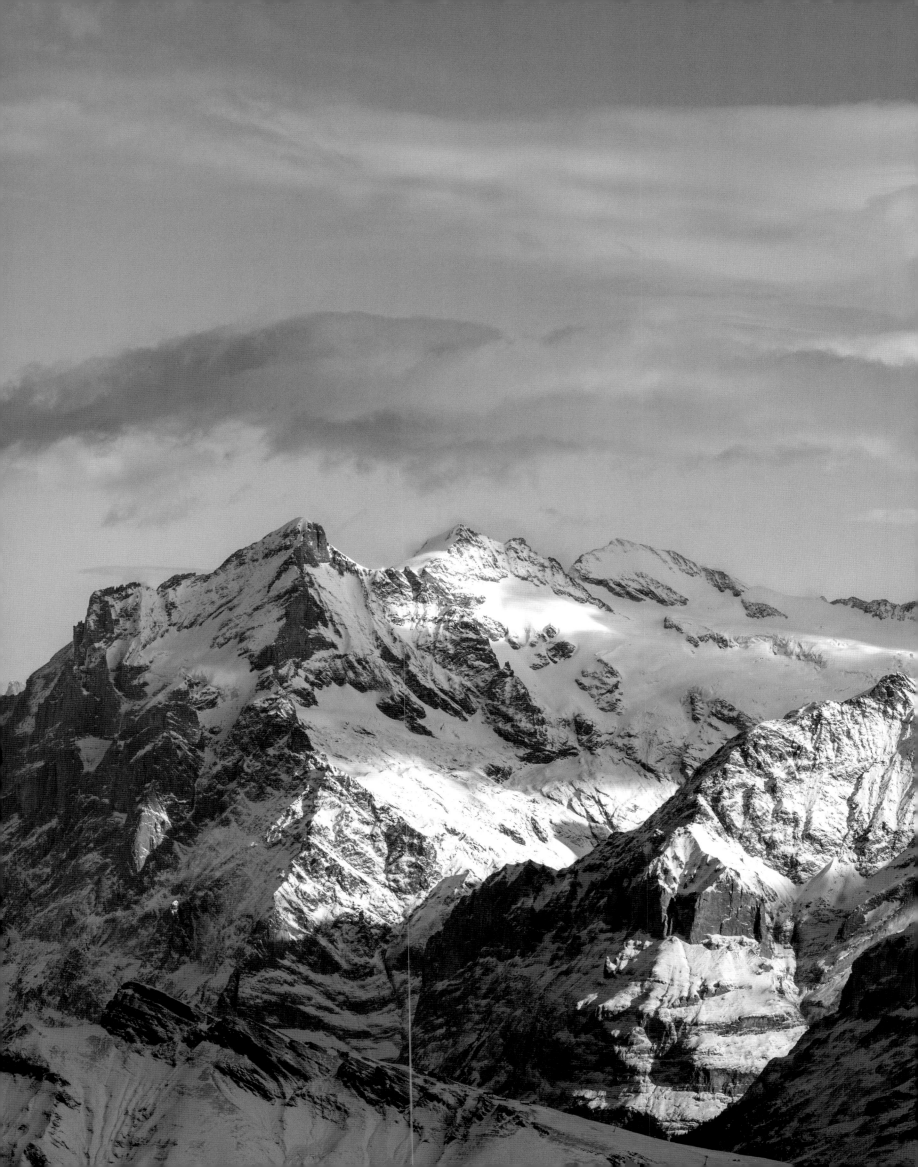

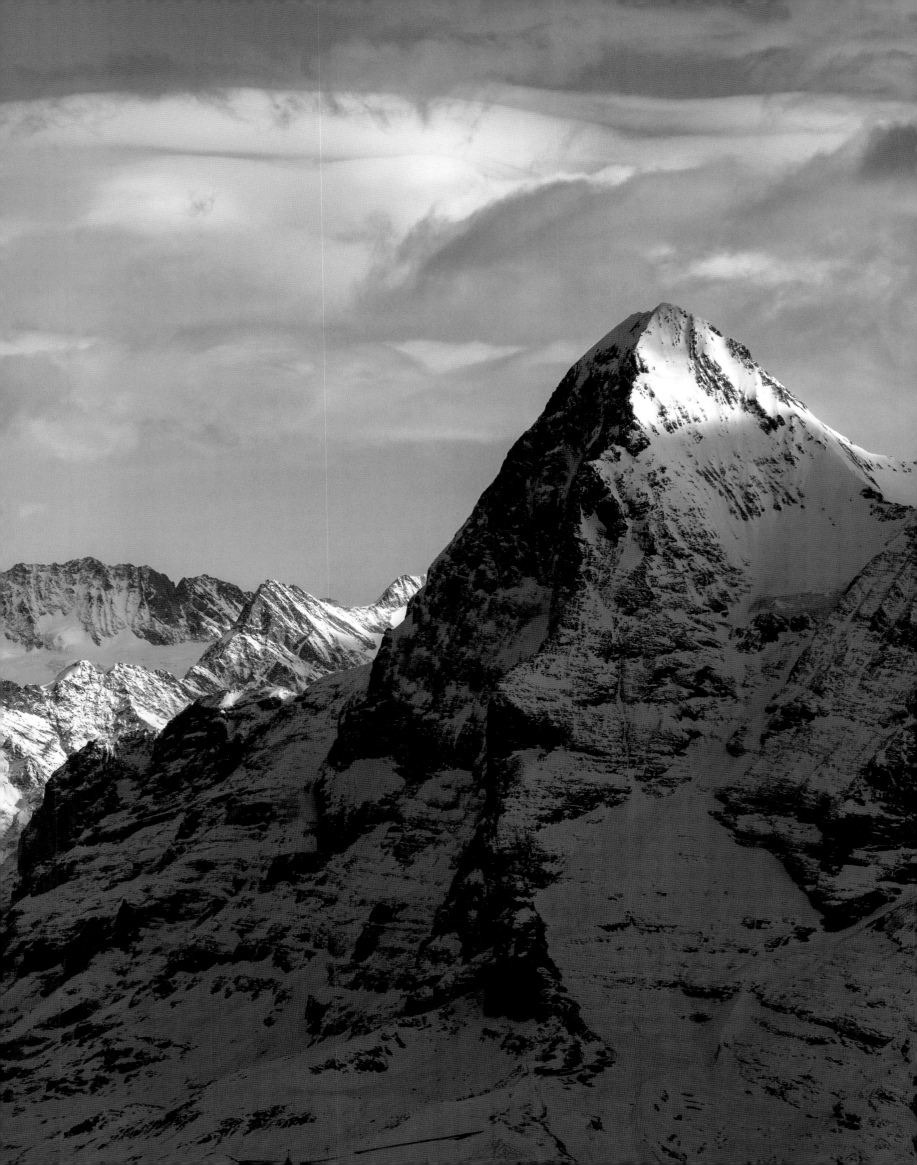

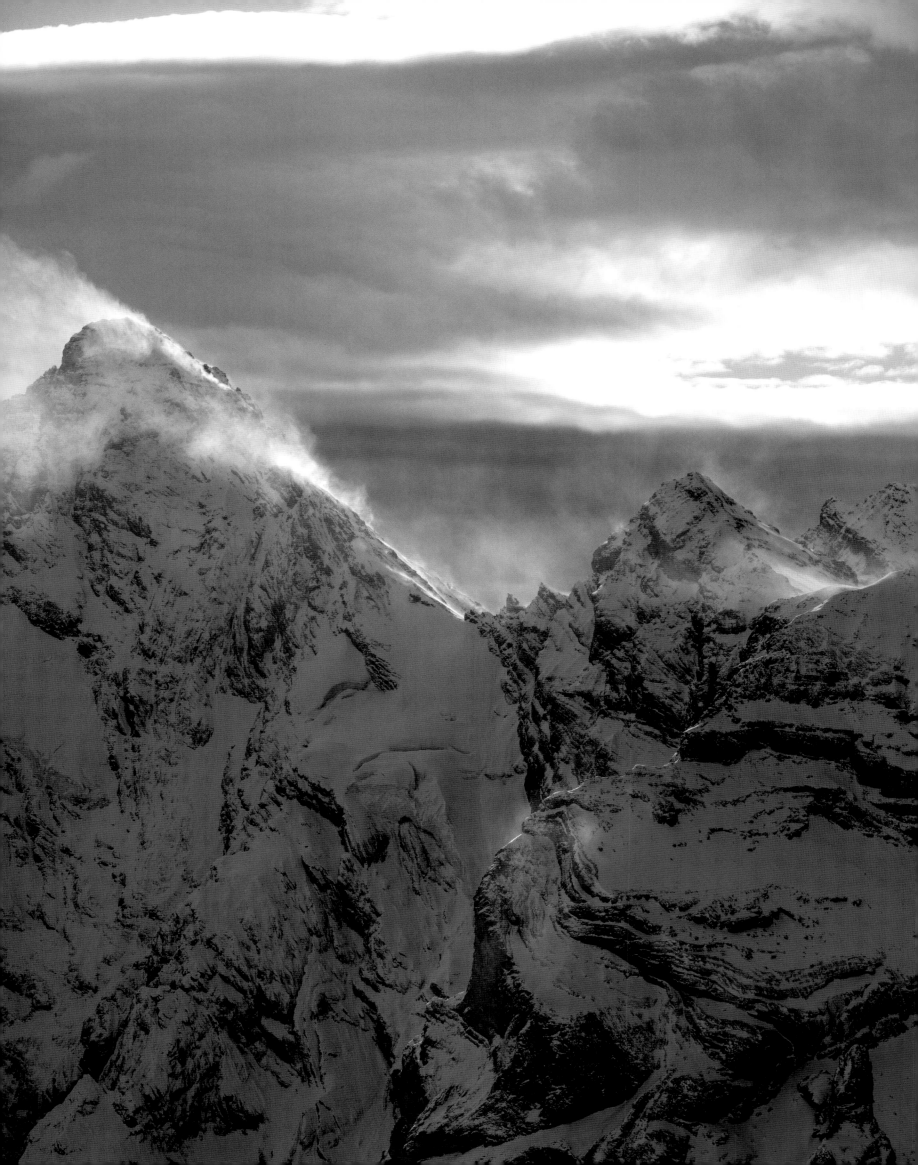

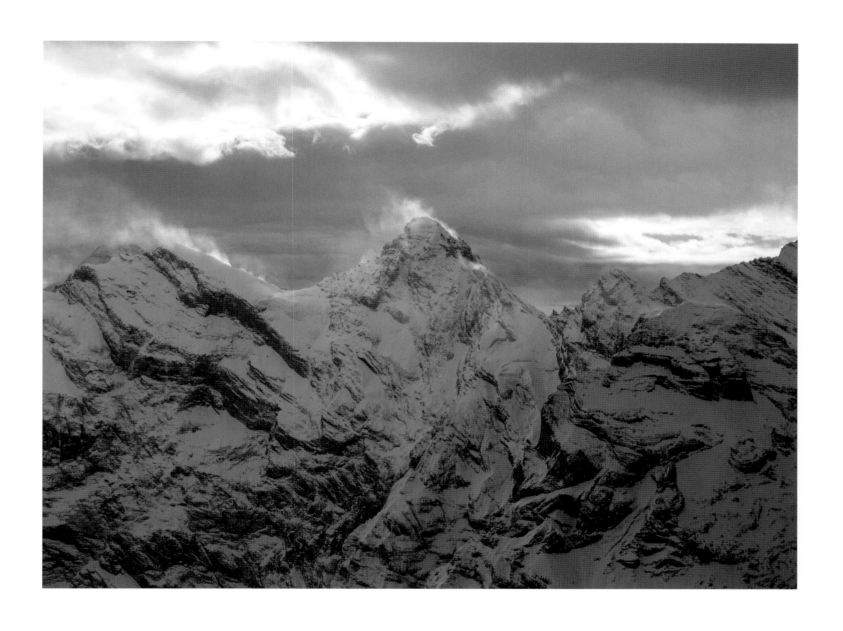

Jungfrau, Bernese Oberland, Switzerland

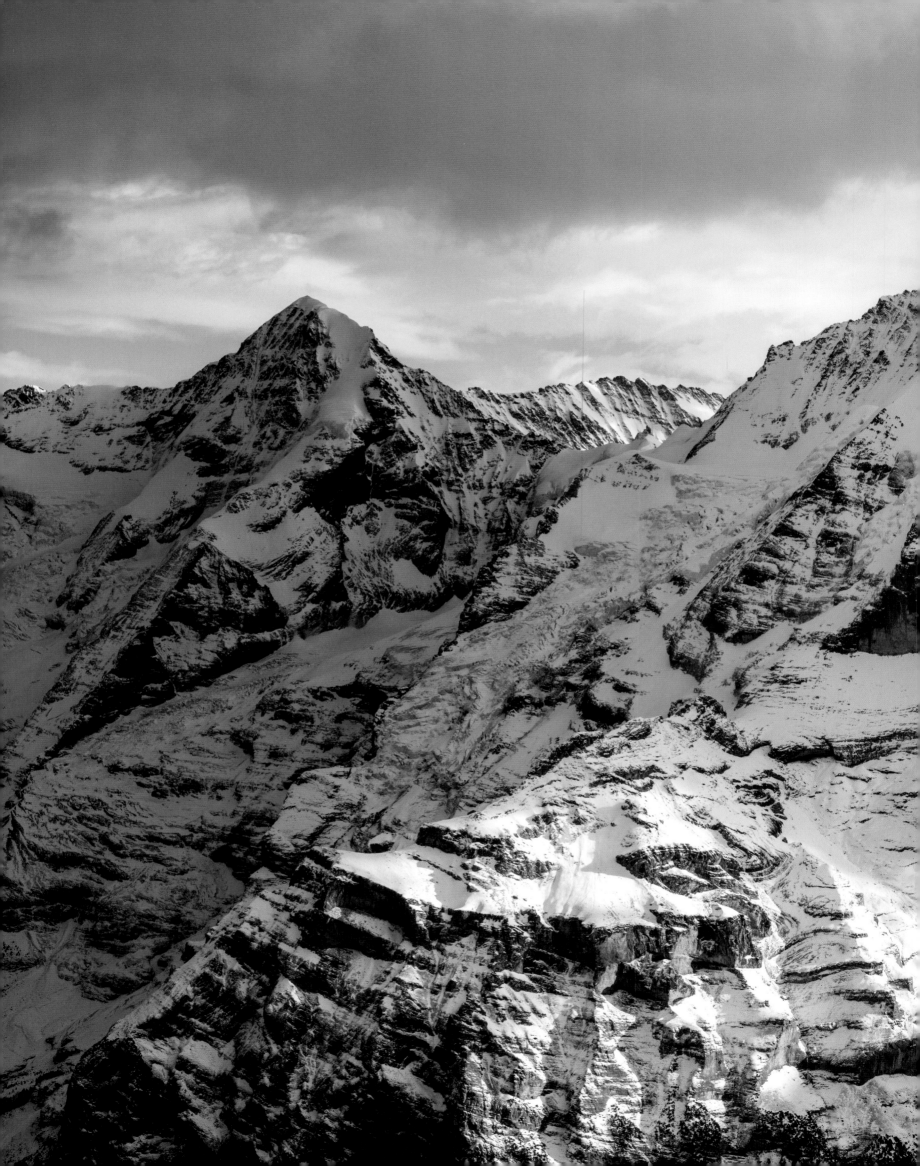

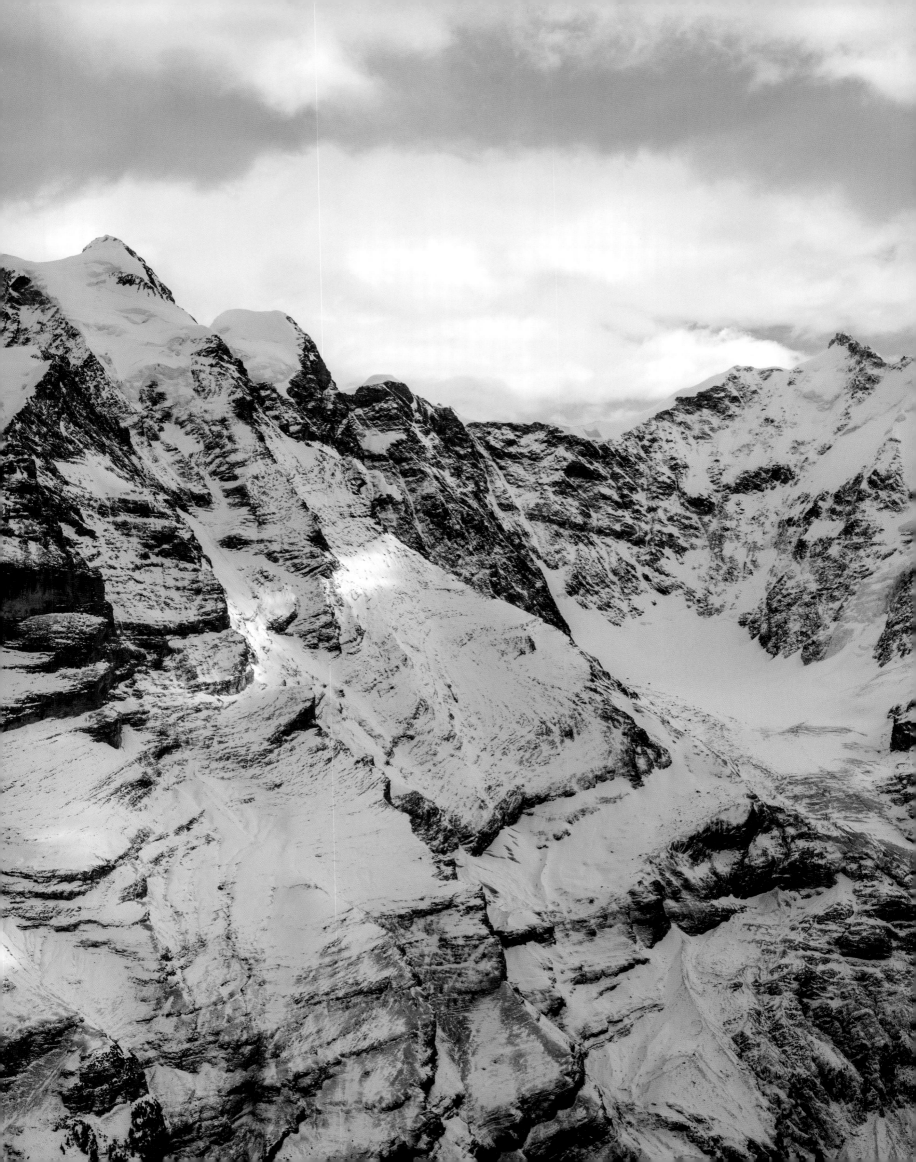

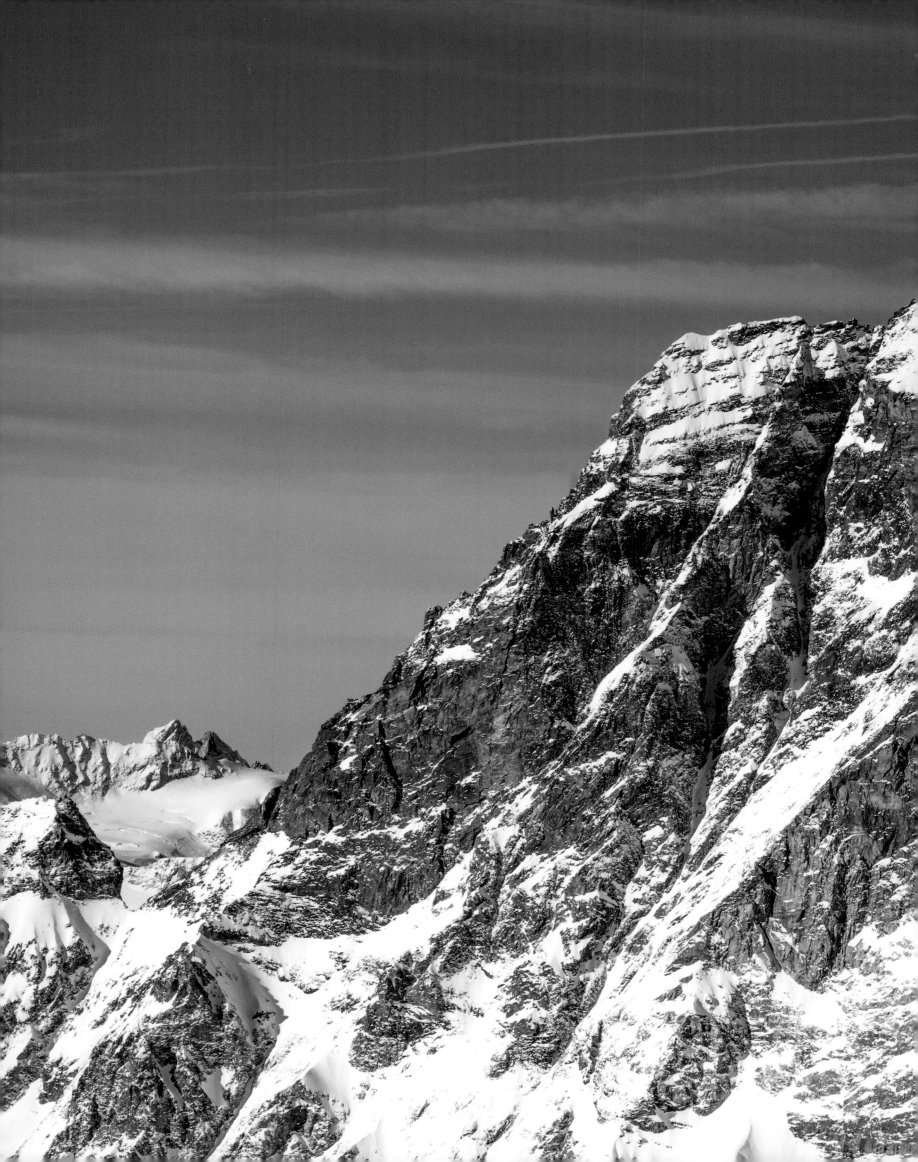

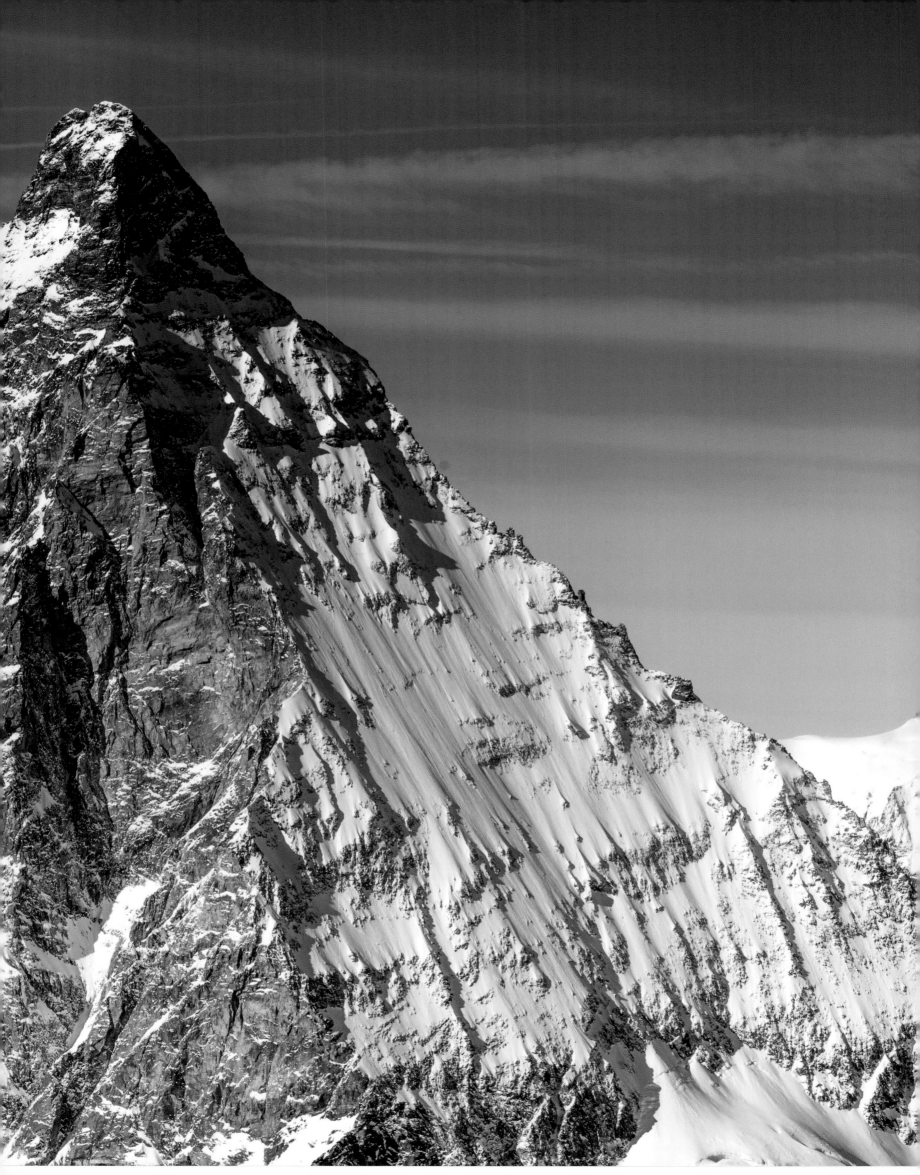

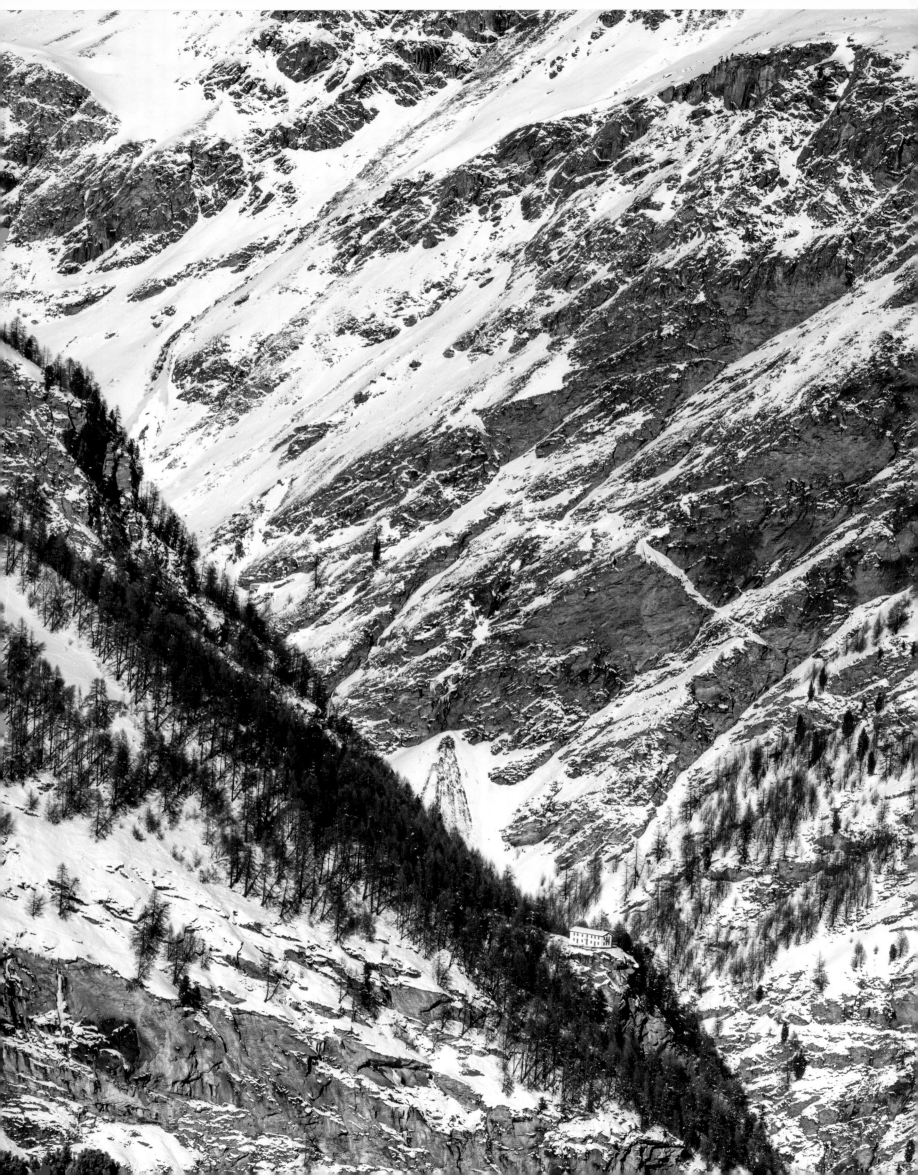

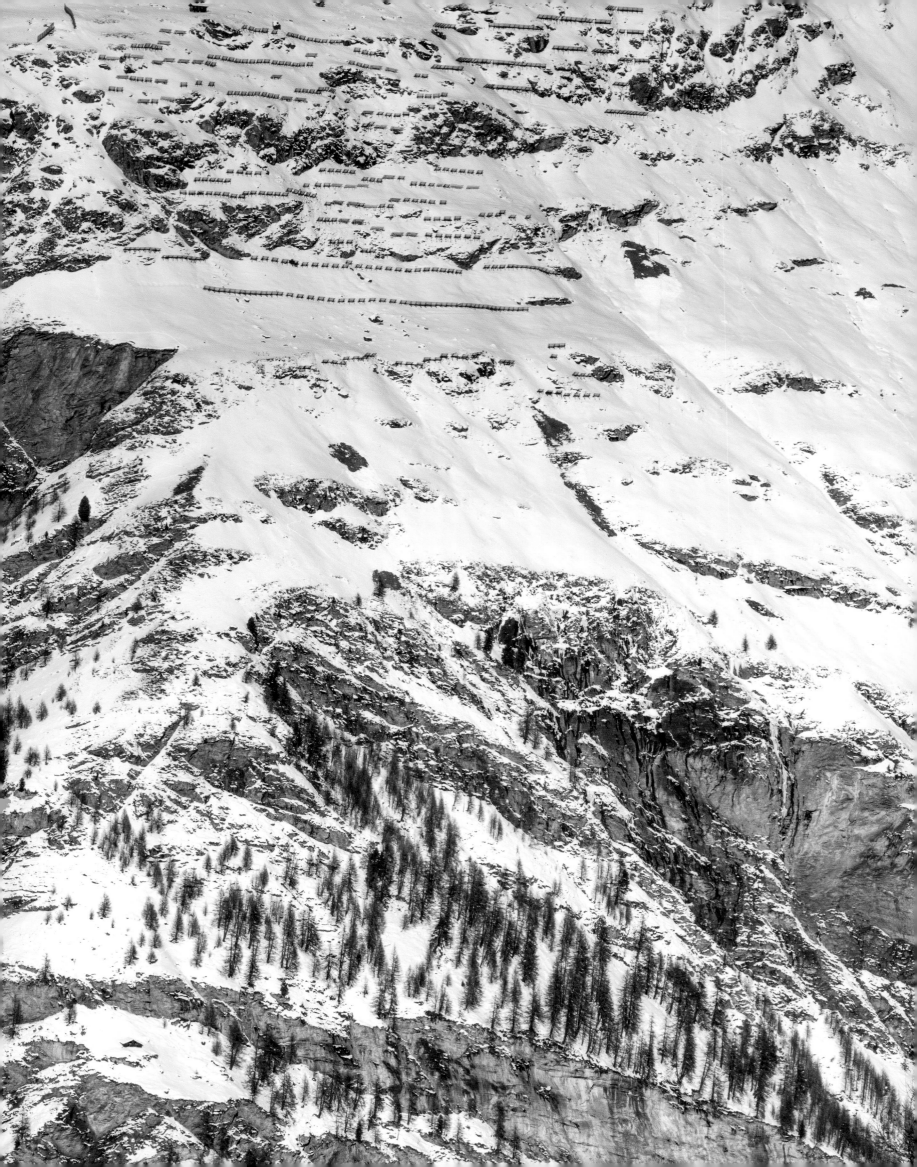

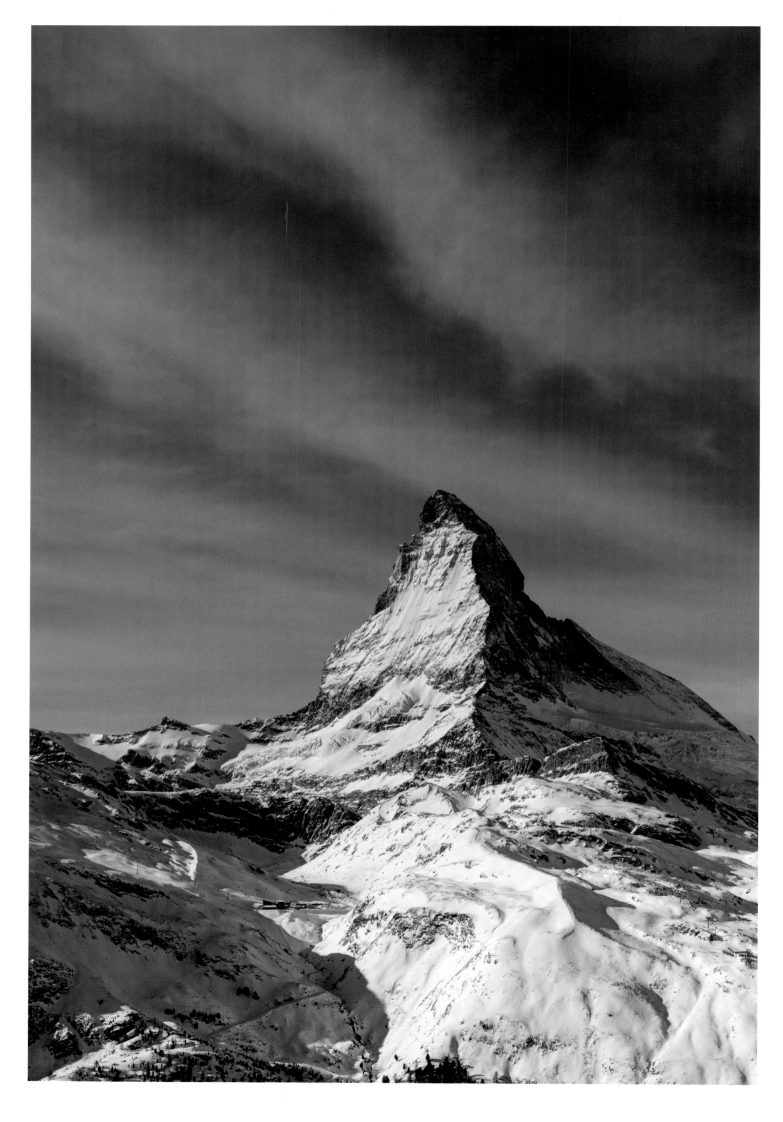

The Matterhorn, Zermatt, Switzerland — 14,692 ft | 4,478 m

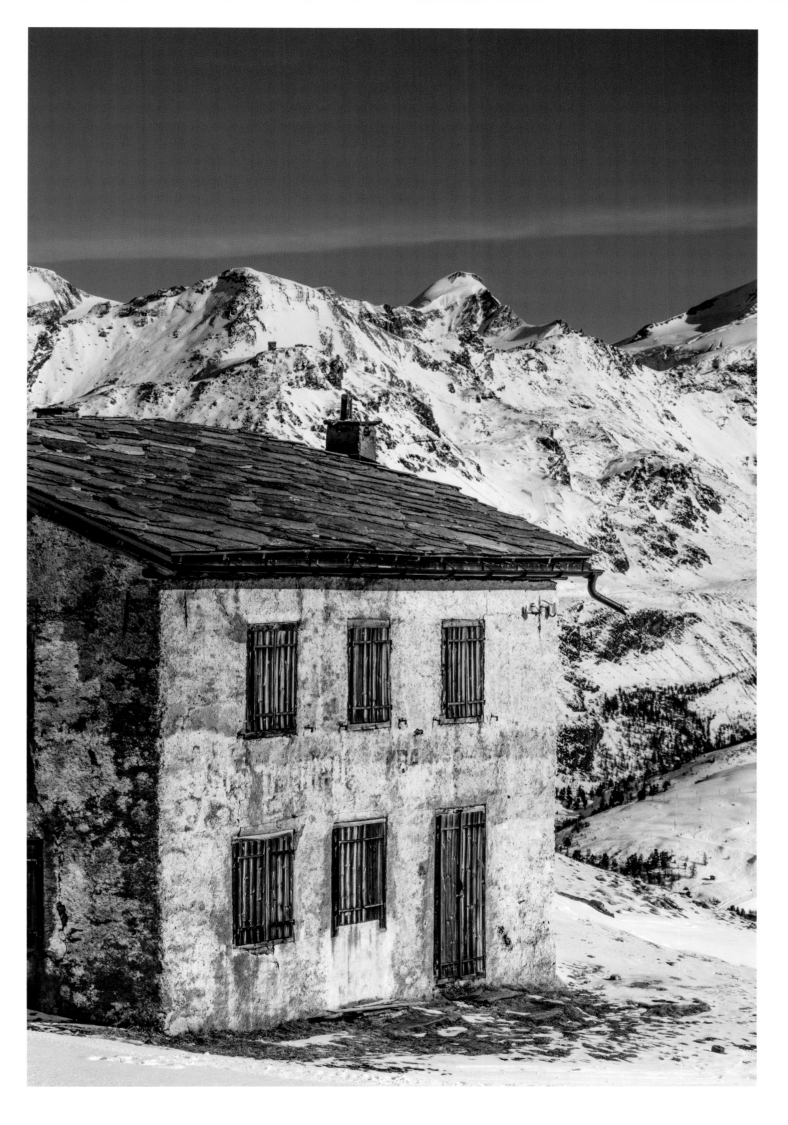

Zermatt, Switzerland

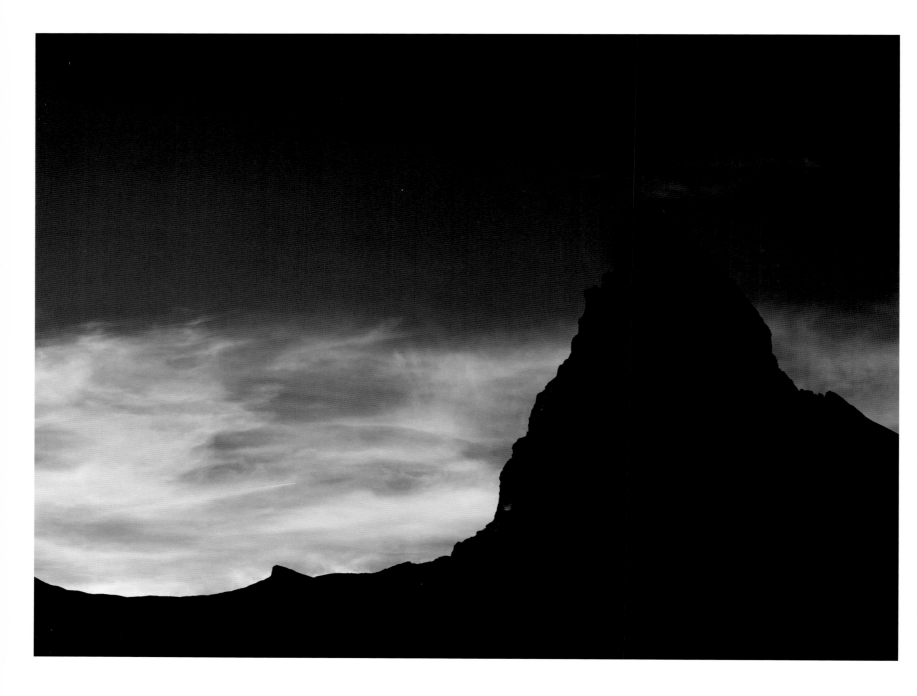

The Matterhorn

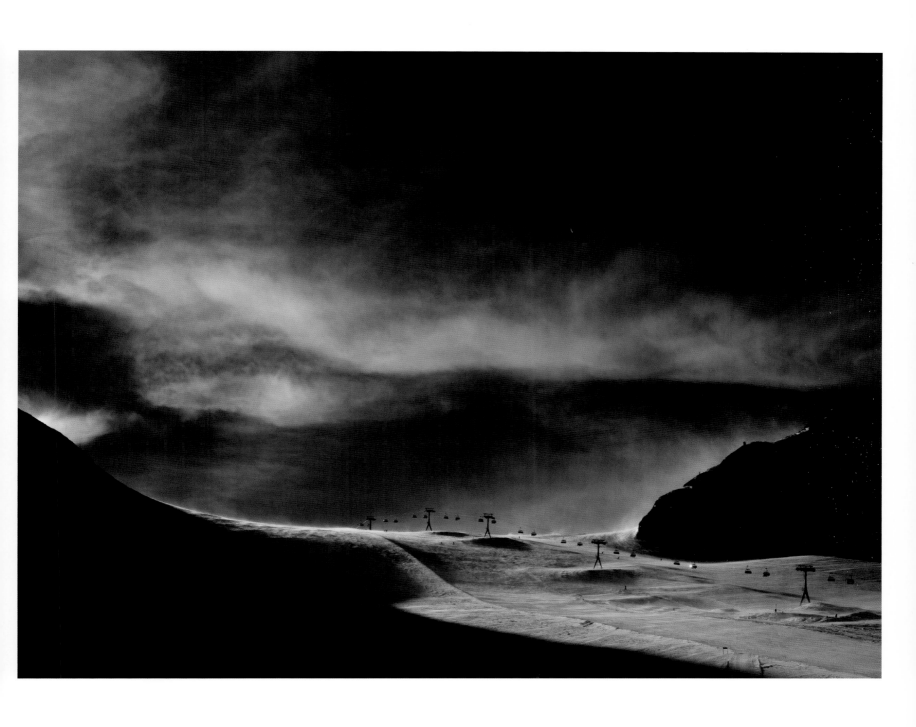

Theodulpass, Zermatt, Switzerland

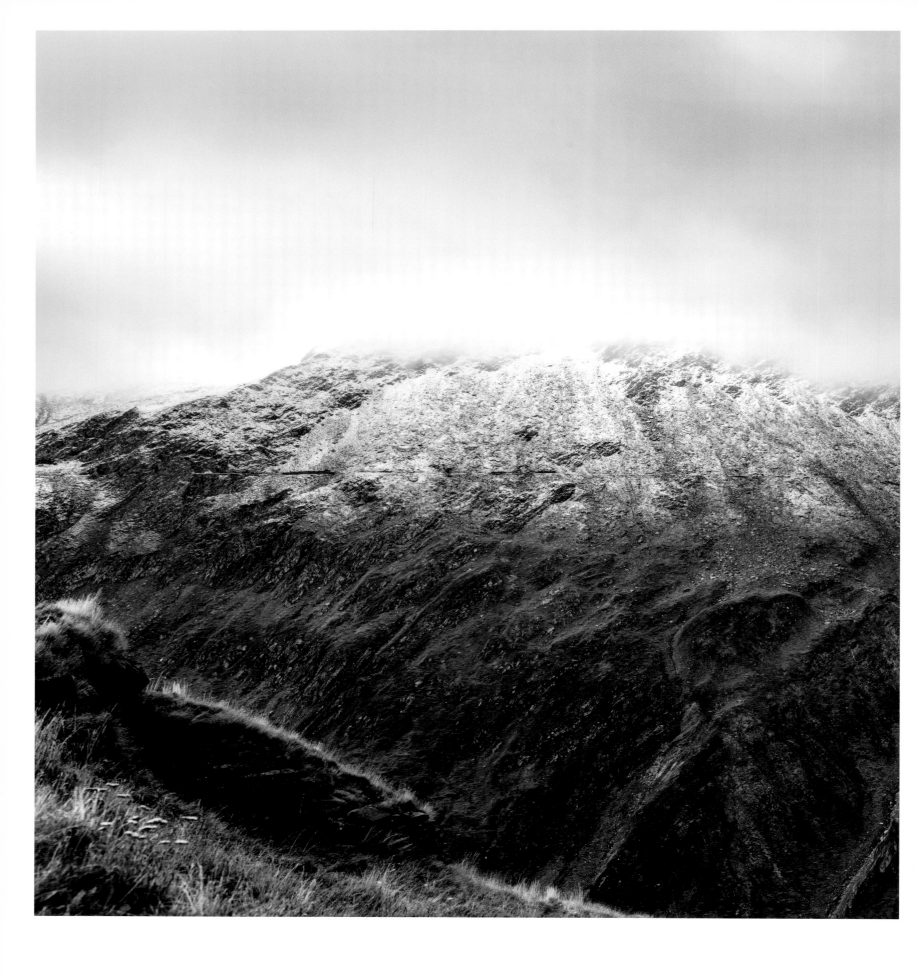

Furka Pass, Switzerland – 7,969 ft | 2,429 m

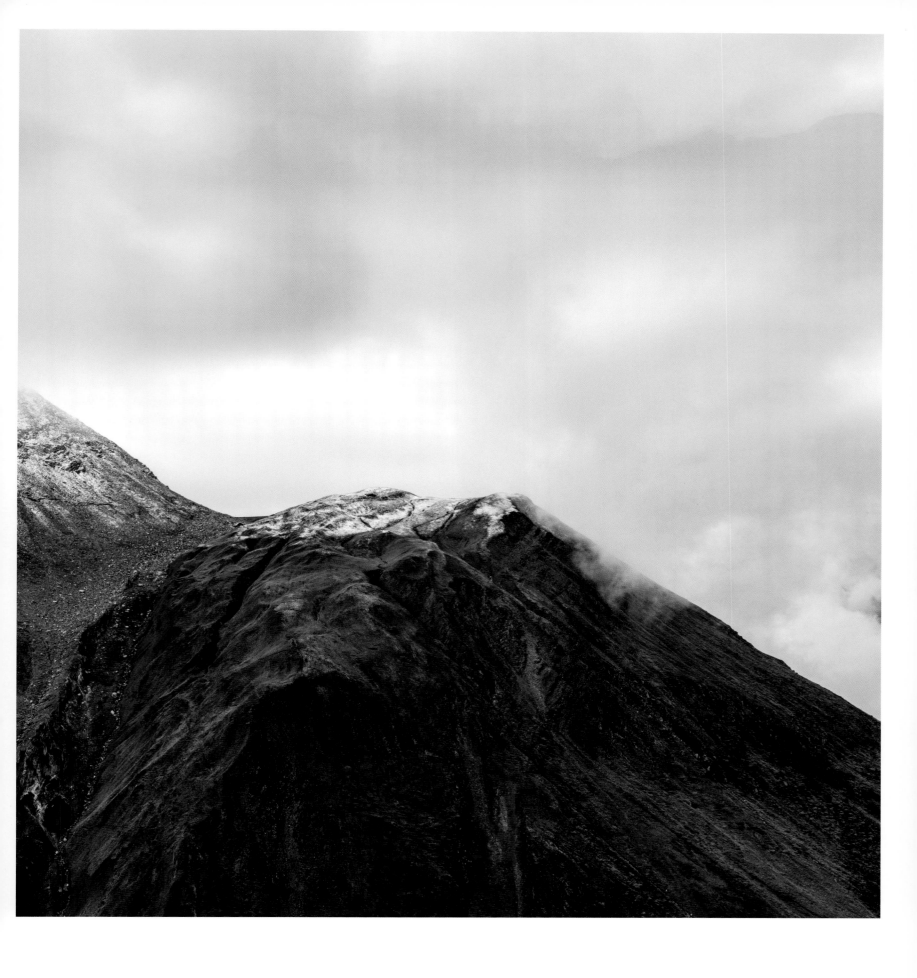

Obergoms, Switzerland

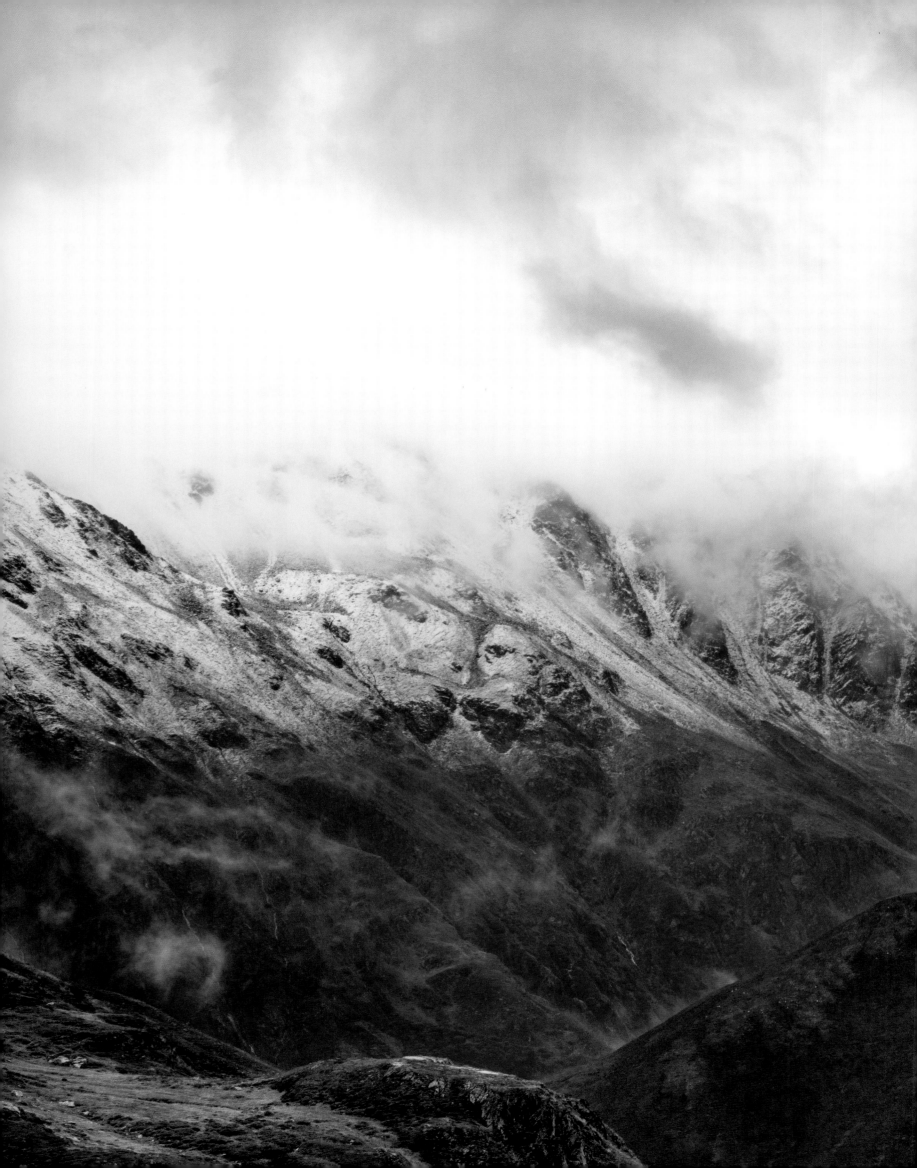

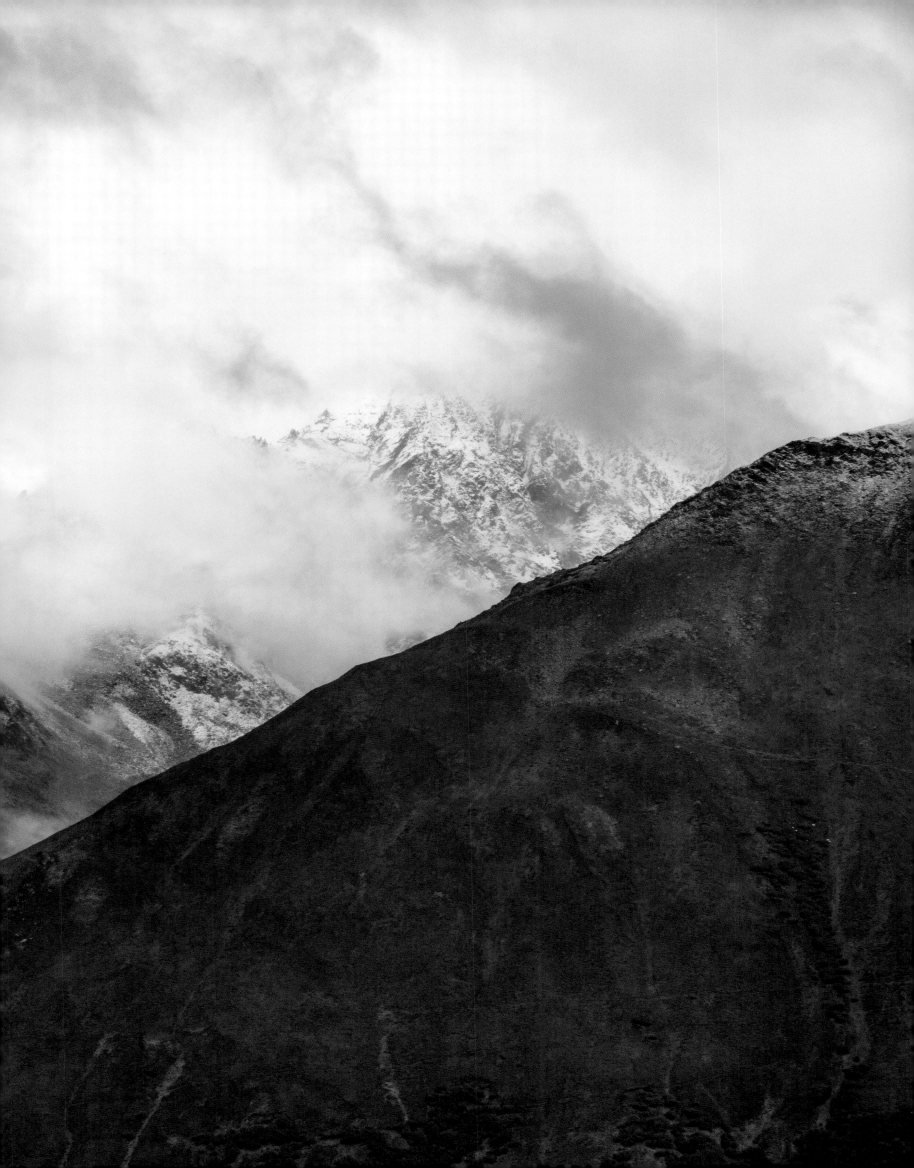

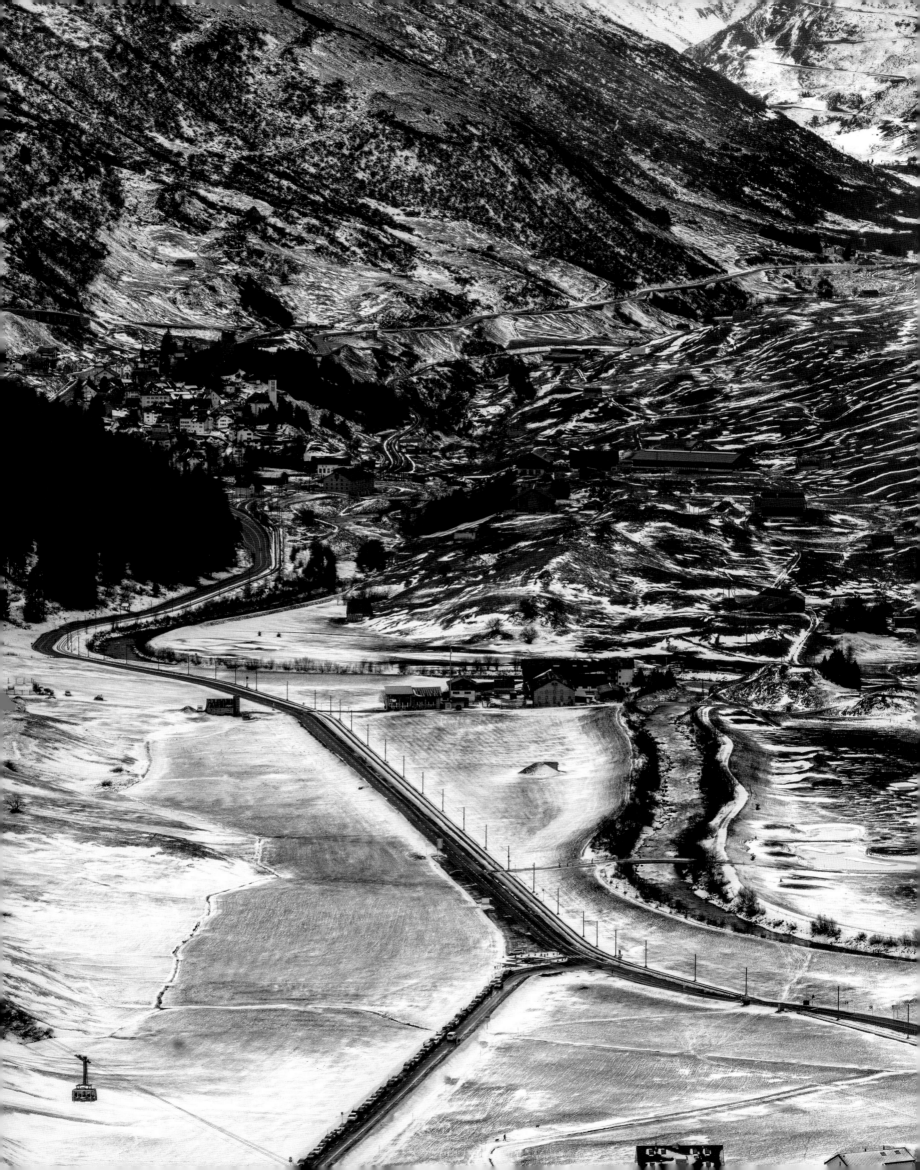

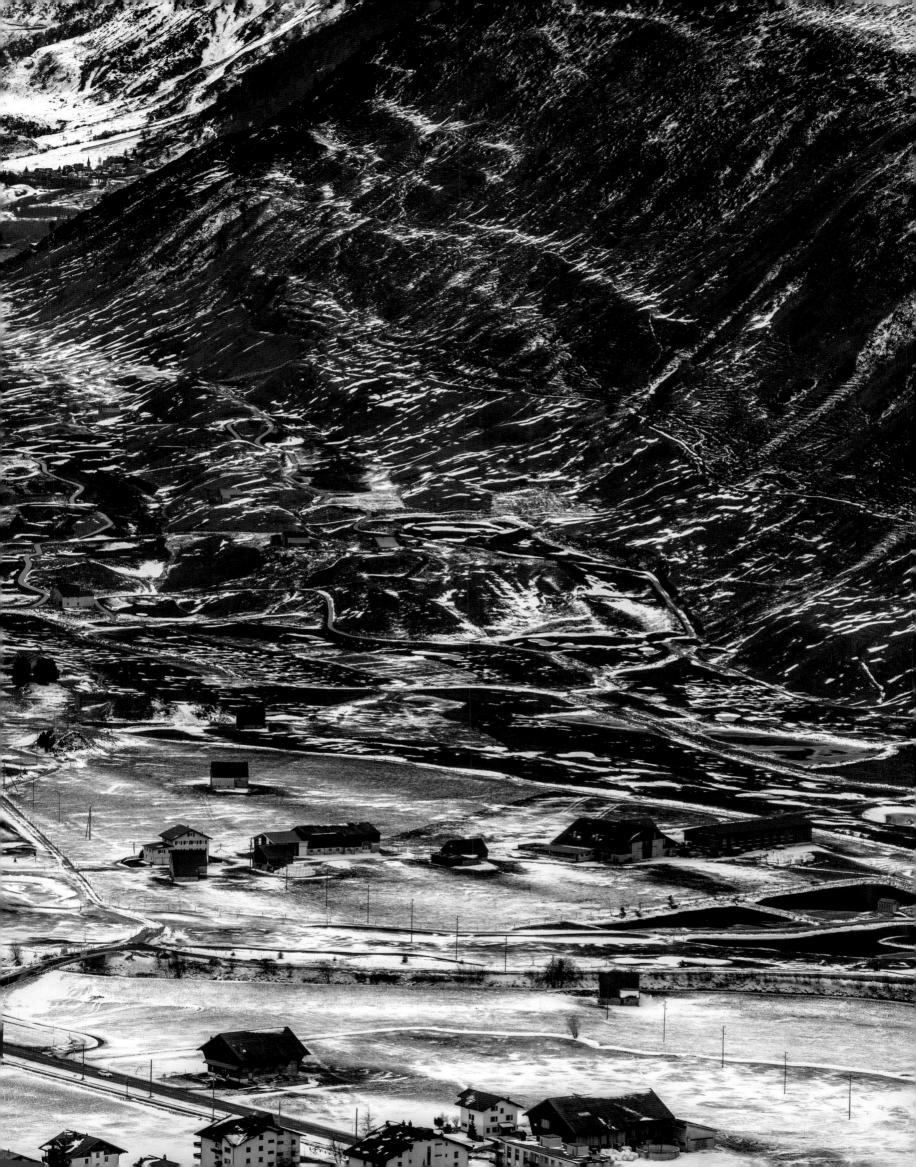

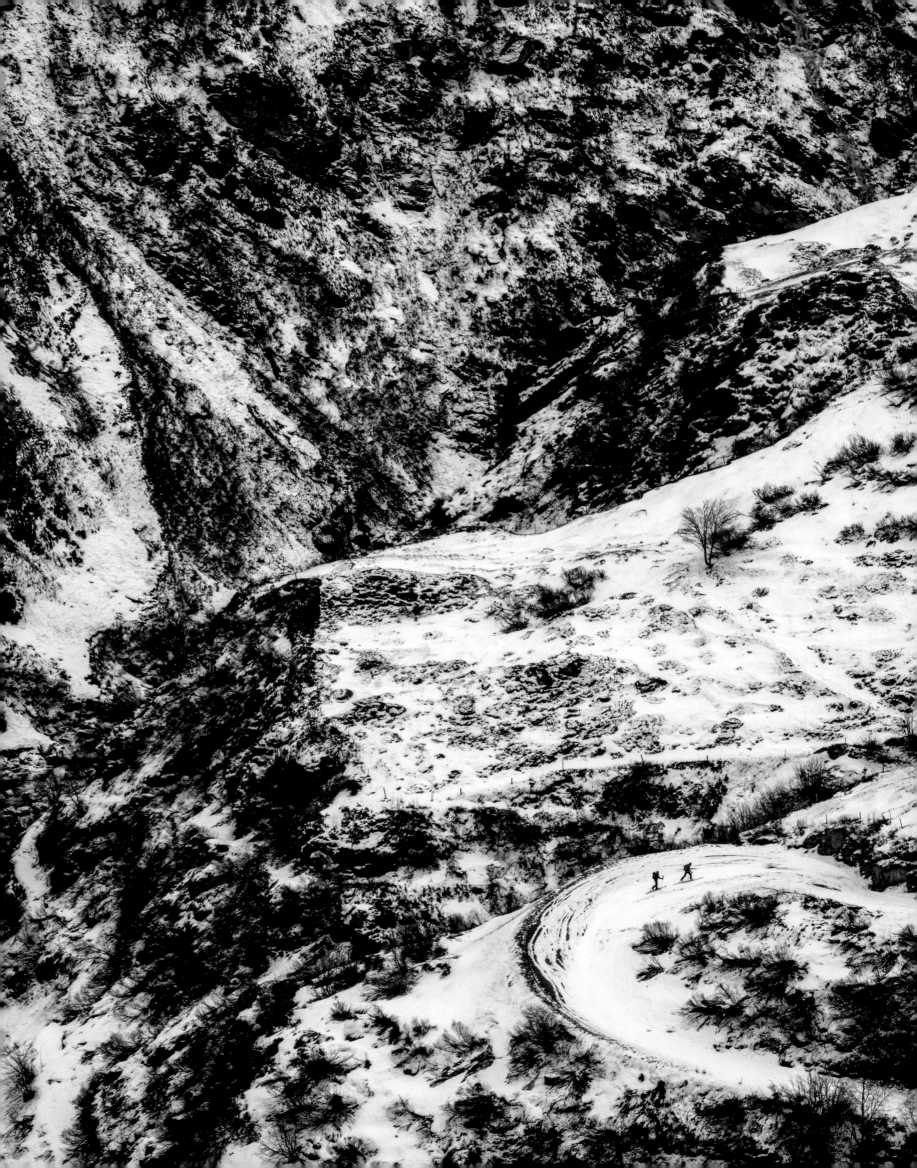

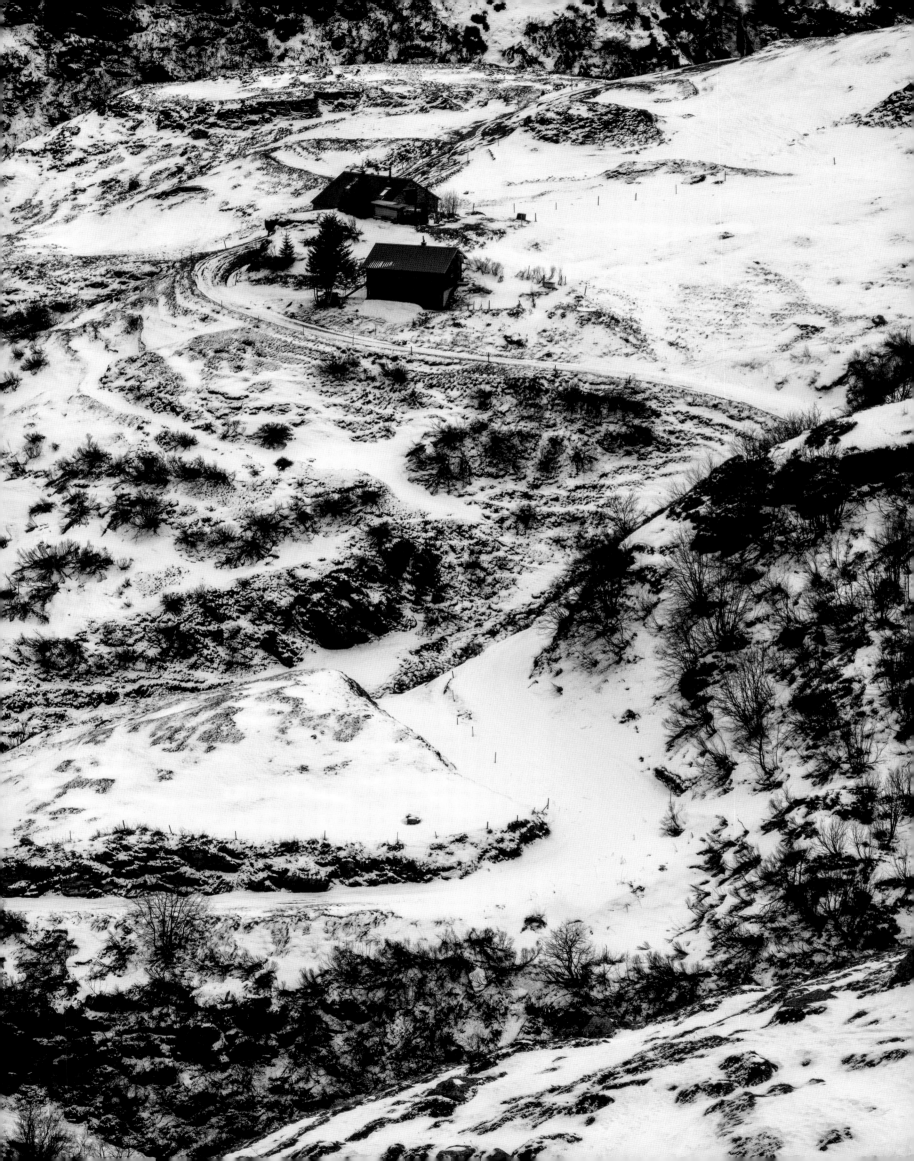

"In the end, you won't remember the time you spent working in the office or mowing your lawn. Climb that goddamn mountain."

Jack Kerouac (1922–1969), novelist

„Am Ende wirst du dich nicht an die Zeit erinnern, die du mit Büroarbeit oder Rasenmähen zugebracht hast. Kletter auf diesen verdammten Berg!"

Jack Kerouac (1922–1969), Romancier

« À la fin de votre vie, vous ne vous souviendrez pas du temps passé au bureau ou à tondre la pelouse. Escaladez cette fichue montagne. »

Jack Kerouac (1922–1969), romancier

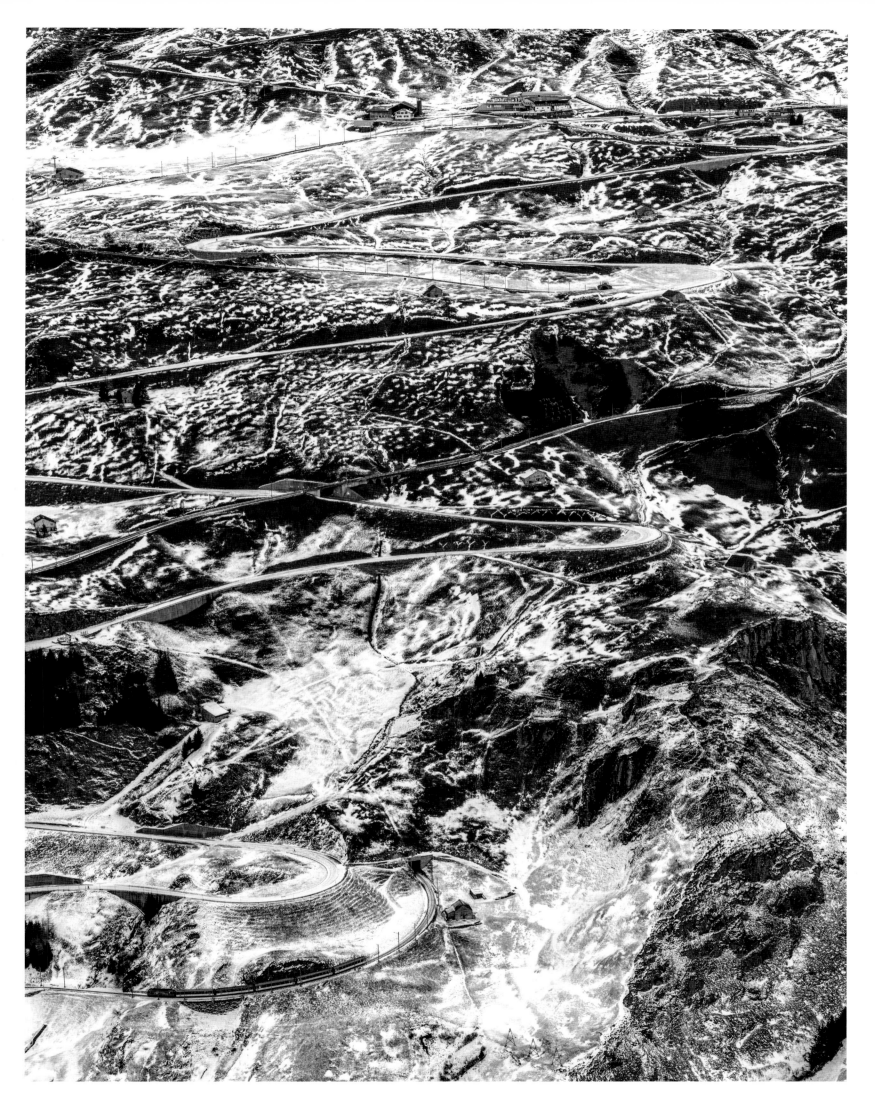

Glacier Express, Natschen, Andermatt, Switzerland

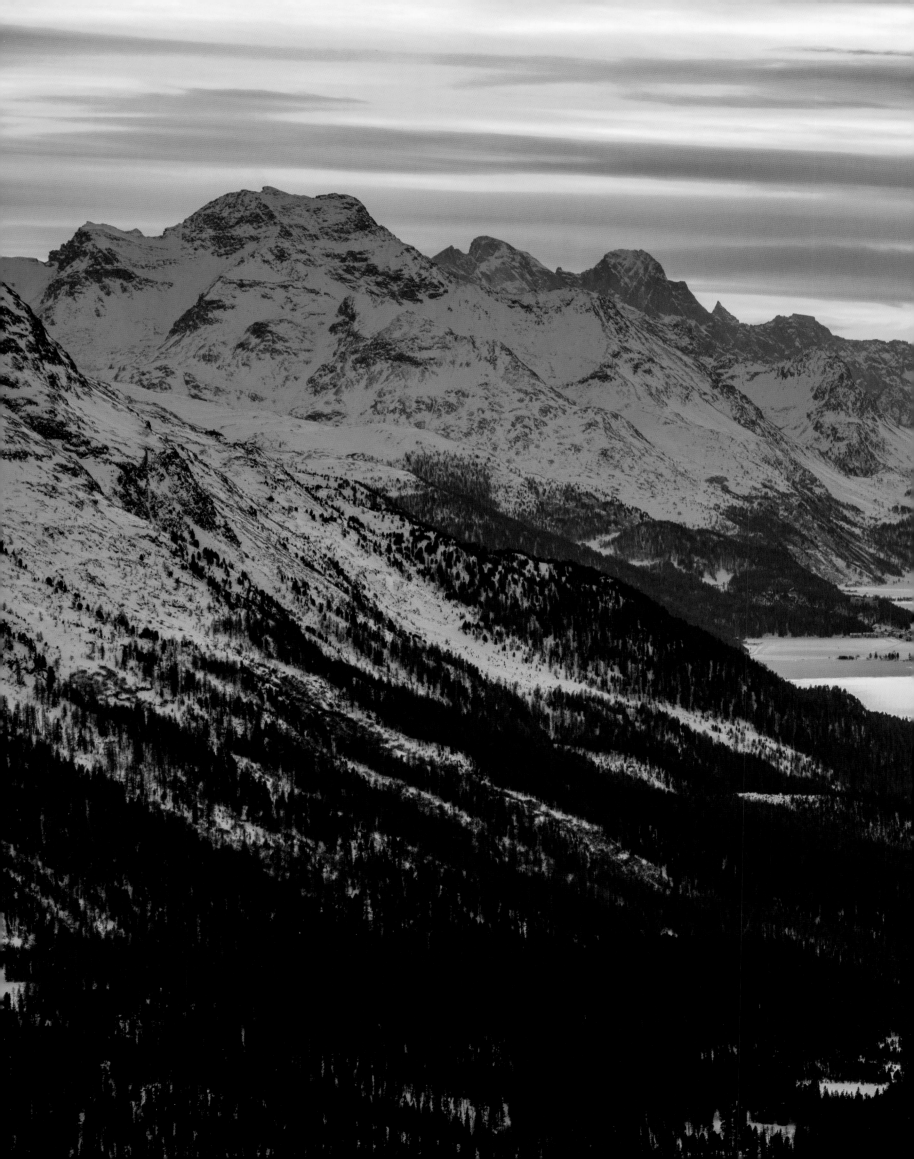

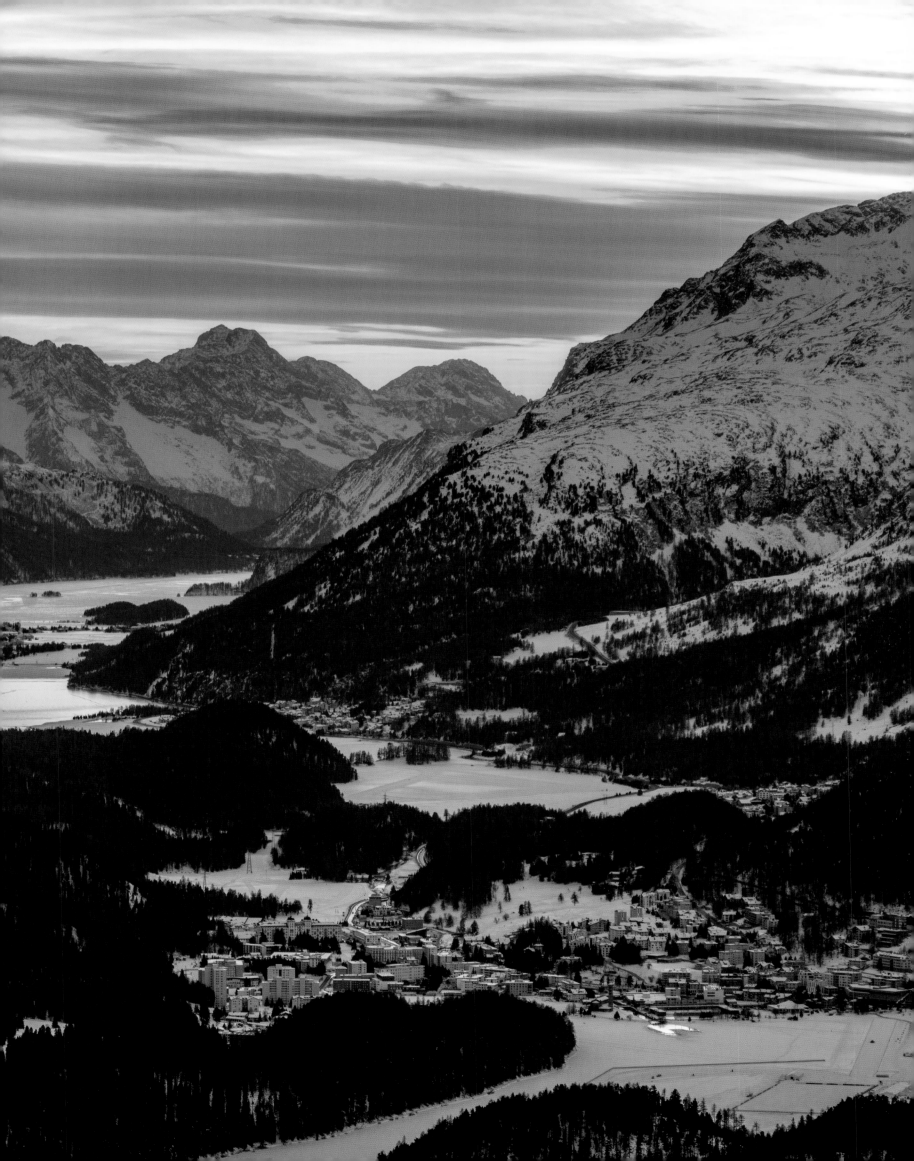

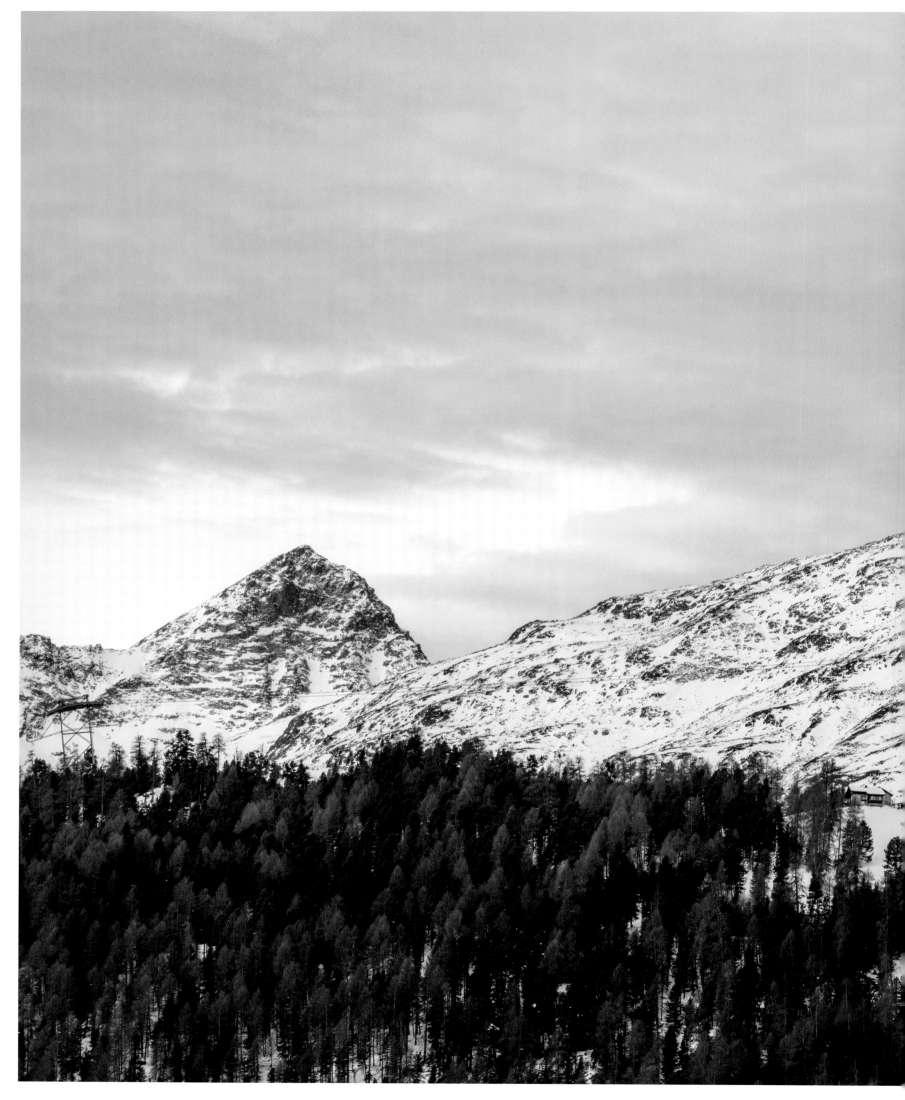

Piz Julier, St Moritz, Switzerland – 11,090 ft | 3,380 m

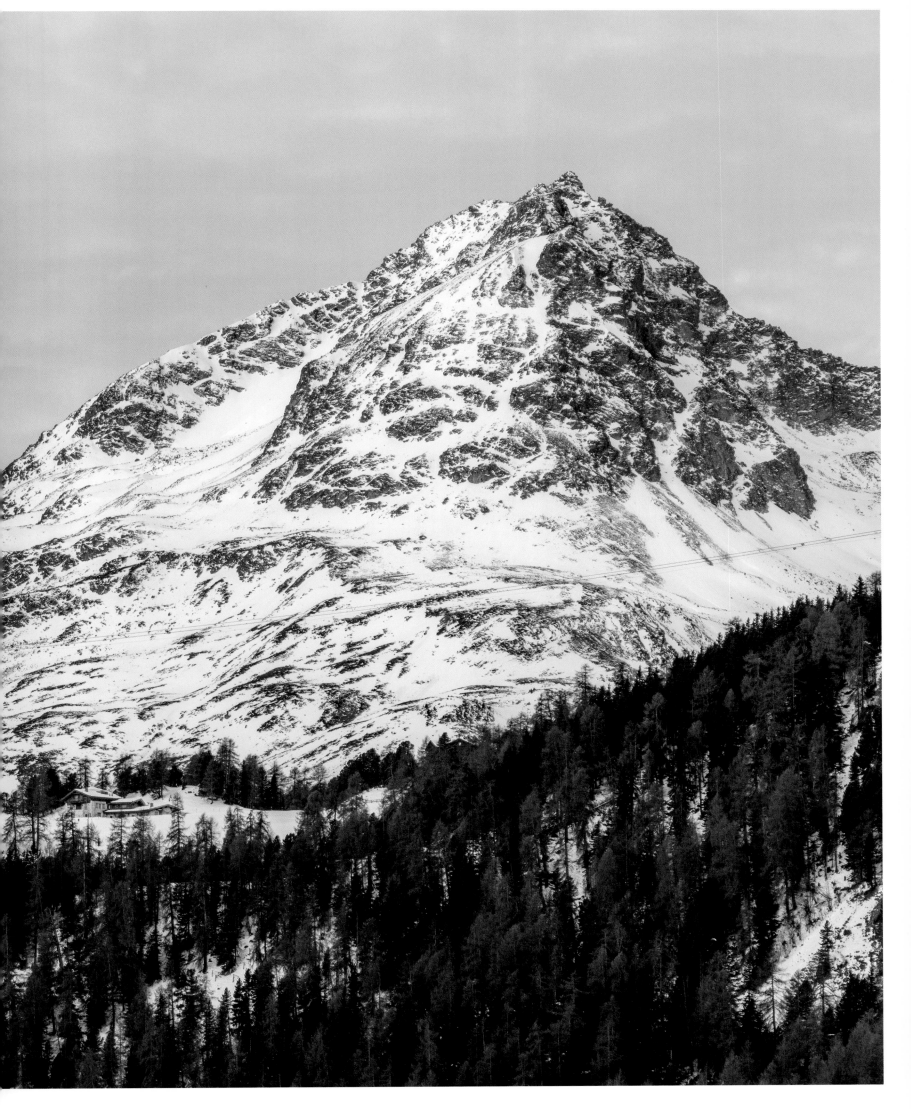

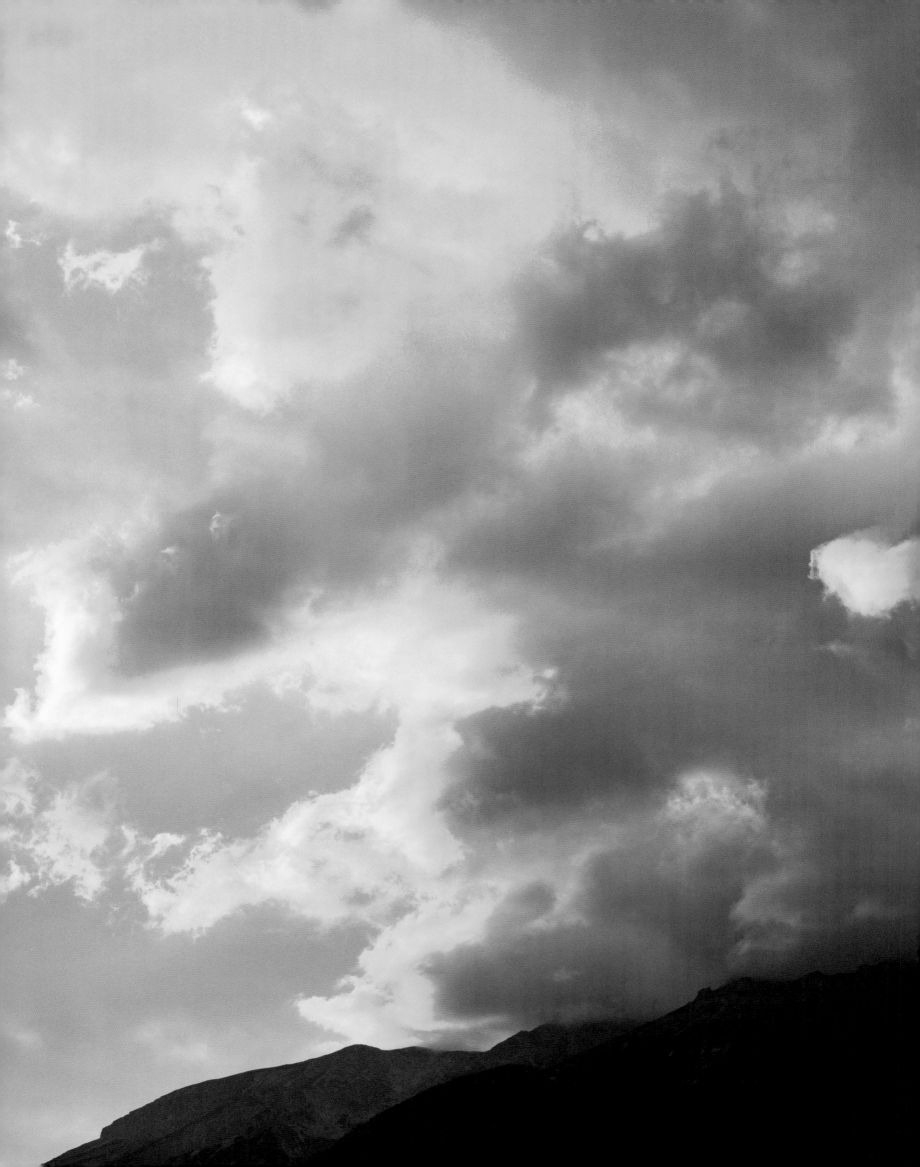

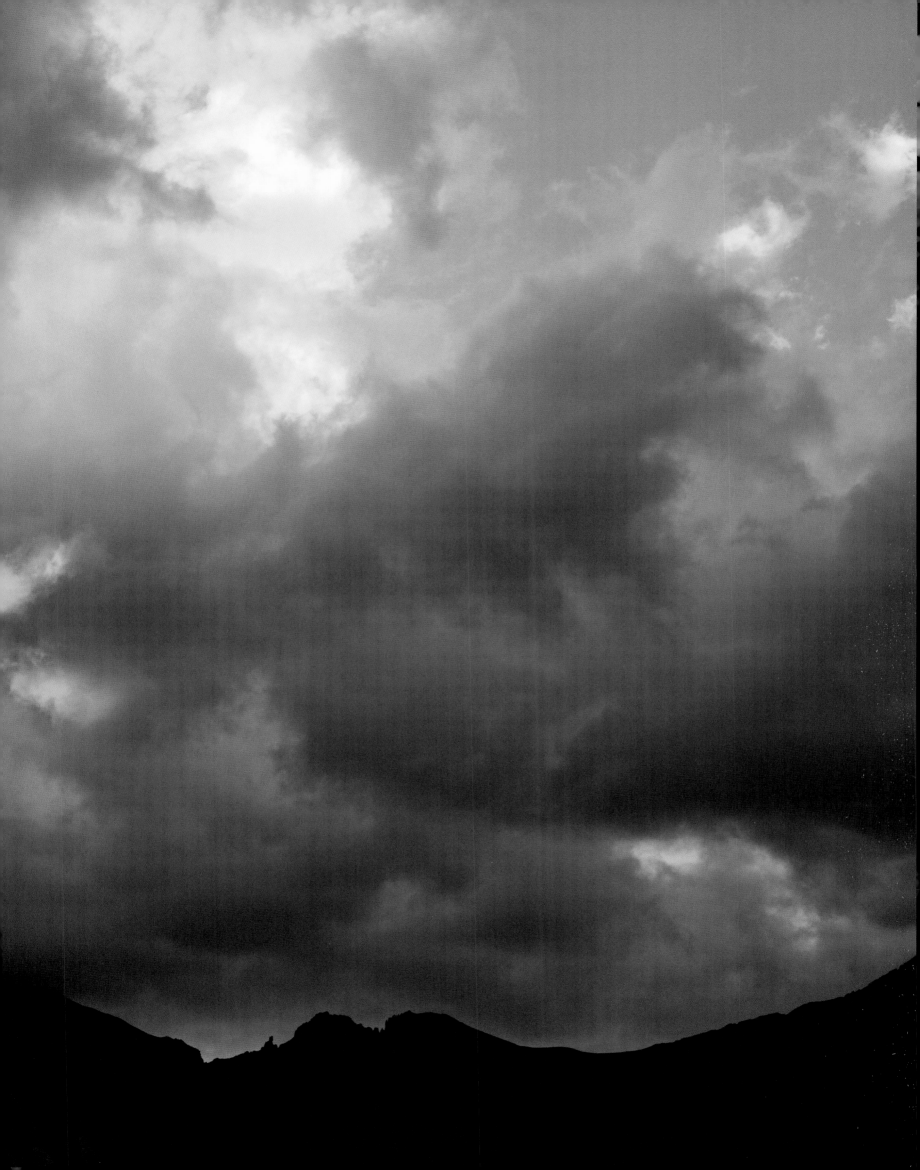

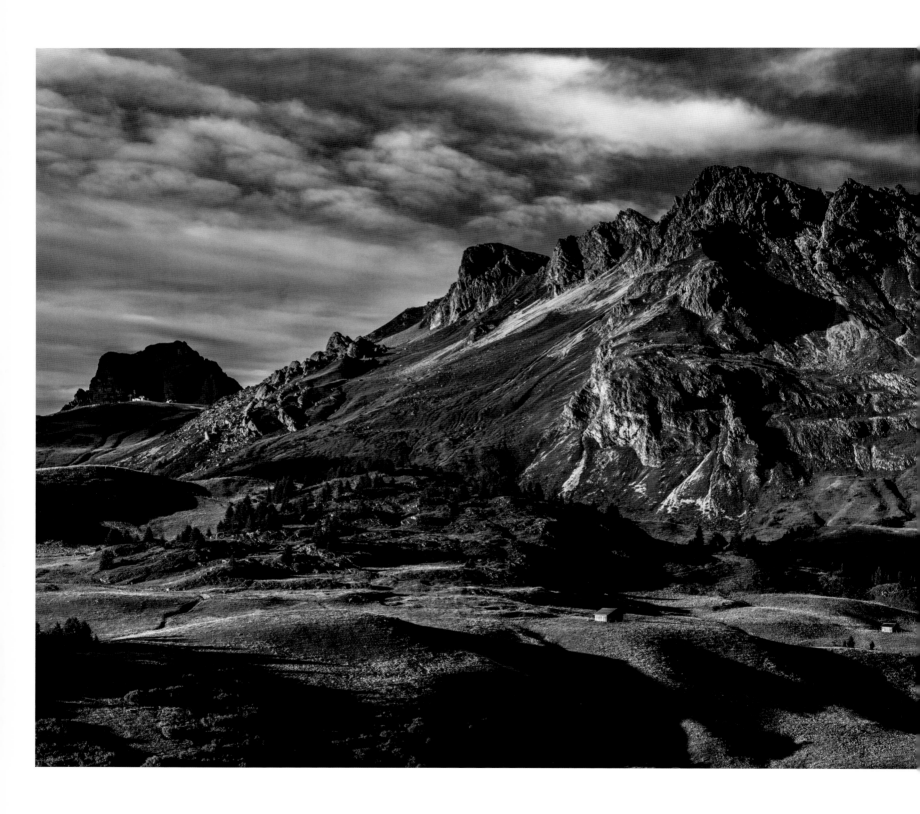

Karhorn, Lech, Vorarlberg, Austria — 7,927 ft | 2,416 m

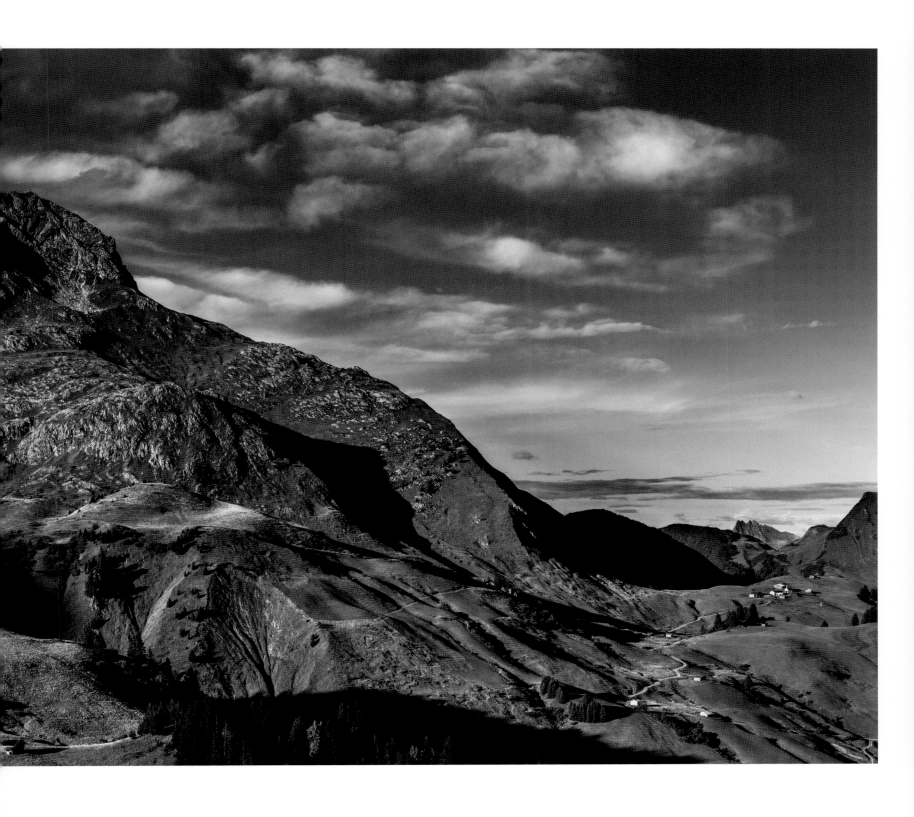

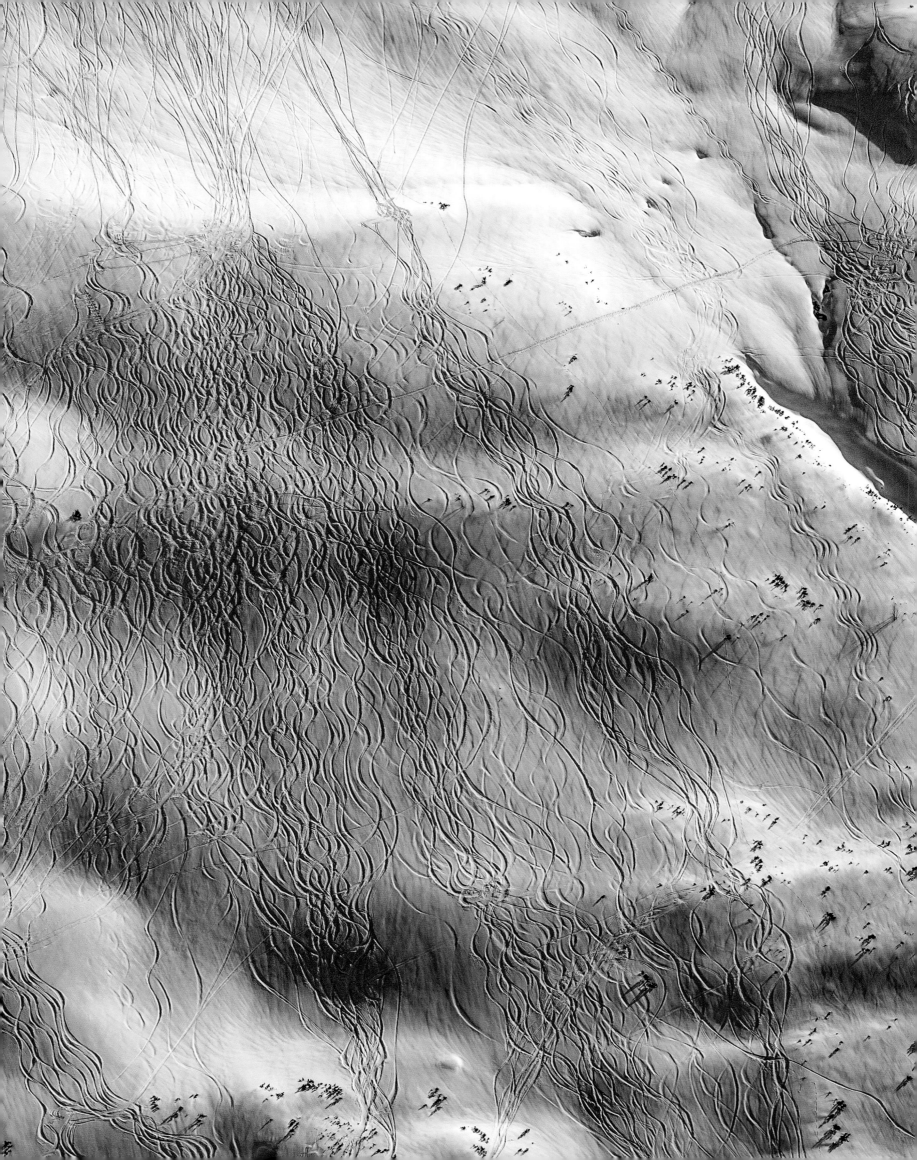

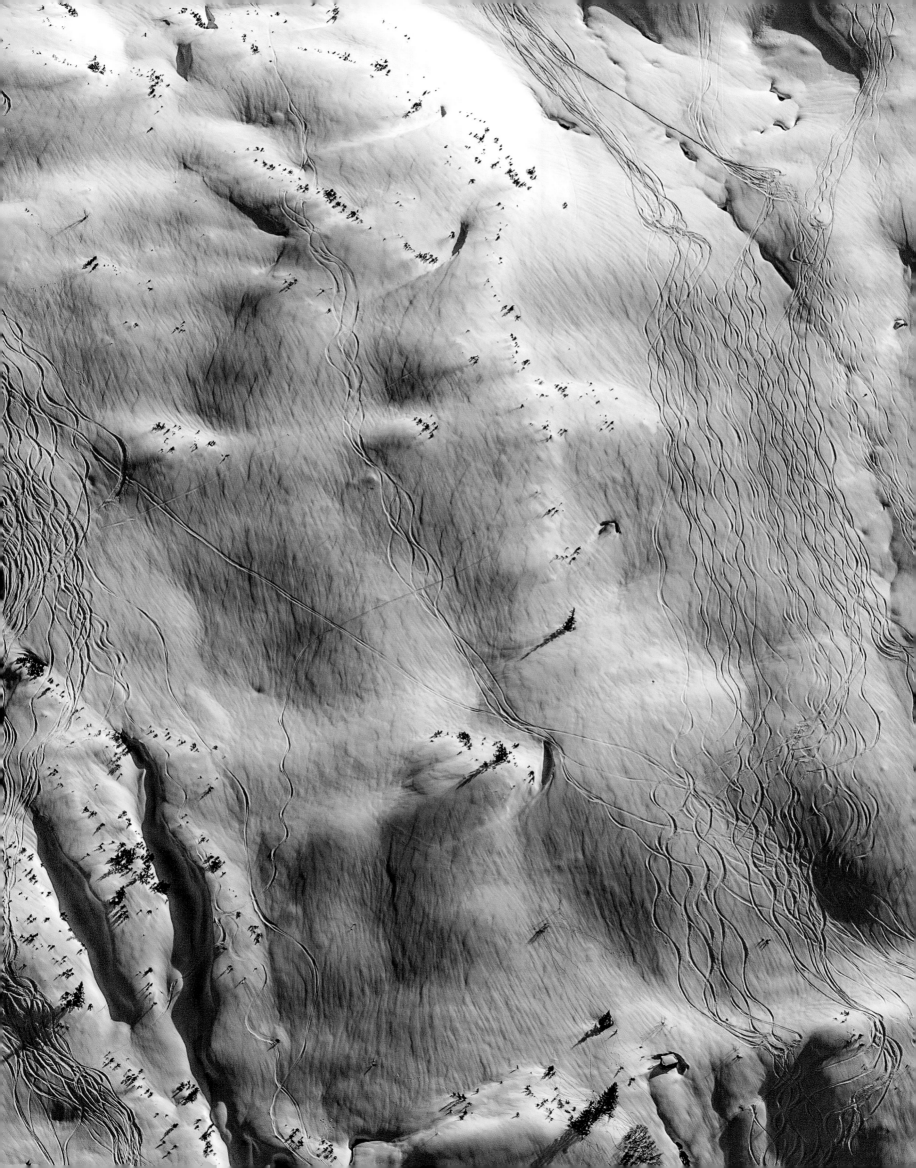

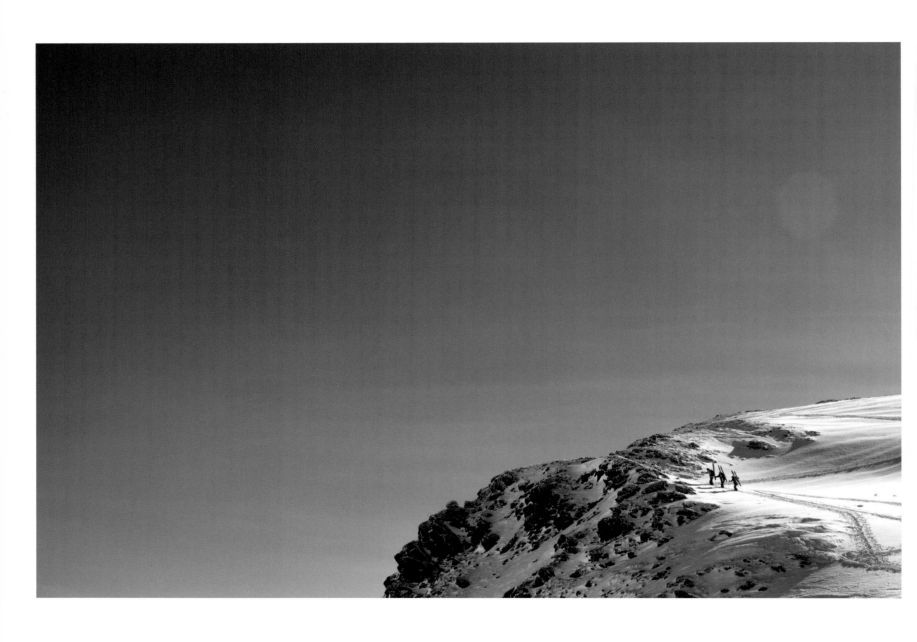

Maroikopf, Arlberg, Austria

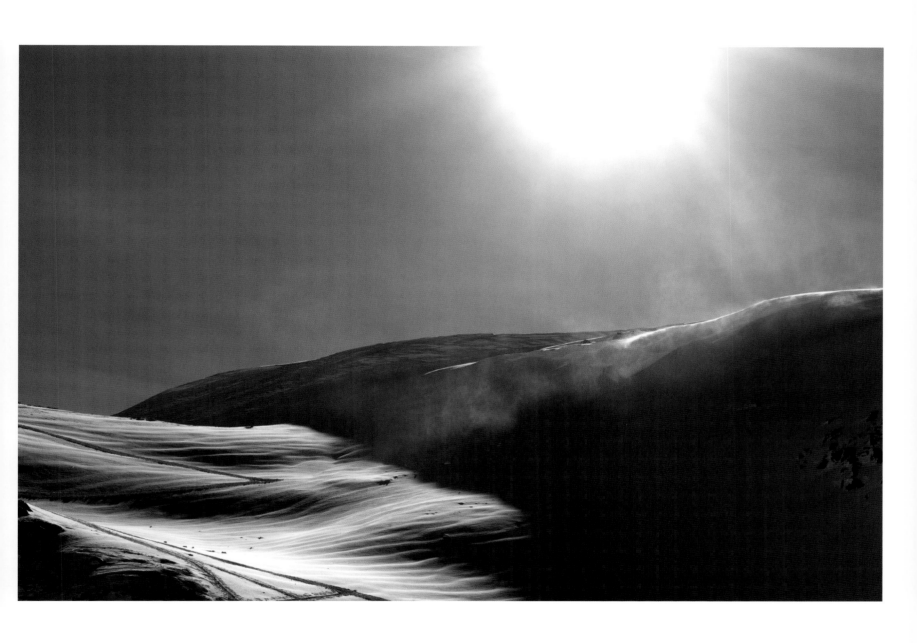

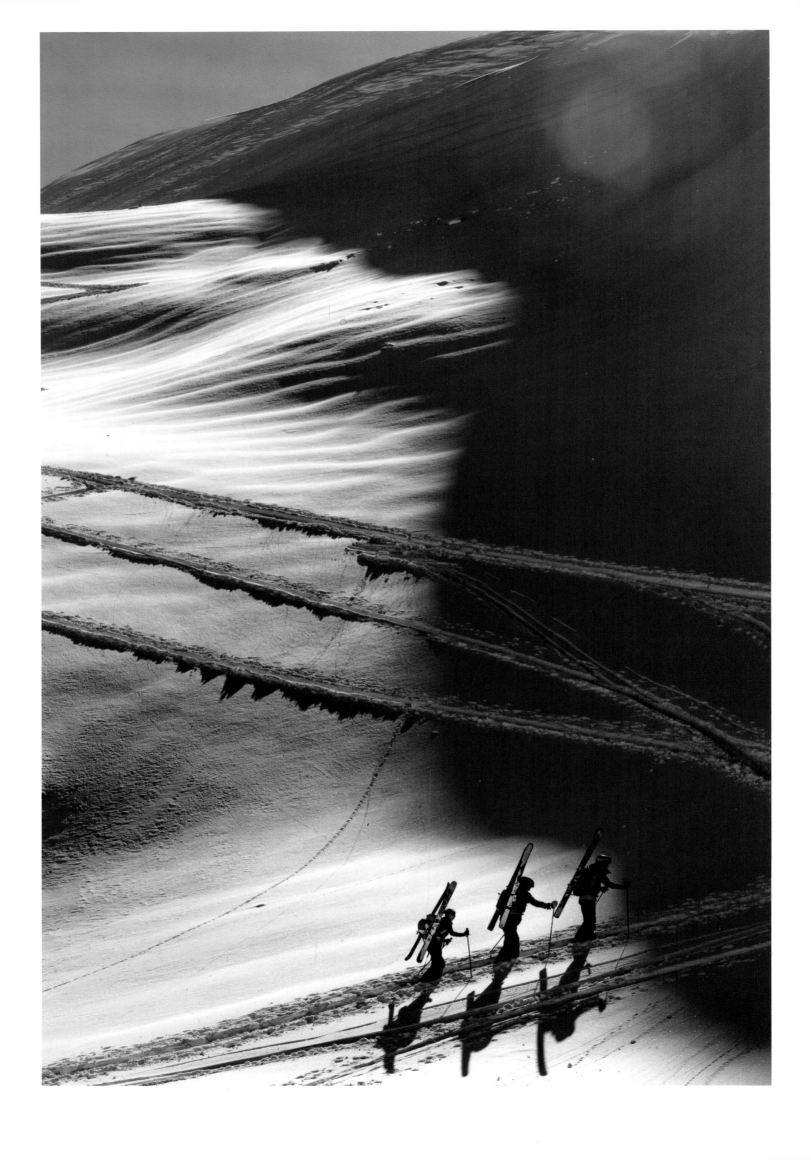

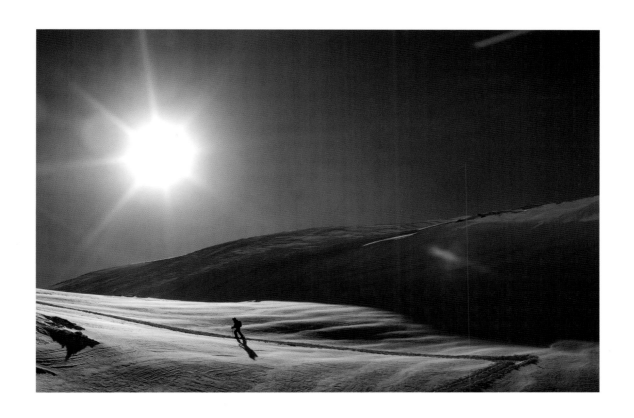

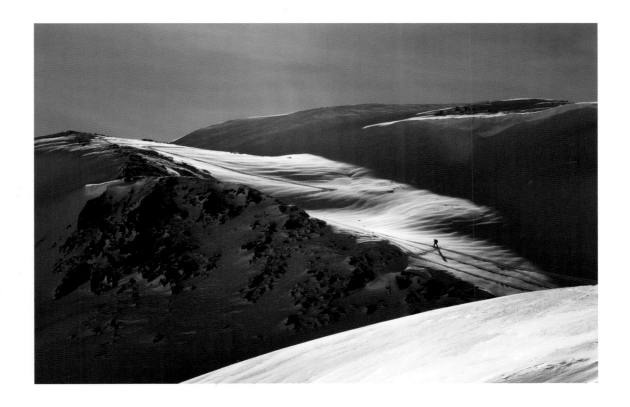

Ski tour, Maroikopf, Arlberg, Austria

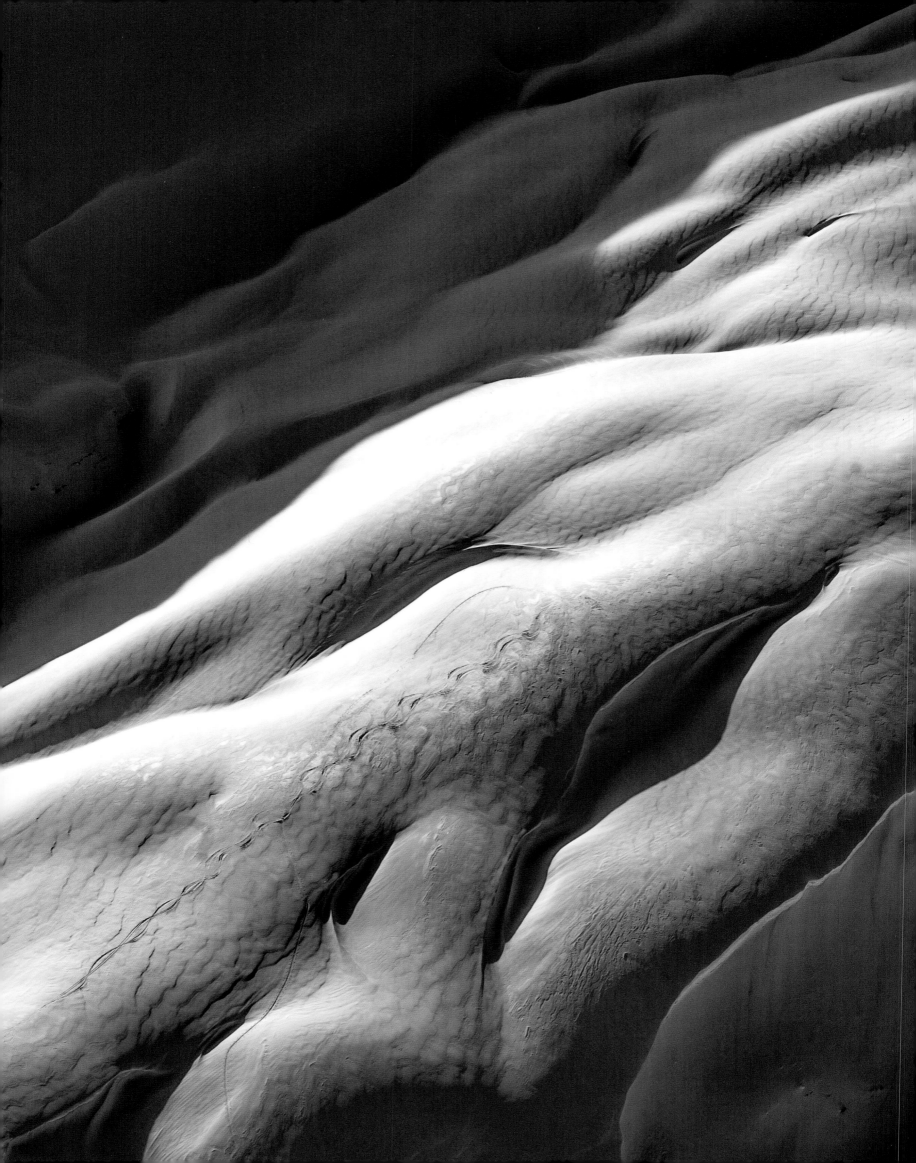

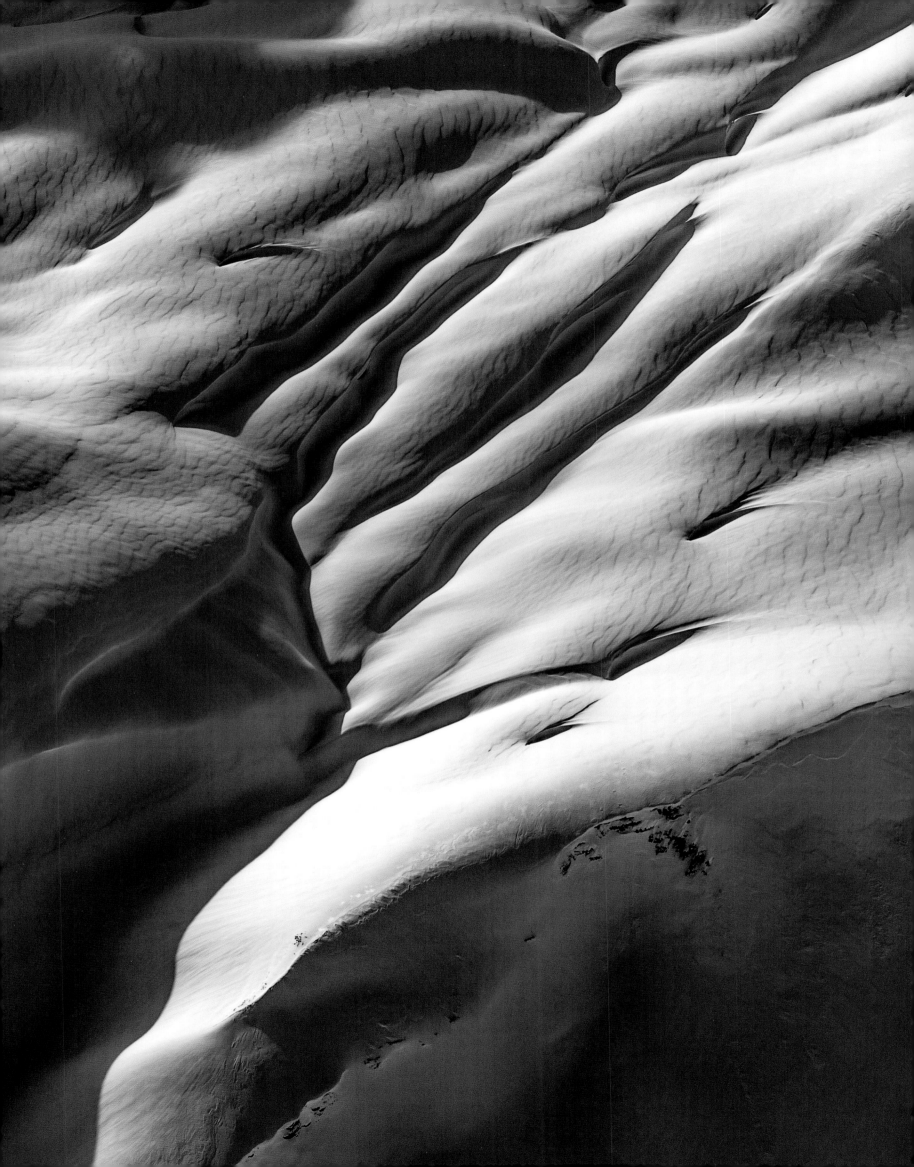

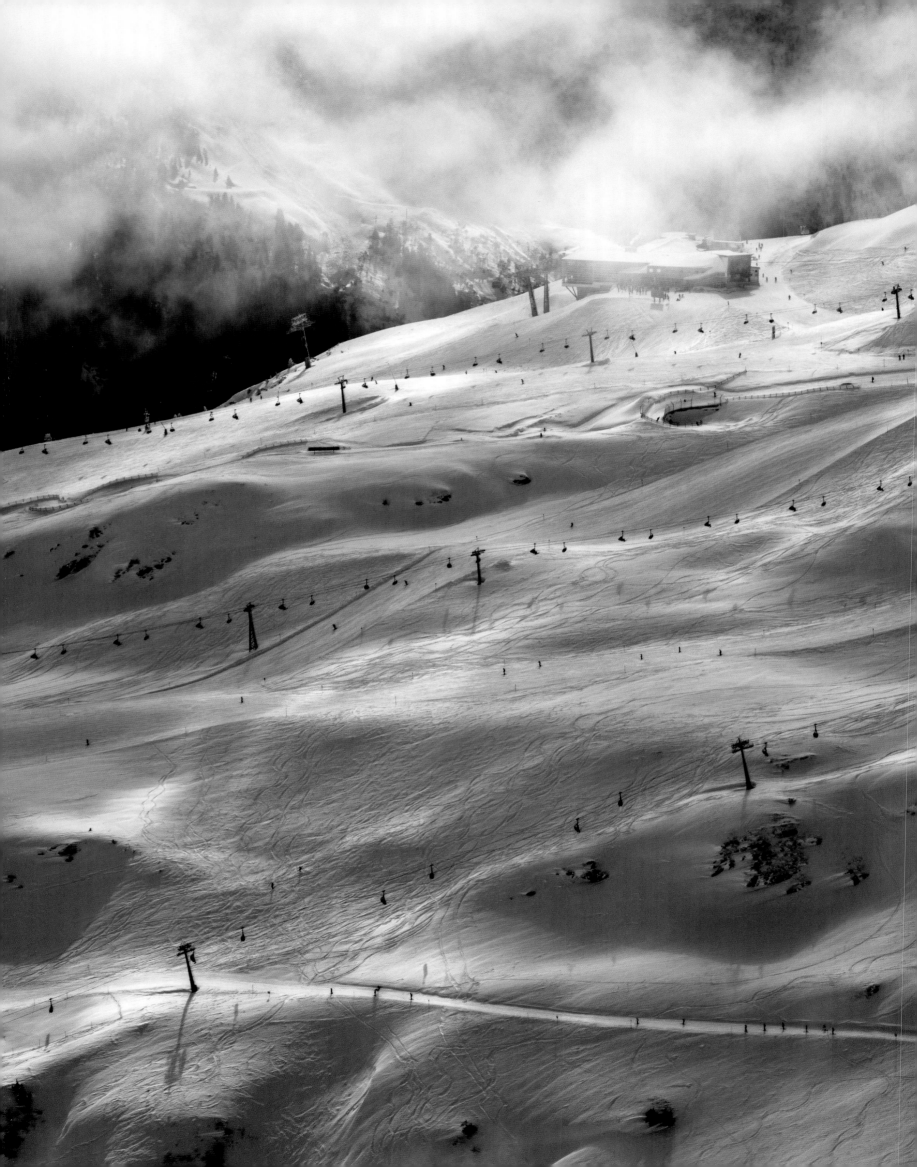

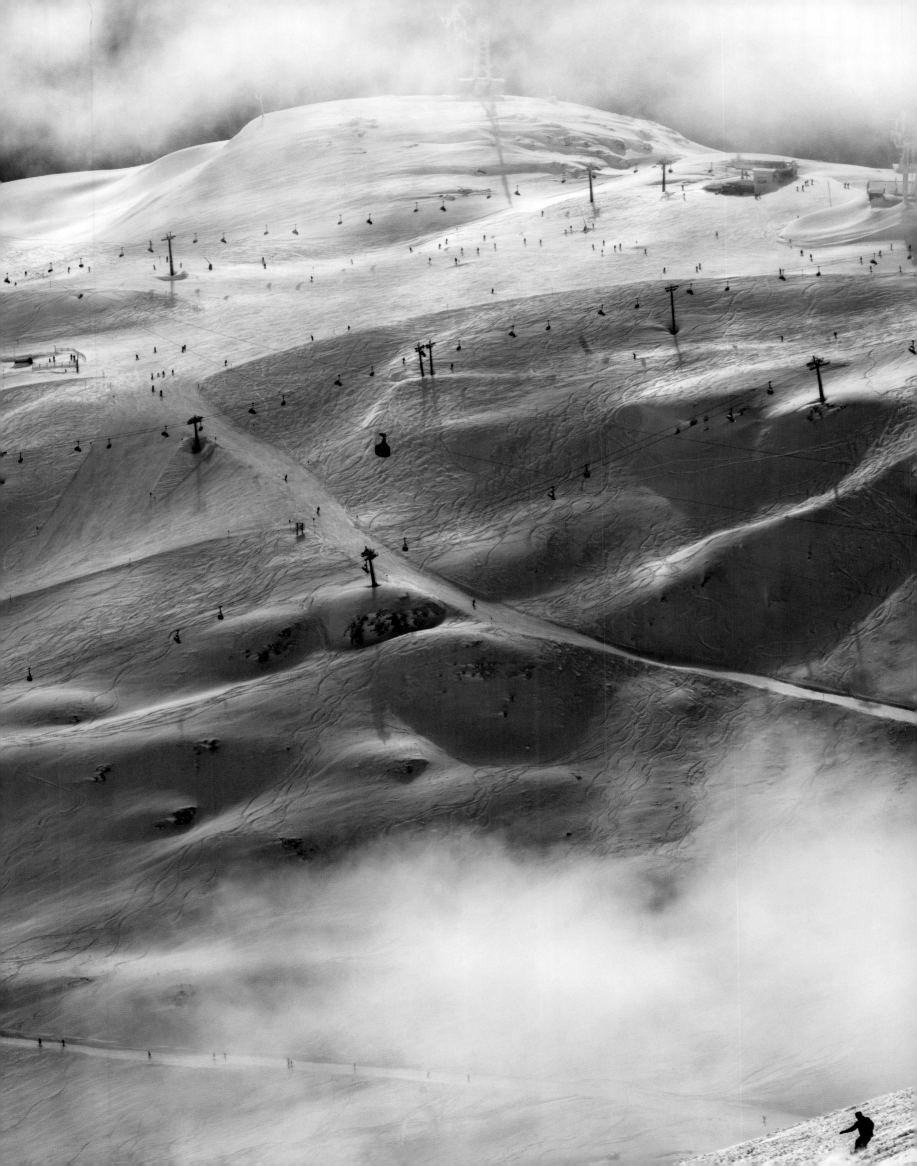

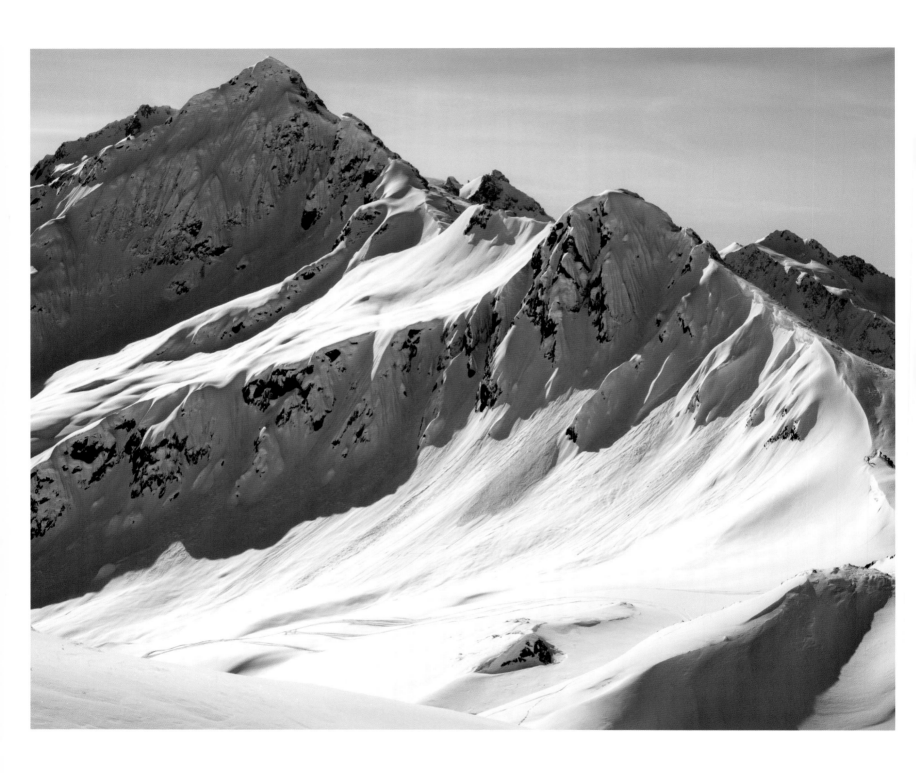

Albonakopf, Stuben, Arlberg, Austria

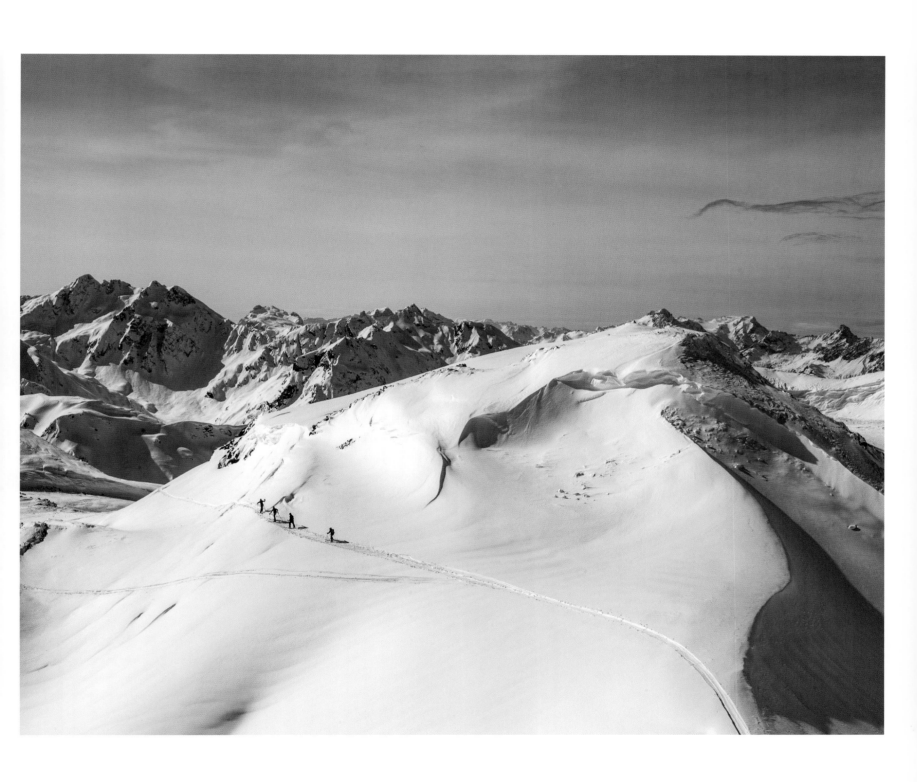

Krachel, Stuben, Arlberg, Austria

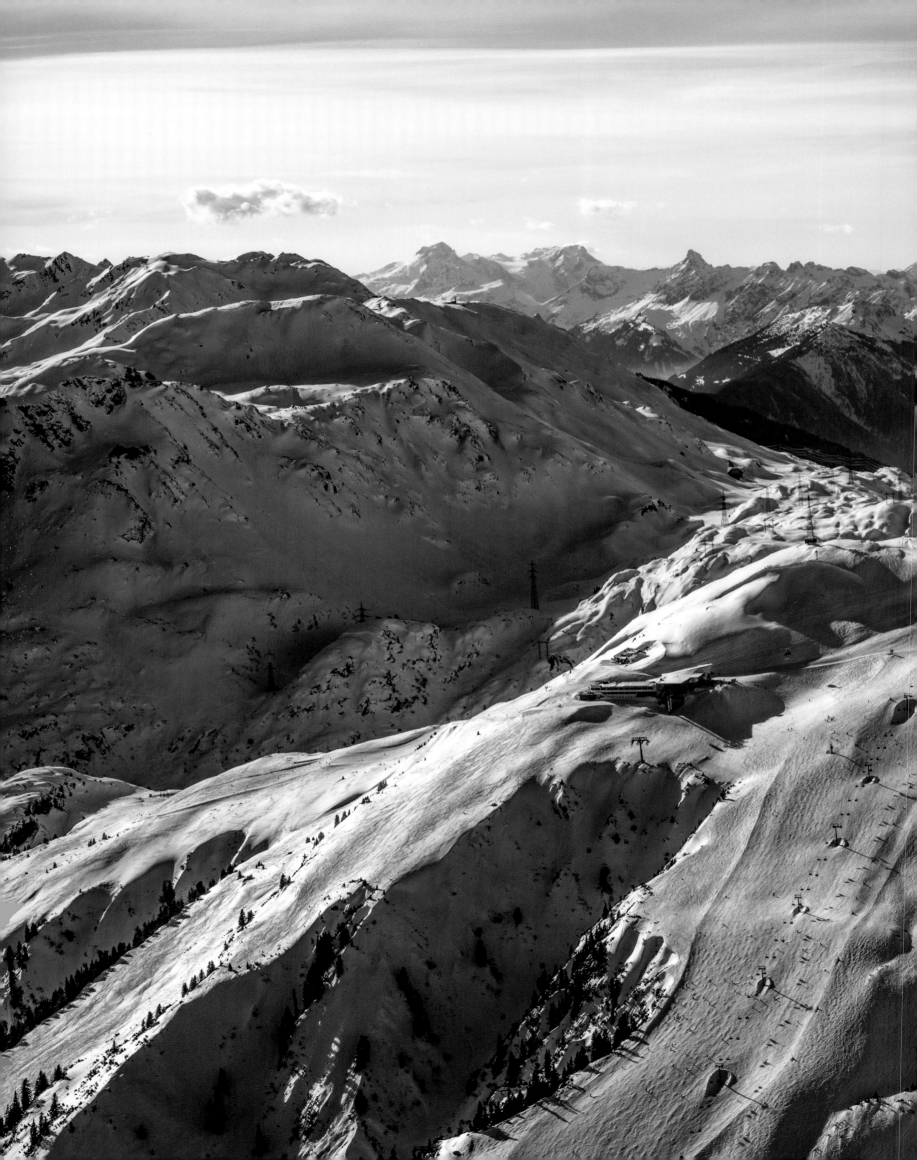

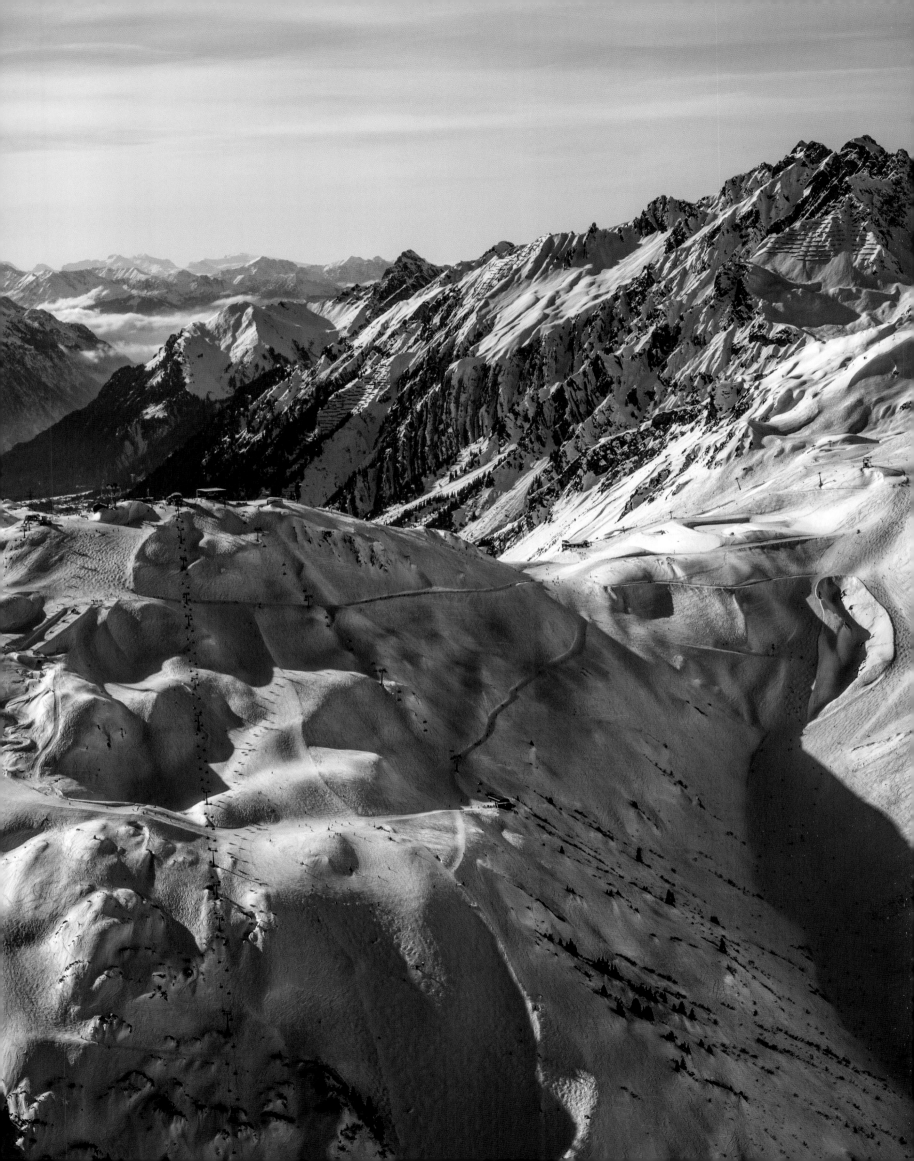

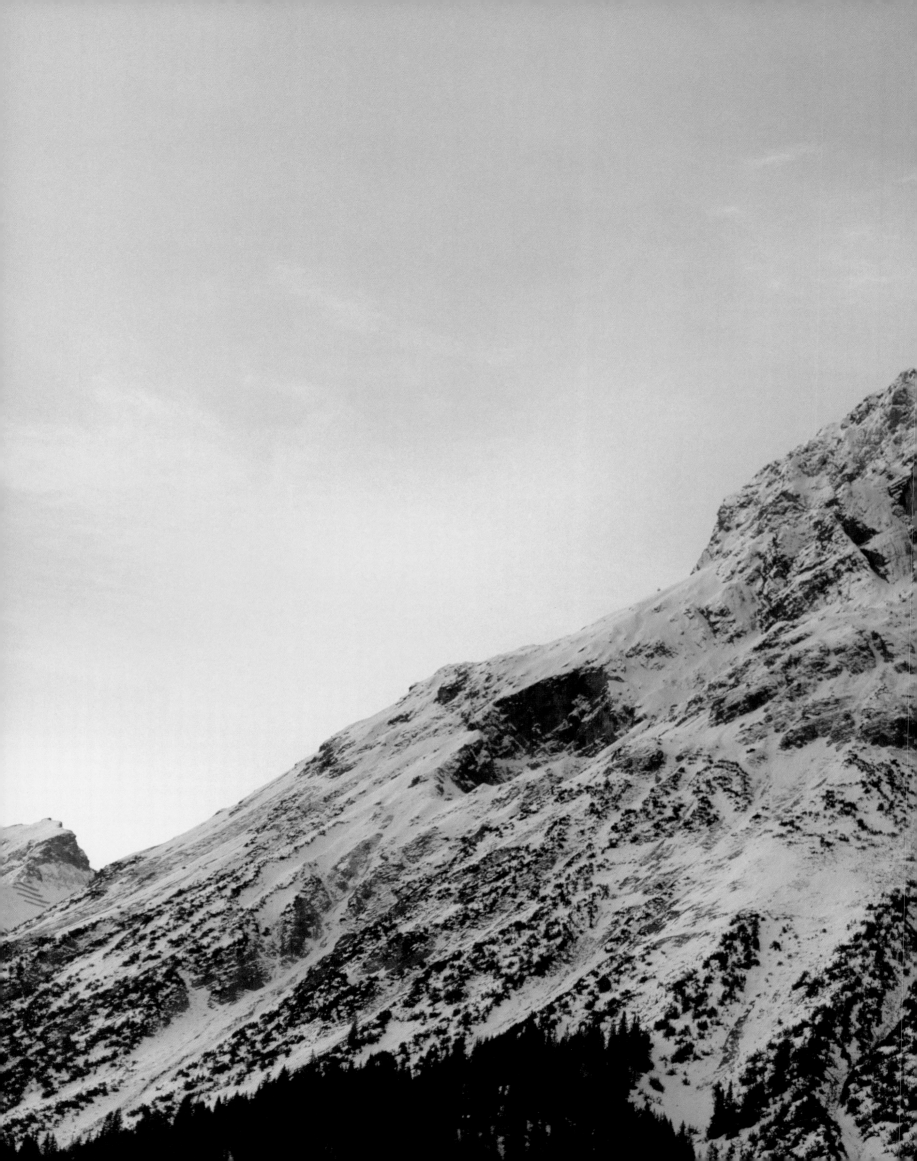

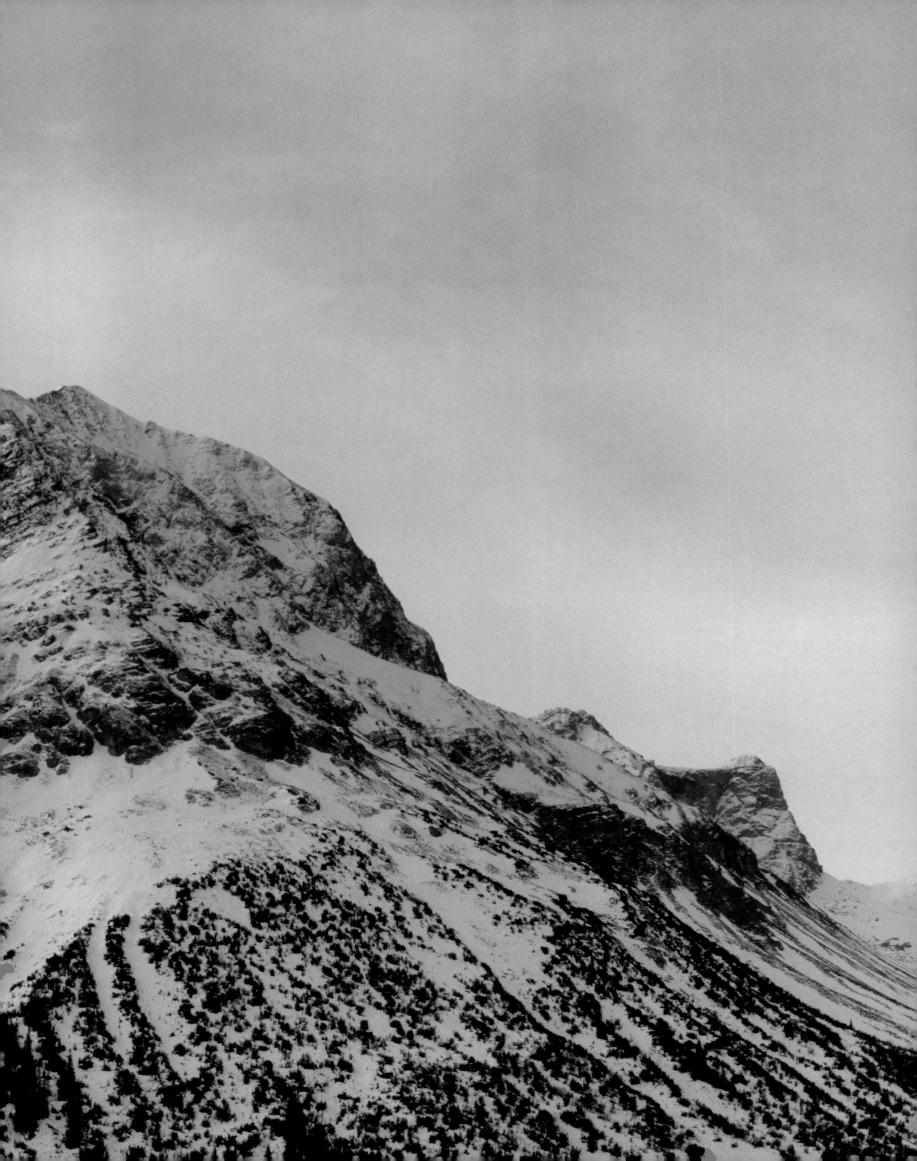

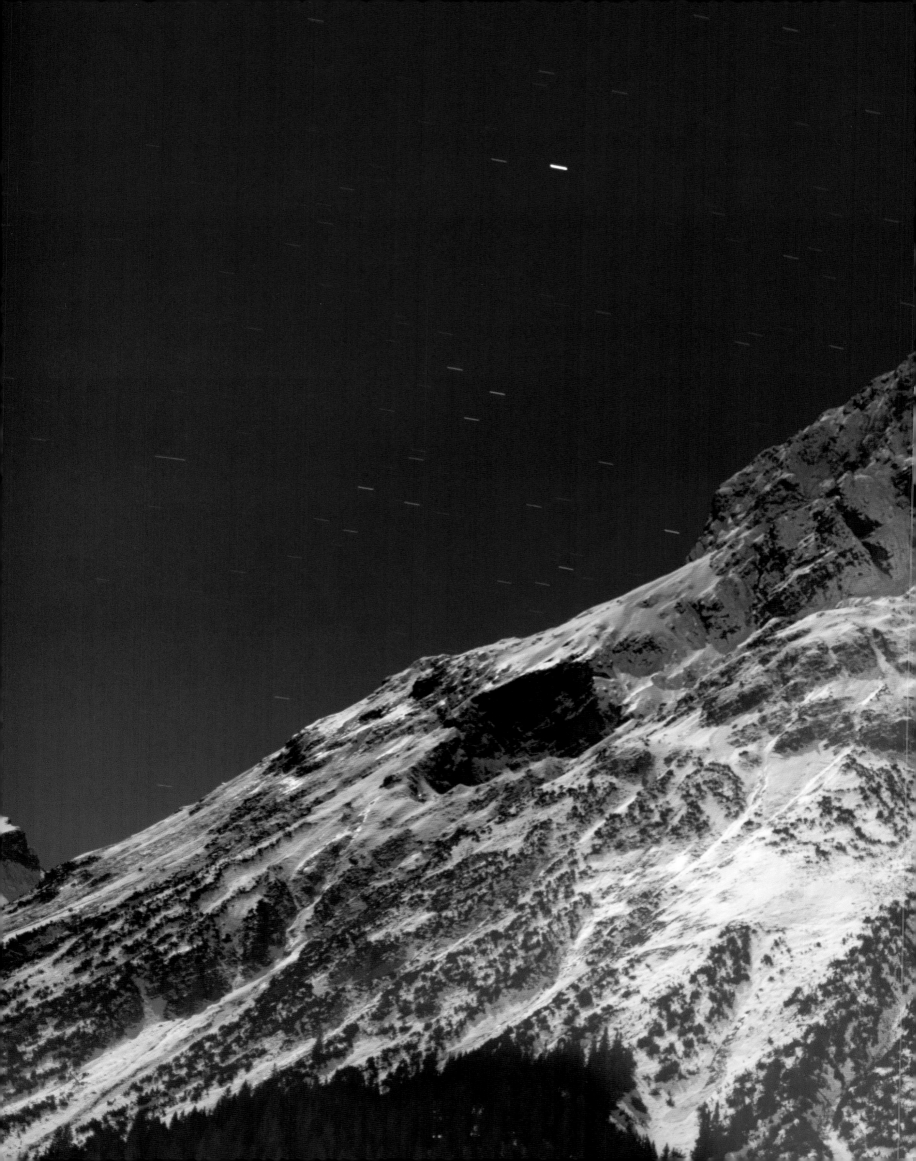

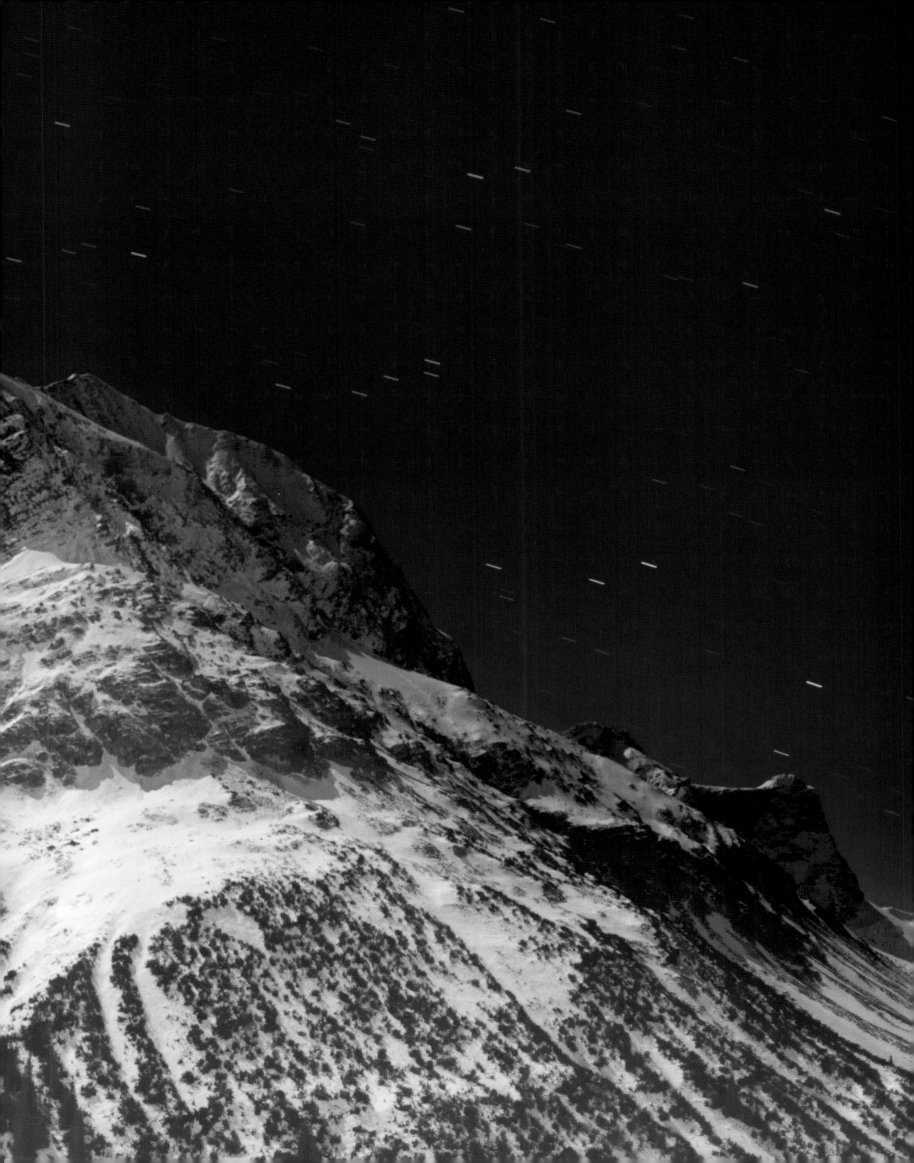

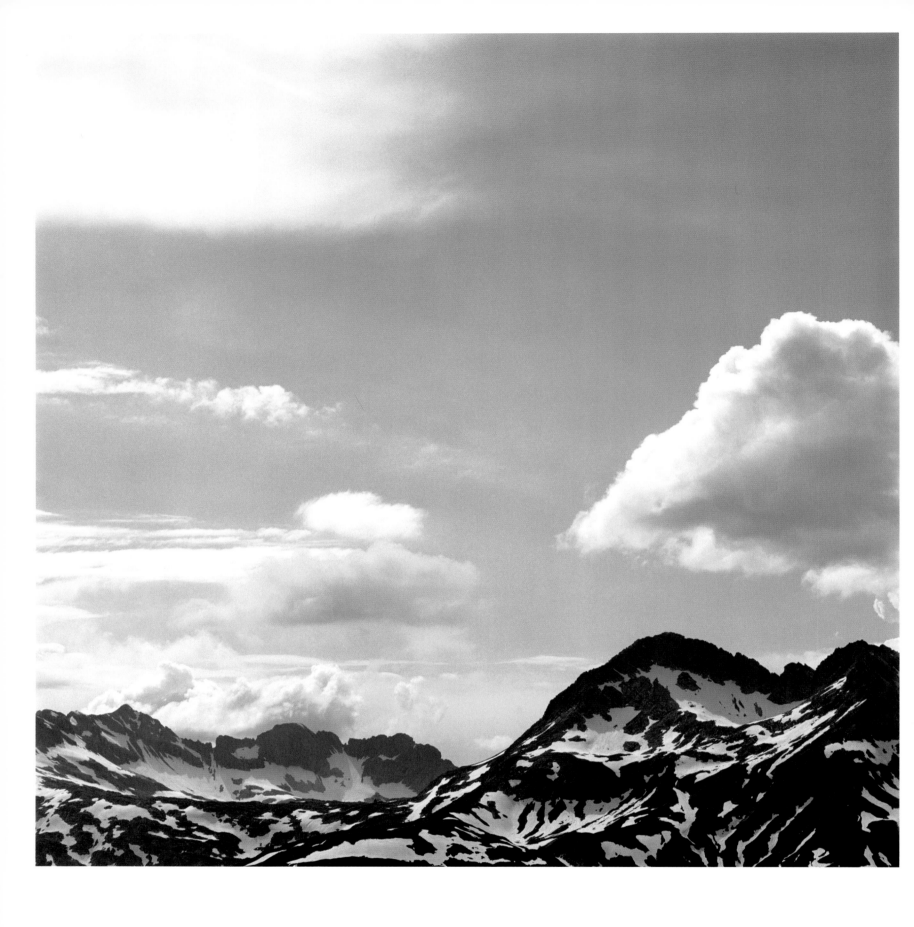

Zuger Hochlicht, Vorarlberg, Austria — 7,799 ft | 2,377 m

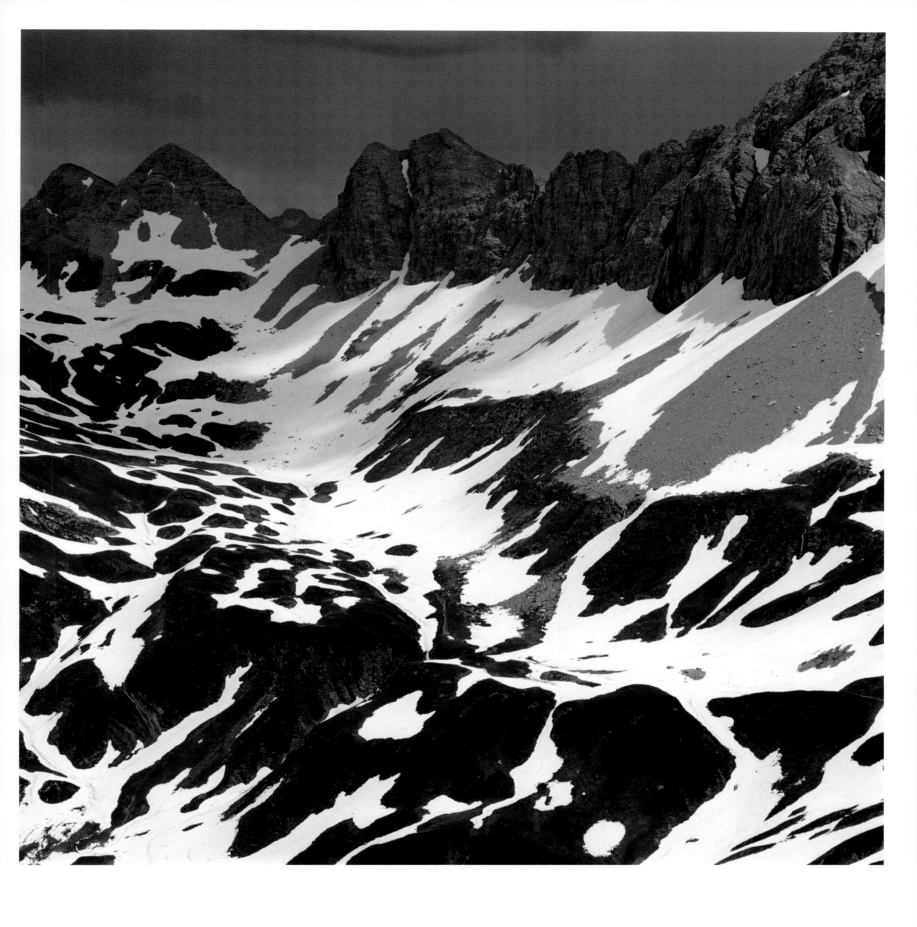

Rauhkopfscharte, Vorarlberg, Austria – 9,843 ft | 3,000 m

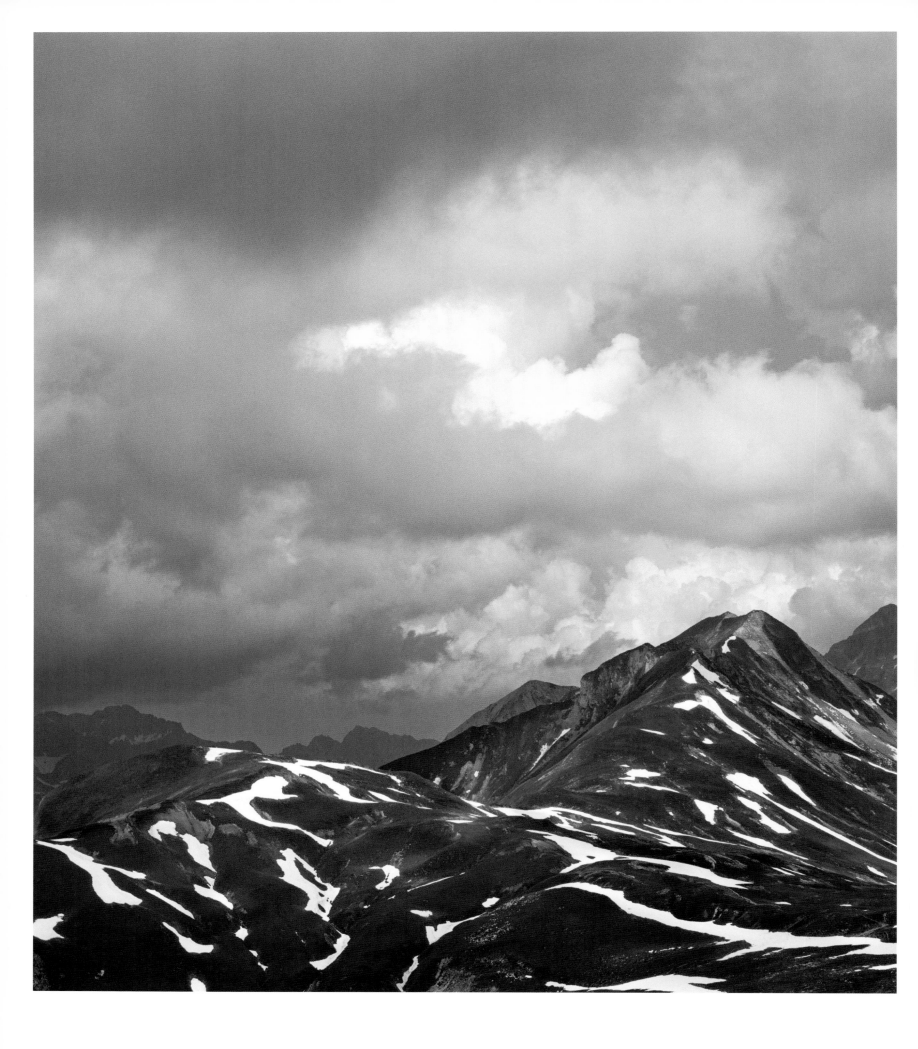

Wösterhorn, Vorarlberg, Austria

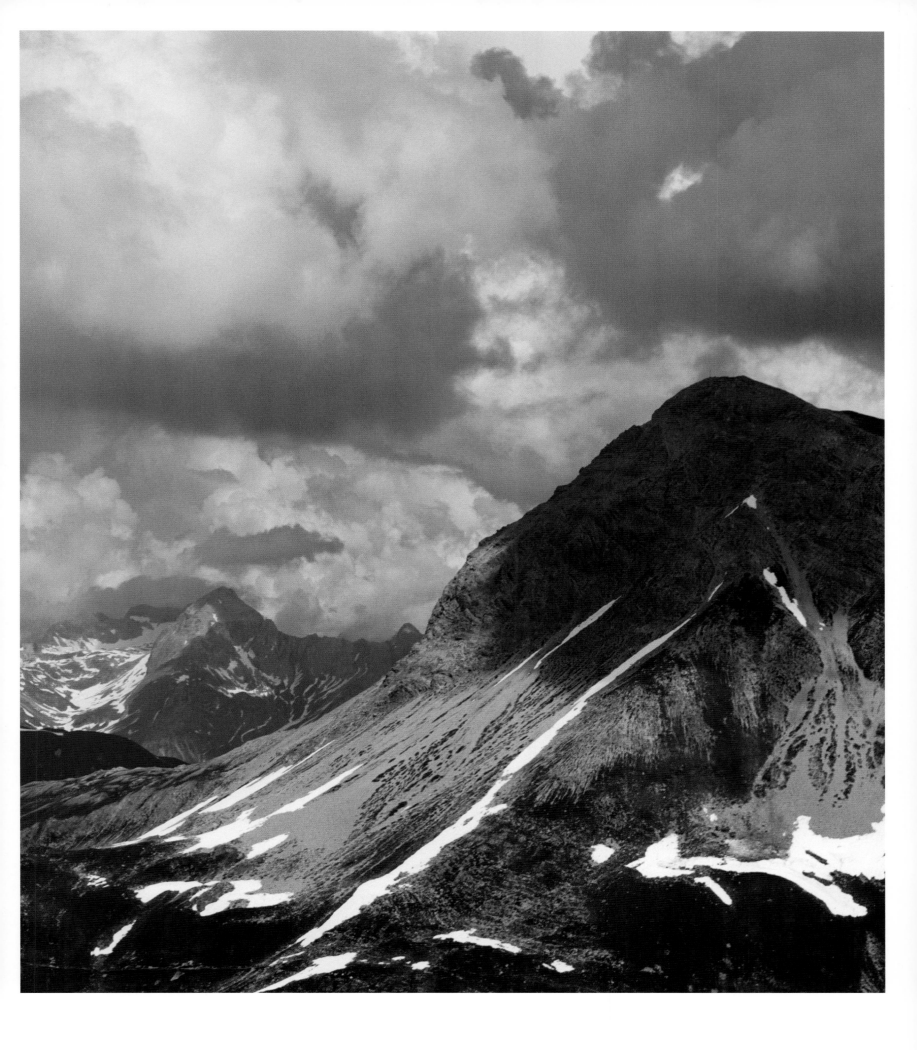

Wösterspitze, Vorarlberg, Austria — 8,392 ft | 2,558 m

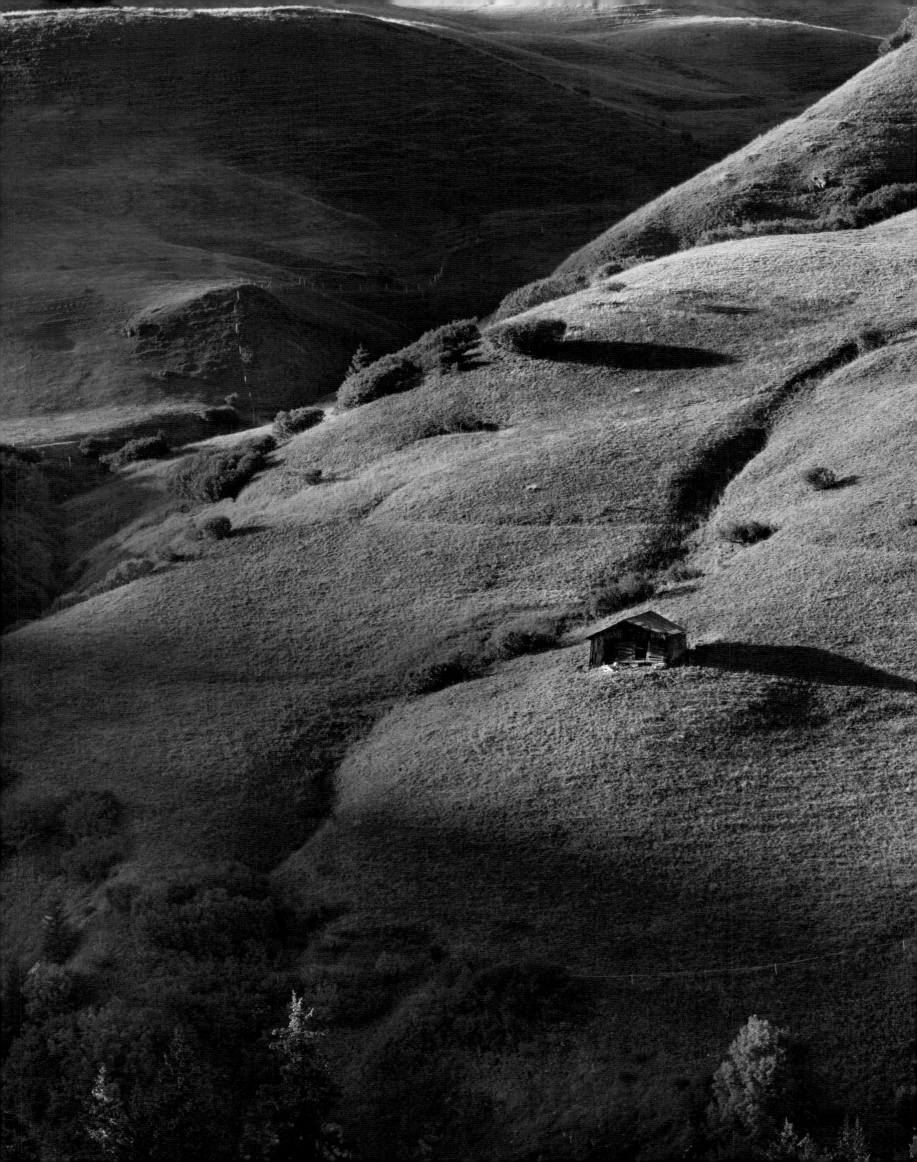

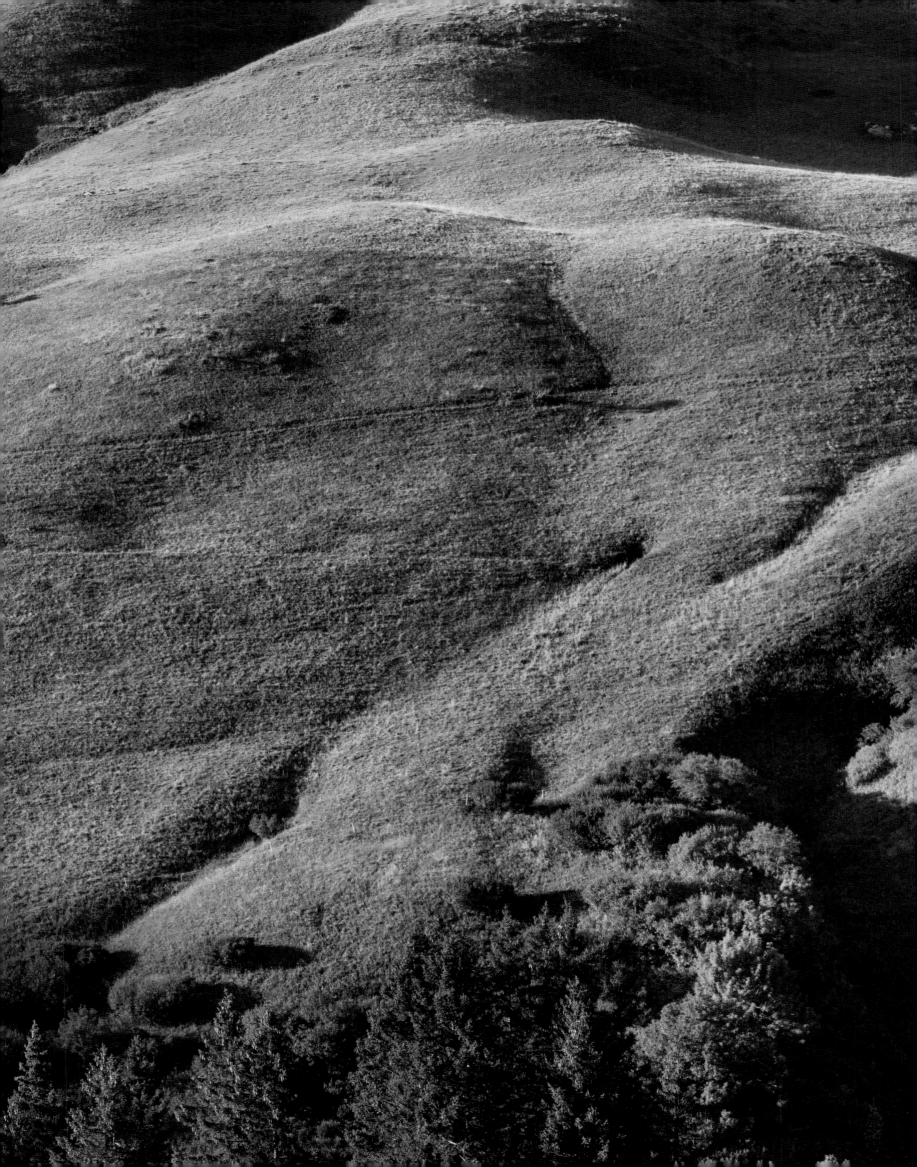

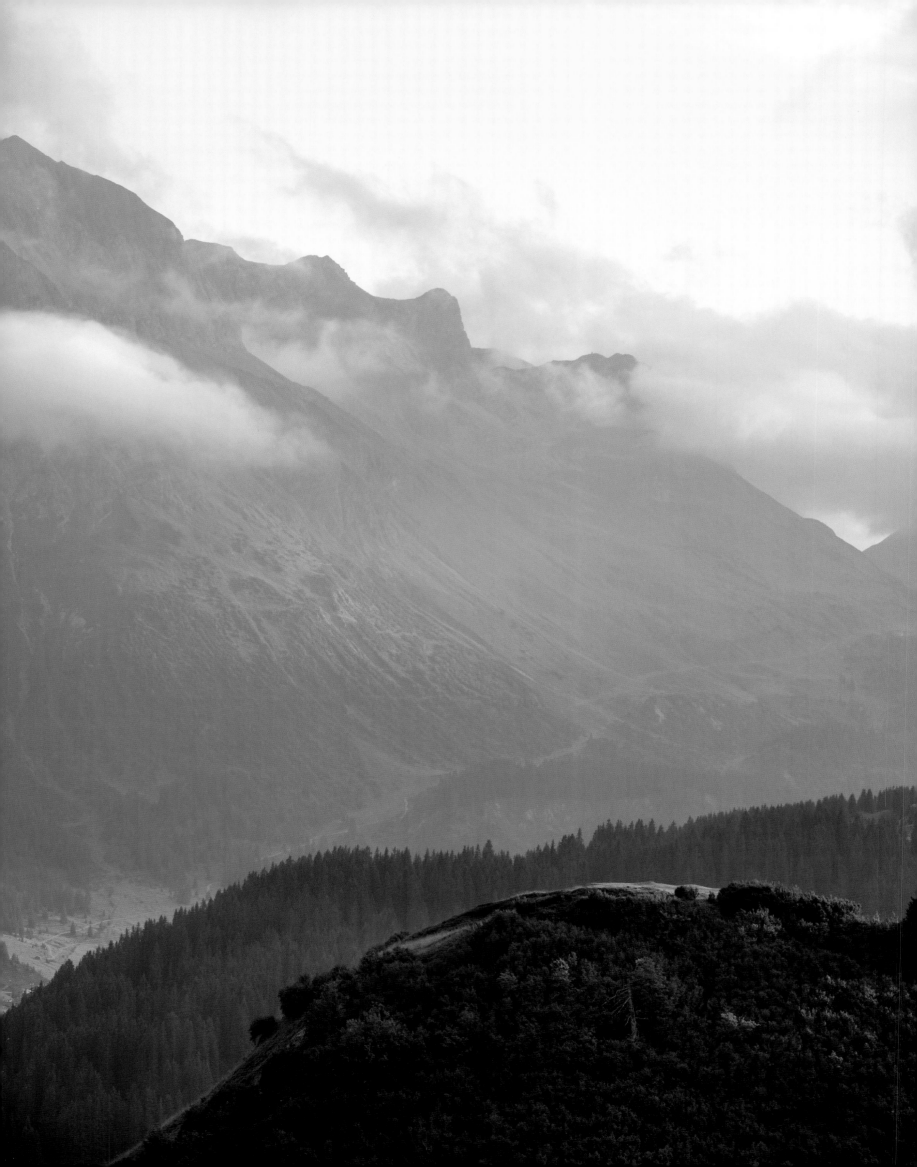

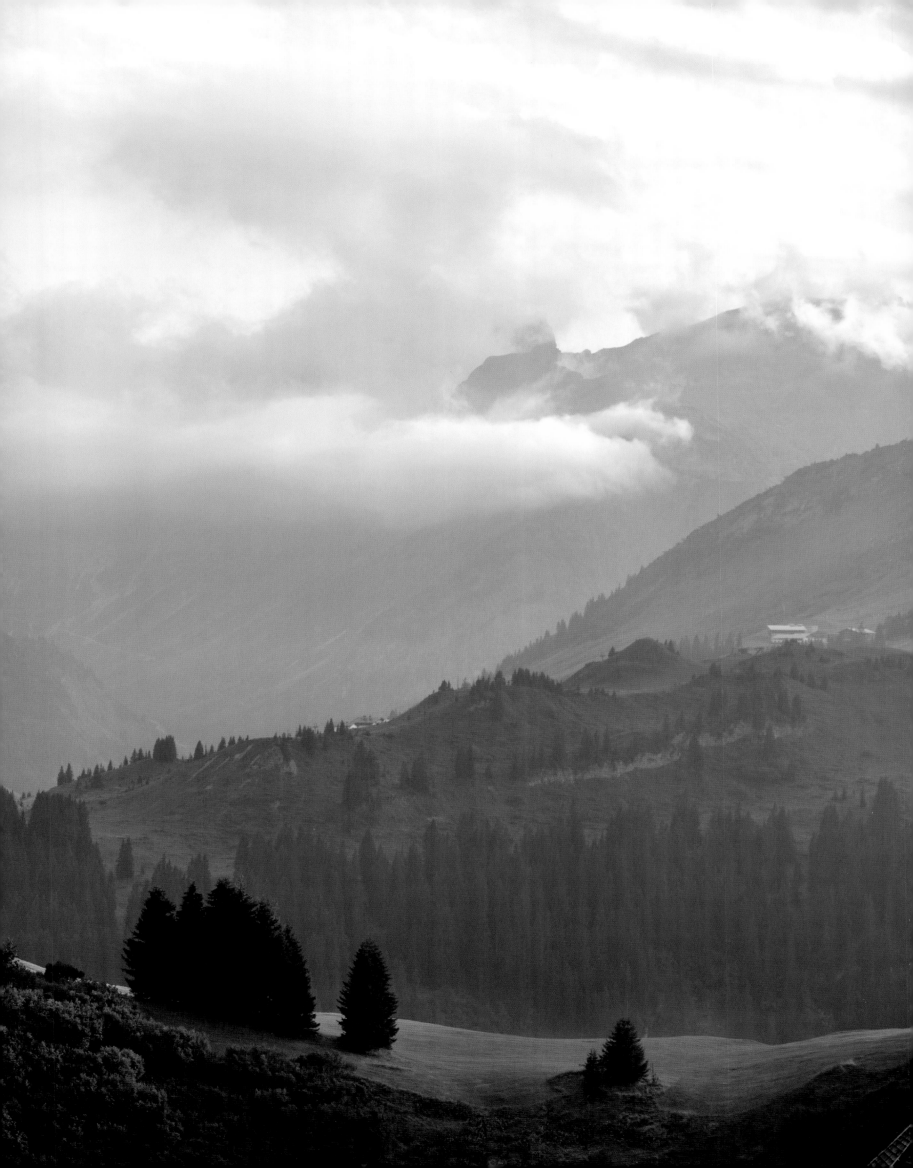

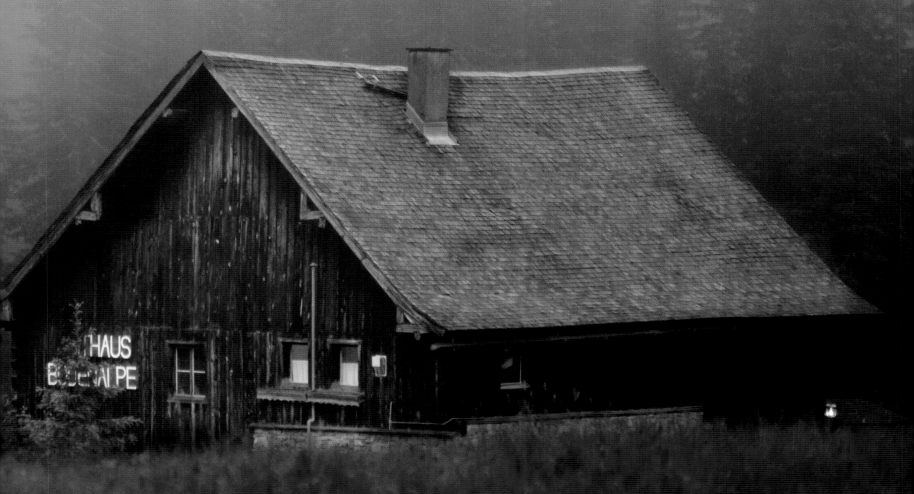

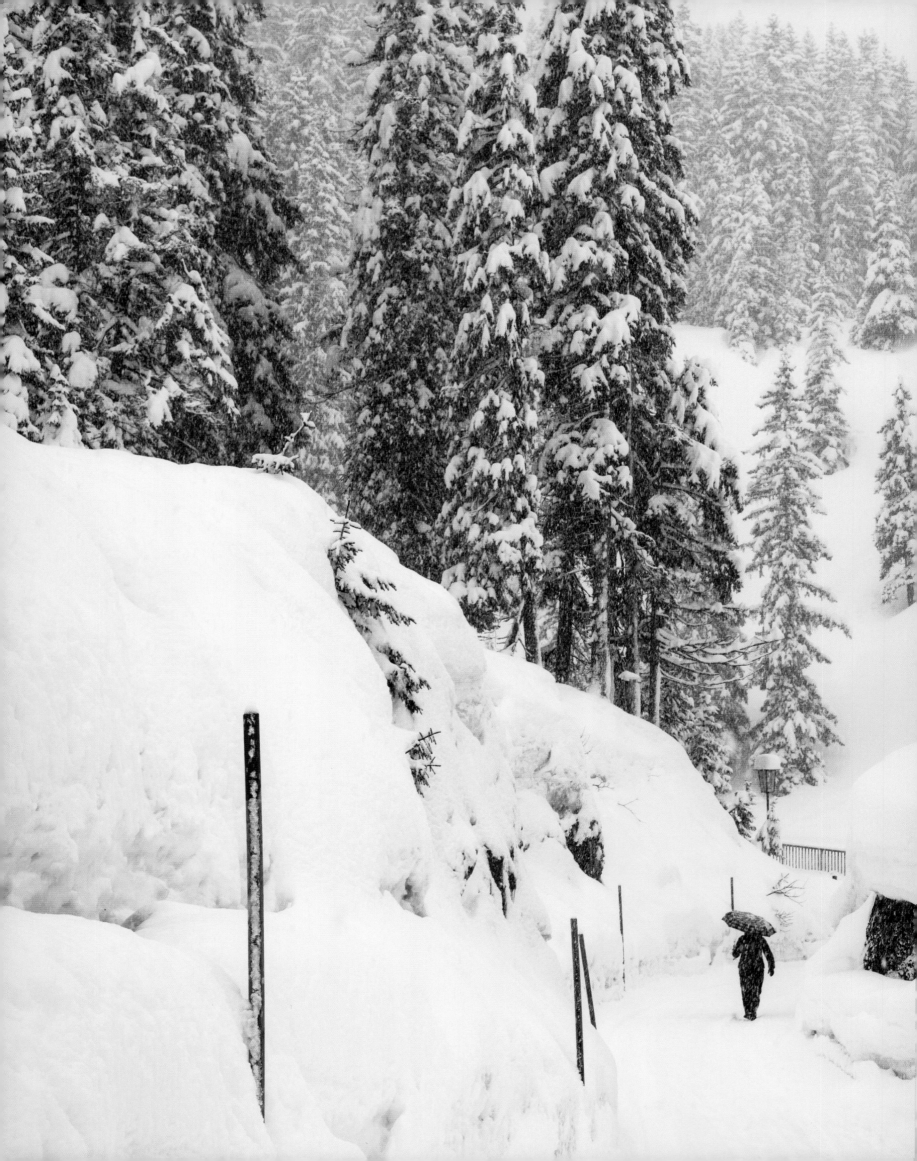

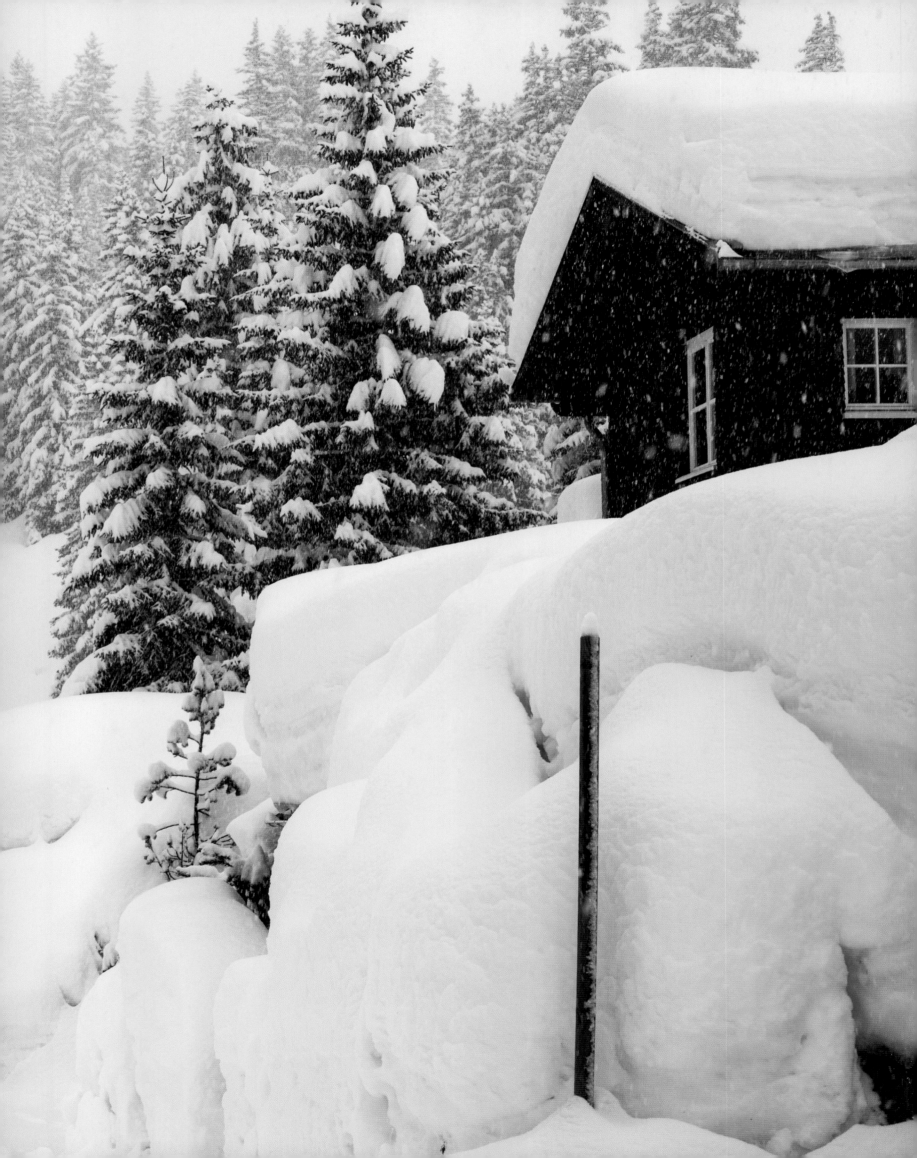

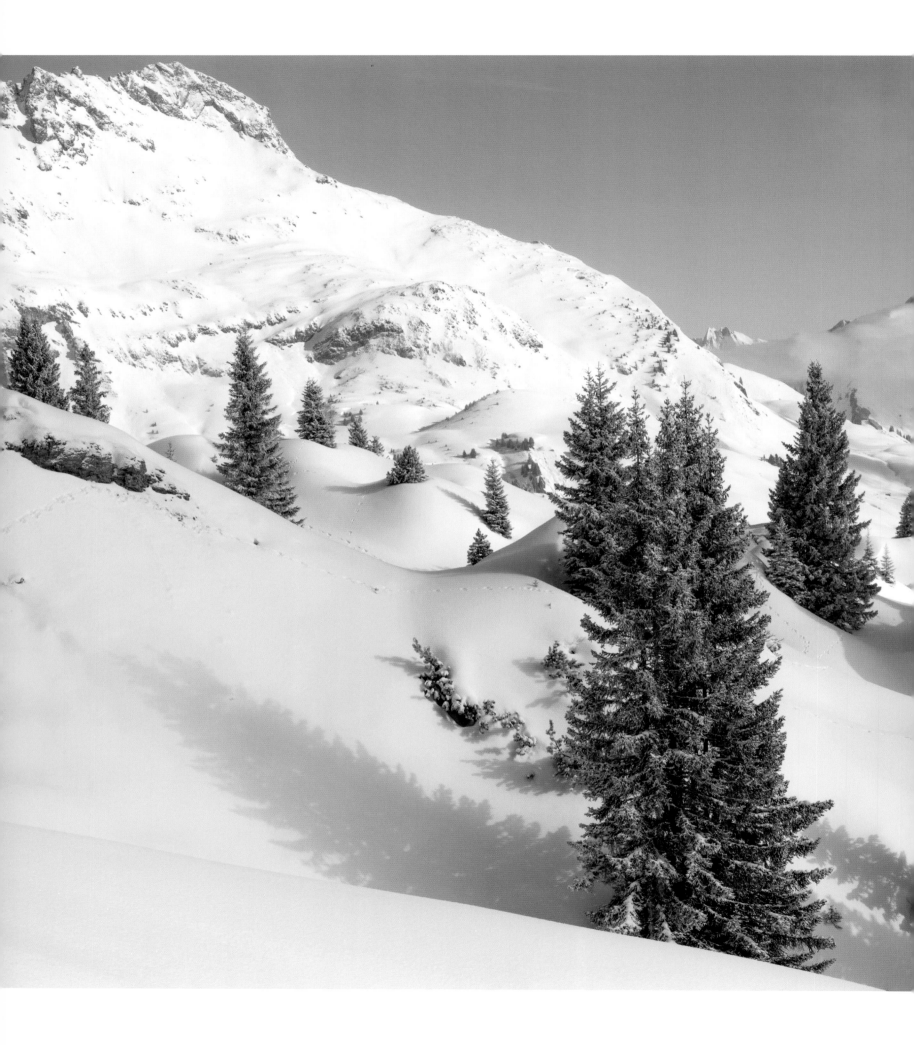

Gipslöcher, Lech, Vorarlberg, Austria

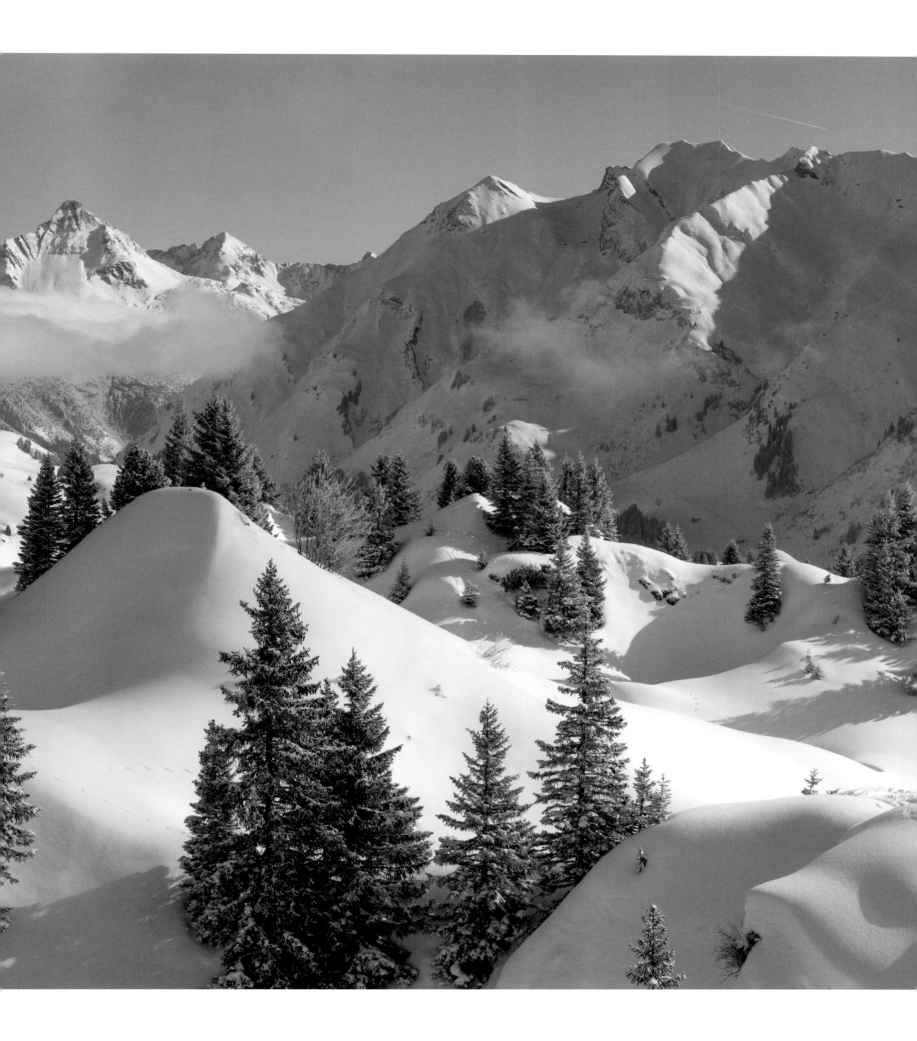

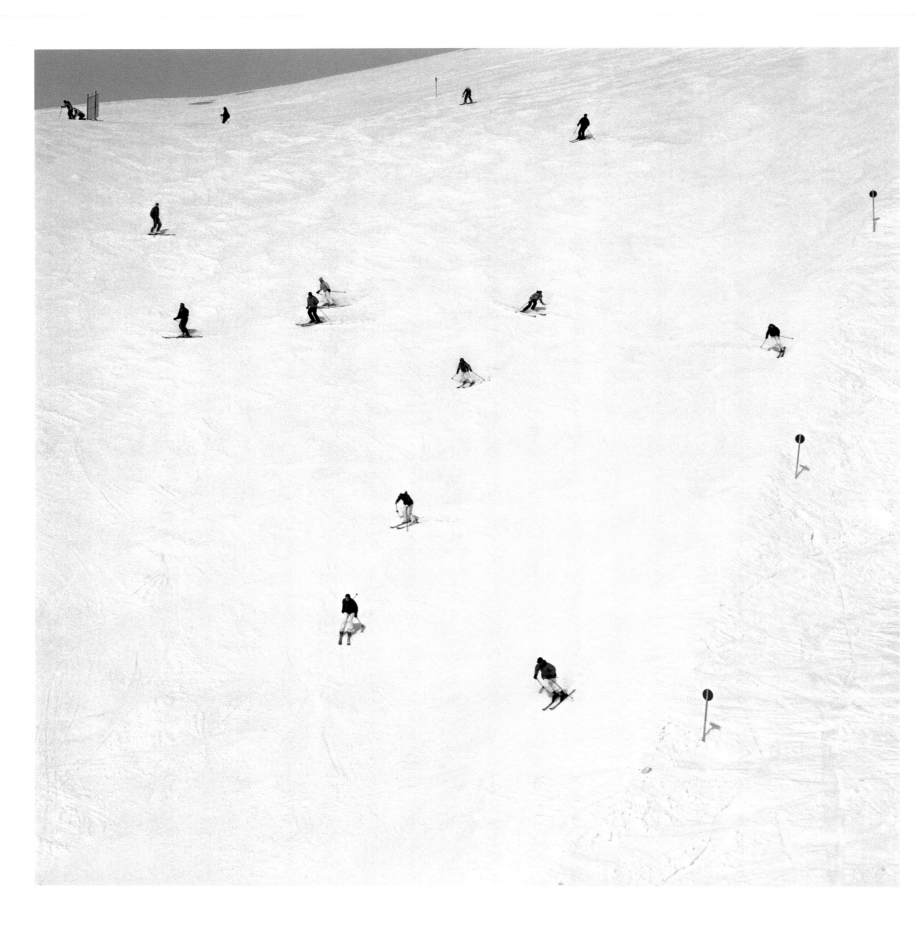

Petersboden, Lech, Austria

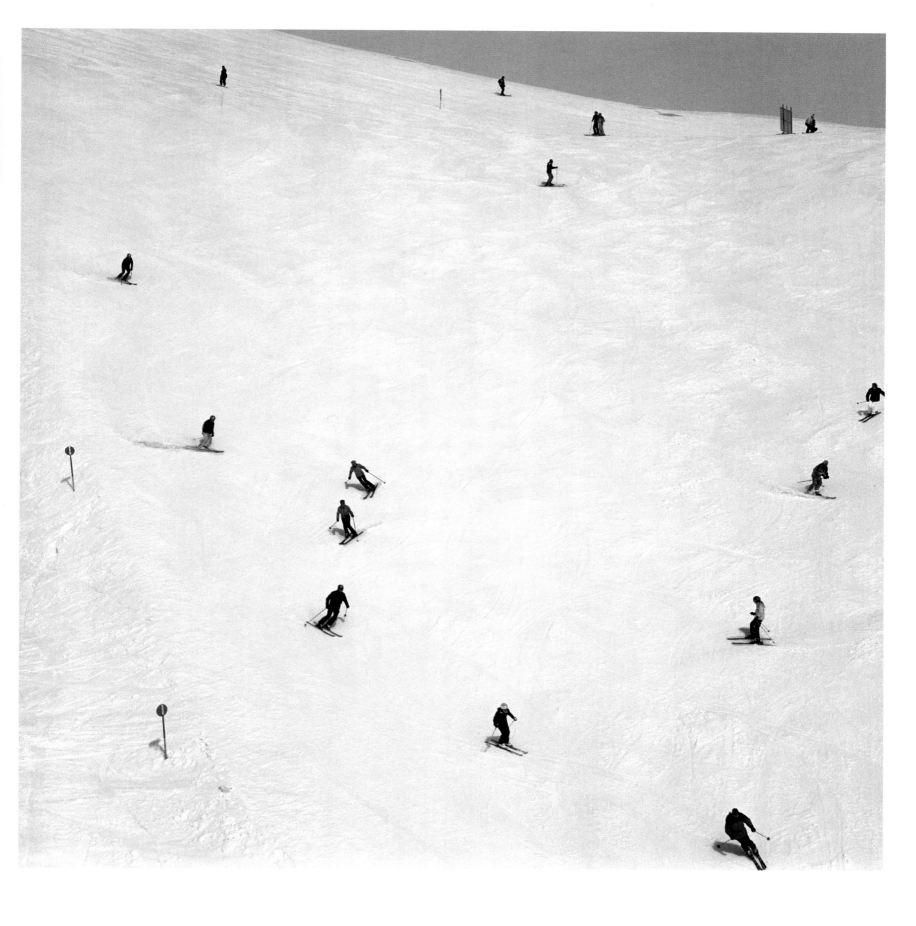

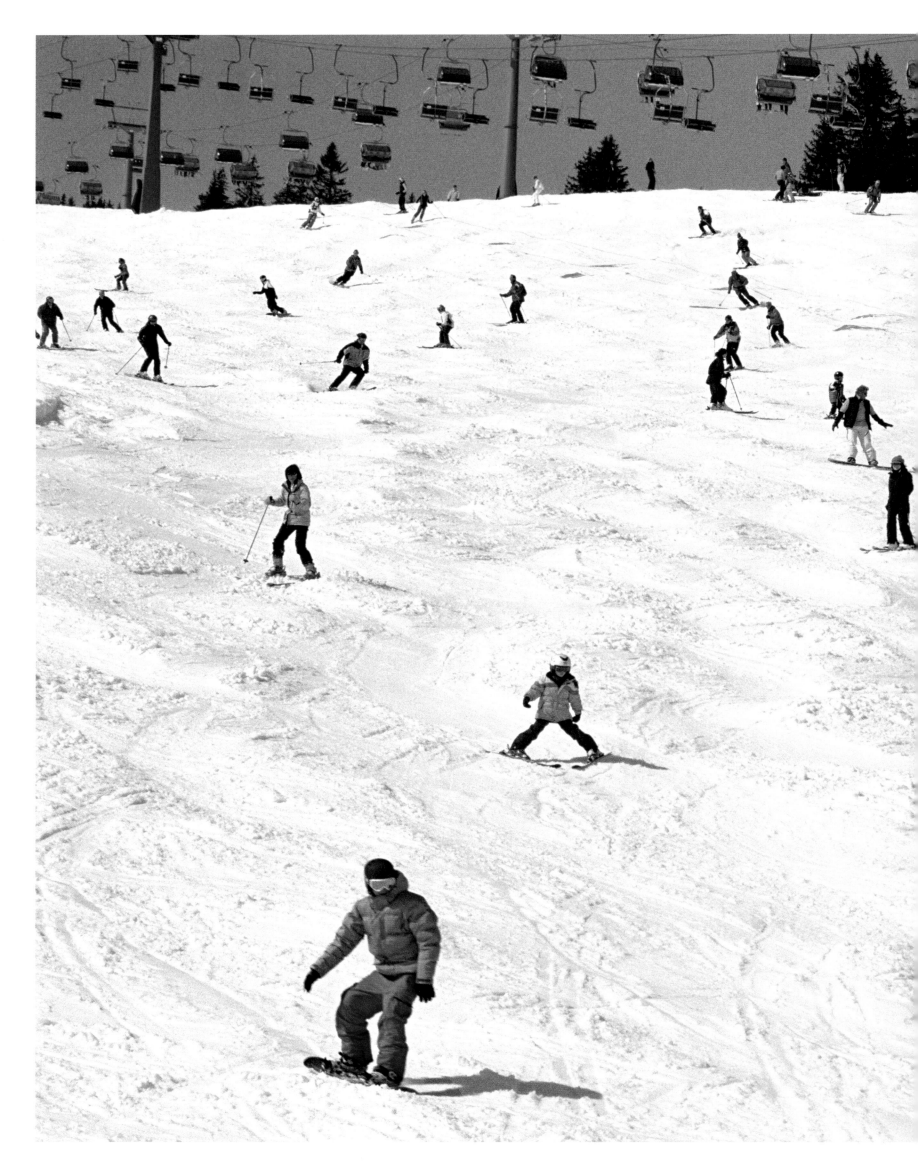

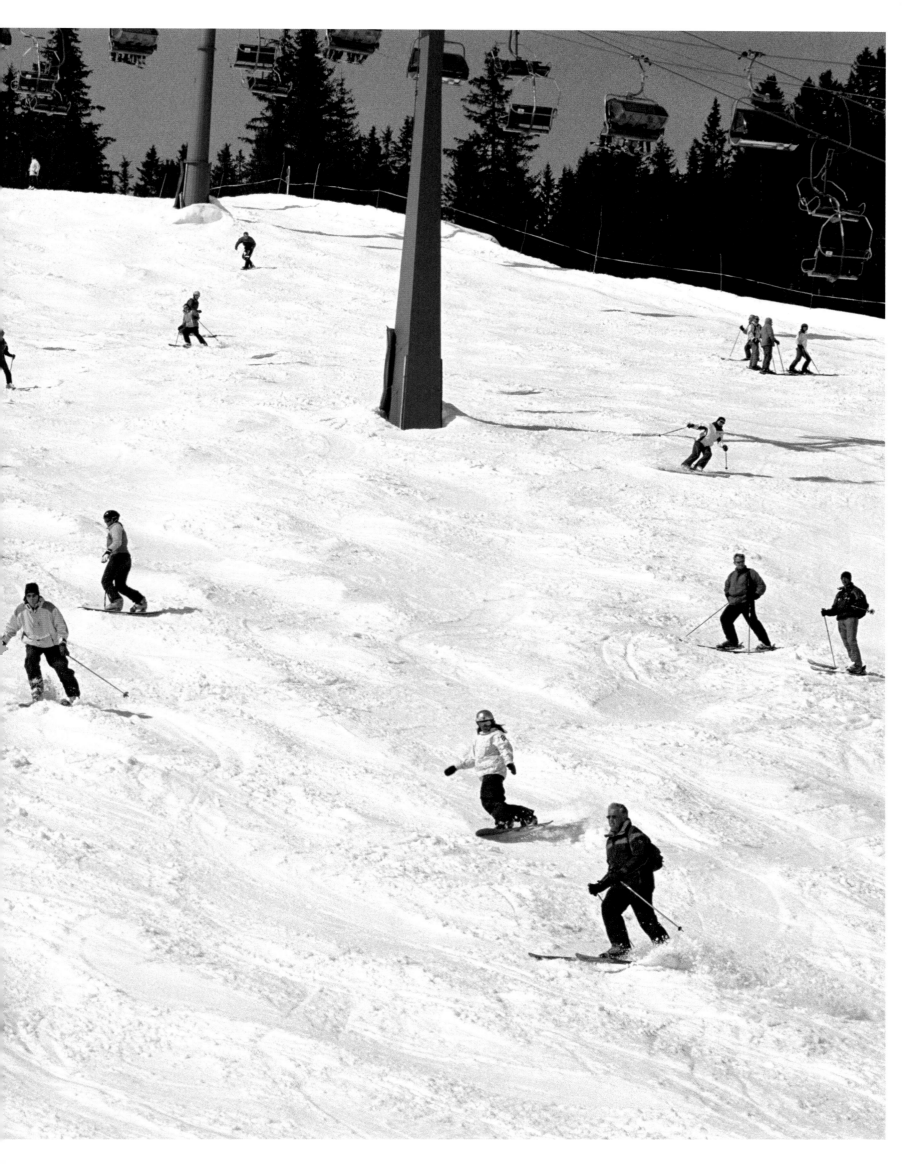

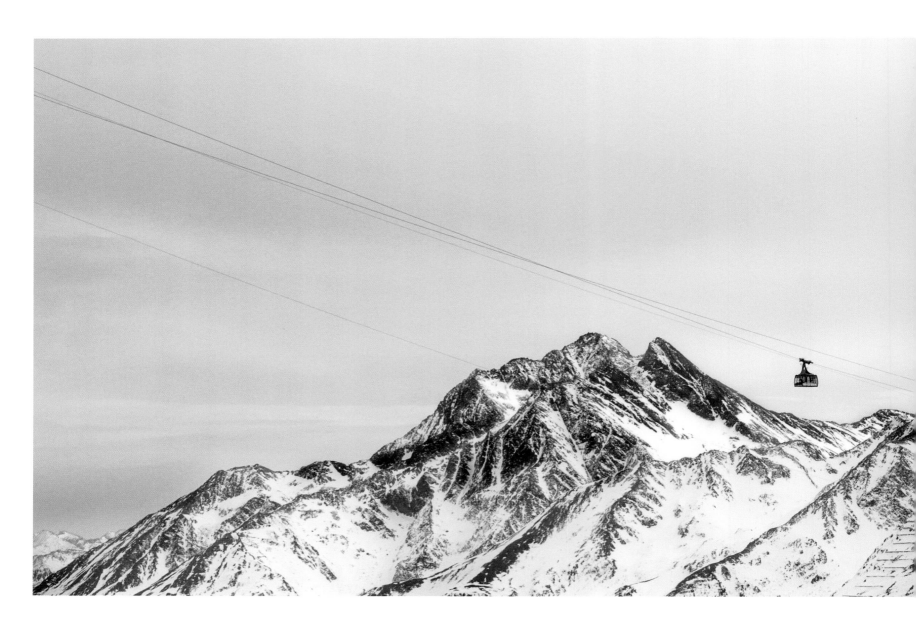

Vallugabahn, St Anton, Arlberg, Austria

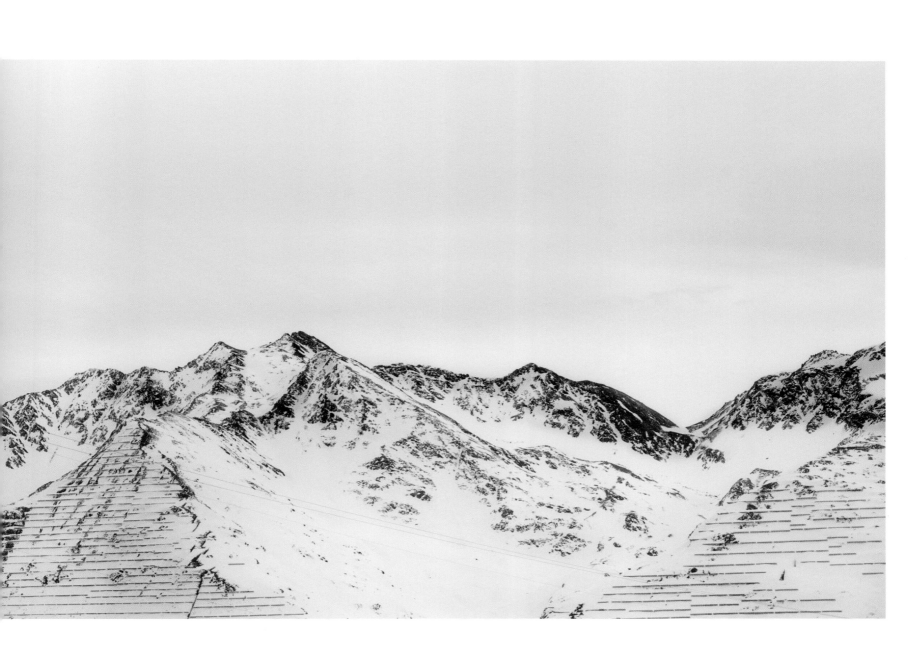

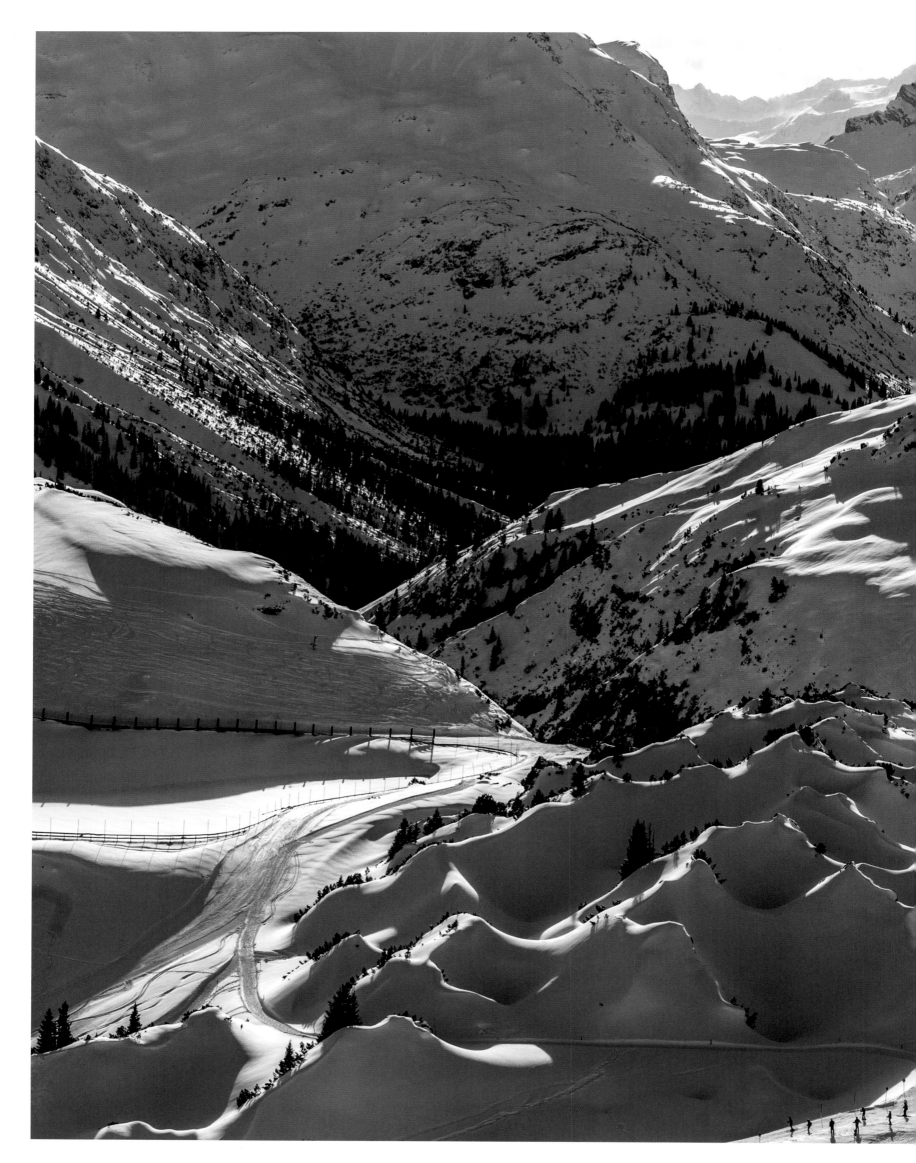

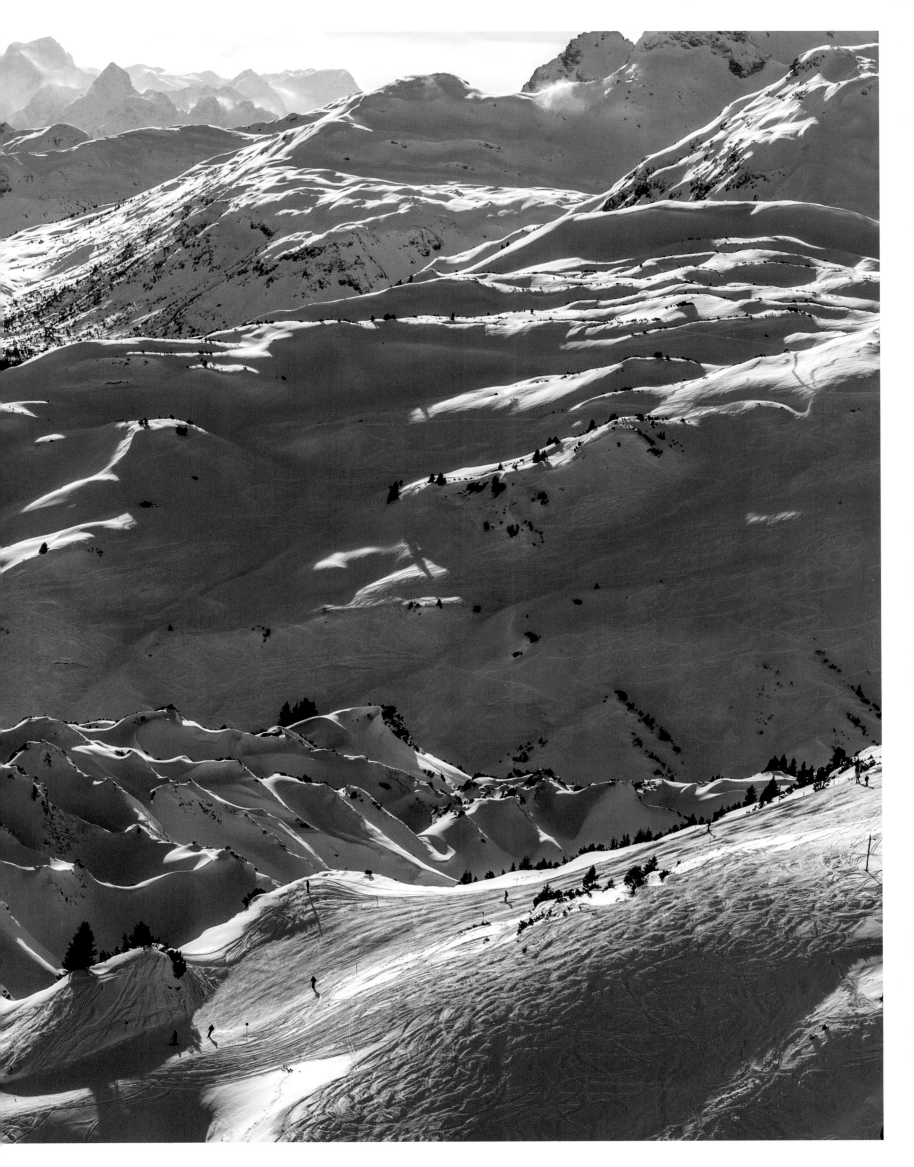

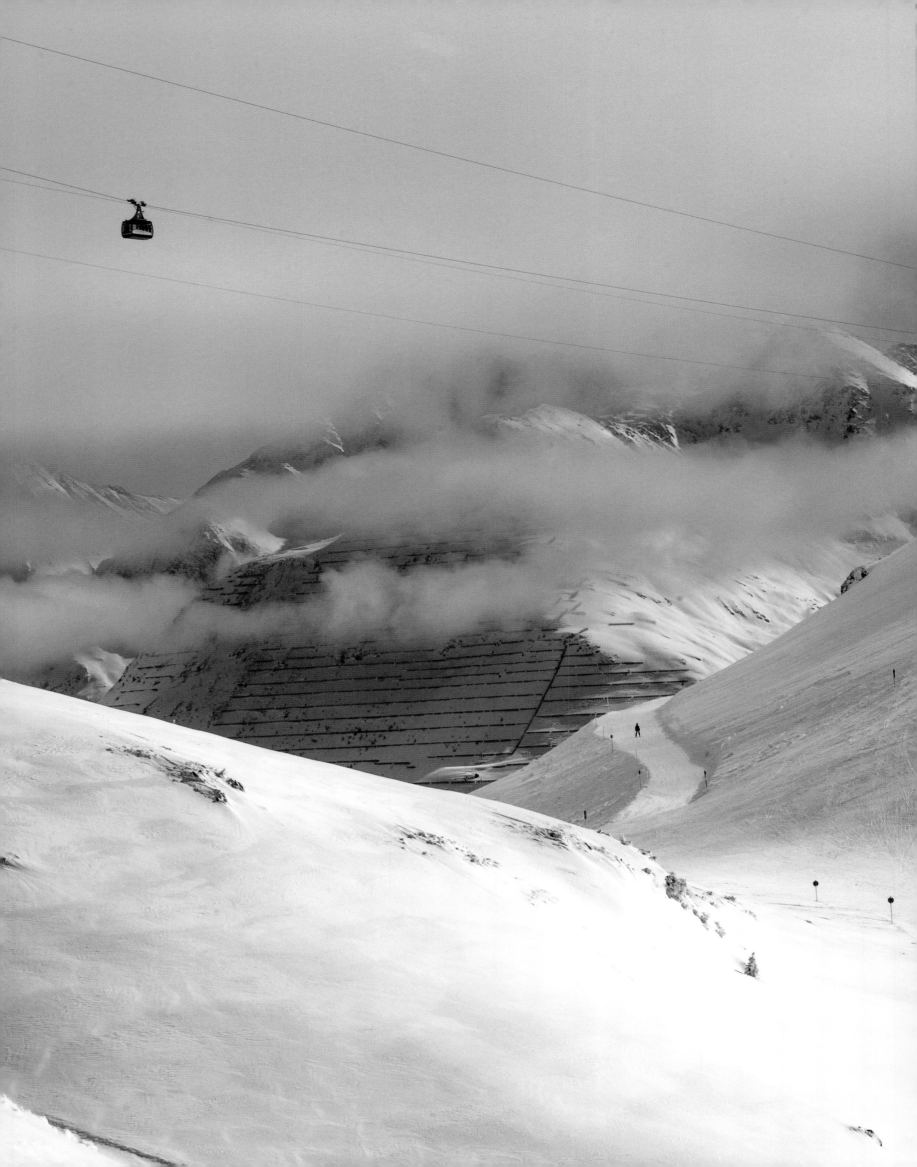

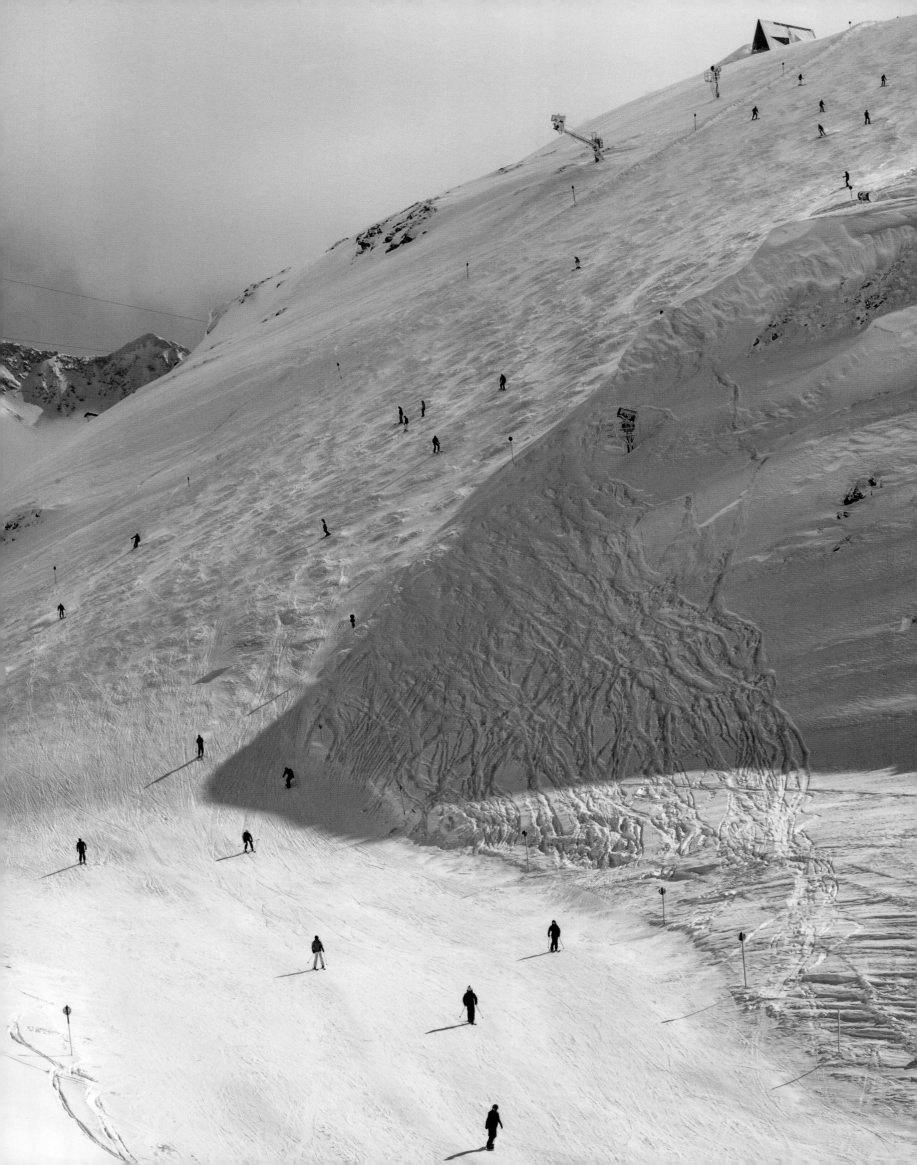

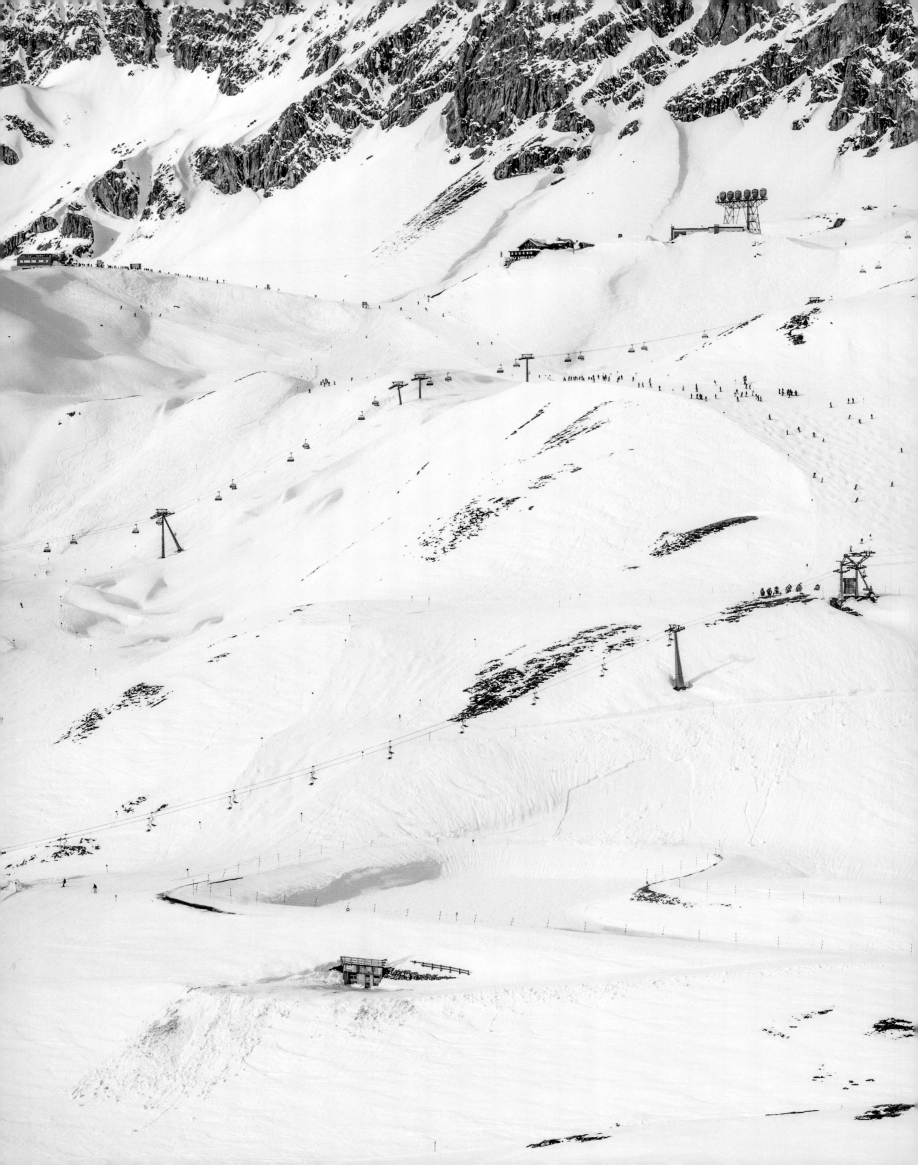

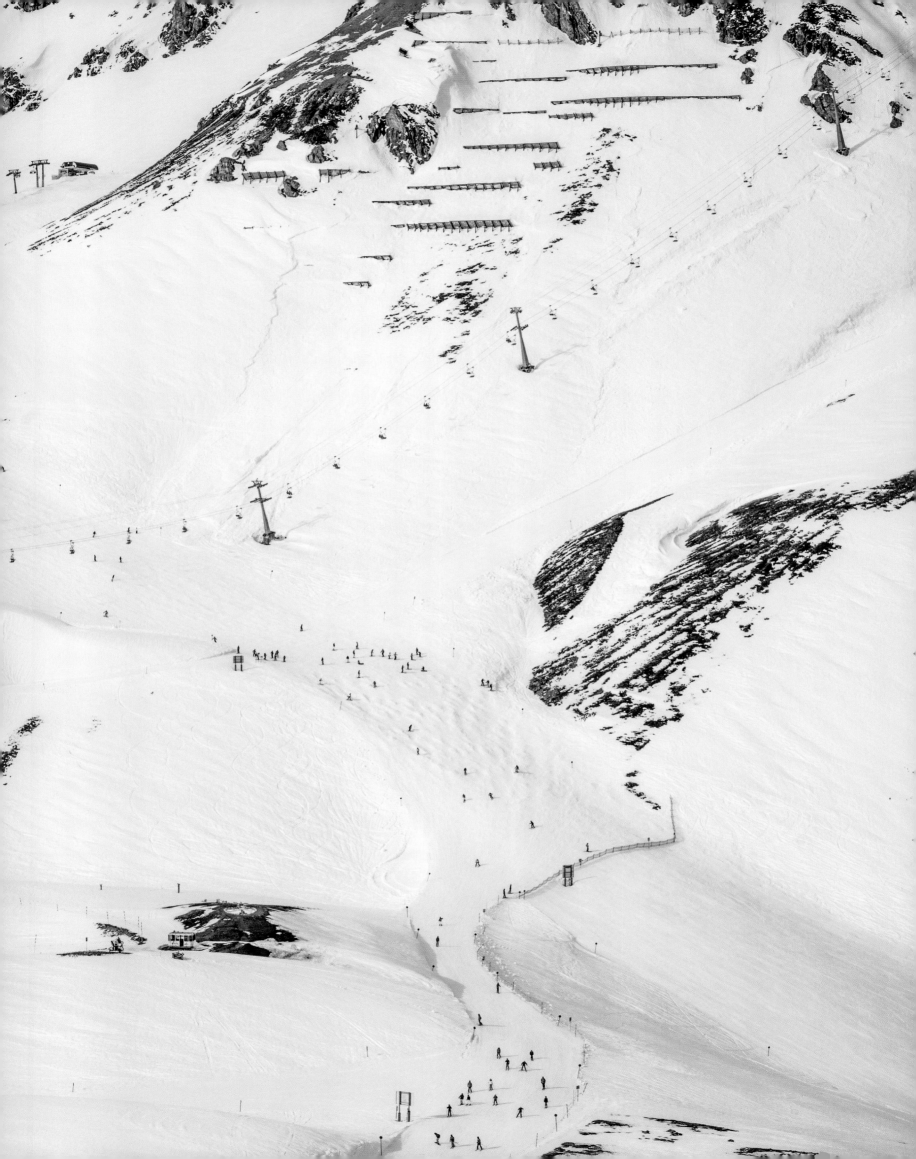

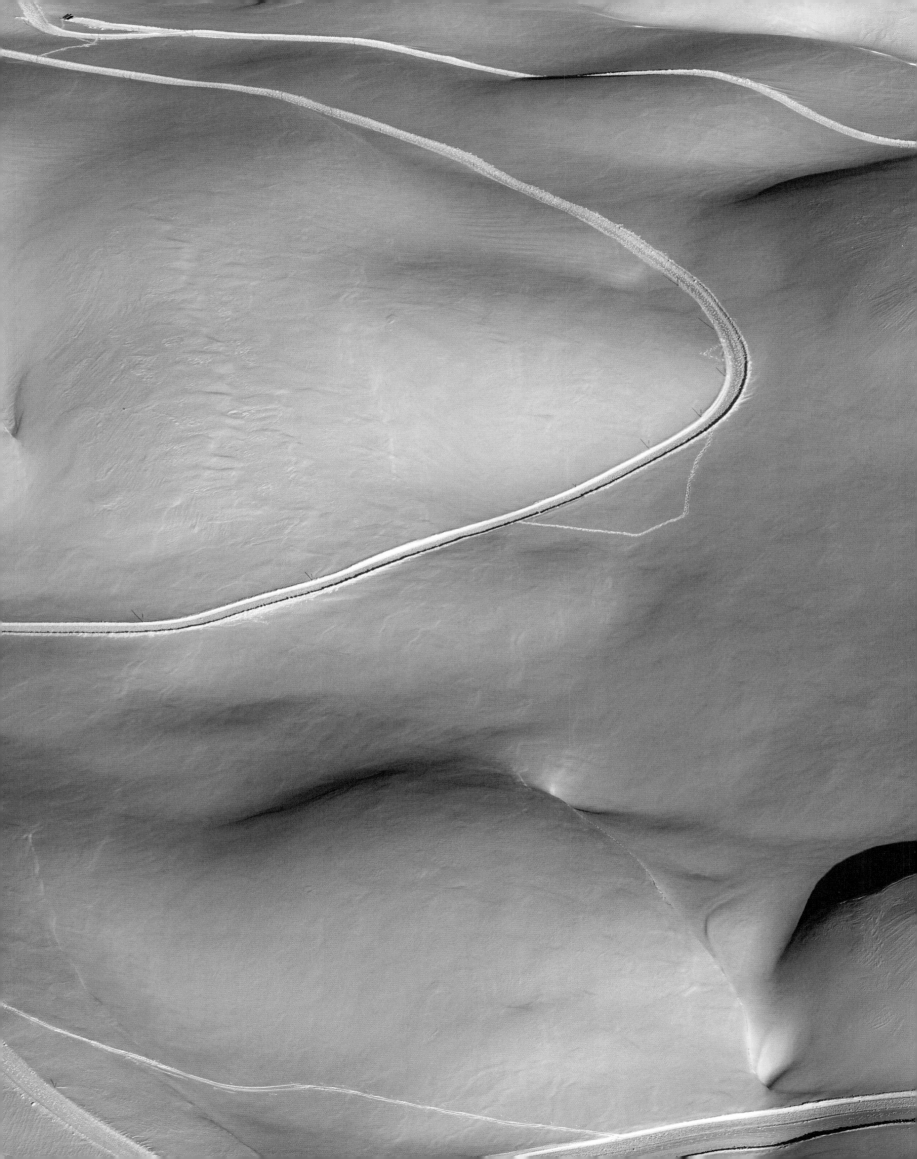

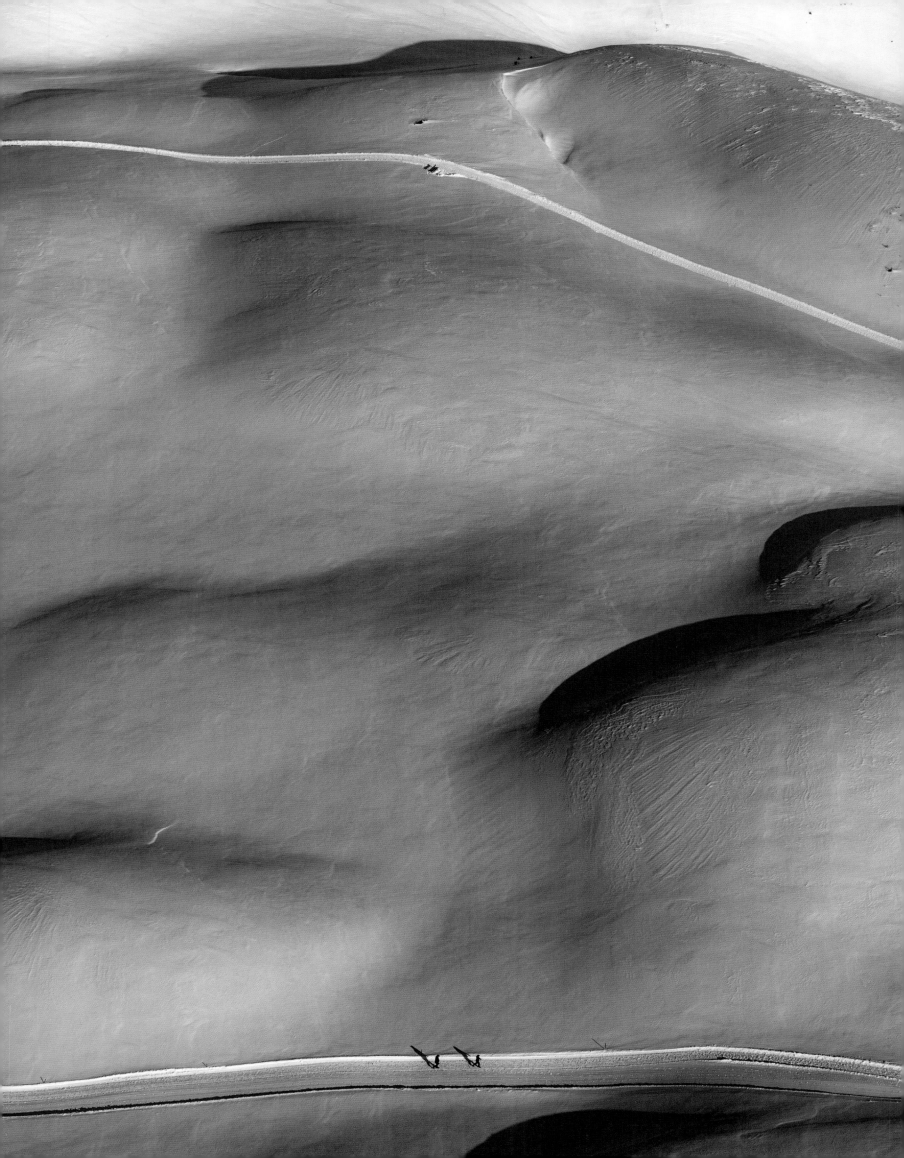

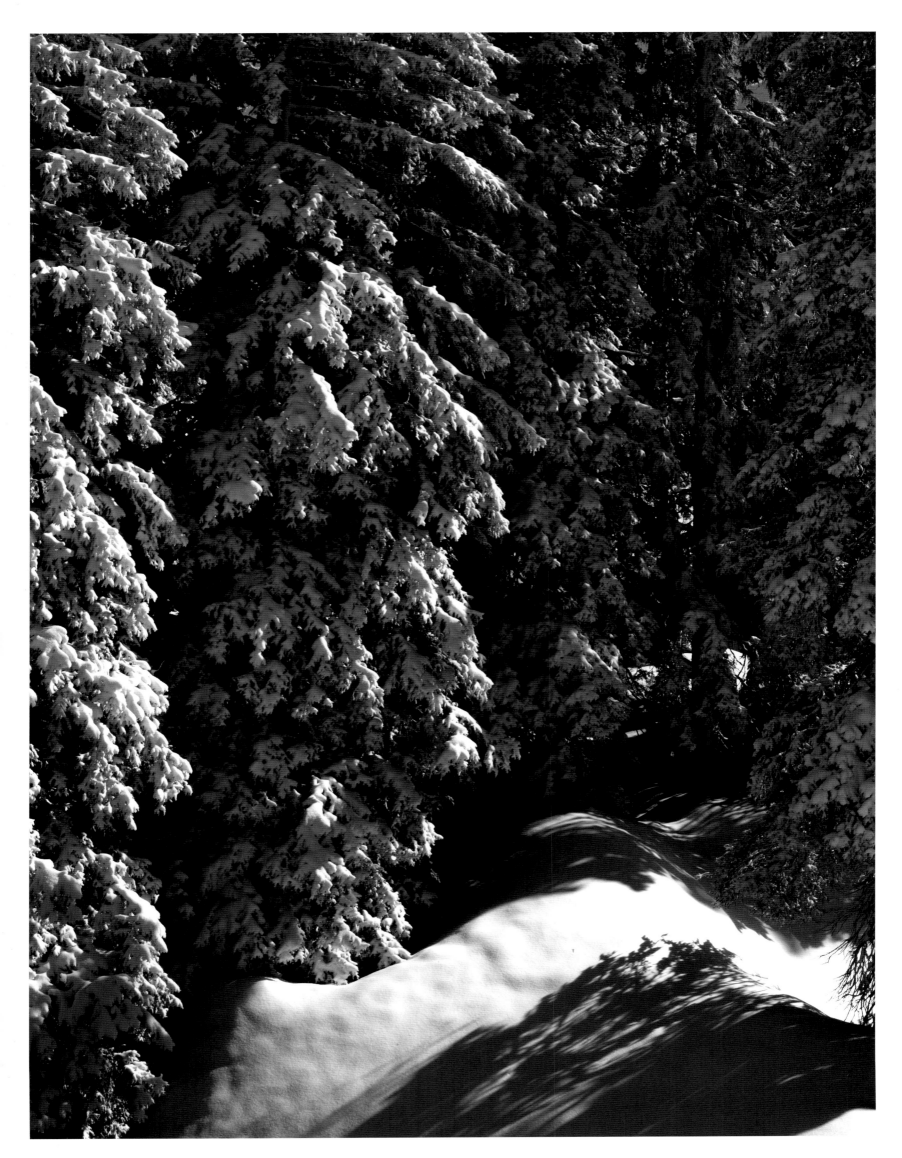

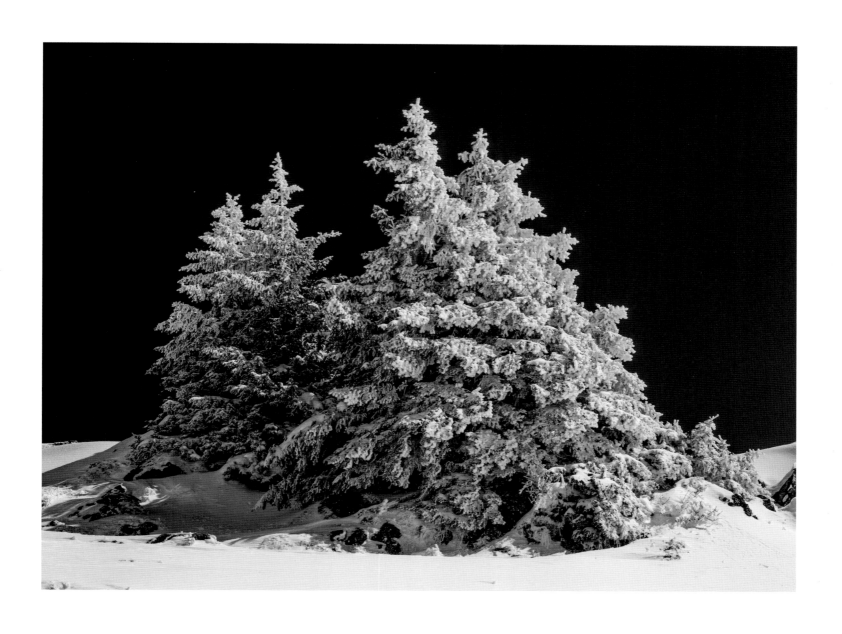

Tannenbaum, Kitzbühel, Austria

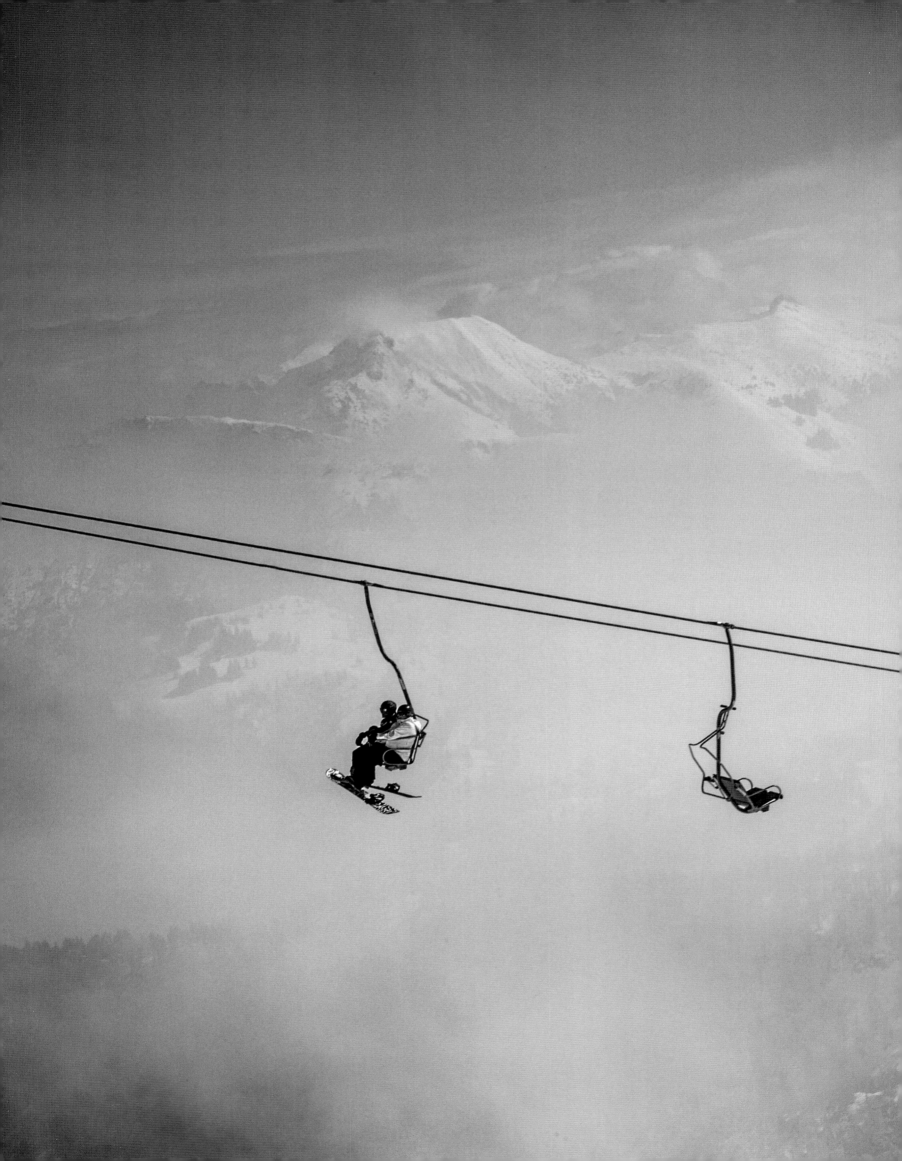

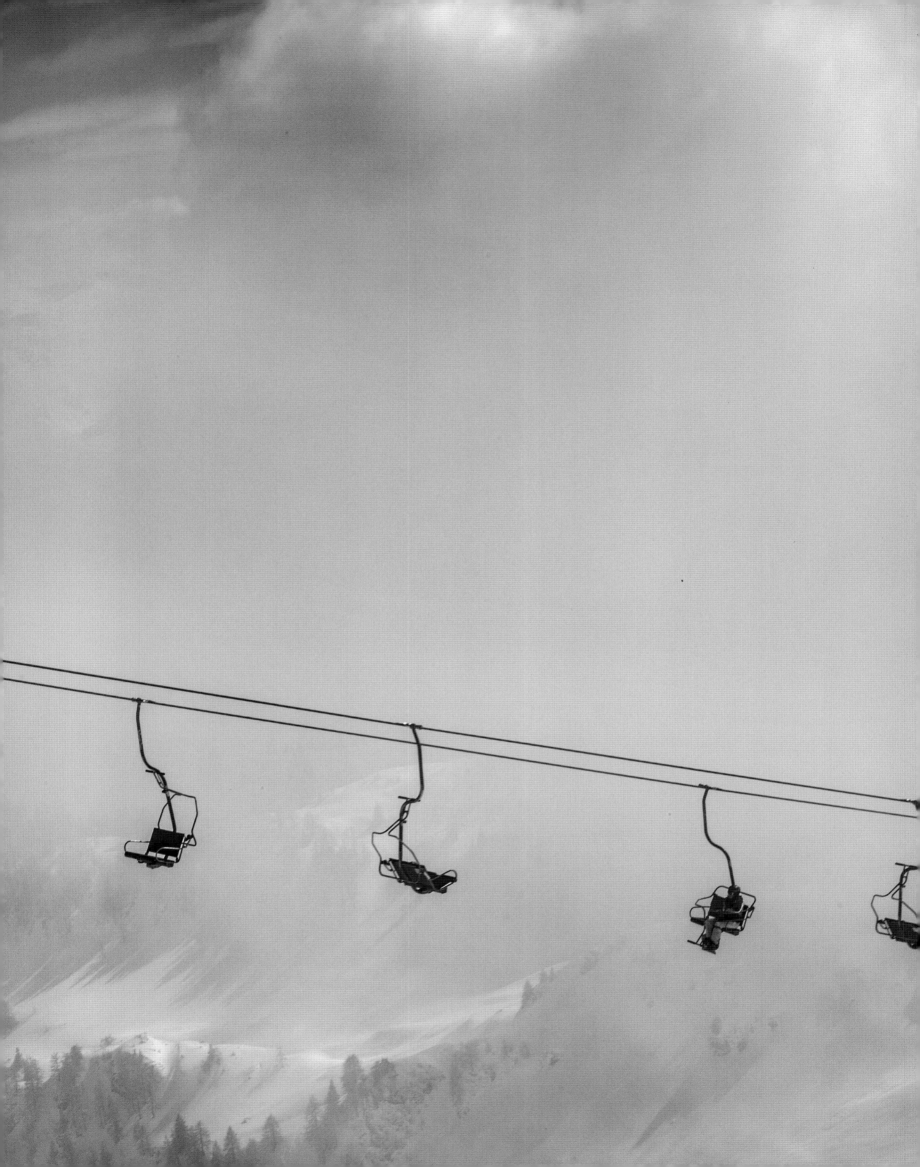

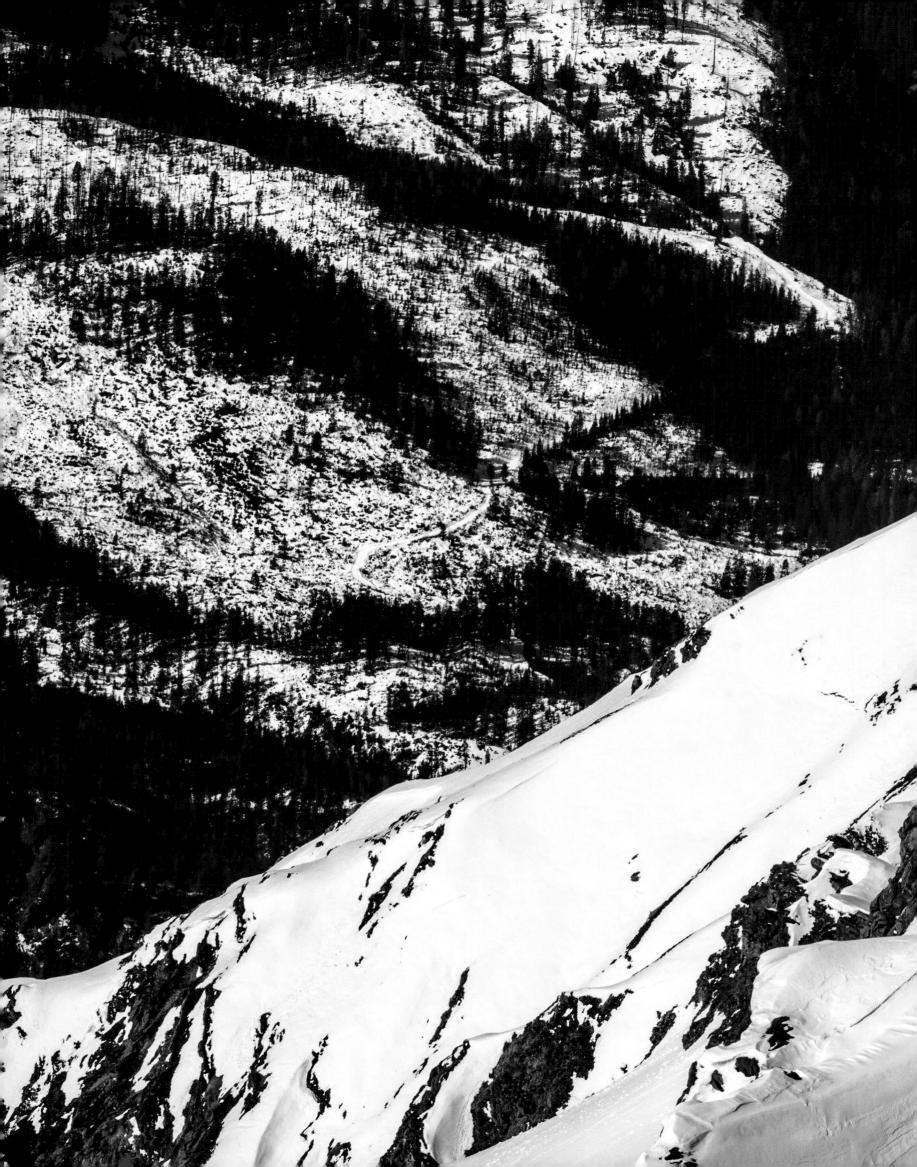

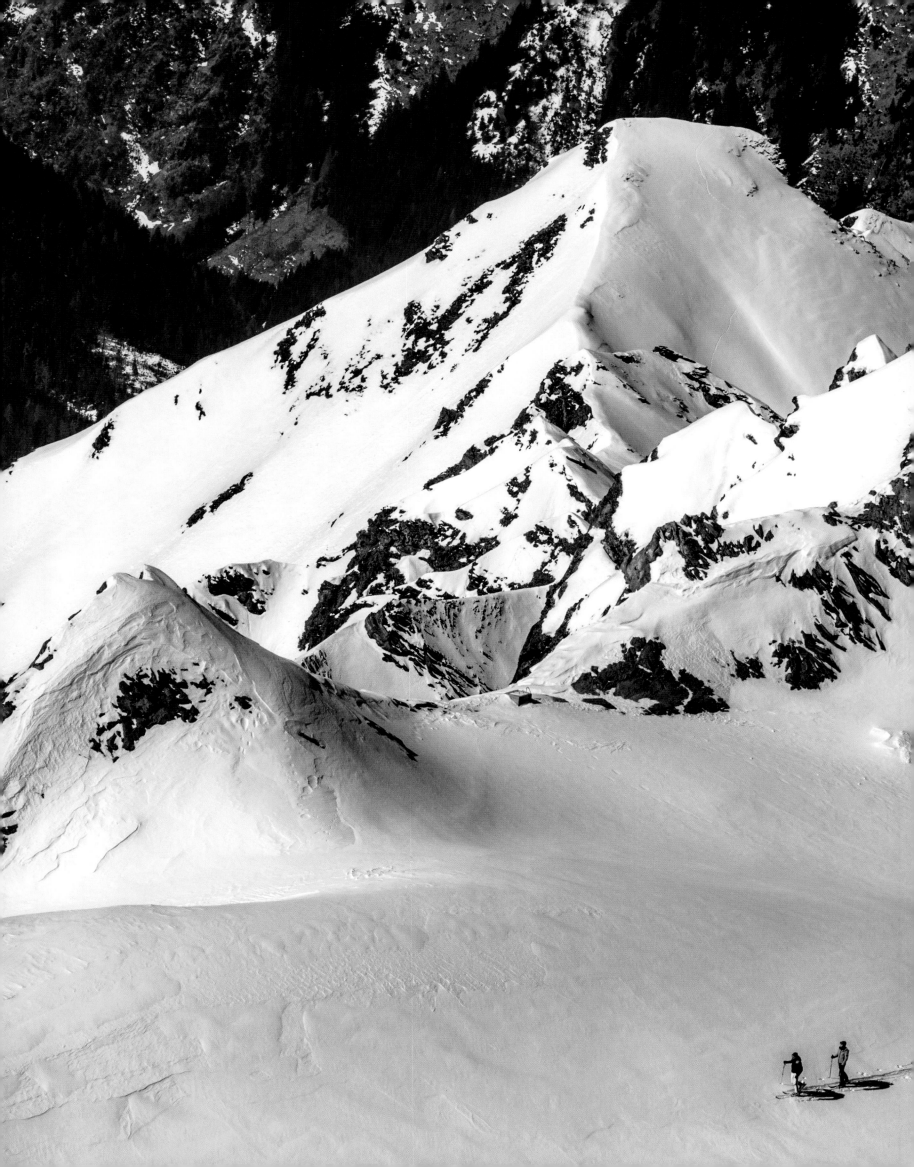

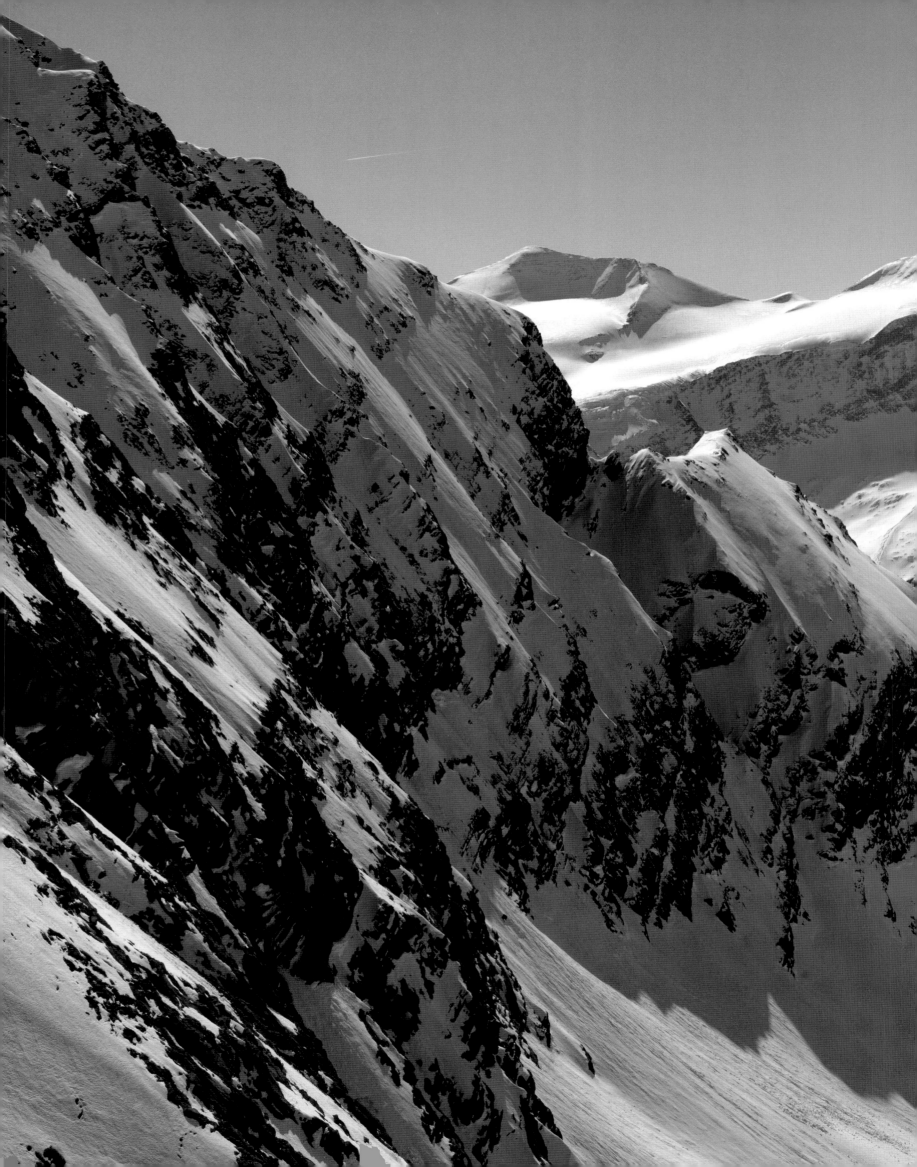

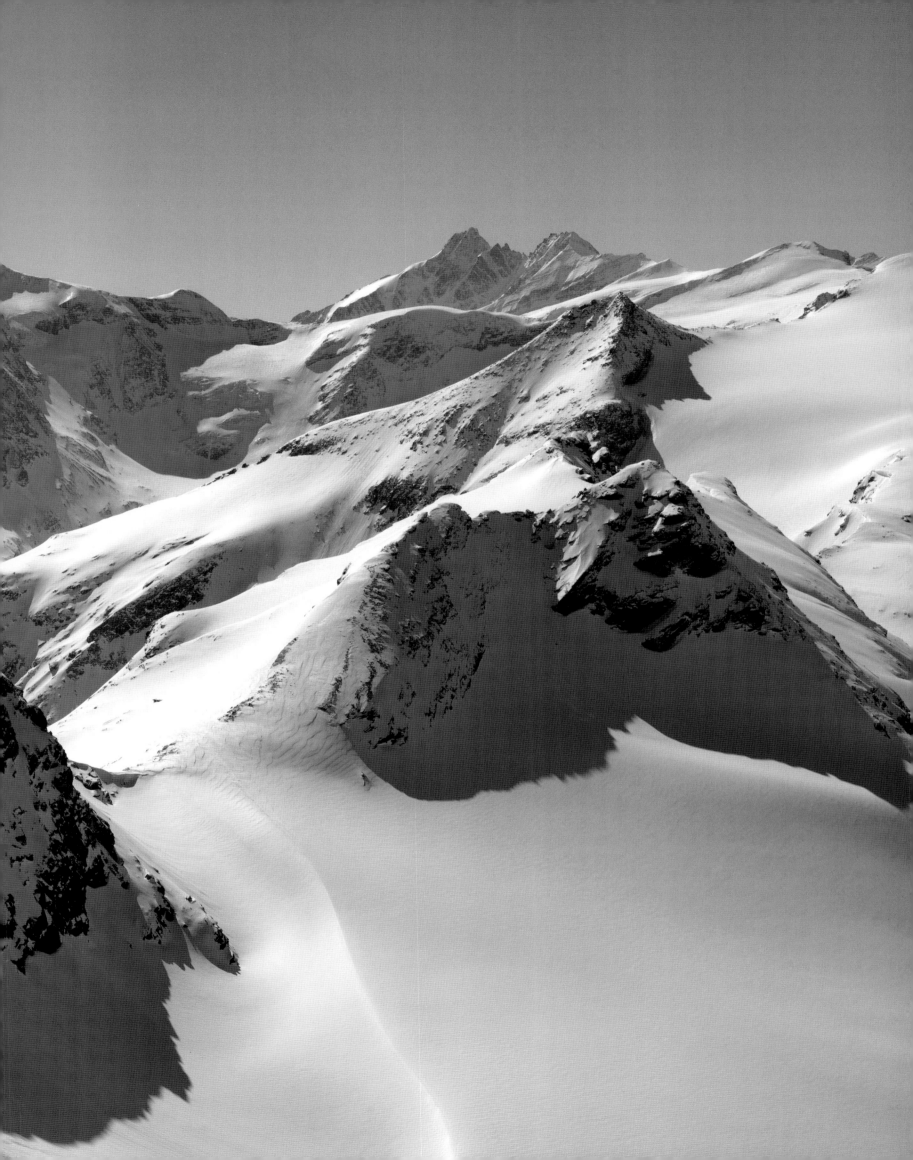

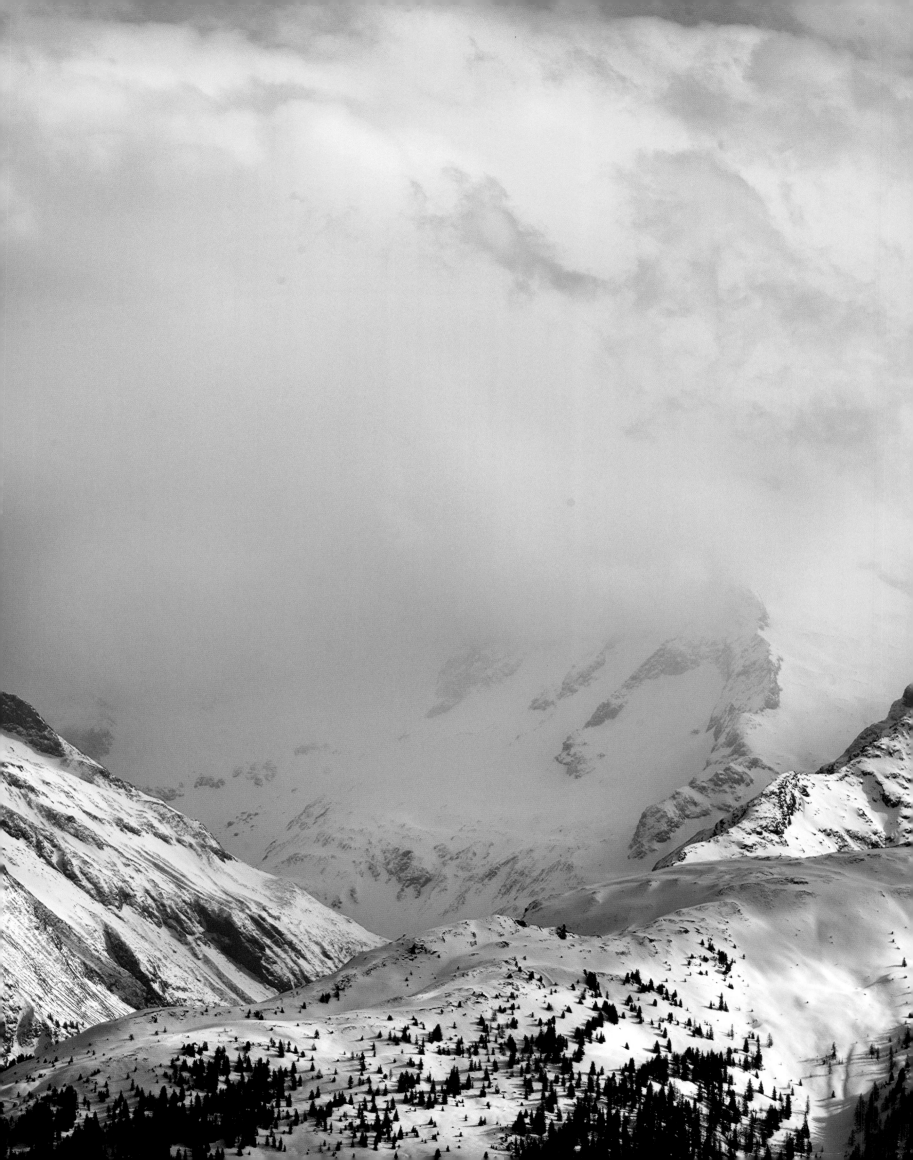

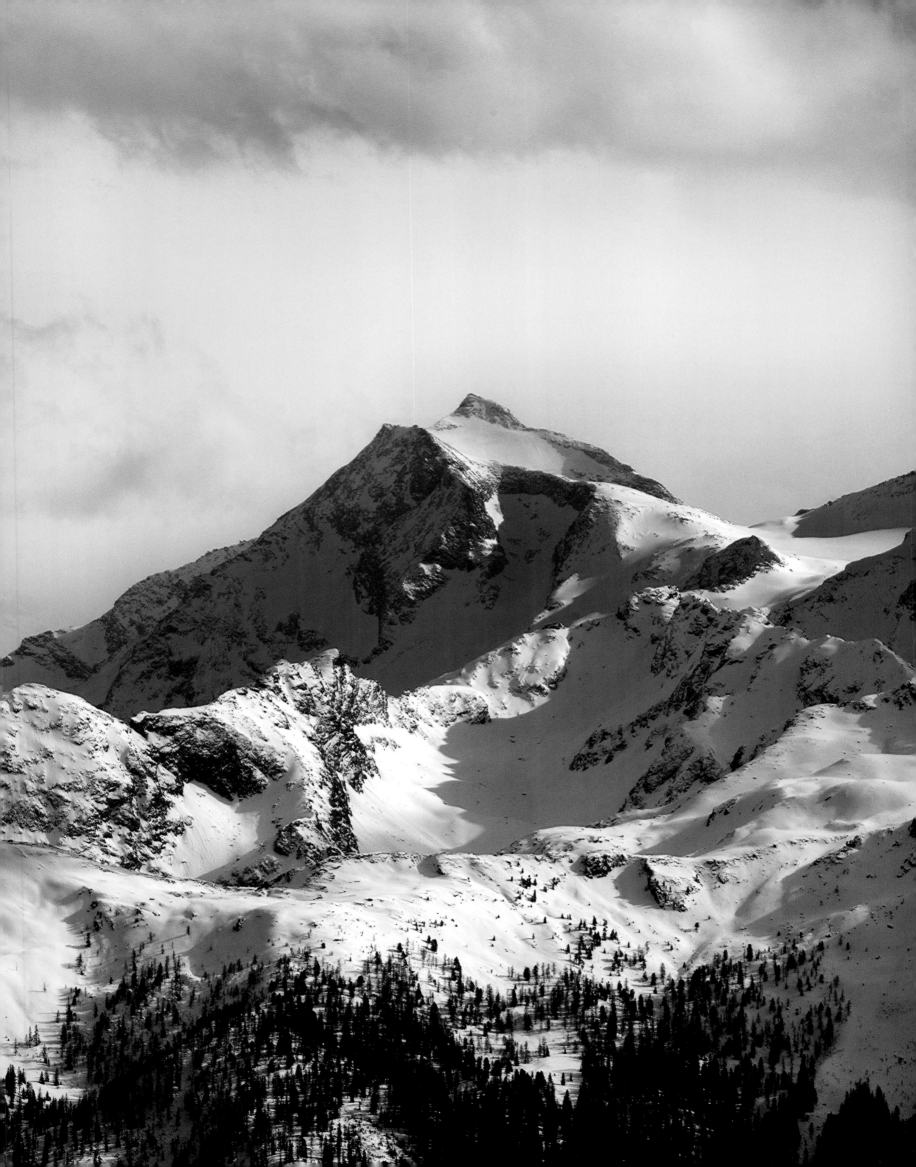

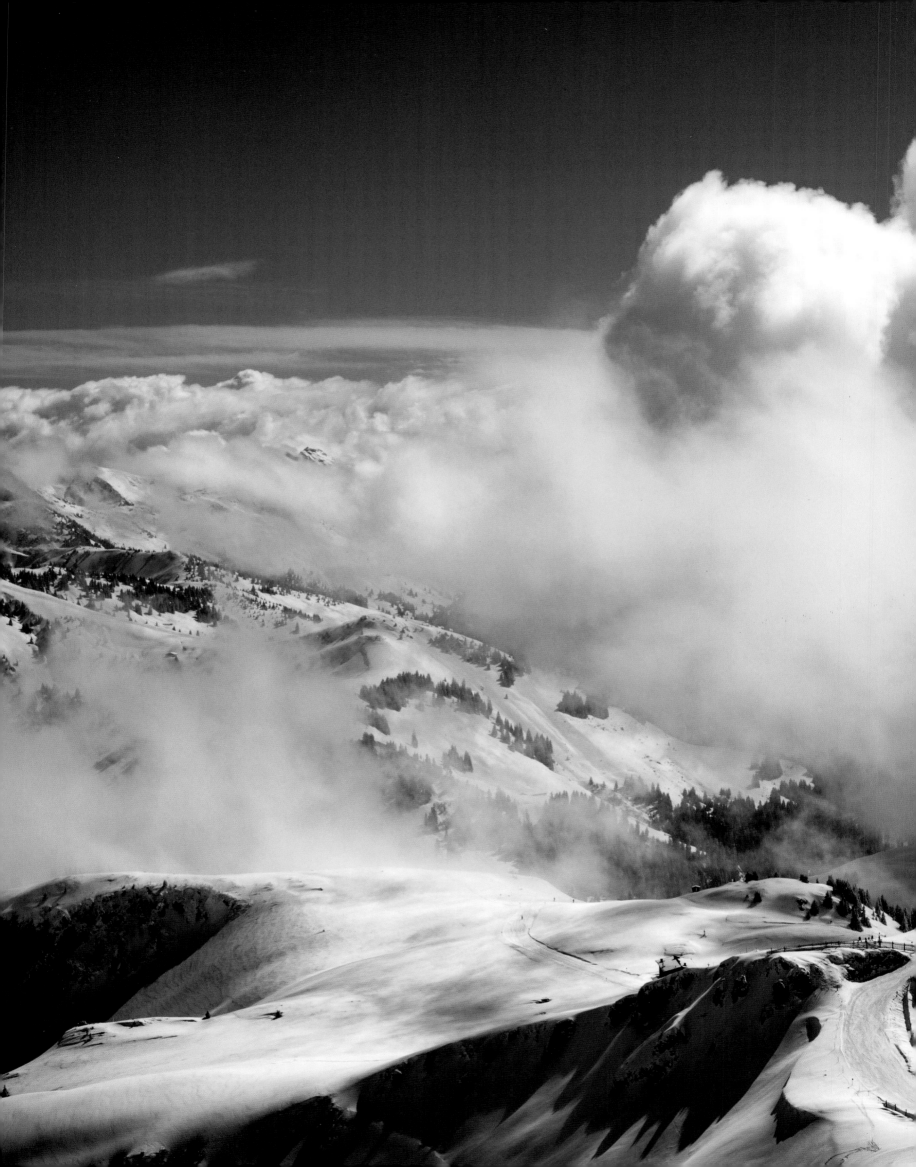

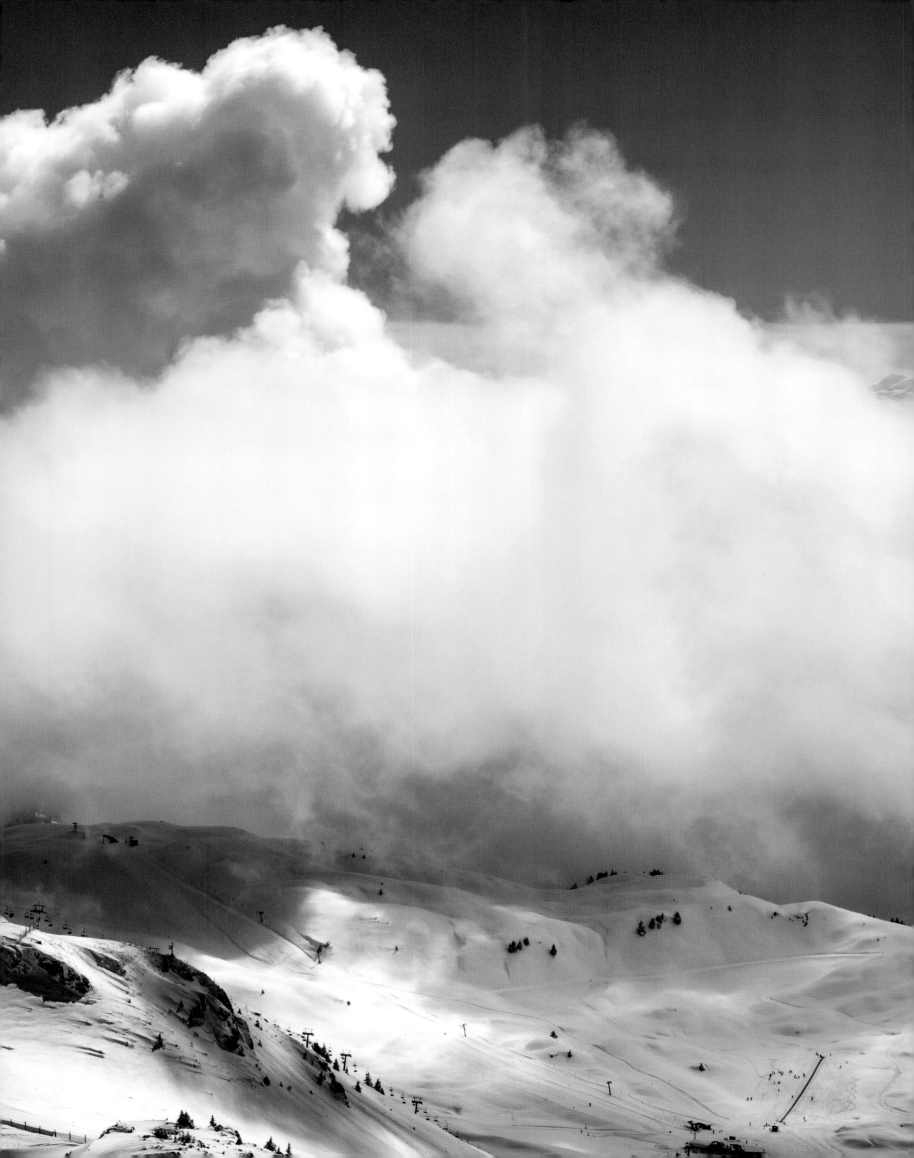

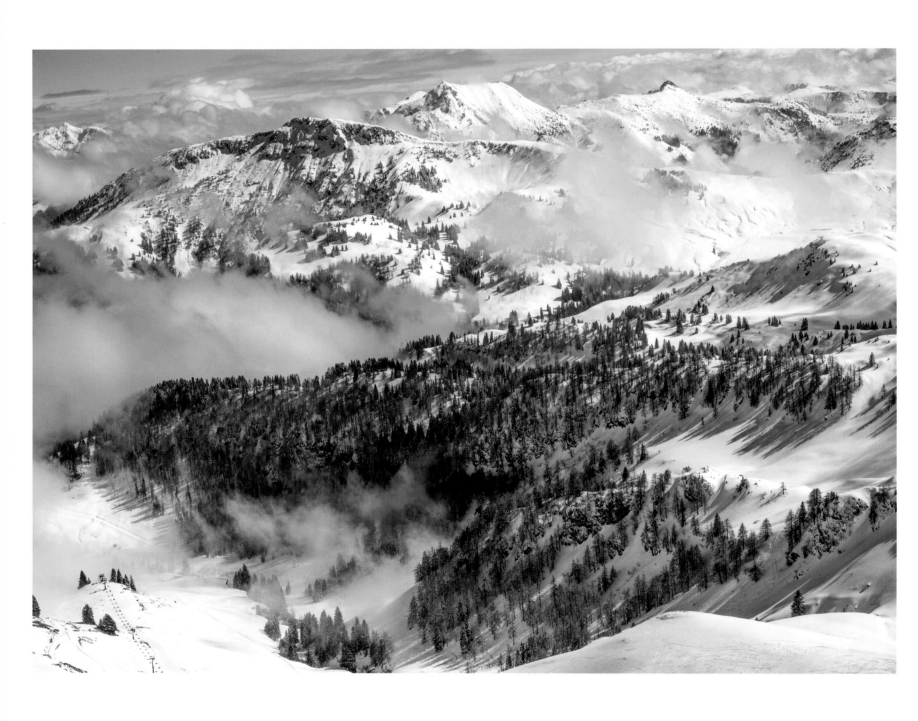

Karstein and Wildseeloder with Pfeiferkogel, Kitzbühel, Austria

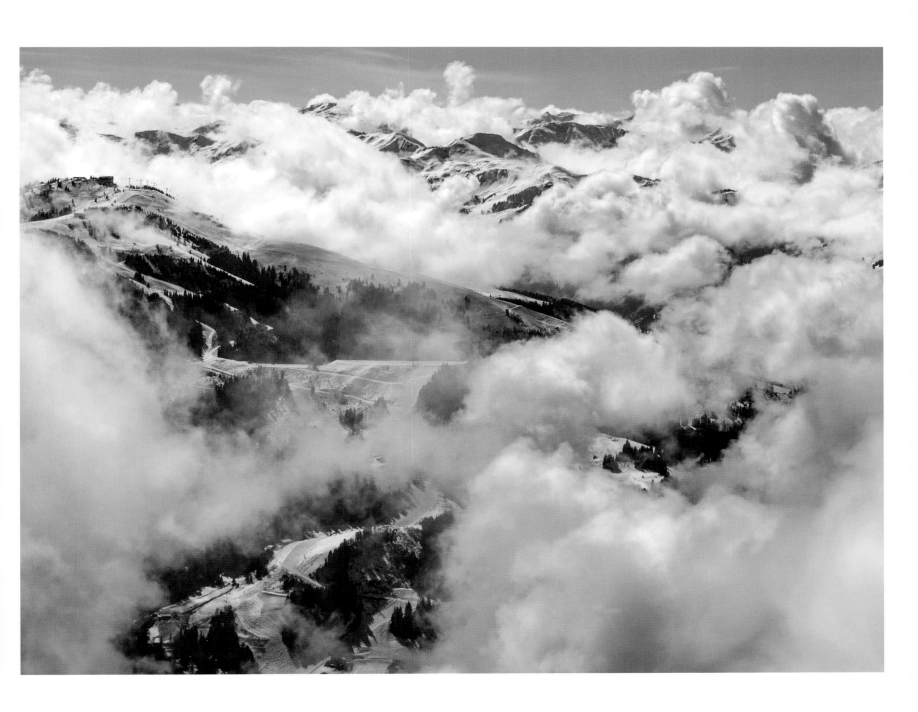

Ehrenbachhöhe and Hahnenkamm, Kitzbühel, Austria

"It is not the mountain we conquer but ourselves."

Edmund Hillary (1919–2008), mountaineer

„Nicht der Berg ist es, den man bezwingt,
sondern das eigene Ich.“

Edmund Hillary (1919–2008), Bergsteiger

« Ce ne sont pas les montagnes que nous
conquérons mais nous-mêmes. »

Edmund Hillary (1919–2008), alpiniste

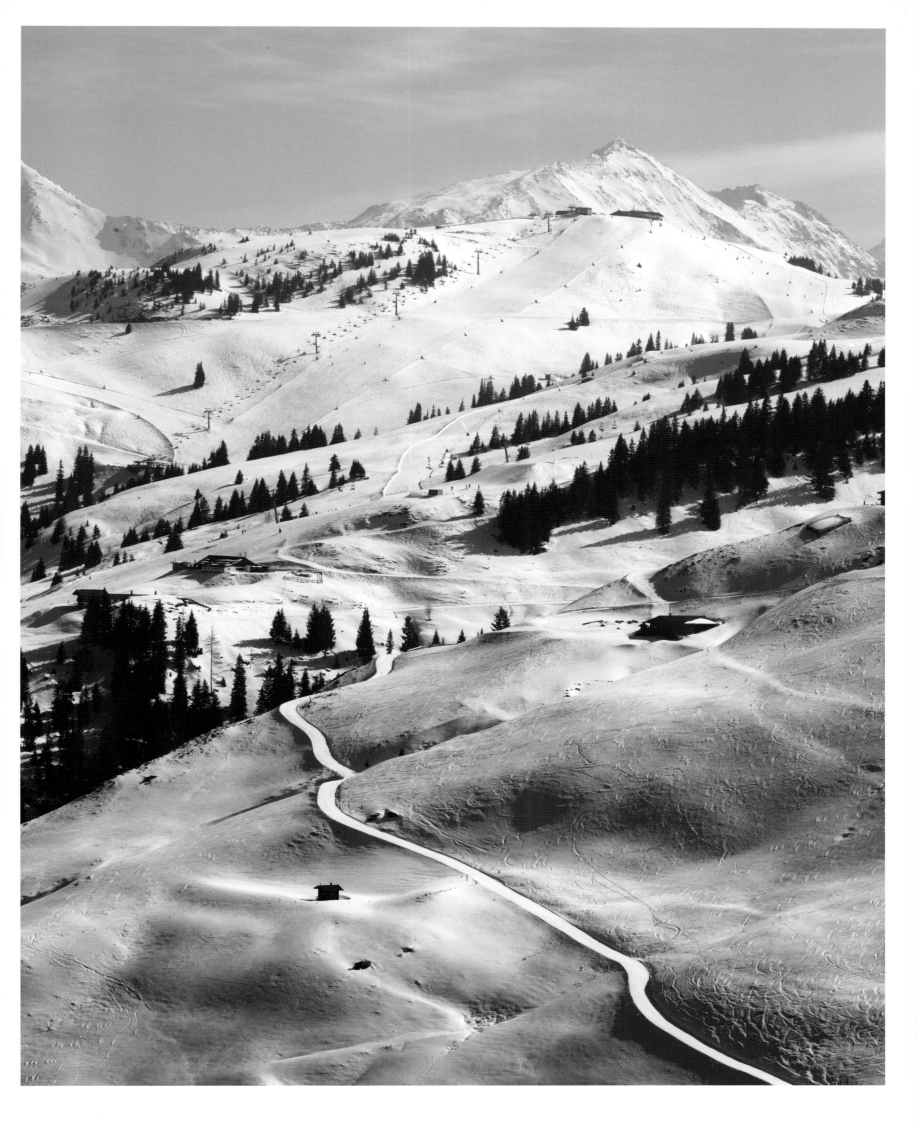

Kitzbühel, Tyrol, Austria

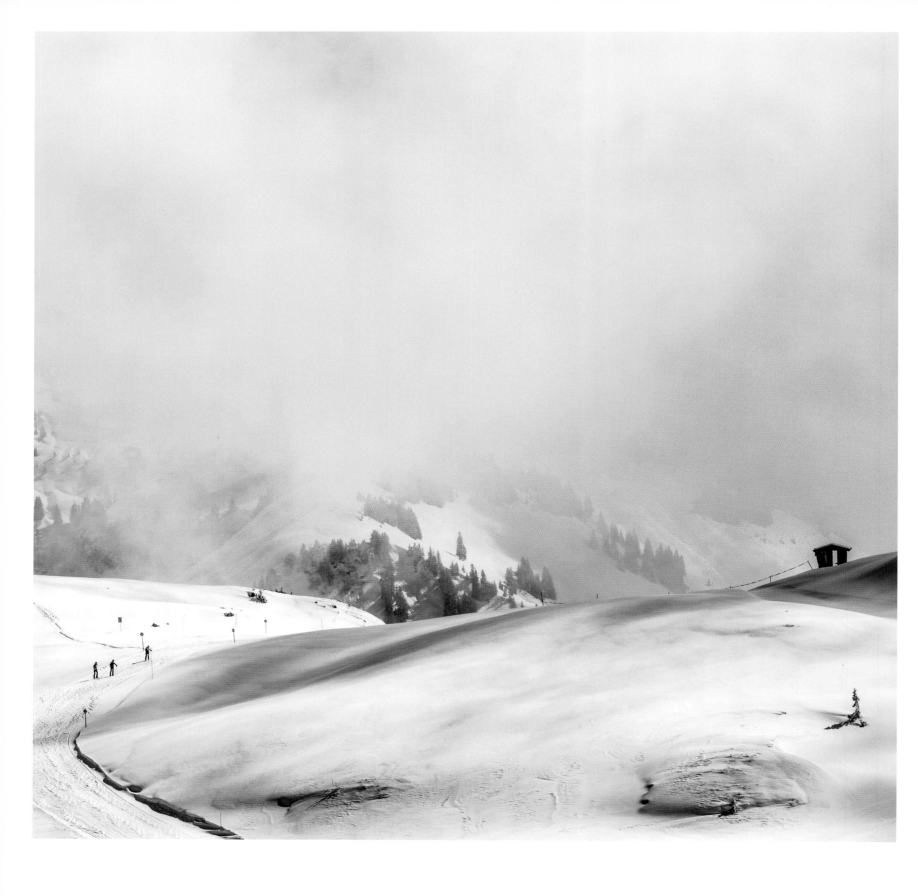

View from the Hornköpflhütte, Kitzbühel, Austria

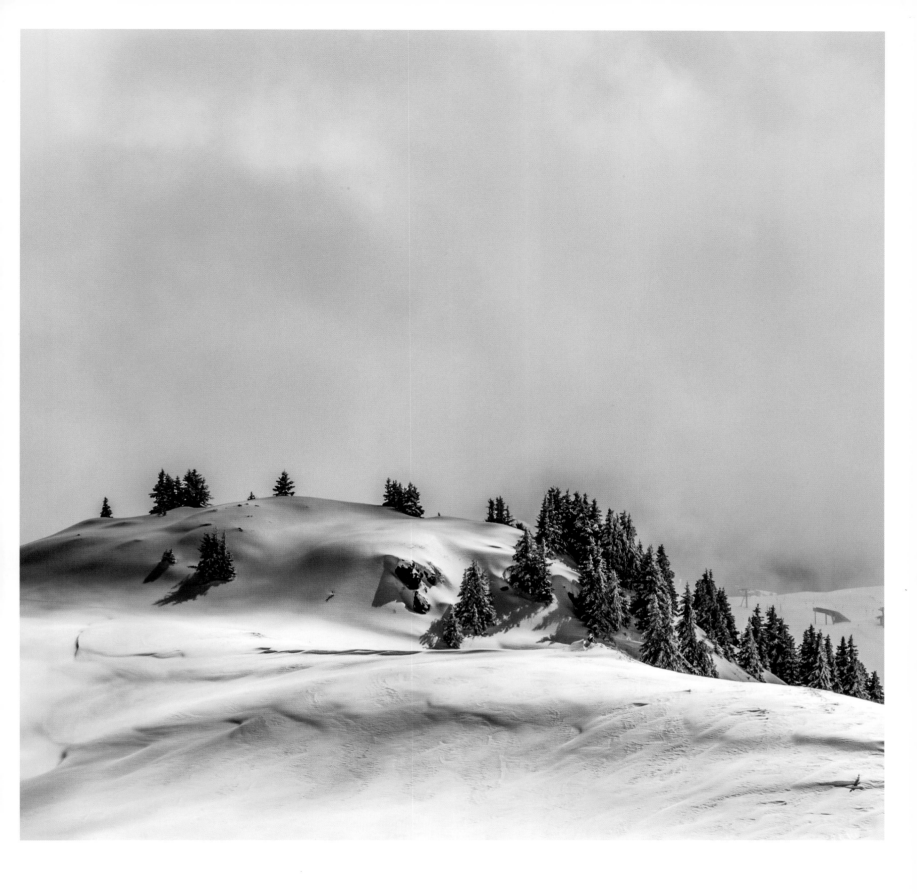

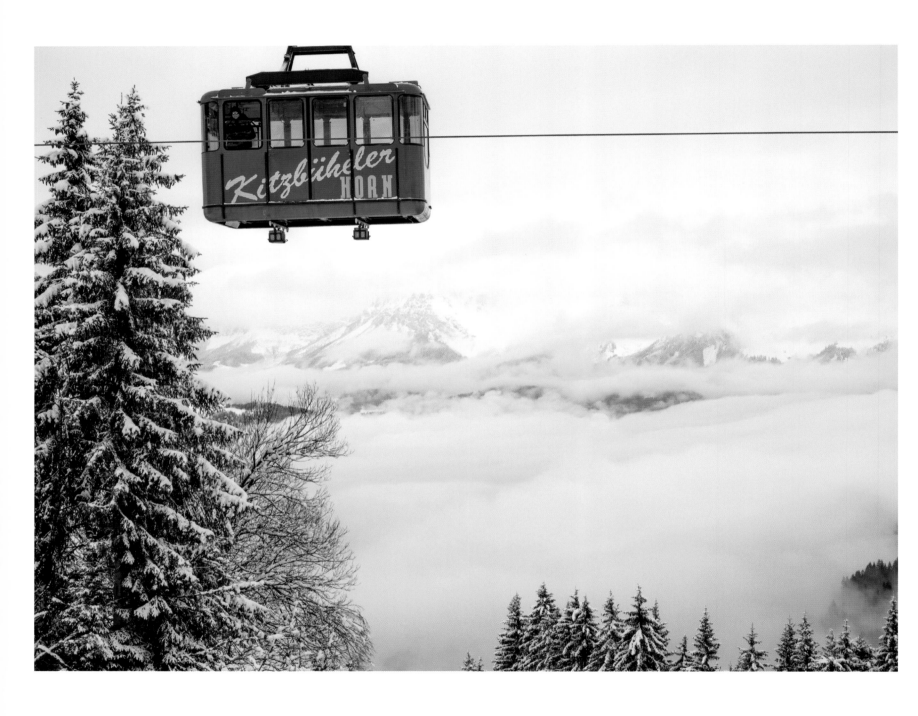

Horngipfel cable car, Tyrol, Austria

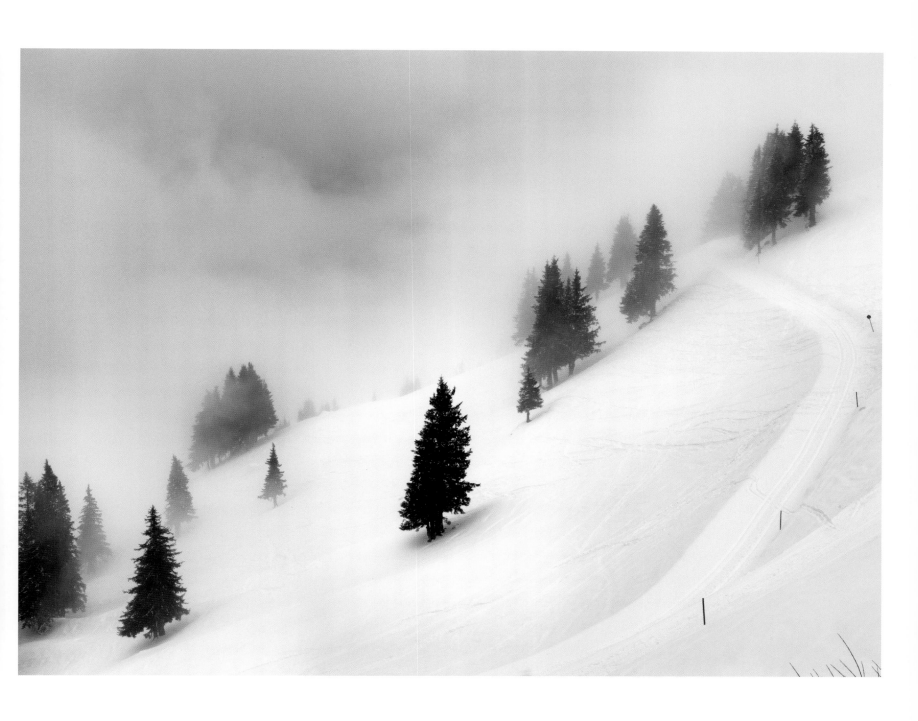

Tannenbaum, Kitzbühel, Austria

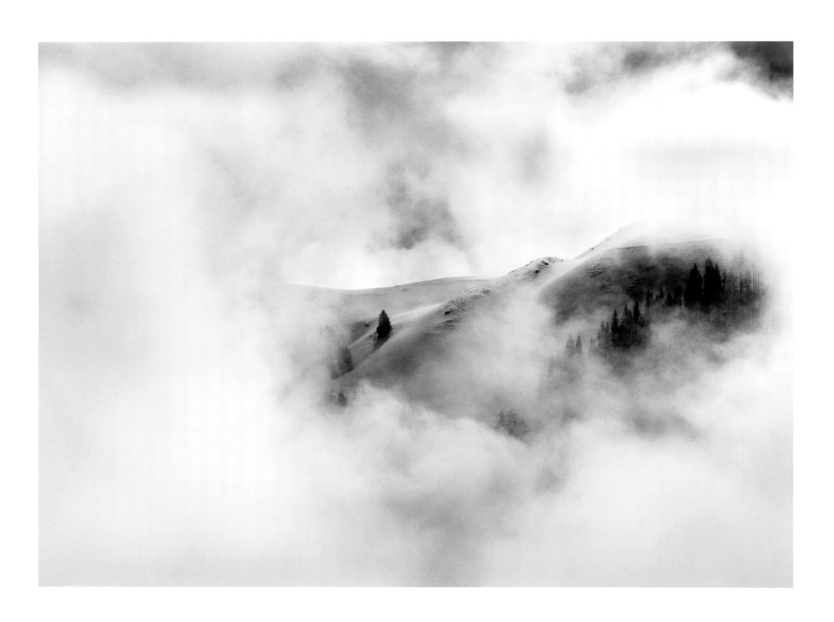

Gebra, Kitzbühel, Austria– 6,749 ft | 2,057 m

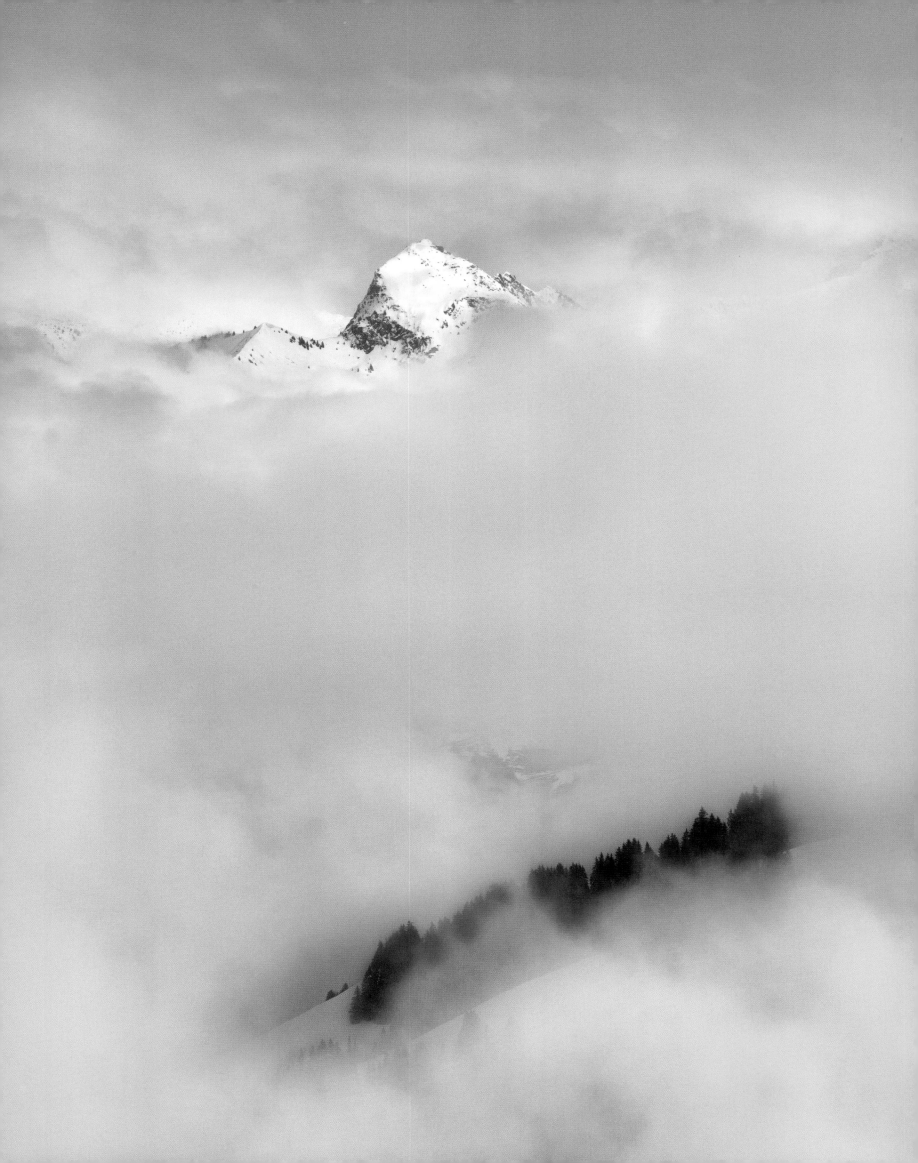

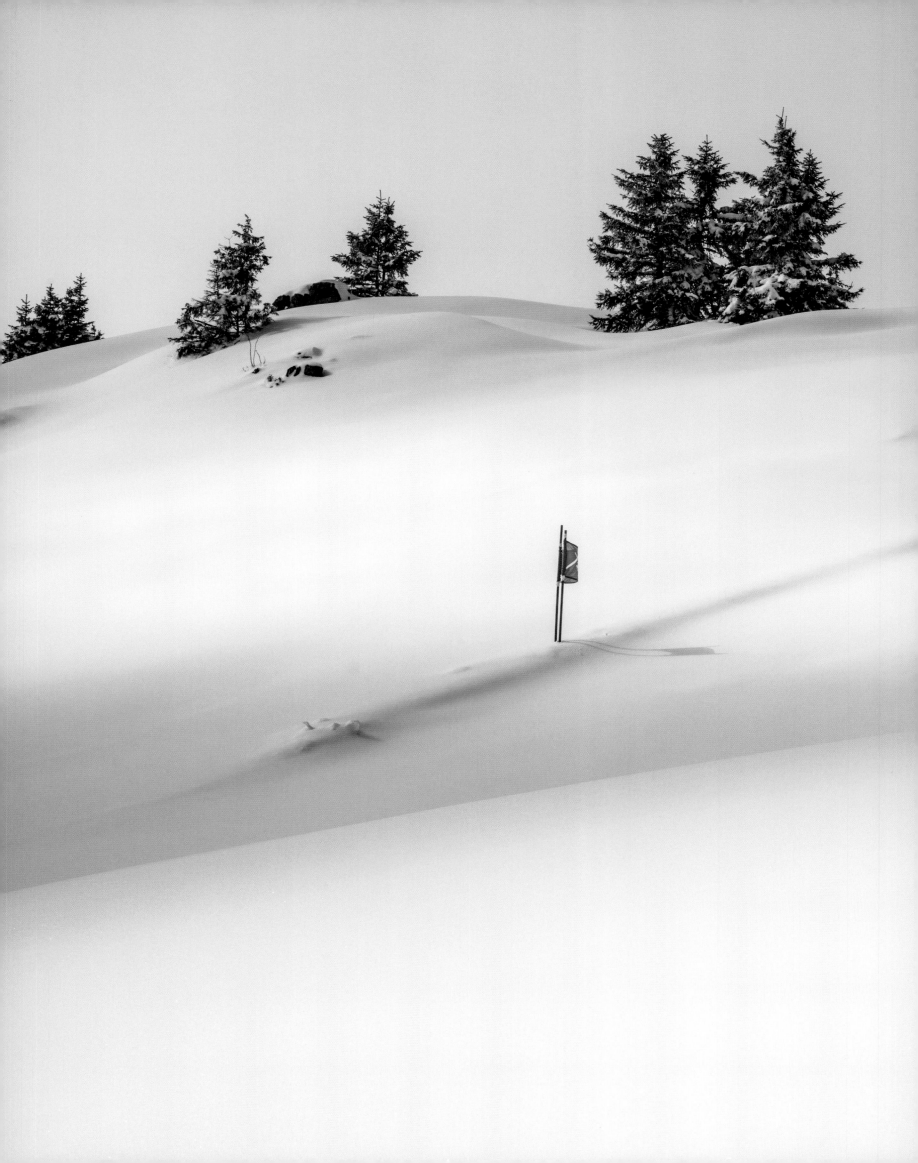

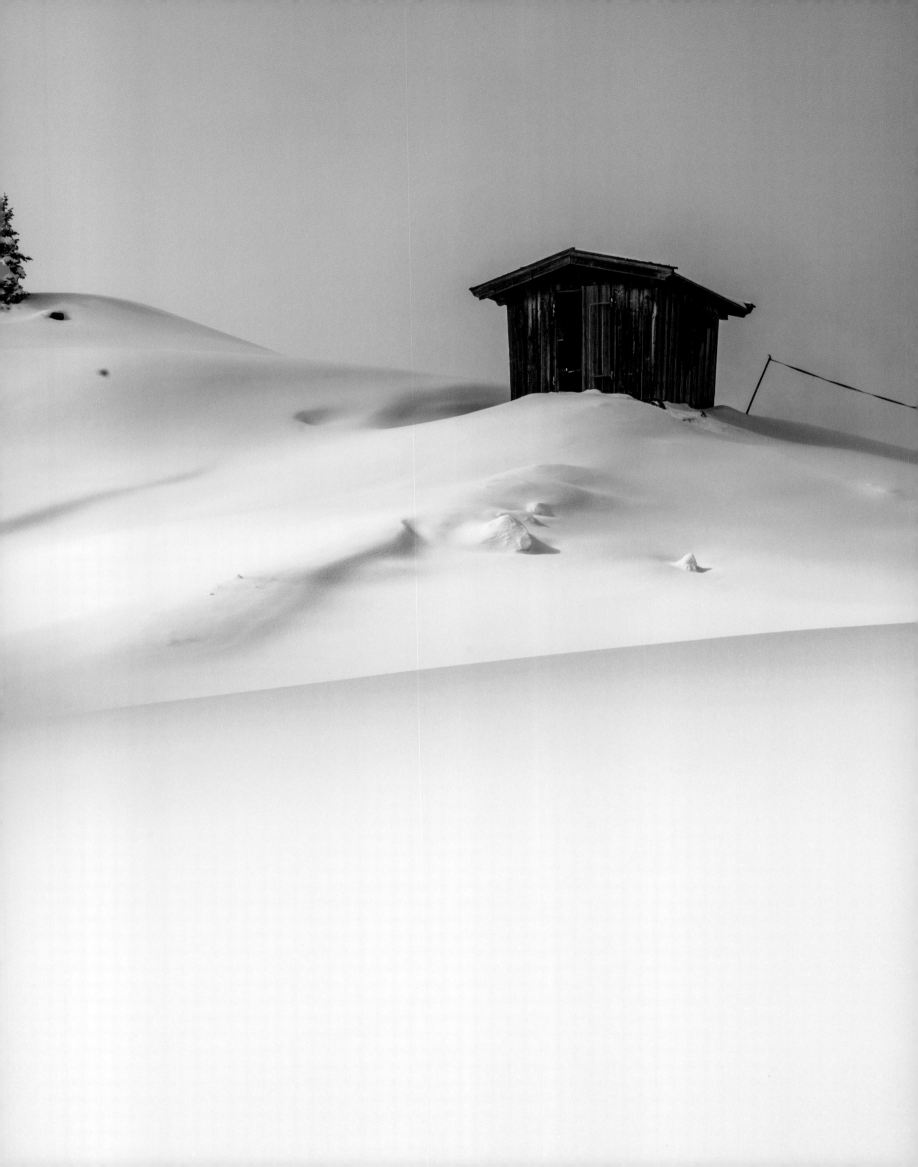

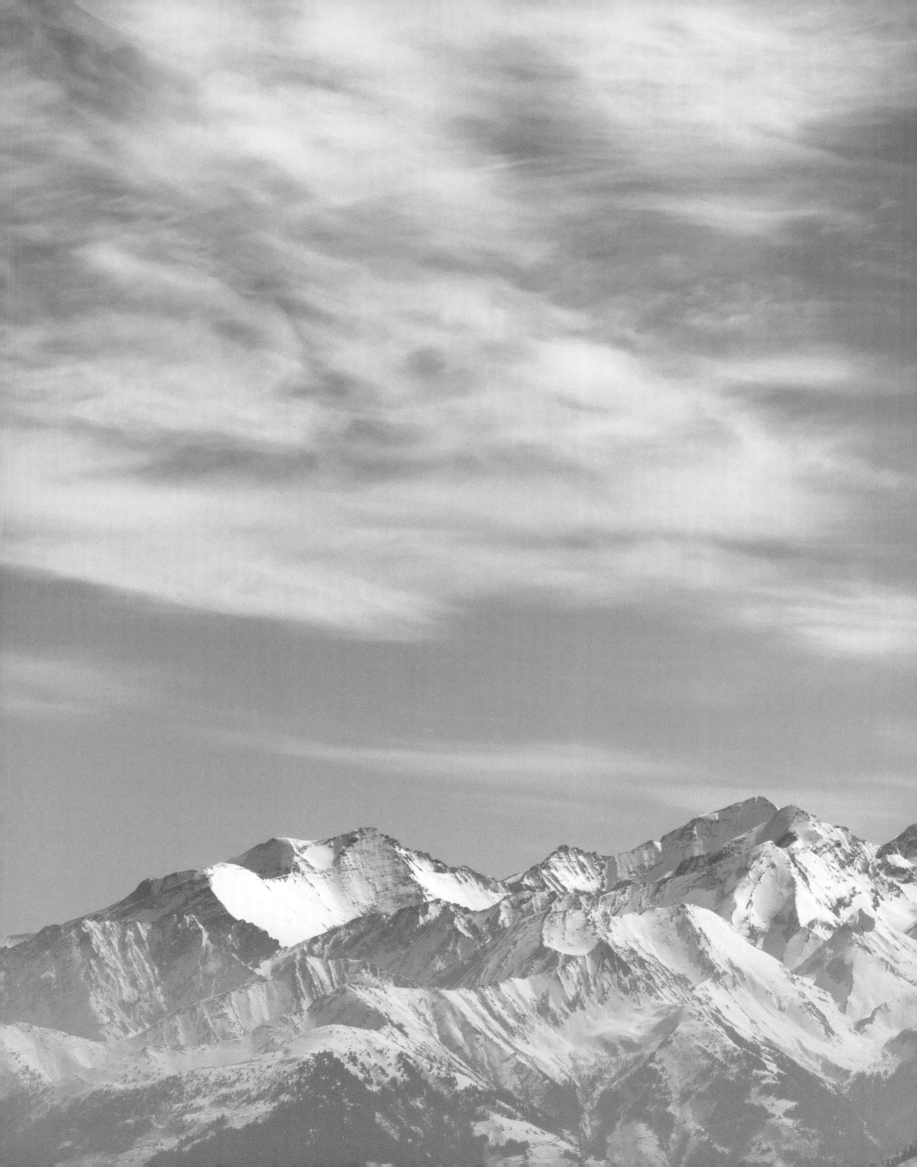

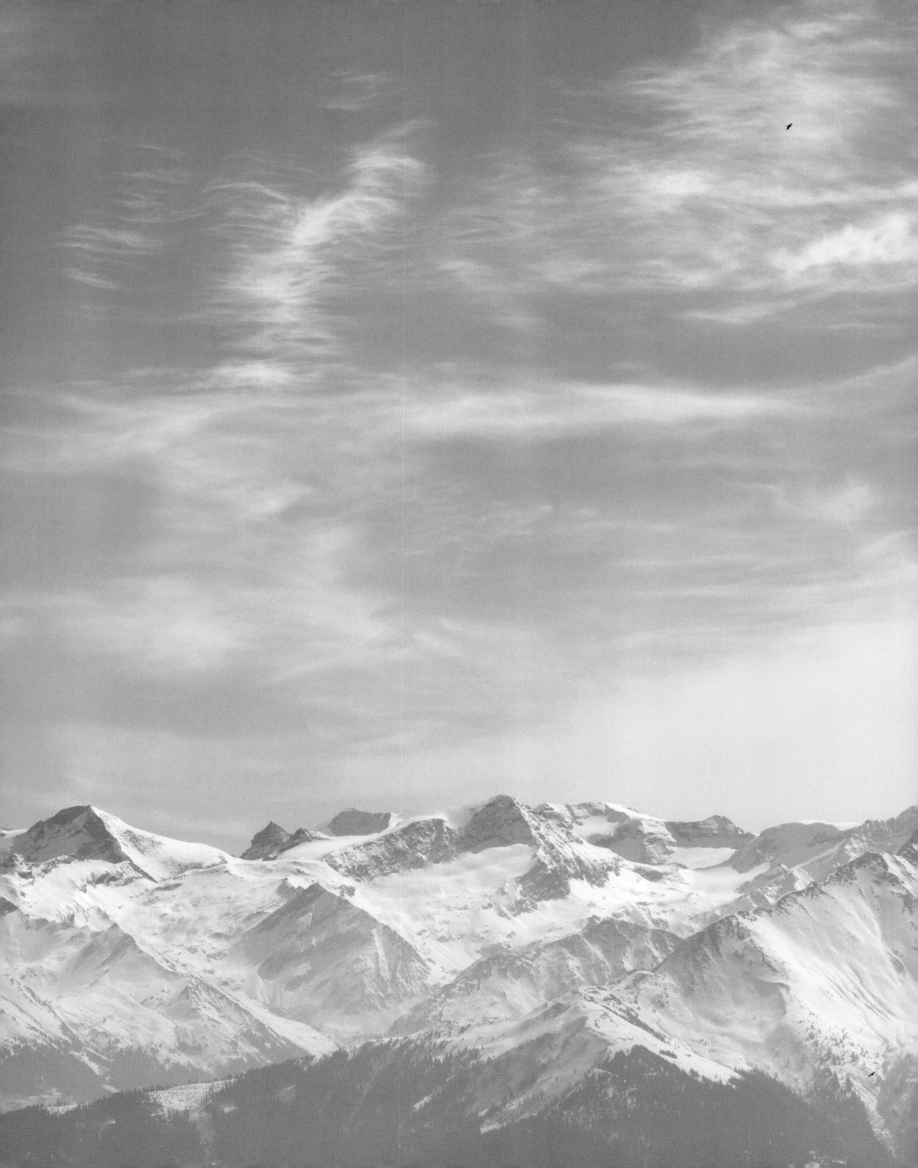

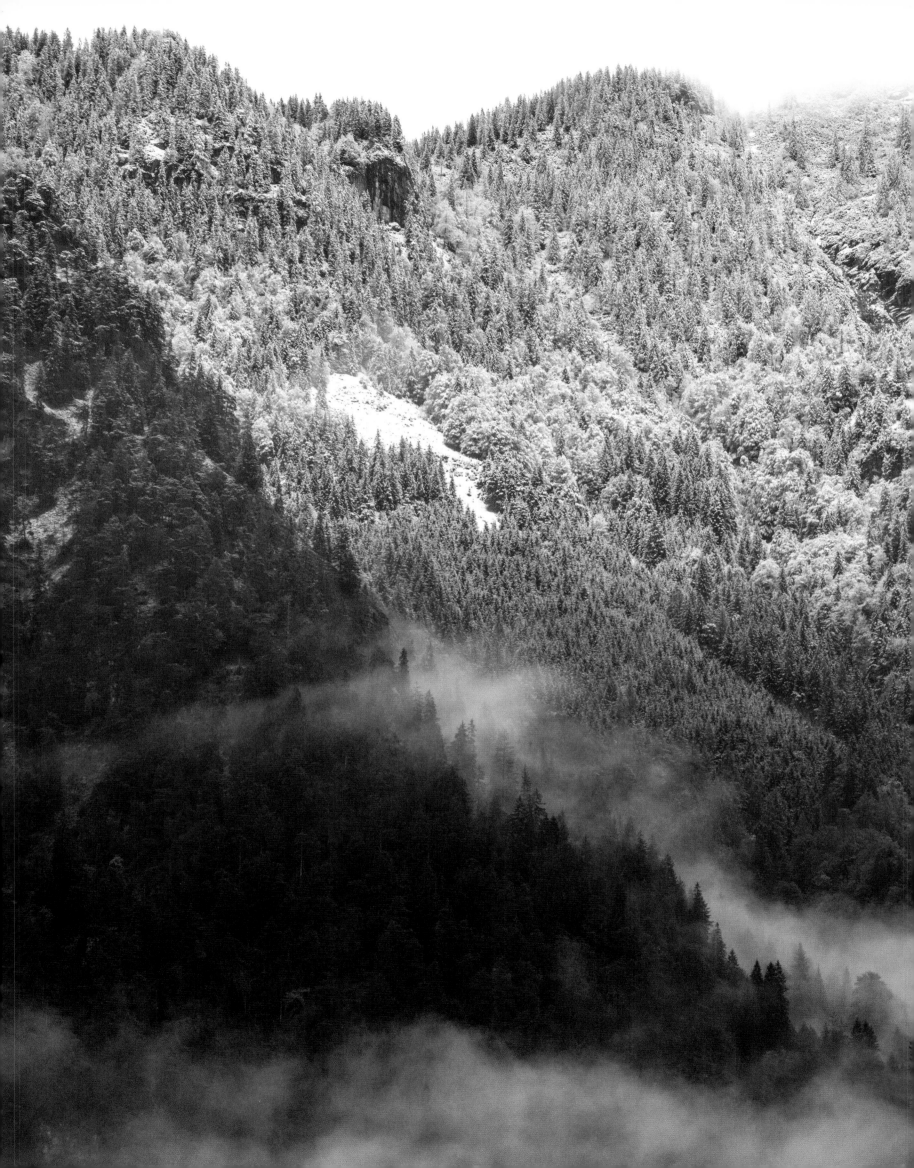

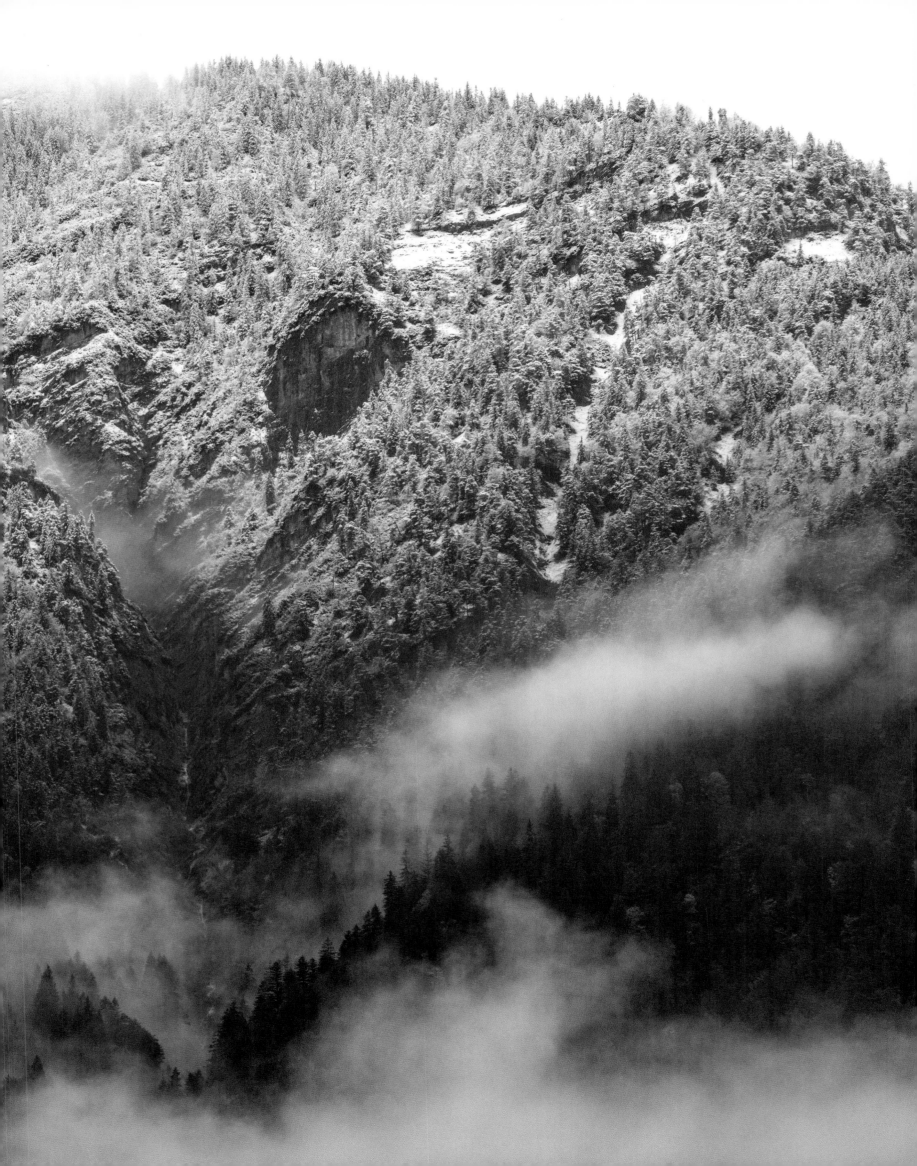

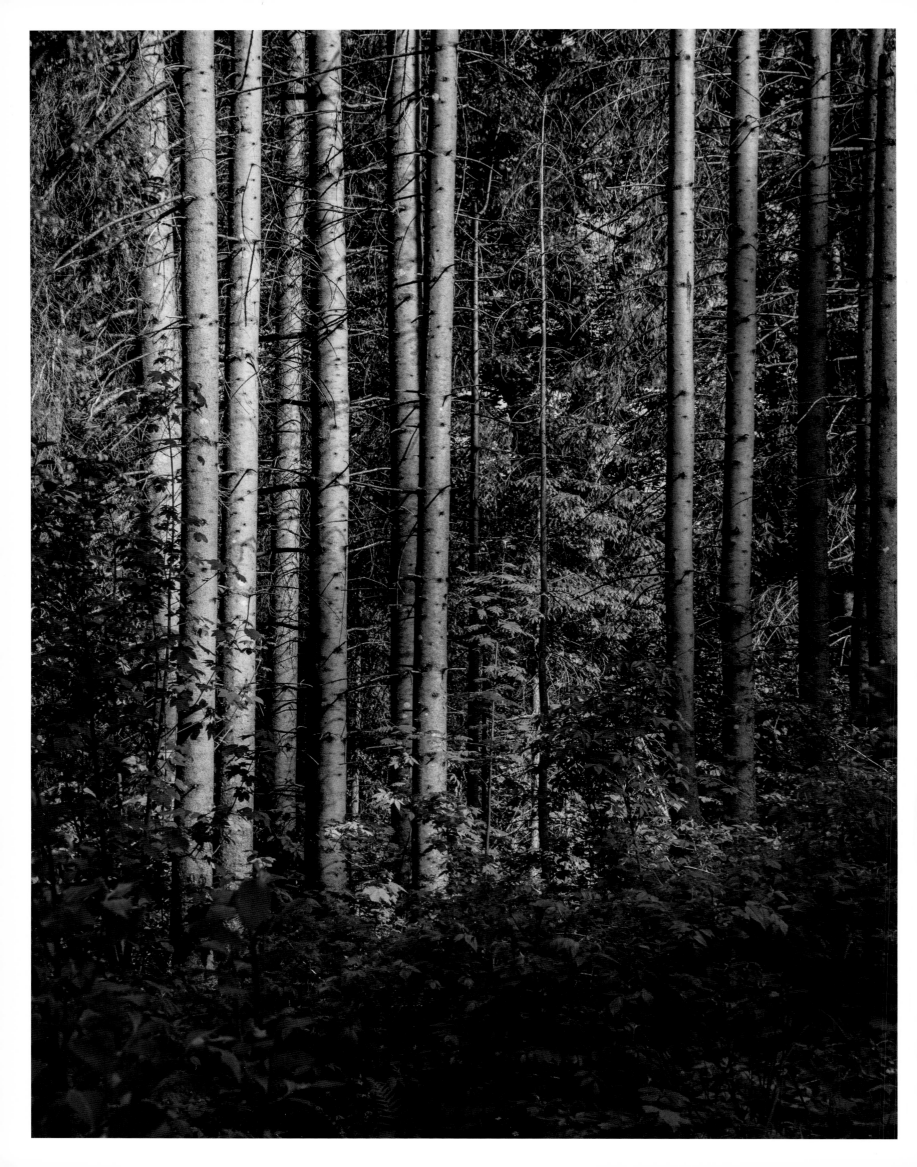

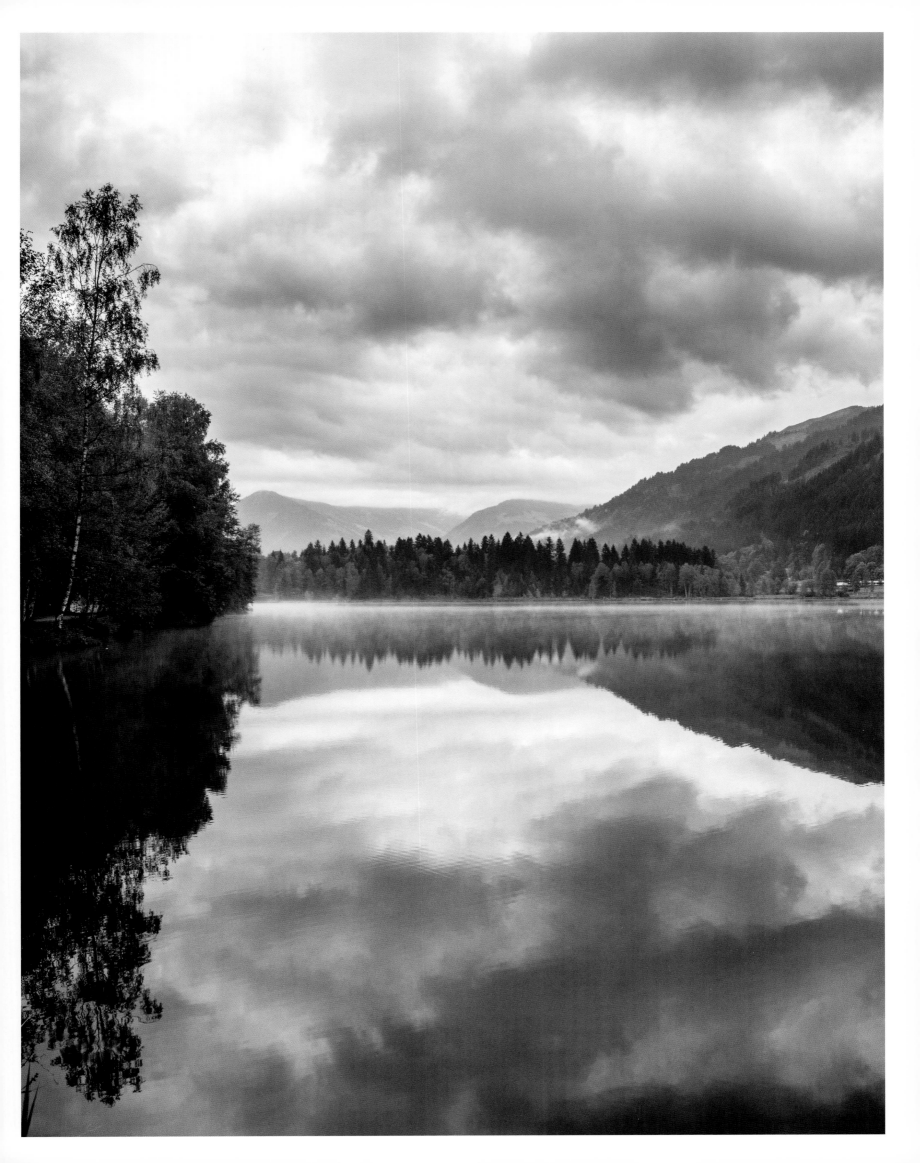

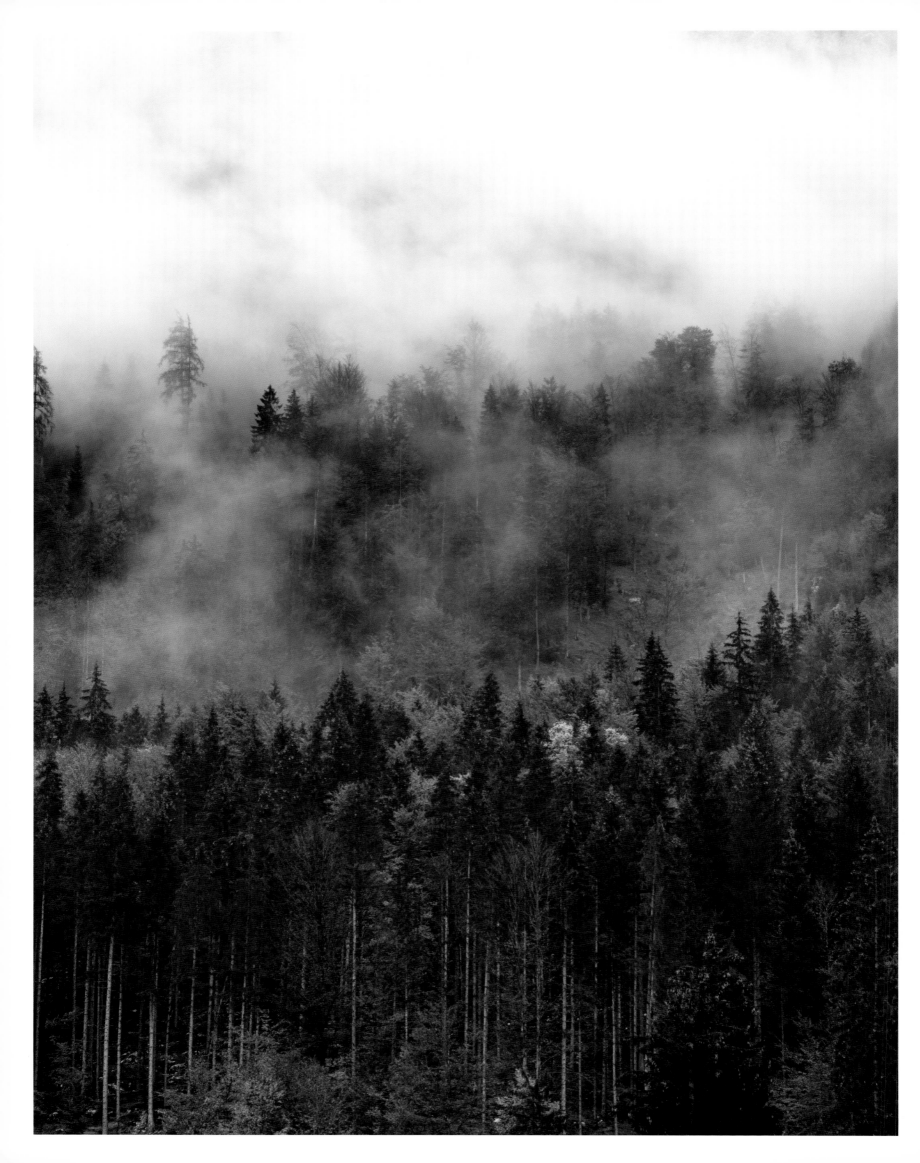

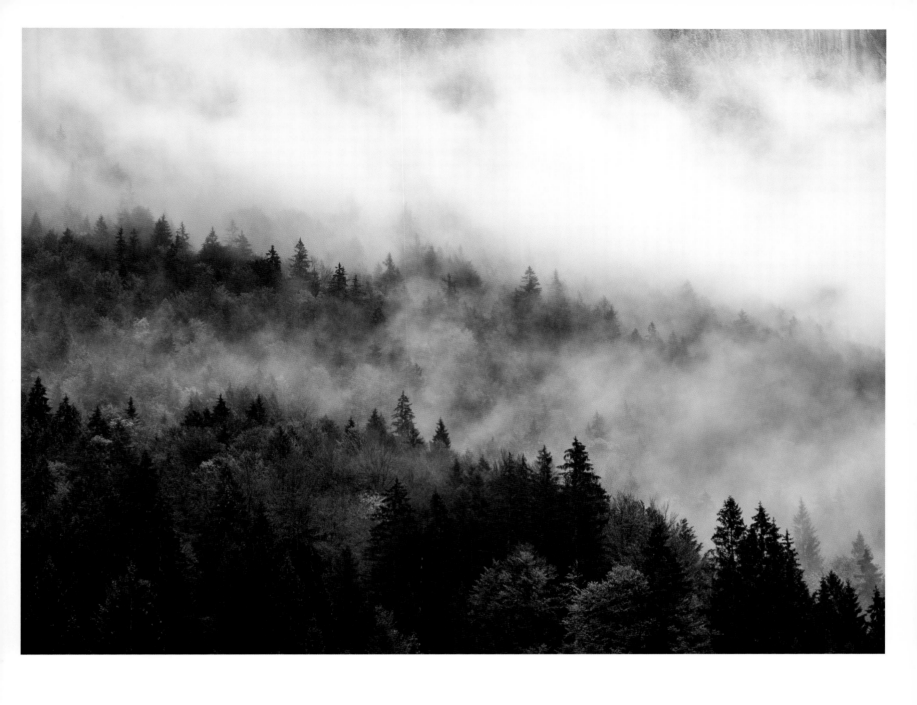

Mountain forest, Salzburgerland, Austria

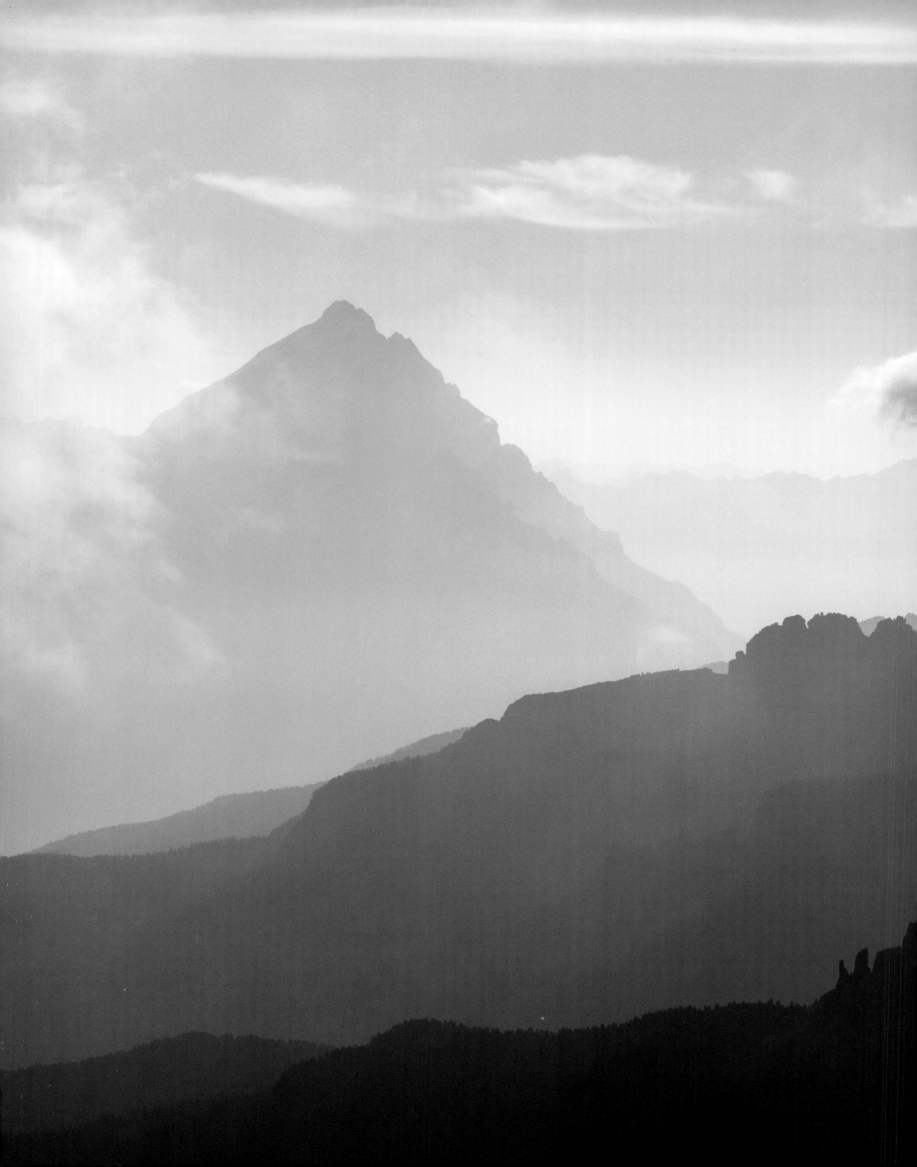

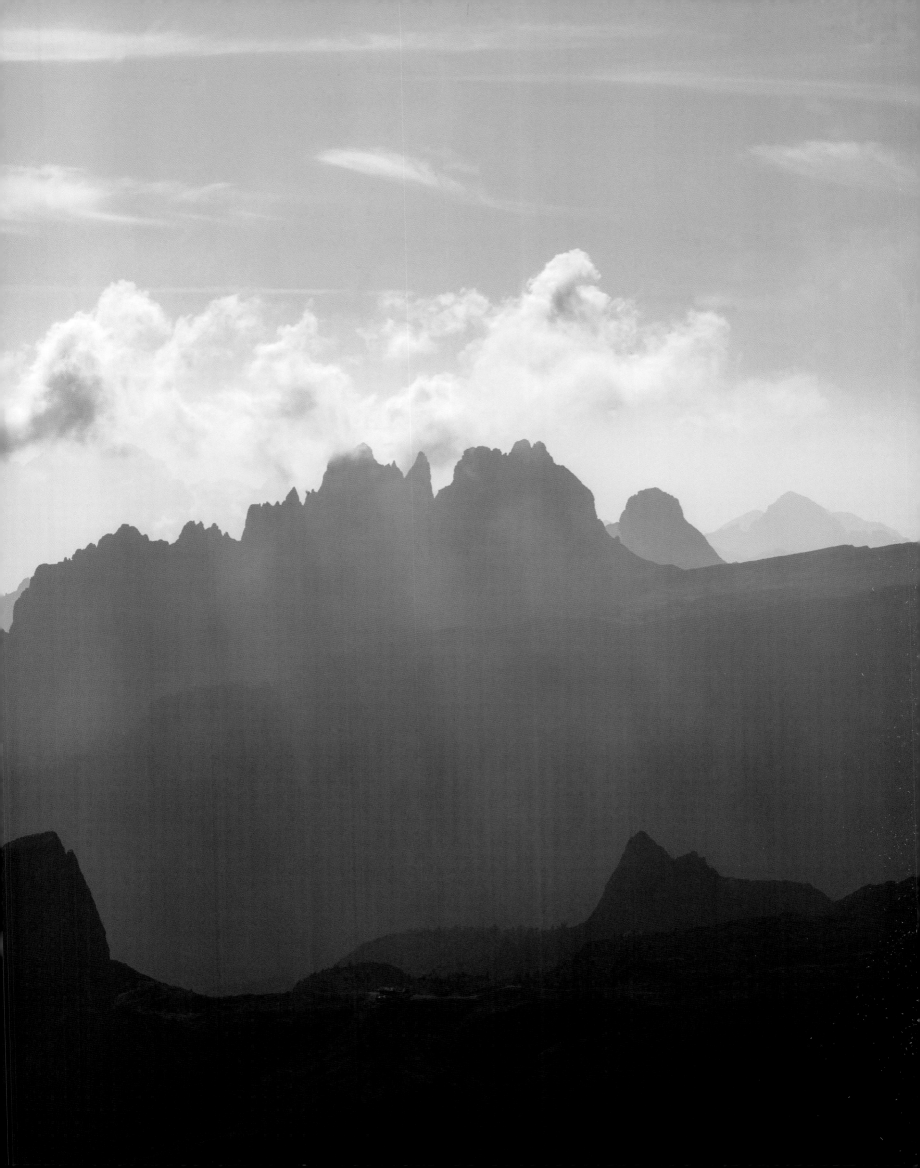

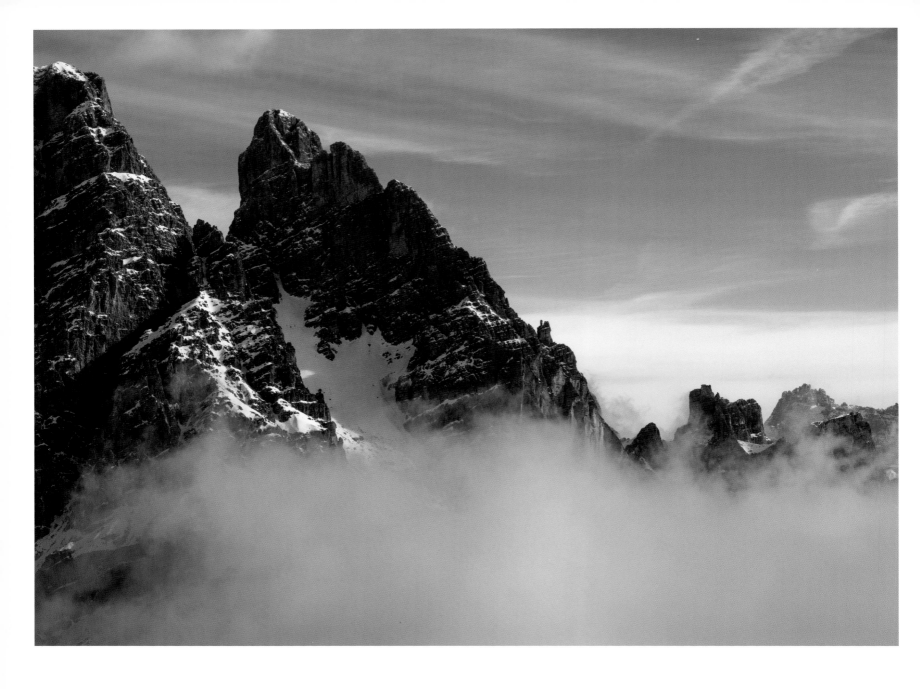

Cristallo, Cortina d'Ampezzo, Italy

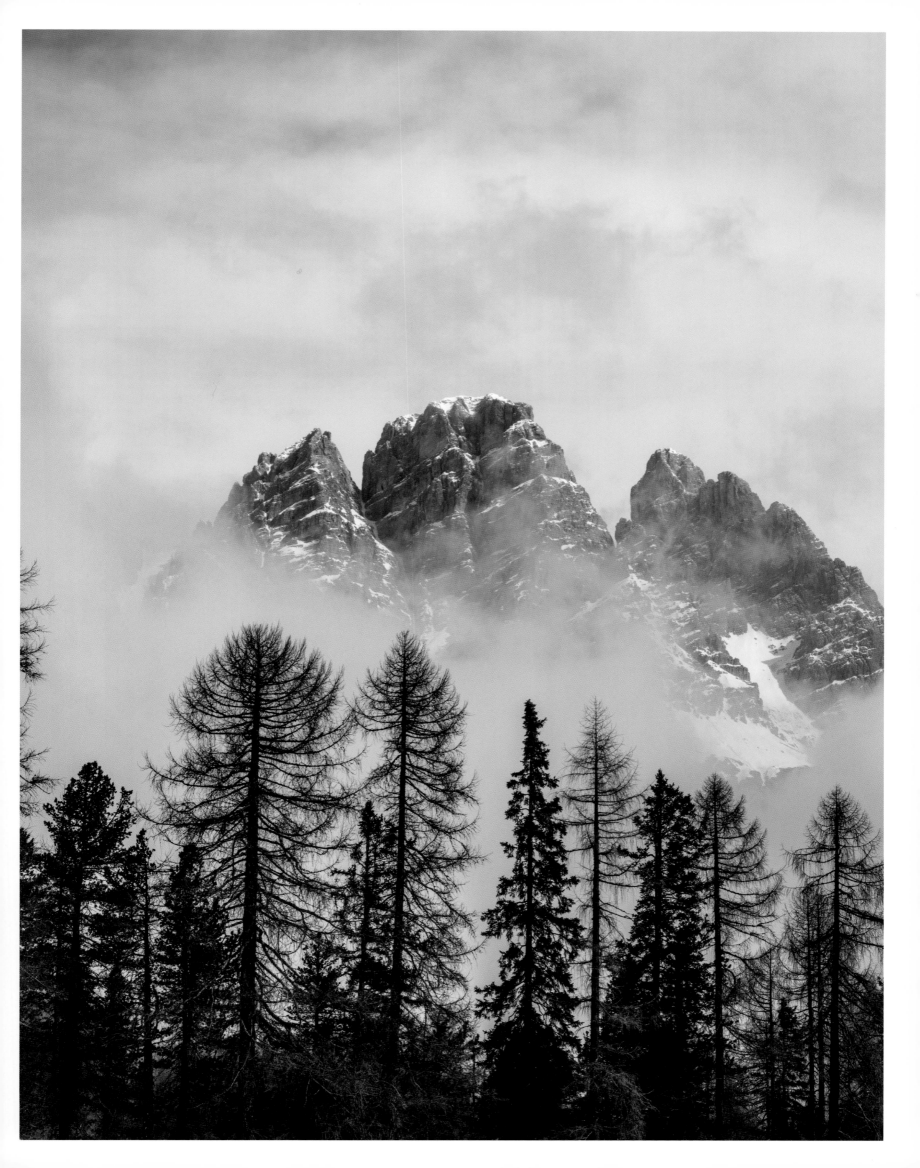

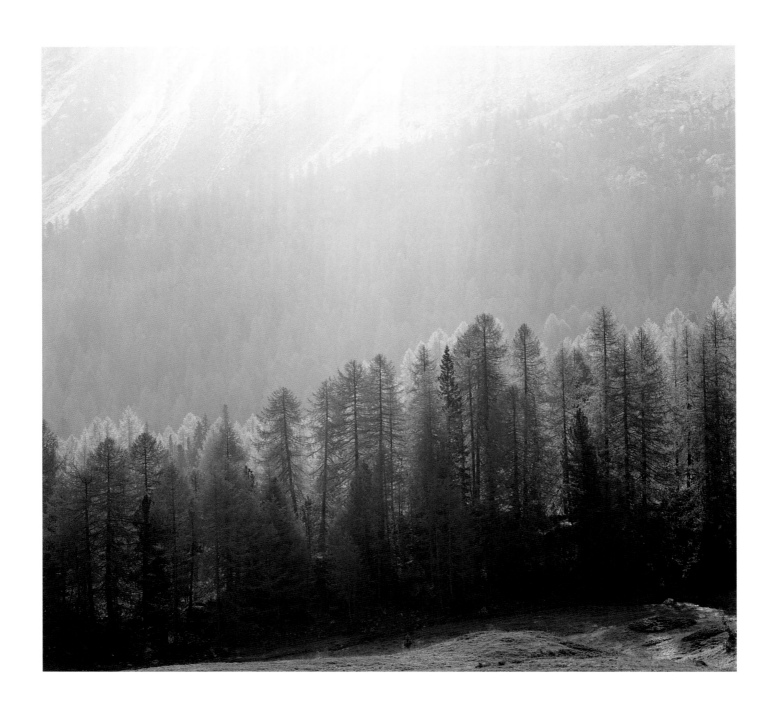

Mountain trees, Dolomites, Italy

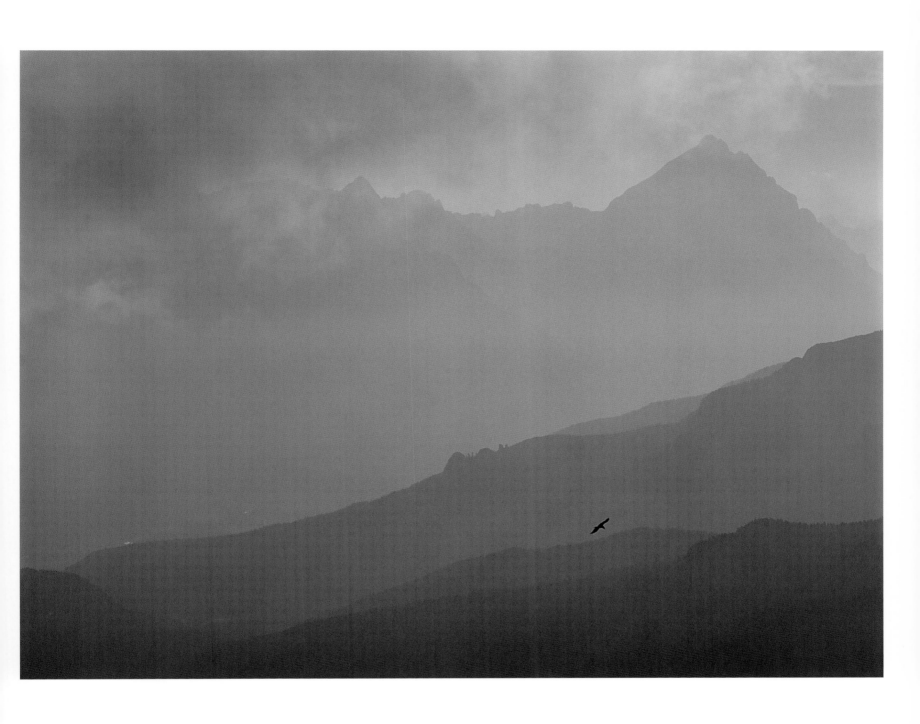

Monte Antelao, Cortina d'Ampezzo, Italy – 10,709 ft | 3,264 m

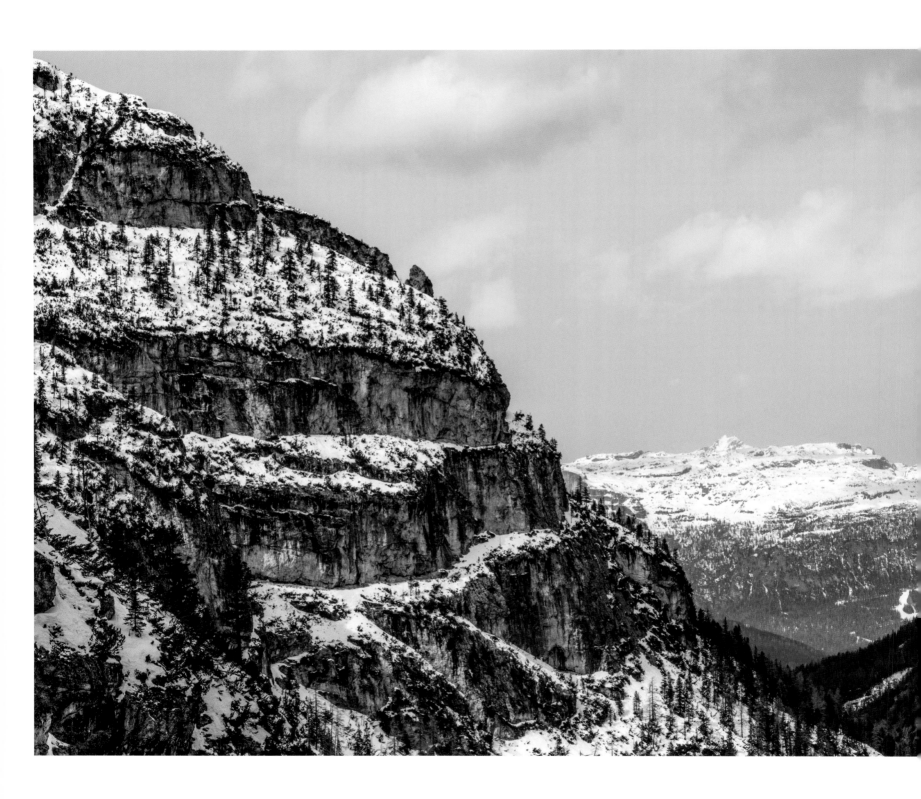

Armentarola, Alta Badia, Italy

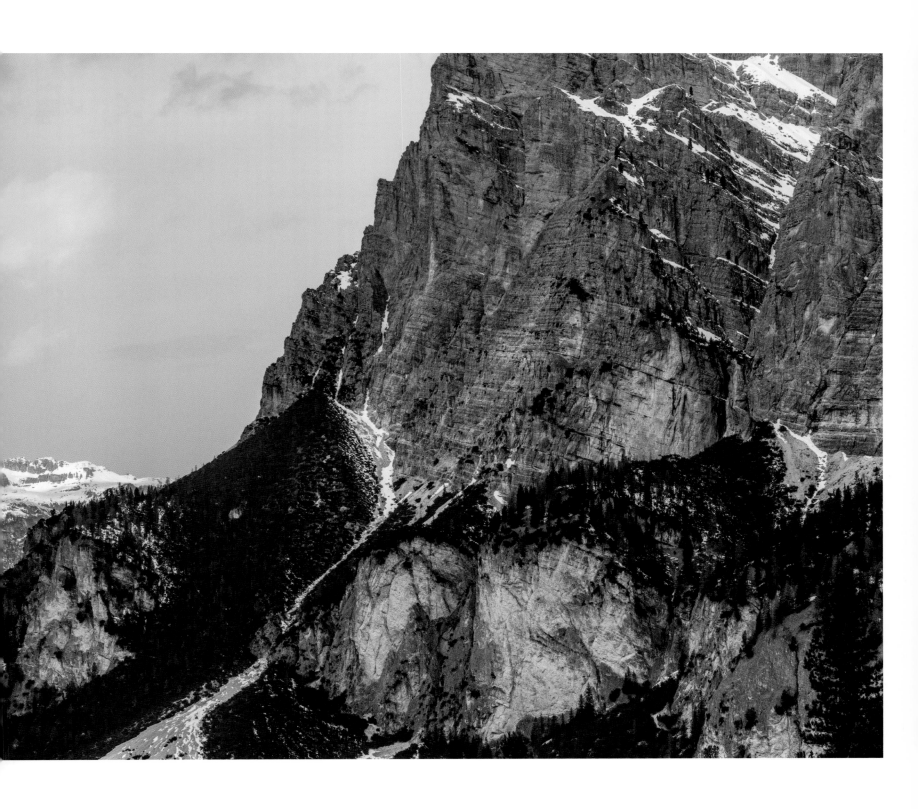

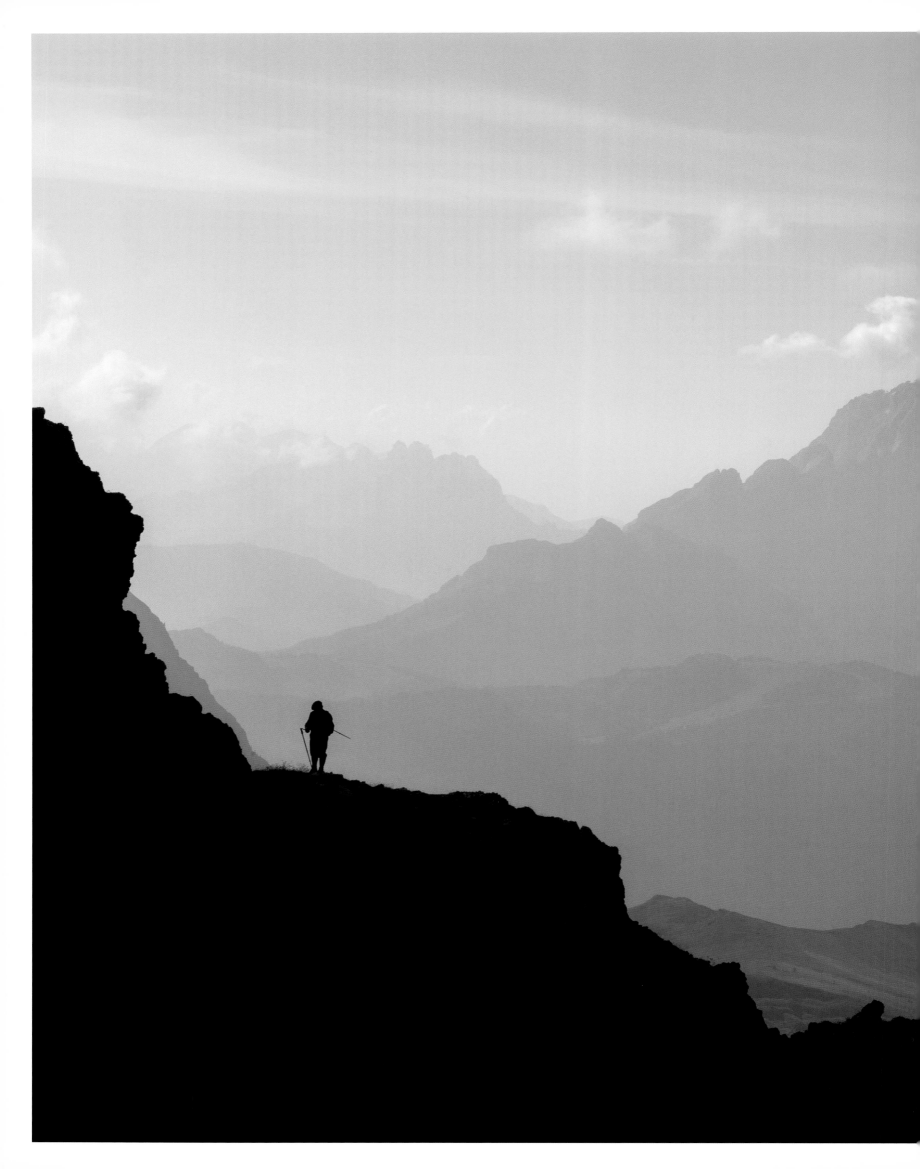

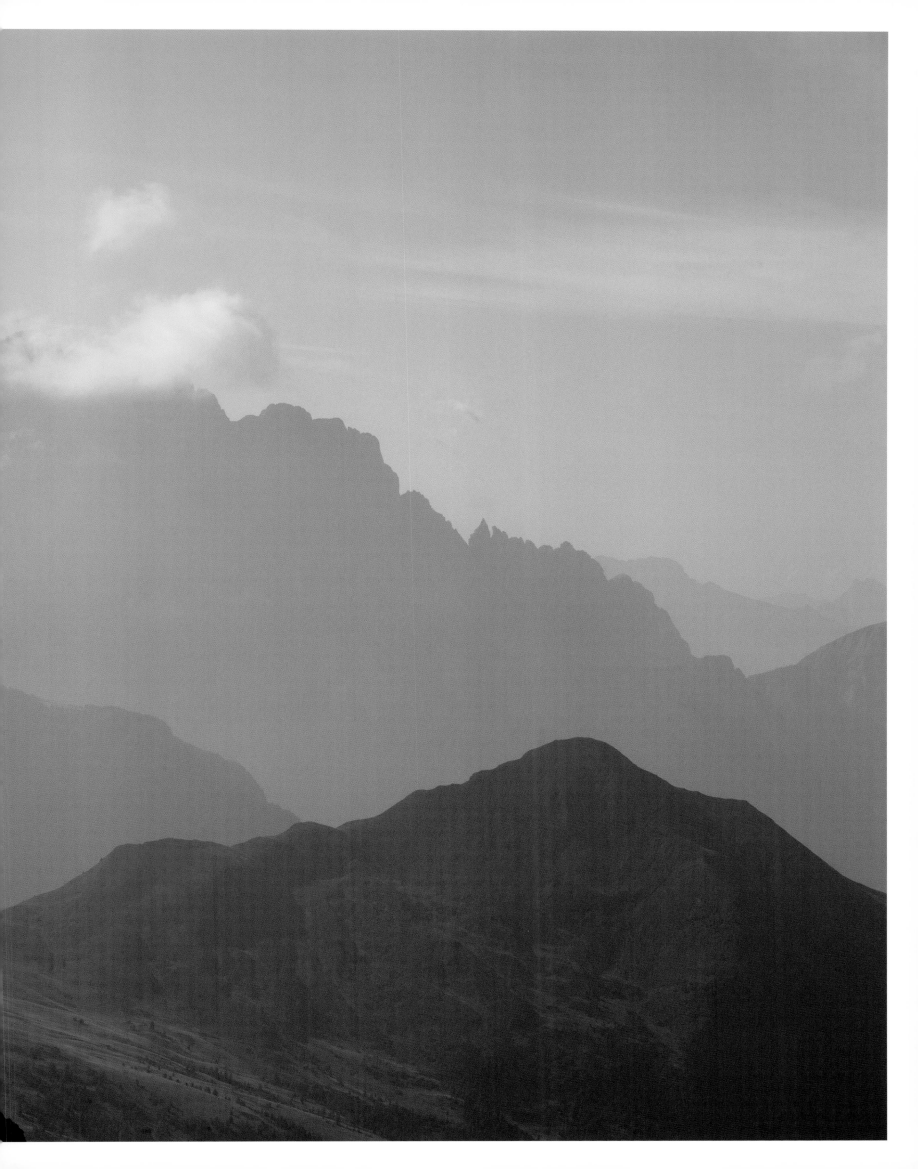

"All the birds have flown up and gone;
A lonely cloud floats leisurely by
We never tire of looking at each other
—Only the mountains and I."

Li Bai (701-762), poet, "Alone on Jingting Shan"

„Alle Vögel am Himmel in die Ferne entfliehen,
Eine einsame Wolke zieht müßig hinan.
Wir werden nicht satt, einander zu sehen,
Nur ich mit dem Jing Ting Shan."

Li Bai (701–762), Dichter, „Allein auf dem Jing Ting Shan"

« Les oiseaux se sont tous envolés ;
Un nuage glisse paisiblement.
Nous ne nous lassons jamais de nous regarder
- Rien que les montagnes et moi. »

Li Bai (701-762), poète, « Assis seul devant le mont Jingting »

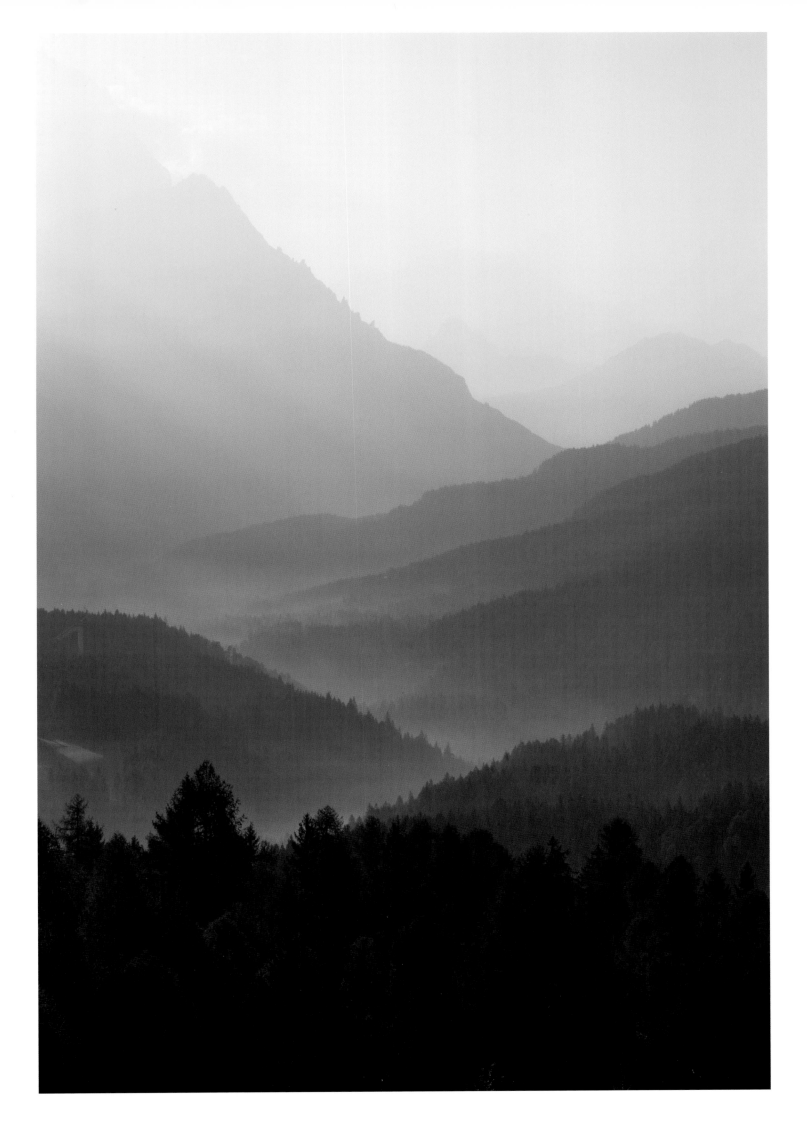

Cadore, Dolomites, Italy

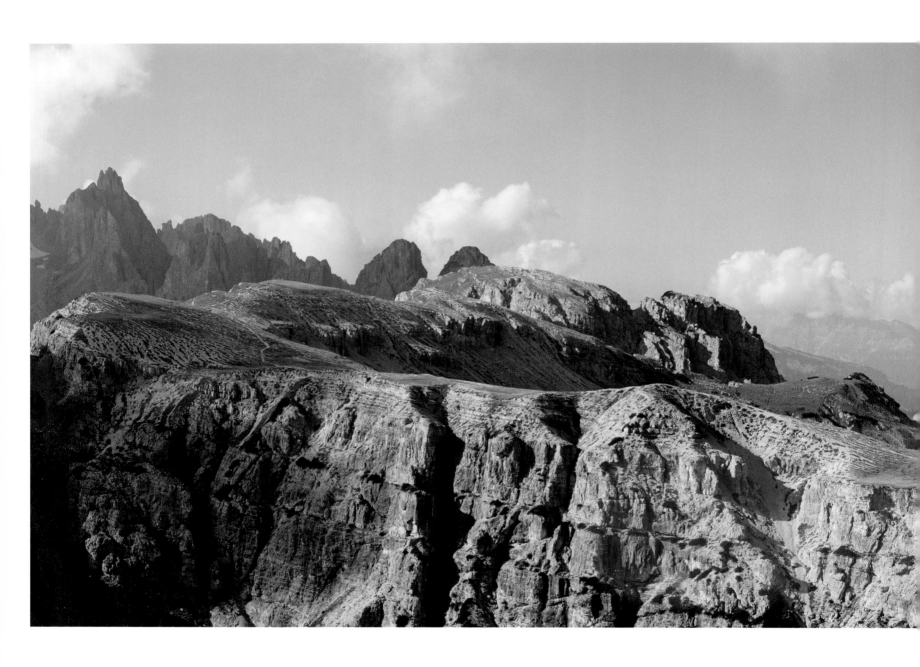

Nuvolau and Piz Popena, Dolomites, Italy

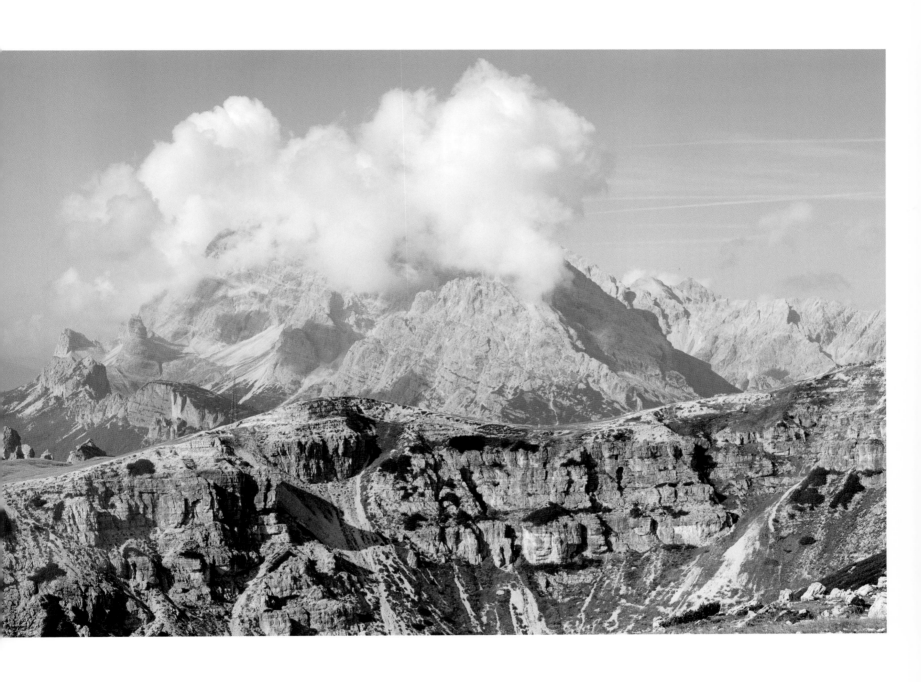

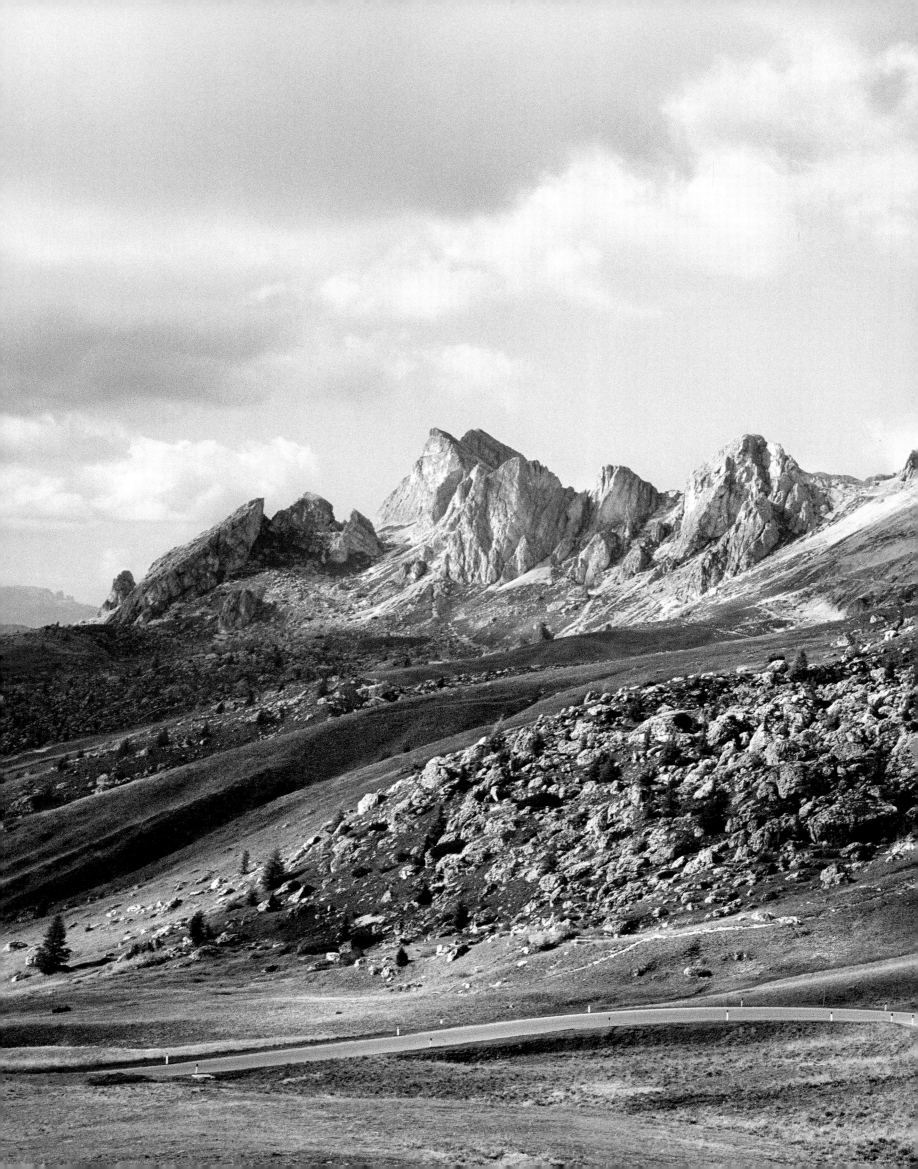

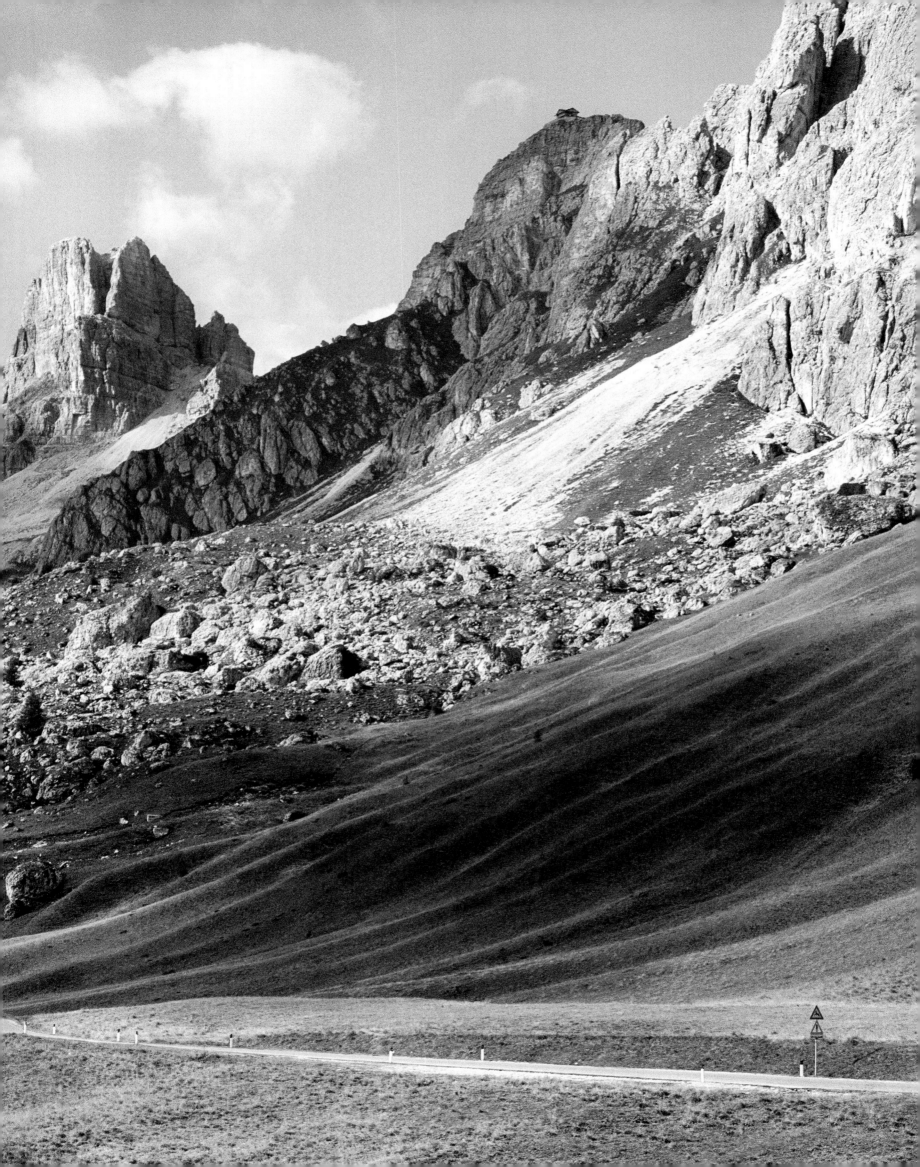

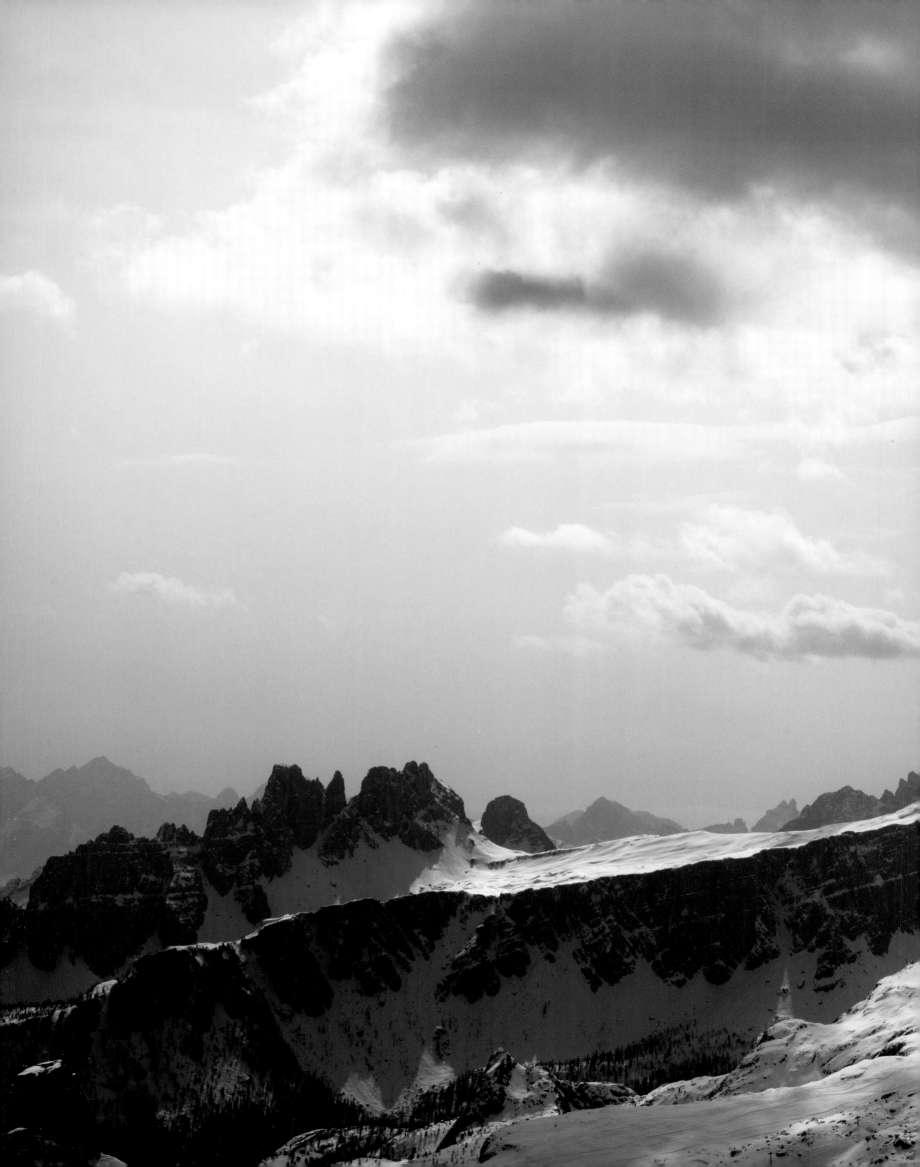

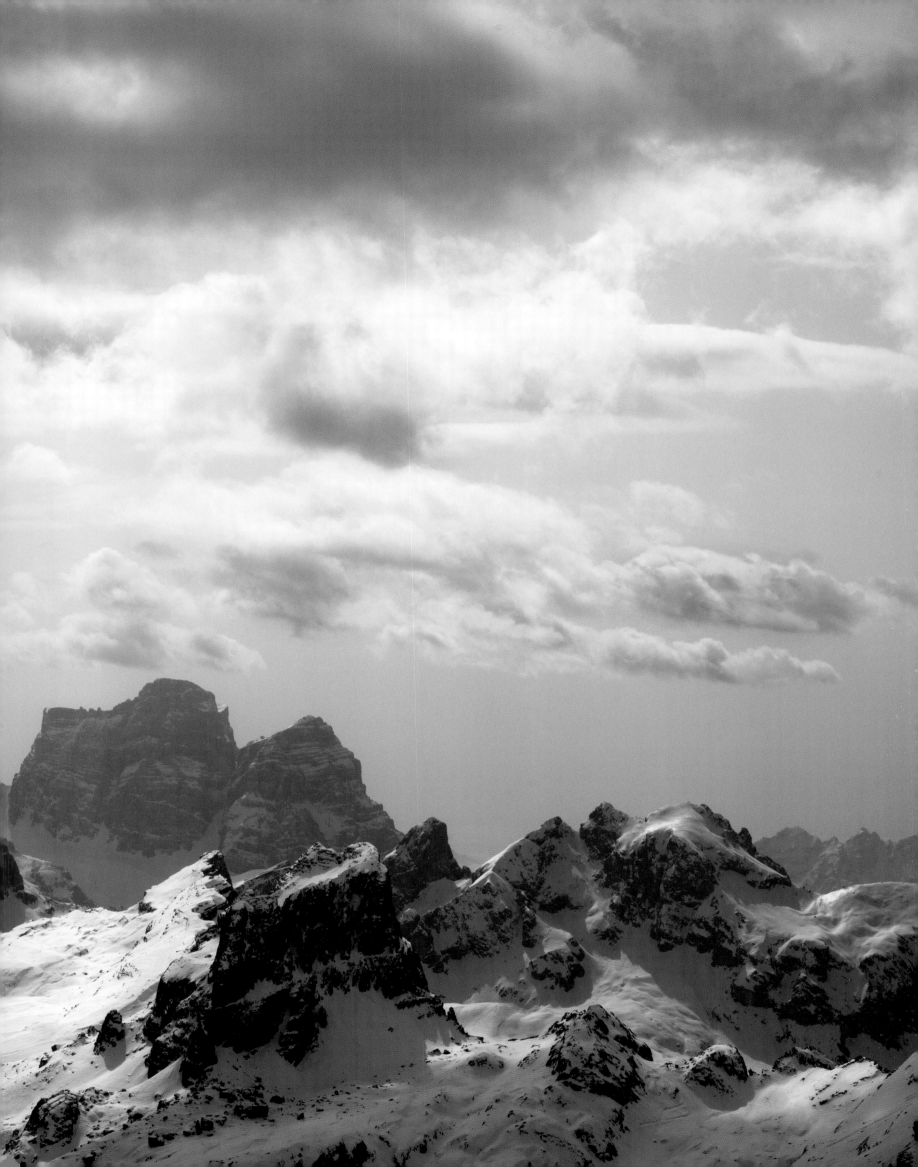

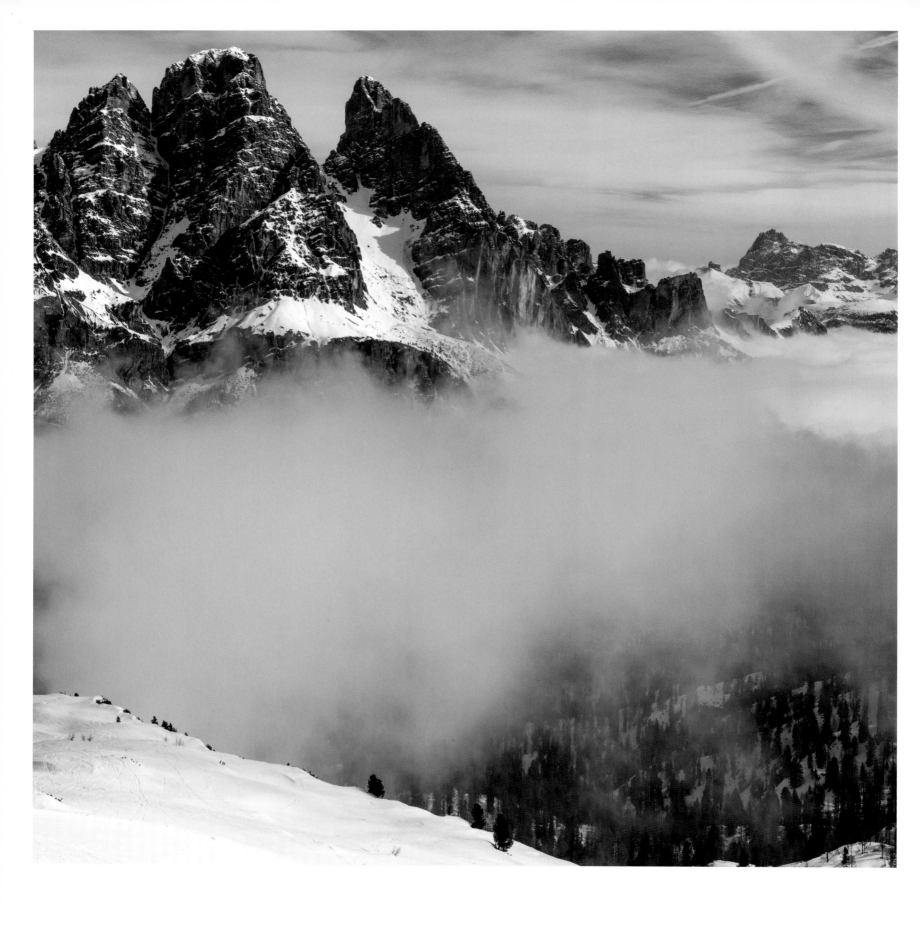

Croda Rossa, Cristallo, Dolomites, Italy

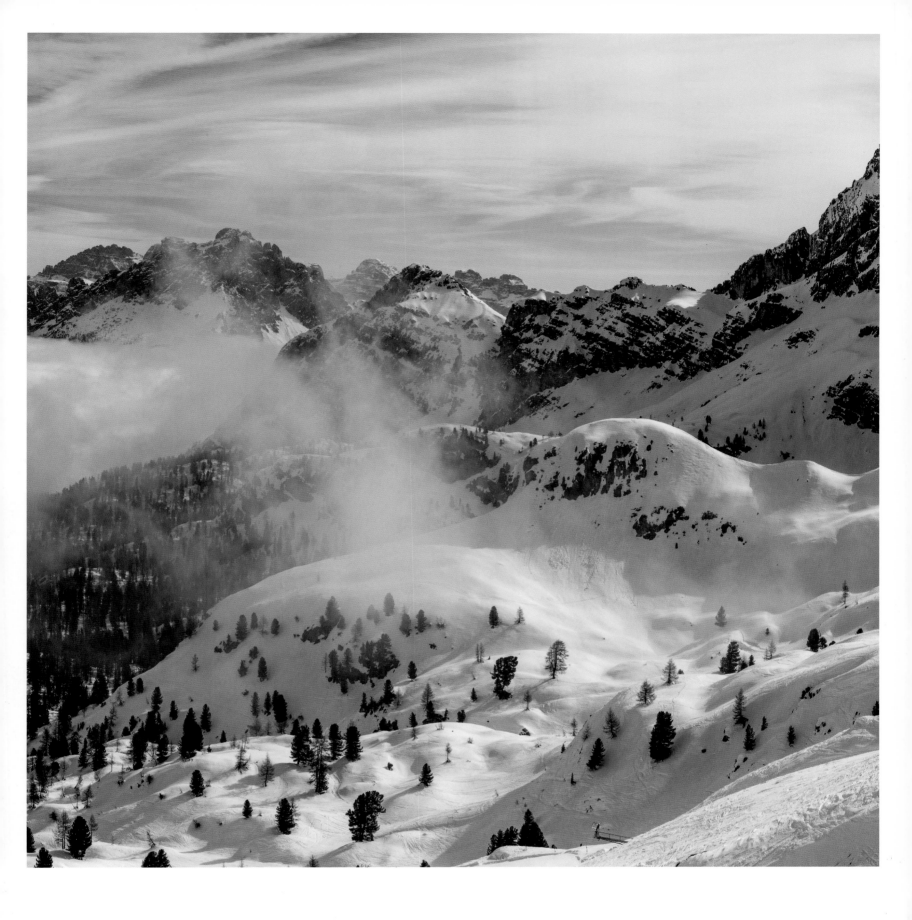

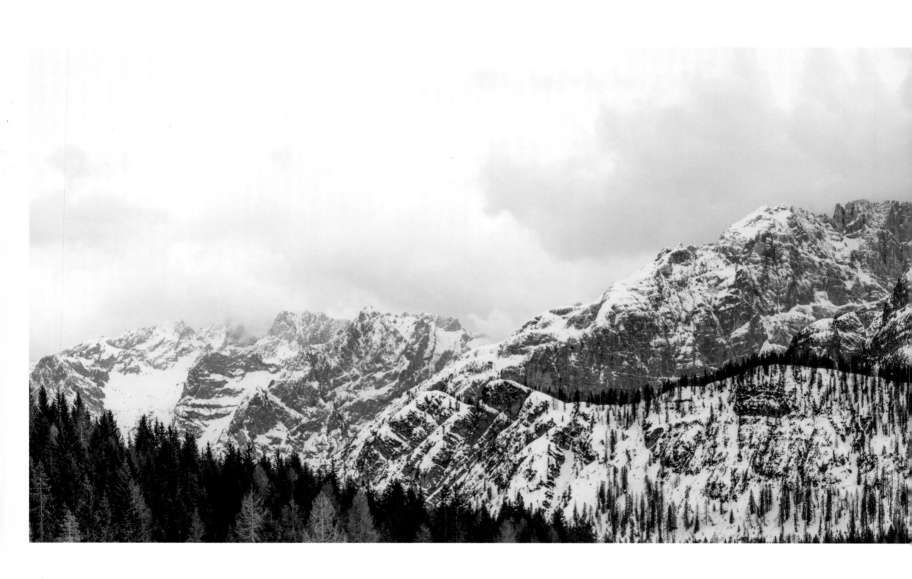

The Peaks of Marcuoira, Belluno, Dolomites, Italy

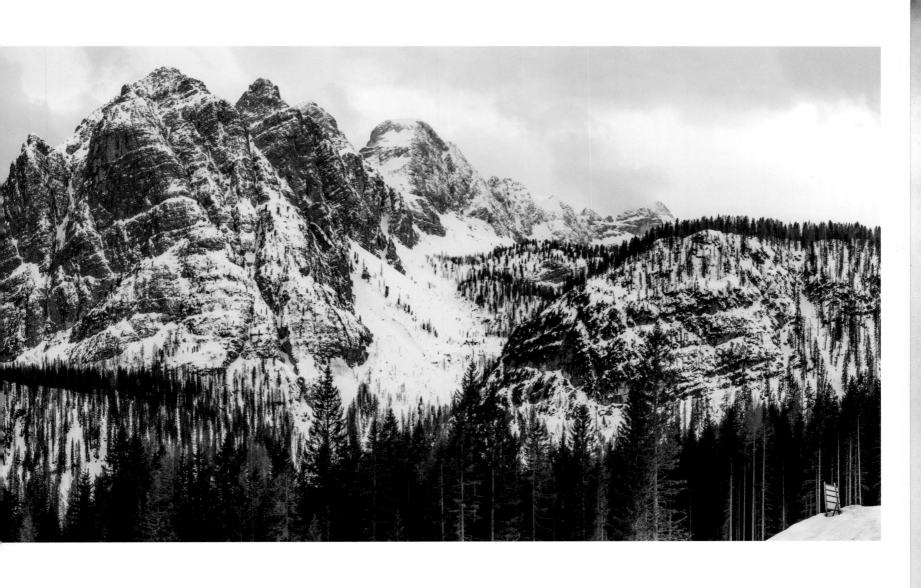

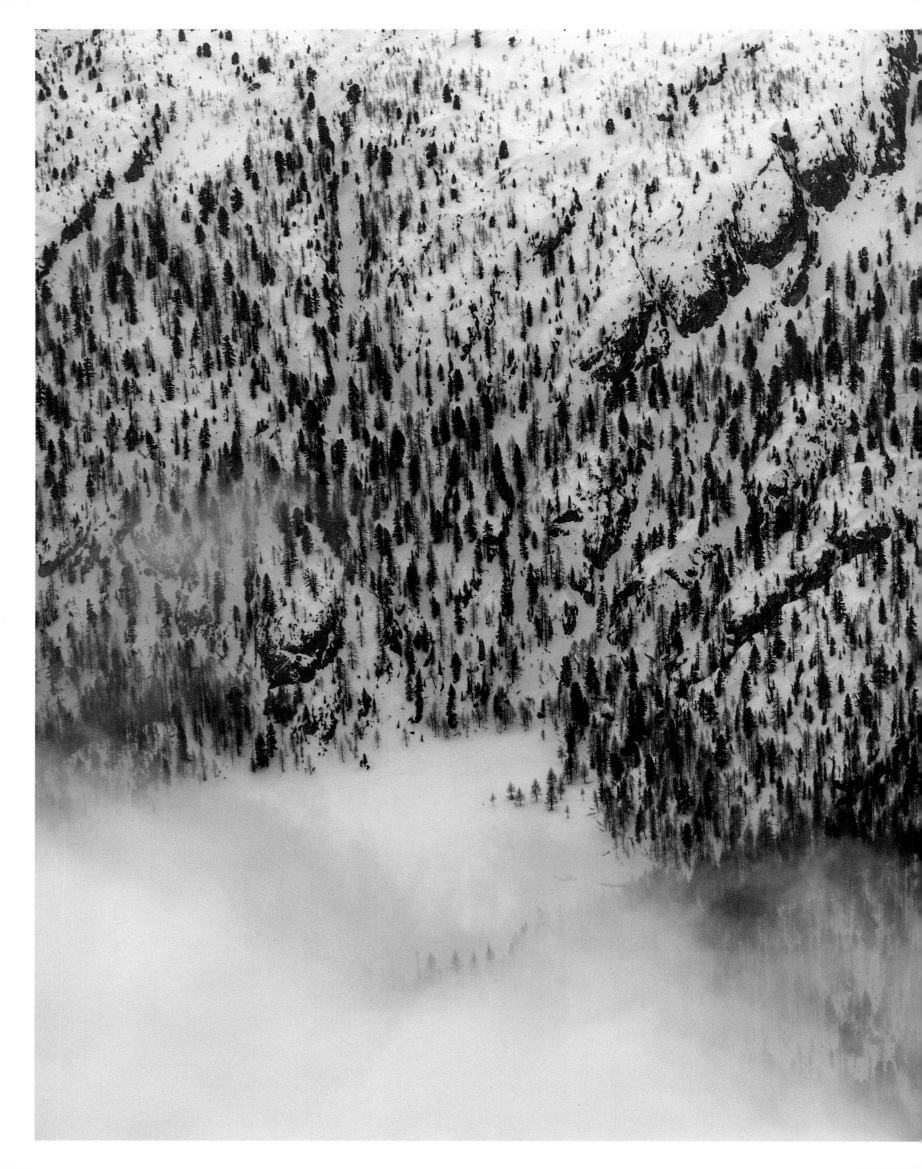

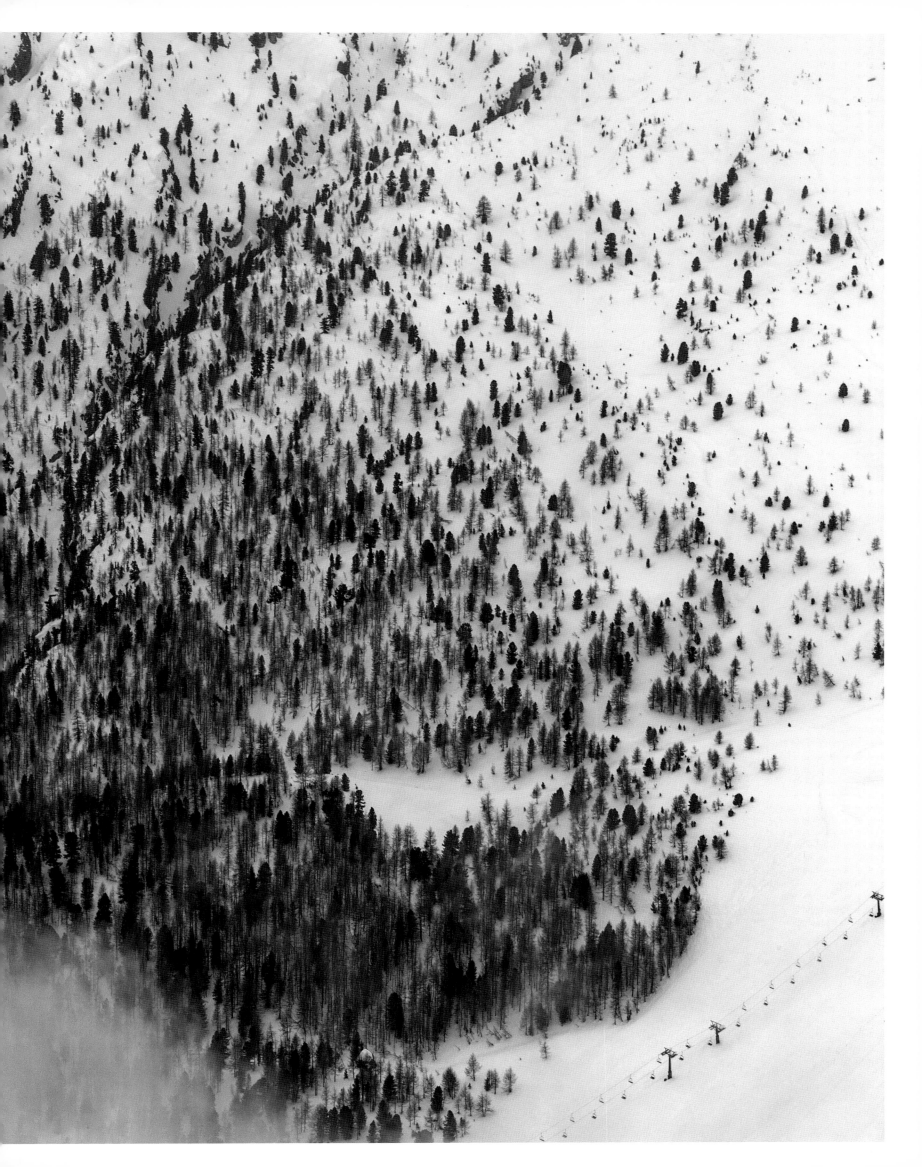

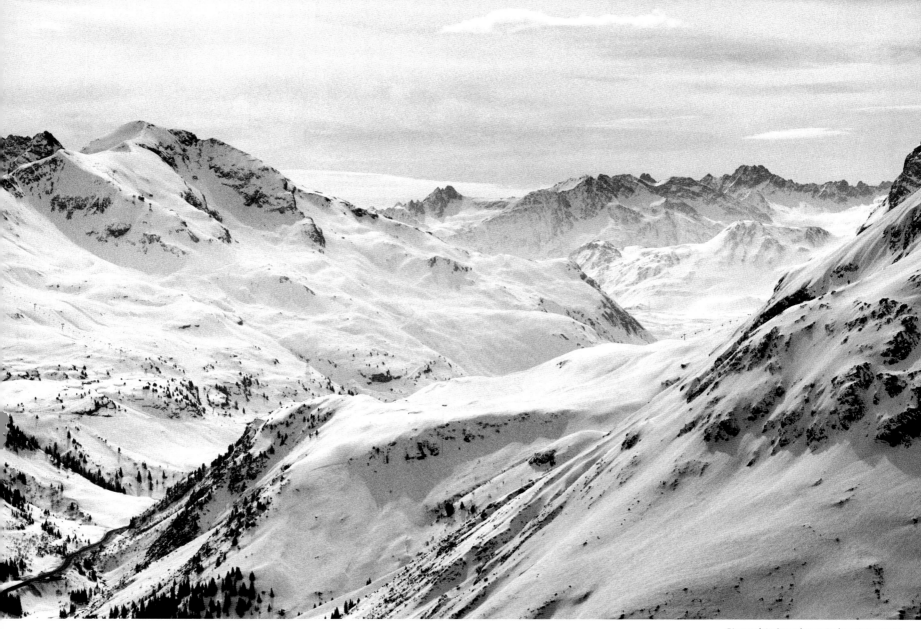

Photo title for print ordering: Arlberg III

Index & photo titles for print ordering

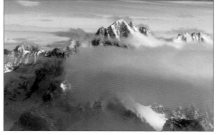
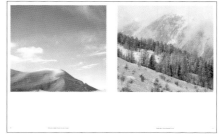
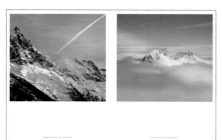
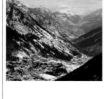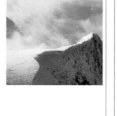
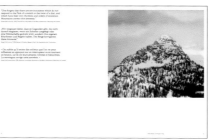
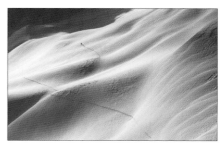

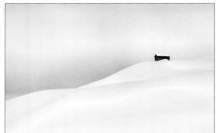

P. 20
Lonely Hut
Verbier

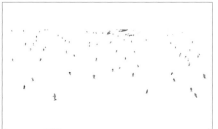

P. 22
Madness
Verbier

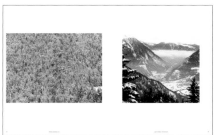

P. 24
Snow Forest
Verbier

P. 25
Les 4 Vallées
Verbier

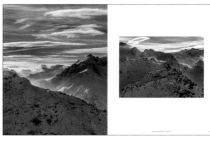

P. 26
Bec des Rosses I
Verbier

P. 27
Bec des Rosses II
Verbier

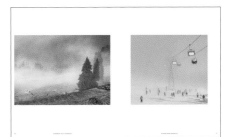

P. 28
Grand Combin
Verbier

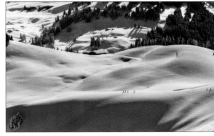

P. 30
Silver Lining
Verbier

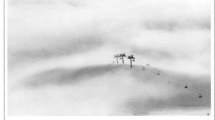

P. 32
Videmanette
Rougemont

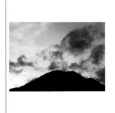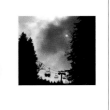

P. 35
Rougemont
Vaud

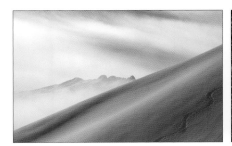

P. 36
Saanersloch
Gstaad

P. 37
Hornberg
Gstaad

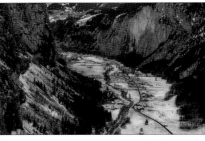

P. 38
Seat in the Clouds
Gstaad

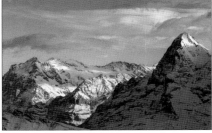

P. 40
Parwengesattel
Gstaad

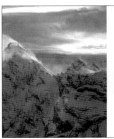

P. 42
Silhouette
Lech

P. 43
Chairlift I
Gstaad

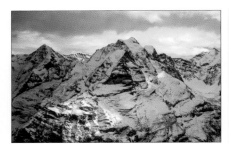

P. 44
First Tracks
Gstaad

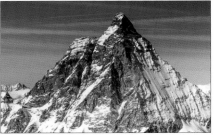

P. 46
Lauterbrunnen
Bernese Oberland

P. 48
The Eiger
Bernese Oberland

P. 50
Jungfrau I
Bernese Oberland

P. 51
Jungfrau II
Bernese Oberland

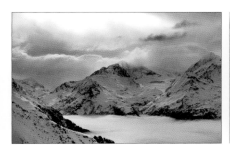

P. 52
Jungfrau III
Bernese Oberland

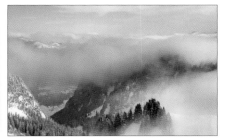

P. 54
The Matterhorn
Zermatt

P. 56
Cervinia
Valle d'Aosta

P. 57
Village
Zermatt

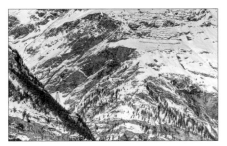

P. 58
Refuge
Zermatt

Index

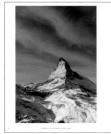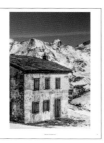
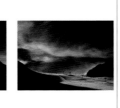
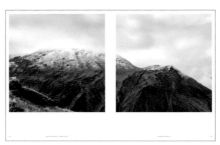
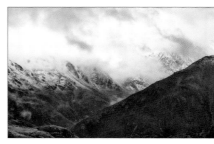
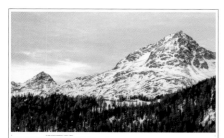
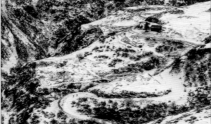
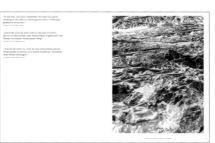
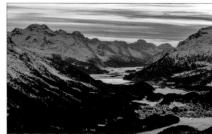
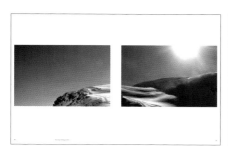
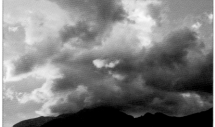
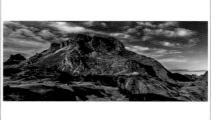

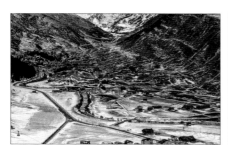
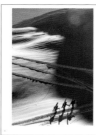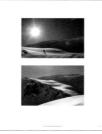
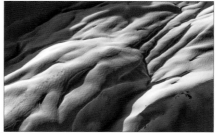
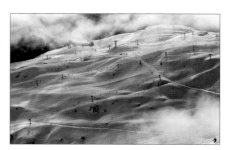
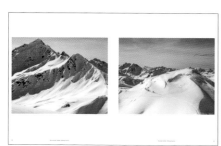
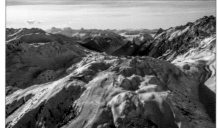
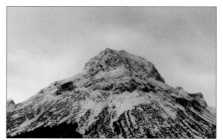
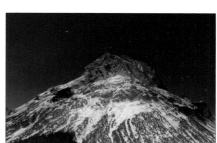

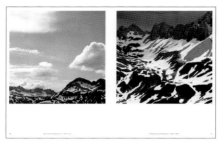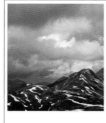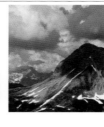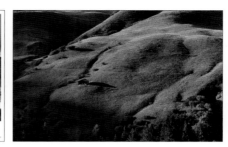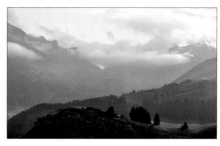

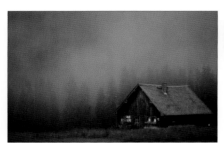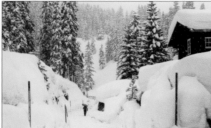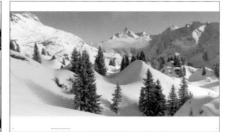

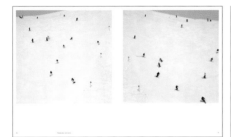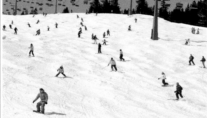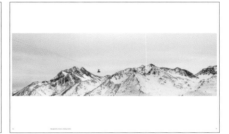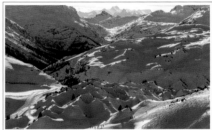

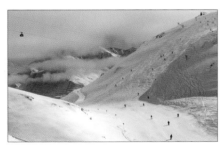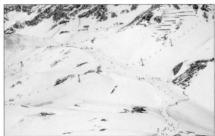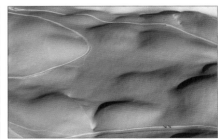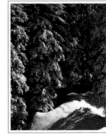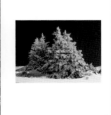

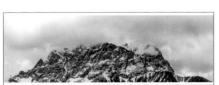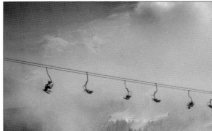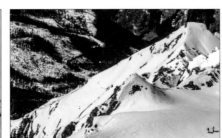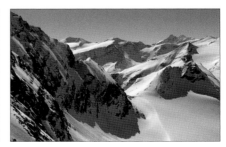

Index

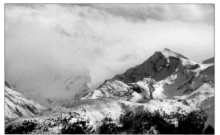
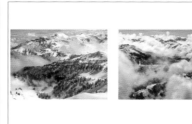
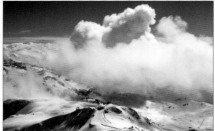
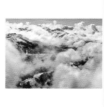
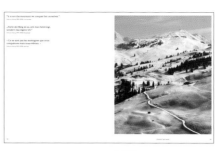
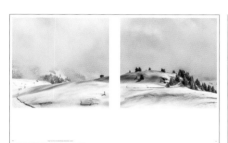
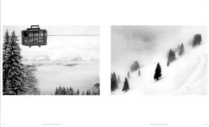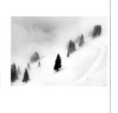
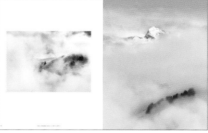
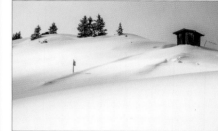
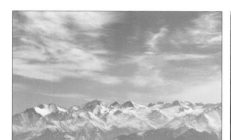
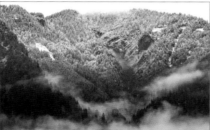
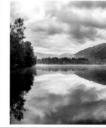
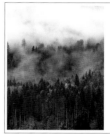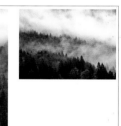
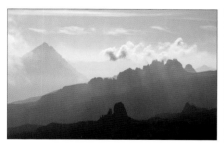
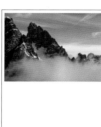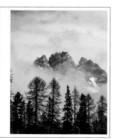
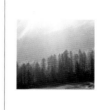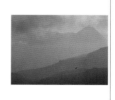
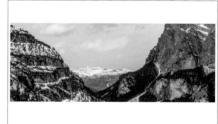
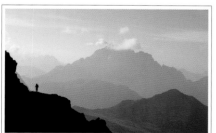
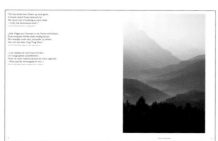
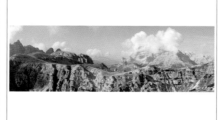
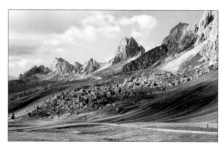

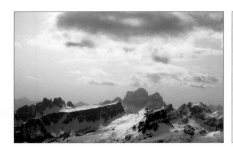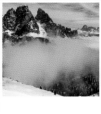

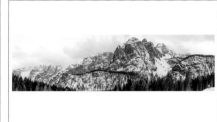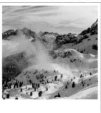

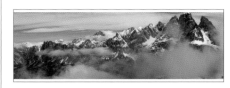

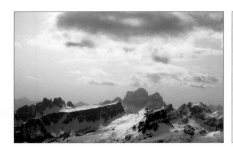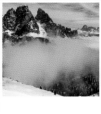

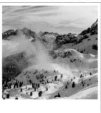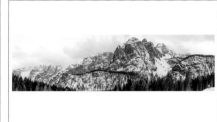

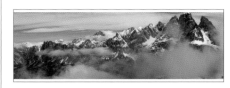

P. 182
Croda da Lago,
Lastoi de Formin and Pelmo
Dolomites

P. 184
Cristallo and the
Three Peaks I
Cortina d'Ampezzo

P. 185
Cristallo and the
Three Peaks II
Cortina d'Ampezzo

P. 186
Peaks of Marcuoira
Dolomites

P. 187
Croda Rosso and Cristallo
Cortina d'Ampezzo

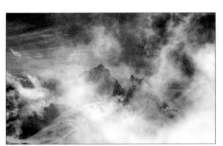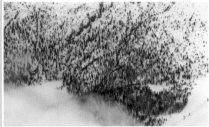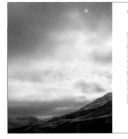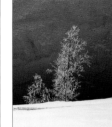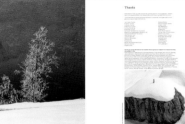

P. 192
Cloudlift
Dolomites

P. 194
Treelines
Dolomites

P. 202
Furka II
Andermatt

P. 206
Frosty Trees
Stuben

P. 207
Tiny Tree
Dolomites

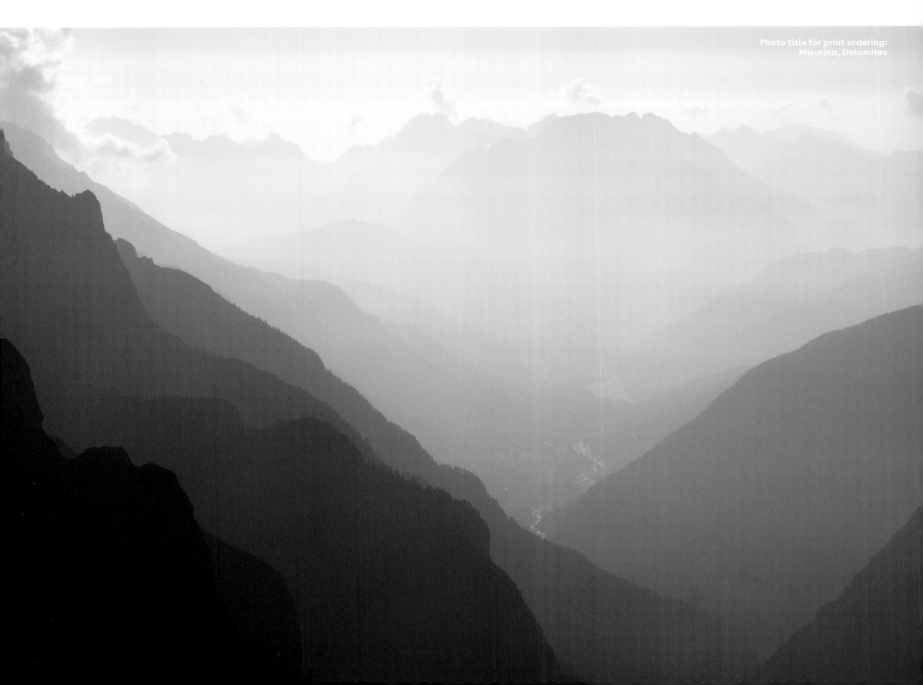

Photo title for print ordering:
Misurina, Dolomites

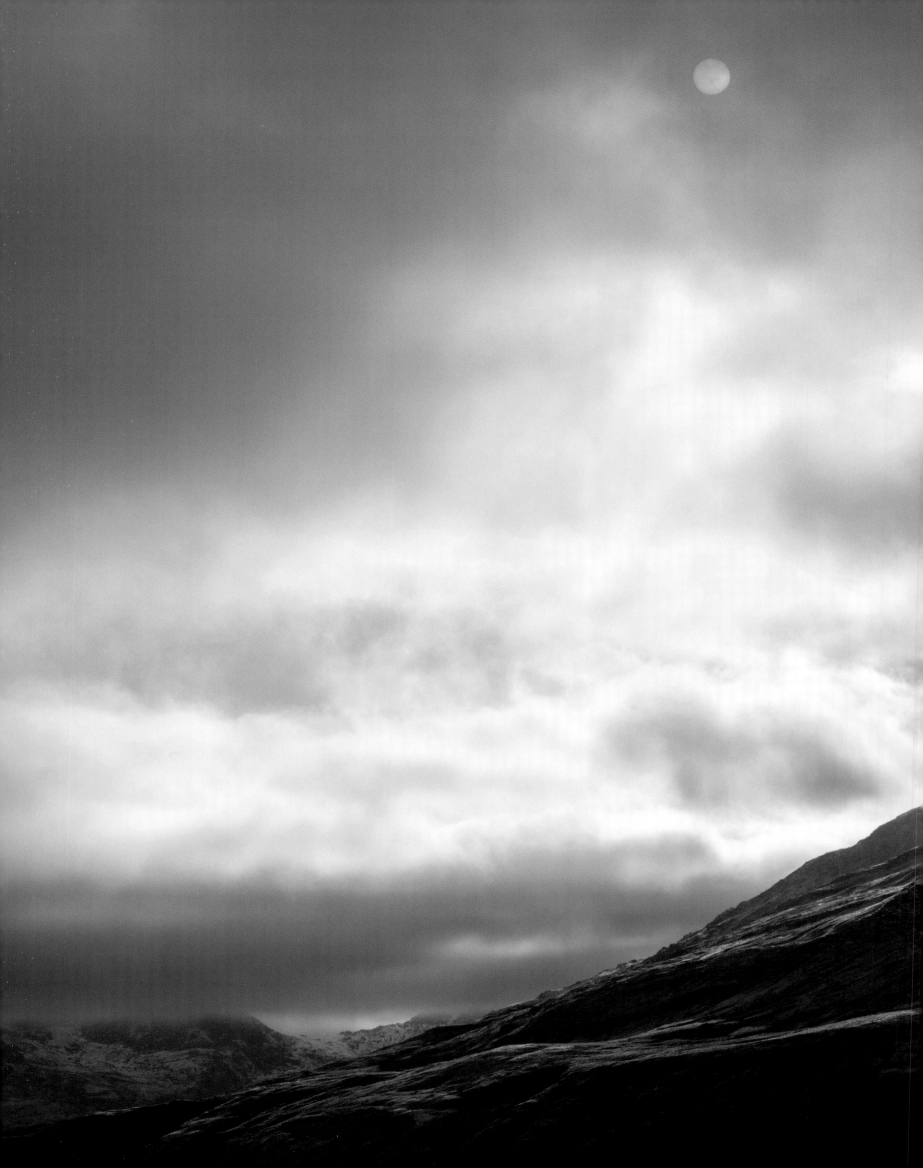

Locations

HAUTE-SAVOIE, FRANCE
VALLE D'AOSTA, ITALY
P. 8–17

Chamonix is the heart of skiing in the Haute-Savoie separated from Courmayeur in Italy by Mount Blanc, the highest peak of the Alps and global epicenter for mountaineering adventures, serpentine ski runs, and long trails for hiking, downhill, and cross-country.

Mont Blanc

Mont Blanc (15,776 ft | 4,809 m) in the Graian Alps is Western Europe's highest mountain, crossing the border between France and Italy. The first recorded climb dates to 1786. Today 20,000 climbers reach the summit each year with a record ascent-descent time of just under five hours.

VERBIER
P. 20–32

Verbier attracts royalty and the rich with pockets deeper than the valleys surrounding this snow-capped Swiss village in the Valais. As part of the Four Valleys resort region, it also claims to be the capital of "off-piste."

BERNESE OBERLAND
P. 32–55

The Eiger

The Eiger, (13,020 ft | 3,970 m) an emblem of the Swiss Alps, overlooks Grindelwald and Lauterbrunnen in the Bernese Oberland.

Gstaad

Gstaad lies in the Bernese Oberland (the Highlands), in the south west of Switzerland. This resort is a snow globe of Swiss bliss combining the best of Alpine scenery and luxury with access to 137 miles (220 km) of slopes. During the season, the "scene" is as important as the scenery, being the winter playground of celebrities past and present.

GLACIER EXPRESS ROUTE
P. 56–79

Many of the most iconic mountains in the Alps flank the Glacier Express, the world famous rail journey that meanders for eight hours through 91 tunnels and across 291 bridges between the illustrious resorts of Zermatt and St Moritz.

ZERMATT
P. 57–65

Zermatt is the Alpine cliché: a twinkling town of narrow streets, timbered chalets, and the horse-drawn carriage all sitting in the shadow of the Matterhorn, one of the world's most photogenic mountains. At 14,692 feet (4,478 m) it has long and various runs—and glacier skiing in summer—that are linked by high-tech lifts and solar-powered ski buses, all the very essence of Swiss-ness.

ANDERMATT
P. 66–75

Andermatt is waking from 30 years of slumber to become the largest ski area in central Switzerland. $2 billion (€1.7 billion) of international investment includes new lifts to upstage the unique tunnel-hopping trains that take adventurous skiers to the off-piste couloirs of Gemsstock Mountain. Geographically sandwiched by the winter meccas of Zermatt and St Moritz, Andermatt, once the traffic hub between Italy and northern Europe and later a Swiss army base for mountain warfare training, is still the largest settlement in the Ursern Valley.

ST MORITZ
P. 76–79

St Moritz is synonymous with superlatives: it is the oldest and still most illustrious Alpine resort with the sunniest days and widest span of winter sports, outside the 220 miles (350 km) of pistes. The eponymous frozen lake hosts competitions in skating, curling, golf, polo, horse racing, and even cricket. It is home to the men-only Cresta Run and the world's only natural bobsled course. In the 16th century, St Moritz drew pilgrims to drink from its bubbling mineral water springs. Now, here in the heart of the Upper Engadin lakes, it is bubbles—and pilgrims—of a different sort.

THE ARLBERG
P. 80–130

"As a photographer one always hopes for that magic moment when an image literally falls into the lens. It kept happening in the Arlberg."
Tim Hall

The Arlberg is the snowy Alpine pass that connects Lake Constance in Voralberg, Innsbruck in Tyrol, and the circuit of old farming villages turned chic ski spots: Lech, Zürs, and Warth, the high altitude hamlet of St Christoph and the Alpine shrine of St Anton as famed for its slopes as its après-ski. This Austrian ski hub is as much about calfskin clothes as snow-capped peaks: here the sporty and the soigné go together just like parallel skiing.

OMESHORN
P. 96–99

Omeshorn (8,389 ft | 2,557 m) in the Vorarlberg in Austria is the iconic mountain that protects the famous ski villages of Lech, Zug, and Zürs beneath.

THE ZUGSPITZE
P. 131–134

The Zugspitze (9,718 ft | 2,962 m) borders Bavaria in Germany and Tyrol in Austria, being the former's tallest mountain—and home to the highest church in the country. Views from the top stretch across 400 peaks and four countries.

KITZBÜHEL
P. 135–165

Kitzbühel in Austria sits at the confluence of three valleys, a medieval town linking a chain of peaks stretching for 15 miles (24 km). As one of the early ski resorts, it has long been an Alpine base for the well-heeled and speed-focused: the *Hahnenkamm-Rennen*, each January, is the most demanding downhill race on the World Cup circuit.

THE DOLOMITES
P. 166–195

The Dolomites span 18 peaks in north-eastern Italy in a distinctive mapping of sheer cliffs and rocky pinnacles that inspired Le Corbusier to describe these mountains as "the most beautiful work of architecture in the world." They famously glow pink (the enrosadira) at sunset when the rays hit the dolomite—the granite formation that inspired their name.

The Dolomites reflect the typical Alpine blend of old and new worlds. Topographical isolation means some villages deep in the valley still speak Ladin, a Latin dialect. This contrasts starkly with the cosmopolitan charisma of Cortina d'Ampezzo, where mink fur coats are mandatory.

Regionen

HAUTE-SAVOIE, FRANKREICH BIS INS AOSTATAL, ITALIEN
S. 8–17
Im Herzen des Skigebiets im französischen Departement Haute-Savoie findet sich die Stadt Chamonix, getrennt vom italienischen Courmayeur durch den Mont Blanc, den höchsten Gipfel der Alpen und das weltweite Epizentrum für Bergabenteuer, Slalomabfahrten sowie lange Wander-, Ski- und Cross-Country-Touren.
Mont Blanc
Der Mont Blanc, in den Grajischen Alpen direkt an der Grenze zwischen Frankreich und Italien gelegen, ist mit seinen 4 809 Metern der höchste Berg Westeuropas. Erstmalig dokumentiert wurde seine Besteigung 1786. Heute erklimmen jedes Jahr über 20 000 Bergsteiger den Gipfel; der Rekord für den schnellsten Auf- und Wiederabstieg liegt bei knapp unter fünf Stunden.

VERBIER, SCHWEIZ
S. 20–32
Das schneebedeckte Dorf Verbier zieht Mitglieder königlicher Familien an und andere wohlhabende Menschen, deren Taschen tiefer sind als die Täler des umliegenden Schweizer Kantons Wallis. Es gehört zum Wintersportgebiet der Vier Täler – Quatre-Vallées – und nimmt für sich in Anspruch, die Hauptstadt des Tiefschneefahrens zu sein.

BERNER OBERLAND, GSTAAD, ROUGEMONT, LAUTERBRUNNEN
S. 32–55
Der Eiger
Der 3970 Meter hohe Eiger ist ein Wahrzeichen der Schweizer Alpen. Sein Gipfel überragt die Ortschaften Grindelwald und Lauterbrunnen im Berner Oberland.
Gstaad
Der Erholungsort Gstaad, im Südwesten der Schweiz gelegen, ist mit seiner Kombination aus atemberaubenden Alpenpanoramen und dem Luxus von insgesamt 220 Kilometer langen Skipisten der Inbegriff von schweizerischer Glückseligkeit. Während der Wintersaison ist die „Szene" mindestens ebenso interessant wie die Szenerie, da Gstaad als beliebtes Urlaubsziel bekannter Persönlichkeiten gilt.

DER GLACIER-EXPRESS
S. 56–79
Viele der bekanntesten Alpengipfel flankieren den Glacier-Express, eine acht Stunden während Eisenbahnfahrt zwischen den mondänen Wintersportorten Zermatt und St. Moritz. Auf dieser weltberühmten Strecke passiert der Zug 91 Tunnel und 291 Brücken.

ZERMATT
S. 57–65
Zermatt ist das alpine Klischee schlechthin: Ein glitzerndes Städtchen mit engen Gassen, mit Holzschindeln gedeckten Chalets und romantische Pferdekutschen im Schatten des Matterhorns, einer der fotogensten Berge der Welt. Auf einer Höhe von 4 478 Metern bietet er nicht nur sommerliche Skitouren auf dem Gletscher, sondern auch lange und sehr unterschiedliche Abfahrtspisten, die durch moderne Hightech-Skilifte und solarbetriebene Skibusse miteinander verbunden sind – alles sehr typisch für die Schweiz.

ANDERMATT
S. 66–75
Andermatt ist gerade dabei, aus einem dreißigjährigen Dornröschenschlaf zu erwachen und sich zum größten Skigebiet der zentralen Schweiz zu entwickeln. Mit internationalen Investitionen von 1,7 Milliarden Euro wurden unter anderem neue Skilifte gebaut, als Alternative zur einzigartigen Bergbahn, die abenteuerlustige Skifahrer durch zahlreiche Tunnel in die abseits der Pisten gelegenen Schluchten am Gemsstock befördert. Das zwischen den Wintersport-Mekkas Zermatt und St. Moritz gelegene Andermatt, früher ein wichtiger Verkehrsknotenpunkt auf dem Weg von Italien nach Nordeuropa und später als Armeebasis für die Gefechtsausbildung im Gebirge genutzt, ist auch heute noch die größte Siedlung im Urserental.

ST. MORITZ UND ENGADIN
S. 76–79
St. Moritz ist ein Synonym für Superlative: Es ist der älteste und mondänste Wintersportort der Alpen, mit den sonnigsten Tagen und der größten Vielfalt an Sportangeboten neben den insgesamt 350 Kilometer langen Skipisten. Auf dem gleichnamigen zugefrorenen See finden Turniere im Schlittschuhlaufen, Curling, Golf, Polo, ja sogar Pferderennen und Cricket-Matches statt. In St. Moritz wird das männlichen Teilnehmern vorbehaltene Cresta-Rennen abgehalten und dort befindet sich die einzige natürliche Bobbahn der Welt. Im 16. Jahrhundert zog St. Moritz zahlreiche Pilger an, die sich am Mineralwasser aus seinen sprudelnden Quellen laben wollten. Heute zieht es eine andere Art von Pilgern hierher, an diesen malerischen Ort inmitten der Oberengadiner Seenplatte.

DER ARLBERG, ST. ANTON, ZÜRS, LECH, WARTH
S. 80–130
„Als Fotograf hofft man stets auf den magischen Moment, wenn das Bild buchstäblich ins Objektiv fällt. Das ist mir am Arlberg immer wieder passiert."
Tim Hall

Der Arlberg ist der schneebedeckte alpine Pass, der die wichtigste Verkehrsader bildet zwischen der Region Vorarlberg am östlichen Ufer des Bodensees, der tirolischen Landeshauptstadt Innsbruck und dem Kreis alter Bauerndörfer, die sich in mondäne Skiresorts verwandelt haben: Lech, Zürs und Warth, sowie ein in großer Höhe gelegenen Ortschaften St. Christoph und St. Anton, die für ihre Pisten ebenso berühmt sind wie für ihr Après-Ski. In diesem österreichischen Skigebiet ist elegante Garderobe mindestens ebenso wichtig wie die schneebedeckten Gipfel: Hier ziehen Sportler und Prominente ihre Bahnen, gleichsam wie ein Paar parallel gleitender Skier.

OMESHORN
S. 96–99
Das 2557 Meter hohe Omeshorn liegt im österreichischen Bundesland Vorarlberg, wo es schützend vor den bekannten Skiorten Lech, Zug und Zürs aufragt.

DIE ZUGSPITZE
S. 131–134
Das Zugspitzmassiv türmt sich auf an der Grenze zwischen Bayern und dem österreichischen Tirol. Mit 2 962 Metern Höhe ist die Zugspitze der höchste Berg Deutschlands – und der Standort der höchstgelegenen Kirche des Landes. Von ganz oben schweift der Blick über 400 Berggipfel und vier Länder.

KITZBÜHEL
S. 135–165
Das österreichische Kitzbühel bildet an der Schnittstelle dreier Täler ein Bindeglied in einer Kette von Berggipfeln, die sich über eine Länge von 24 Kilometern erstreckt. Als einer der ersten Wintersportorte ist Kitzbühel schon seit Langem das alpine Basislager für betuchte Freunde des Geschwindigkeitsrausches: Das alljährlich im Januar stattfindende Hahnenkamm-Rennen ist der schwierigste Skiabfahrtslauf der Weltcupserie.

DIE DOLOMITEN
S. 166–195
Zu den Dolomiten zählen achtzehn Berge im nordöstlichen Italien, die mit ihren schroffen Felswänden und steilen Gipfeln den berühmten schweizerisch-französischen Architekten Le Corbusier dazu inspirierten, diese Gebirgskette als „das schönste Architektur-Kunstwerk der Welt" zu bezeichnen. Ihr berühmtes rosa Glühen (die enrosadira) entsteht, wenn beim Sonnenuntergang die Lichtstrahlen auf den Dolomit treffen – das Granitgestein, dem das Gebirge seinen Namen verdankt.

Die Dolomiten spiegeln die typisch alpine Mischung wider aus alten und neuen Welten. In manchen tief im Tal gelegenen Dörfern wird aufgrund ihrer topographisch isolierten Lage nach wie vor Ladinisch gesprochen, ein romanischer Dialekt. Diese Urtümlichkeit bildet einen krassen Gegensatz zum modernen kosmopolitischen Flair eines Cortina d'Ampezzo, wo Nerzmantel Pflicht ist.

Régions

HAUTE-SAVOIE, FRANCE
VALLÉE D'AOSTE, ITALIE
P. 8–17
Au cœur des activités de ski haut-savoyardes, Chamonix est séparé de Courmayeur, en Italie, par le mont Blanc, point culminant des Alpes et épicentre mondial d'aventures alpestres, de pistes de ski sinueuses pour la descente et le fond, ainsi que de longs sentiers de randonnée.
Mont Blanc
Massif des Alpes gréées à cheval sur la frontière franco-italienne, le mont Blanc (4 809 mètres) est le point culminant de l'Europe de l'Ouest. La première ascension homologuée date de 1786. Aujourd'hui, 20 000 grimpeurs atteignent le sommet chaque année. Le record d'ascension aller-retour est d'un peu moins de cinq heures.

VERBIER, SUISSE
P. 20–32
Attirant des têtes couronnées et des riches aux poches plus profondes que ses vallées, ce village enneigé valaisan appartenant à la région touristique des Quatre Vallées se veut la capitale du « hors-piste. »

OBERLAND BERNOIS, GSTAAD, ROUGEMONT, LAUTERBRUNNEN
P. 32–55
L'Eiger
Figurant parmi les emblèmes des Alpes suisses, l'Eiger, (3 970 mètres) domine Grindelwald et Lauterbrunnen, dans l'Oberland bernois.
Gstaad
Ville de l'Oberland bernois (« Haut pays de Berne »), Gstaad est située dans le sud-ouest de la Suisse. Écrin enneigé de félicité suisse, cette station réunit ce qui se fait de mieux en matière de beauté et de luxe alpins avec ses 220 km de pistes skiables. En saison, les « acteurs » sont aussi importants que le cadre, dans lequel célébrités passées et actuelles viennent se distraire en été.

L'ITINÉRAIRE DU GLACIER EXPRESS
P. 56–79
La plupart des sommets les plus emblématiques des Alpes bordent l'itinéraire du Glacier Express, qui relie les célèbres stations de Zermatt et de Saint-Moritz en suivant, 8 heures durant, un trajet sinueux jalonné par 91 tunnels et 291 ponts.

ZERMATT
P. 57–65
Cliché alpestre, Zermatt est une ville scintillante aux rues étroites, avec ses chalets en bois et ses calèches à l'ombre du Cervin, l'un des sommets les plus photographiés au monde. À 4 478 m, le massif offre des pistes longues et variées – et du ski sur glacier en été – que l'on peut relier par des télésièges high-tech et des bus solaires, incarnation même de la « suissitude ».

ANDERMATT
P. 66–75
Après 30 ans en sommeil, Andermatt s'éveille pour devenir le plus grand domaine skiable du centre de la Suisse. Des fonds internationaux de 1,7 milliard € ont été investis pour créer des remontées mécaniques volant la vedette aux extraordinaires trains qui empruntent les tunnels pour emmener d'intrépides skieurs dans les couloirs de hors-piste du Gemsstock. Géographiquement coincé entre les hauts lieux hivernaux de Zermatt et de Saint-Moritz, Andermatt, jadis nœud de circulation entre l'Italie et l'Europe du Nord puis base de l'armée suisse pour l'entraînement à la guerre en montagne, reste le principal village de la vallée de l'Urseren.

SAINT-MORITZ ET ENGADINE
P. 76–79
Saint-Moritz rime avec superlatifs : station de ski alpin la plus ancienne, la plus célèbre et la plus ensoleillée, elle offre la plus large gamme de sports d'hiver, en dehors du ski sur les 350 km de pistes. Le lac gelé éponyme sert de cadre à des compétitions de skating, de curling, de golf et de polo, des courses de chevaux et même du cricket. La ville accueille la Cresta Run, une course sur glace masculine et possède la seule piste de bobsleigh naturelle du monde. Au XVIe siècle, les pèlerins venaient boire l'eau des sources minérales de Saint-Moritz. Aujourd'hui, les lacs de la Haute-Engadine attirent des bulles – et des pèlerins – d'un autre type.

L'ARLBERG, SANKT ANTON, ZÜRS, LECH, WARTH
P. 80–130
« Tout photographe espère ce moment magique où la lentille capte littéralement l'image. Dans l'Arlberg, c'est toujours le cas. » Tim Hall

Ce col alpin d'altitude relie le lac de Constance dans le Vorarlberg, Innsbruck au Tyrol et les anciens villages paysans devenus des stations de ski huppées : Lech, Zürs, Warth, le hameau d'altitude de Sankt Christoph et l'écrin alpin de Sankt Anton, aussi fameux pour ses pentes que pour ses loisirs en soirée. Dans ce haut lieu du ski autrichien, il y va autant de la maroquinerie fine que des sommets enneigés : élégants et sportifs vont de pair, comme les skis parallèles en descente.

OMESHORN
P. 96–99
Omeshorn (2 557 m), dans le Vorarlberg, est l'emblématique montagne d'Autriche qui protège les célèbres villages de ski de Lech, Zug et Zürs en contrebas.

LE ZUGSPITZE
P. 131–134
Formant une frontière entre la Bavière en Allemagne et le Tyrol en Autriche, le Zugspitze (2 962 m) est le plus haut sommet d'Allemagne, dont il abrite l'église d'altitude la plus élevée. Du sommet, on peut admirer 400 pics de quatre pays différents.

KITZBÜHEL
P. 135–165
Située à la confluence de trois vallées d'Autriche, cette cité médiévale fait le trait d'union entre les sommets d'un massif s'étirant sur près de 24 km. L'une des premières stations de ski, elle a longtemps été le camp de base alpin des nantis et des fous de vitesse : disputé en janvier, le Hahnenkamm-Rennen est l'épreuve de descente la plus exigeante du circuit de la Coupe du monde de ski alpin.

LES DOLOMITES
P. 166–195
Les Dolomites regroupent 18 sommets du nord-est de l'Italie suivant un profil caractéristique alternant falaises abruptes et promontoires rocheux, que Le Corbusier a décrit comme étant « la plus belle œuvre architecturale au monde ». Phénomène célèbre, les monts se teintent en rouge (enrosadira) lorsque les rayons du soleil couchant atteignent la dolomite – formation granitique qui a donné son nom au massif.

Les Dolomites reflètent le mélange typiquement alpin entre ancienneté et modernité. Certains villages isolés au plus profond de la vallée continuent de parler le ladin, une langue romane. Ce qui contraste fortement avec le charisme cosmopolite de Cortina d'Ampezzo, où les manteaux en vison sont obligatoires.

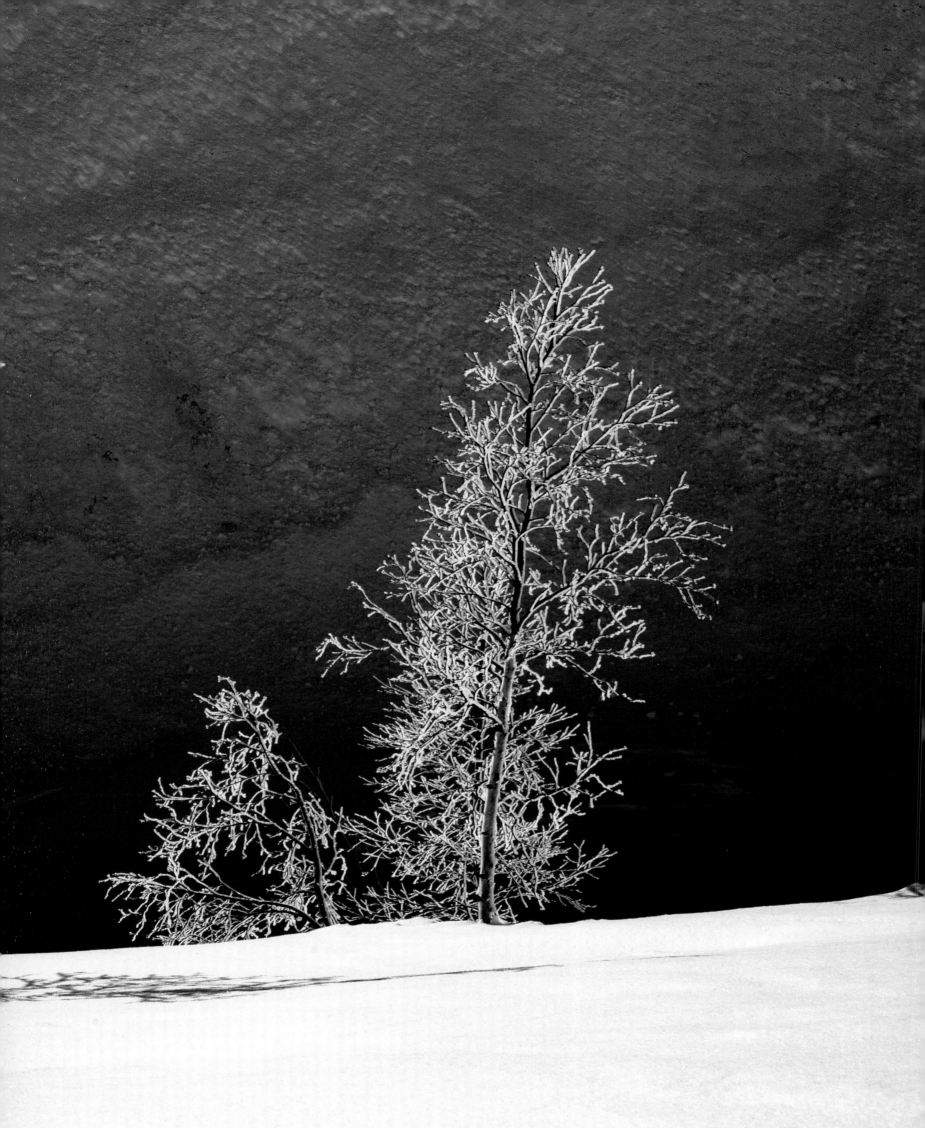